*Kingdom of Beauty*

ASIA-PACIFIC:

CULTURE, POLITICS,

AND SOCIETY

*Series Editors:* Rey Chow,

H. D. Harootunian,

and Masao Miyoshi

A STUDY OF

THE WEATHERHEAD

EAST ASIAN INSTITUTE,

COLUMBIA UNIVERSITY

# Kingdom of Beauty

MINGEI AND THE POLITICS OF

FOLK ART IN IMPERIAL JAPAN

## KIM BRANDT

Duke University Press  Durham and London  2007

© 2007

DUKE UNIVERSITY PRESS

All rights reserved

Printed in the United States of

America on acid-free paper ∞

Designed by Amy Ruth Buchanan

Typeset in Quadraat by Keystone

Typesetting, Inc.

Library of Congress Cataloging-in-

Publication Data and republication

acknowledgments appear on the

last printed pages of this book.

For Vincent and Hi Kyung Brandt

# Contents

# Acknowledgments

A great many people have helped me to write this book. I am delighted to be able to acknowledge my debt to them. First, I thank Carol Gluck. Her passionate commitment to the art and science of Japanese history writing and the generosity and integrity of her teaching have shaped my scholarship—as indeed she has shaped the entire field of Japanese studies. It is a privilege to be her student. I have also learned much from Henry Smith, whose encyclopedic knowledge about the Japanese past and rigorous standards of scholarship and writing continue to inspire me and many others to ever renewed efforts. At Columbia I was also aided by Betsy Blackmar, Barbara Brooks, Victoria de Grazia, and Nancy Stepan. Among the dozens of fellow graduate students who buoyed me and this project in its early years, I owe special thanks to the members of my dissertation writing group: Kristine Harris, Charles Laughlin, Hiroshi Ohta, Andre Schmid, Kris Torgeson, and Margarita Zanasi.

During two periods of research in Japan I received extraordinary kindness, guidance, and support from the modern Japan historians at Waseda University, particularly from Kano Masanao, Yui Masaomi, Anzai Kunio, Kitagawa Kenzō, and Okamoto Kōichi. I am also deeply indebted to the staff of the Nihon Mingeikan, especially Sugiyama Takashi, Mimura Kyoko, and Utsumi Teiko. Sugiyama-san, in particular, was unstintingly helpful, friendly, and generous as a guide to the world of folk art (and good food) in Tokyo and beyond. While he and his colleagues may not agree with all of the arguments presented here, I hope they will tolerate them as an earnest effort to make my

own sense of the mingei archive. Also very helpful and encouraging in Japan were Ajioka Chiaki, Noriko Aso, Alan Christy, Igarashi Akio, Masui Yukimi, Janice Matsumura, Nakami Mari, Narita Ryūichi, Lucy North, Ōshita Atsushi, Greg Pflugfelder, Louisa Rubinfien, Barbara Satō, Satō Kazuki, Sarah Teasley, and Louise Young.

A number of friends and colleagues have read all or part of the manuscript at different points in its gestation. For their comments and support, I thank Cathy Ciepiela, Janet Gyatso, Margaret Hunt, Mark Jones, Mary Jones, Okamoto Kōichi, Janet Poole, Sean Redding, Jordan Sand, Andre Schmid, Mark Shapiro, Alan Tansman, Miriam Wattles, Gennifer Weisenfeld, and Kären Wigen. I owe a special word of thanks to Harry Harootunian, who has been a bracingly critical reader for many years now.

Various institutions helped to defray the costs of research and writing. I am grateful to Columbia University, the Japan Foundation, the Social Science Research Council, the Matsushita Foundation, the Whiting Foundation, and Amherst College. At Duke University Press, Reynolds Smith, Sharon Torian, and Pam Morrison have shown great patience as well as professionalism in guiding the manuscript and its author through the process of academic book publishing.

This book received its inspiration from my parents, Vincent and Hi Kyung Brandt. Indeed, it was my father who first suggested the topic to me. Finally, I thank Mark and Ezra Jones, whose love, patience, and boundless good humor have been most important of all.

# Introduction

In many parts of the world, the years after World War I witnessed an upsurge of interest in the lives of those groups ordinarily relegated to the margins of modern, industrial society. One consequence was the discovery of various types of "primitive" and "folk" art. First collectors and artists, and later a broader public, began to admire not only the art and artifacts produced by tribal peoples of Africa, Oceania, and the Americas, but also the work of outsiders closer to home, such as children, immigrants, the insane, and the rural folk of both the present and the past. Interest in these groups was, of course, not new in the early twentieth century. The modern study of folklore, for example, had its beginnings a century earlier, in the efforts of German and British scholars to unearth what they romanticized as the surviving vestiges of ancient national traditions.[1] The emergence of the Arts and Crafts movement in 1880s England, and shortly thereafter in other parts of Europe and in the United States, partook of the same nineteenth-century impulse to idealize the national past; at the same time, it was shaped by an antimodernist reaction against urban industrialization and promoted, ironically, by the habits of domestic consumption among a rising bourgeoisie.[2] And there were even older antecedents to the interwar discovery of folk culture. In Japan and China, for example, twentieth-century interest in the folk was informed not only by earlier developments in Europe and the United States, but also by much older, indigenous histories of curiosity among the literati about rural customs, lore, and material culture.[3] Nevertheless, the middle-class intellectuals who embraced folk culture and folk art in 1920s Tokyo or

in Beijing, or Berlin, Paris, Dublin, New York, or Mexico City, were also doing something new, for reasons and in ways that were peculiar to their own, very modern moment.[4]

This book takes as its subject the rise of folk art in Japan. By focusing on folk art in prewar and wartime Japan, and in particular on the activities of those collectors and artists associated with what would later become known as the *mingei*, or "folk-craft," movement, this study seeks to illuminate yet another aspect of Japan's modern experience as a nation-state struggling to find its place within a highly unequal international order. It might reasonably be asked why, in telling the story of folk art in Japan, I have chosen to focus on the advocates of mingei and not on the many other groups who admired and studied the arts and crafts of rural Japan. After all, Tokyo in the 1920s and 1930s was bustling with aesthetes and scholars preoccupied with the objects they called, variously, *minzoku geijutsu* (folk art), *nōmin bijutsu* (farmers' art), *mingu* (folk implements), *nōmin tekōgei* (peasant handicrafts), or *kyōdo gangu* (local toys), to name just a few terms. The most immediate and obvious reason is that the mingei group won the contest to define folk art in Japan. By the end of World War II, mingei as a term and idea had received official approval and ratification from the Japanese state. A decade or two later, mingei, a neologism coined in the late 1920s, was well on its way to becoming a household word, a widely diffused type of commodity, and a seamless part of the common sense of Japanese cultural identity. Nor has the dissemination of mingei been restricted to Japan. Unlike the various other candidates that jostled in the 1920s and 1930s to name the ceramics and textiles and other artifacts of the preindustrial Japanese farm household, the category of mingei has been exported successfully to North America and Western Europe, where it is commonly employed by museum curators, art dealers, collectors, and the like.

In many respects, we can understand the emergence of folk art in Japan as part and parcel of a more common, indeed a global, phenomenon. As in other parts of the early-twentieth-century world where the primitive aesthetic found increasing favor, the Japanese discovery of folk art was shaped by imperialism and colonialism, by new strains of nationalist thought and feeling, and by the structures and processes of industrial capitalism. Japan's experience was thus similar to that of many other modernizing countries, and the story of mingei is one that compares readily to the story of folk art in bourgeois nation-states everywhere. Yet there are also important differences to be noted in the Japanese case.

The rise of mingei was also shaped by the peculiarities of Japan's condition as a late-developing, non-Western society in a world order dominated by the industrialized Western powers. In seeking to build a modern nation-state capable of resisting European and U.S. imperialism, Japan's governing elites undertook to make Japan itself an imperial power—by annexing and colonizing the island of Formosa (Taiwan) in 1895, then Korea in 1910, and by engaging in various types of informal empire in mainland China and later in the Pacific region and Southeast Asia. Chapter 1 considers, therefore, the origins of the Japanese discourse on folk art in the ambivalence of a non-Western imperialism. Several of the young collectors and artists who would later be recognized as key figures of mingei—namely, Yanagi Muneyoshi (1889–1961) and his friends and associates—began their careers as champions of folk art by embracing the material culture, and particularly the ceramics, of Korea's Chosŏn period (1392–1910).[5] An examination of the texts produced by Yanagi and others on Korean arts and crafts suggests the pivotal influence of what might be called an Oriental orientalism on the invention of folk art in Japan.[6] At the same time the Japanese appreciation of Korean art, and later of folk art in Japan and elsewhere in Asia, not only reflected Japanese colonial power but also helped to shape and augment it. Thus chapter 1 explores the specific ways Yanagi's efforts to celebrate and promote Korean art aided in producing legitimacy for Japanese rule in Korea. Later, during the wartime years of the late 1930s and early 1940s, the definition of mingei expanded to include not only Japanese handicrafts, but also the folk art of the Ainu and of Korea, China, Manchuria, Okinawa, and Southeast Asia. Chapter 5 takes up the story of Greater East Asian mingei to show that folk art became an integral part of the Japanese state's project to construct and justify an autarchic regional empire in Asia.

The process by which Japan became modern is also distinguished by the nature of the relationship that developed between state and society. In a manner reminiscent of the statist polities of continental Europe, especially Germany, Japanese public life before (and to some degree even after) 1945 was dominated by a powerful bureaucratic state which conceived of itself as a transcendent entity above the society it managed. As Sheldon Garon has argued, however, one especially distinctive feature of the Japanese brand of bureaucratic statism is that it was consistently employed to manage aspects of ordinary, everyday life through campaigns of "moral suasion" featuring the active participation of groups of middle-class reformers.[7] This insight helps to explain the nature of the folk art, or mingei, movement. That is, it

offers an explanatory context within which to understand how and why the middle-class intellectuals preoccupied with folk art in the 1920s and 1930s found themselves translating their private predilections into public programs for social and cultural reform. Chapters 2 and 3 show that mingei, initially a type of antique curio associated with literati collectors, was redefined to serve as a means both of revitalizing rural society and of producing moral-aesthetic uplift in urban households. The mingei movement, which emerged in the early 1930s, gained momentum as certain key collectors and artists sought to achieve greater influence for their ideas by joining with new constituencies, including local elites and the representatives of government agencies.

And yet the story of folk art not only illustrates but also complicates the idea that a collaborative relationship developed in the first half of the twentieth century between Japan's middle class and the imperial state. Chapters 2 and 3 present evidence suggesting that folk art activists were oriented to social reform efforts for reasons that included, but were not limited to, a commitment shared with higher civil servants to the top-down betterment of Japanese society at large. Just as salient, I argue, was the competition between various segments of an increasingly dynamic and complex social "middle." The men who first championed folk culture in the early decades of the twentieth century tended to be the representatives of an older cultural elite whose social power derived from a monopoly on certain forms of educational and aesthetic capital. Their position was challenged, however, by the cultural pretensions of a rising industrial haute bourgeoisie on the one hand, and the emergence of new groups of upwardly mobile men and women gaining access to higher education on the other. The development of the mingei movement as a campaign to reform Japanese society in tandem with state initiatives and agencies also represented, therefore, a potent means for one group of middle-class elites to retain and even increase their power and status in the context of a rapidly changing society. As such, it offers another perspective from which to analyze the interaction of middle-class reformers with both state and society.

Finally, close study of mingei highlights the special role played by aesthetic capital in the emergence of a distinctively Japanese modernity. As noted earlier, individual taste and standards of aesthetic cultivation were vital to the negotiation of bourgeois class status in early-twentieth-century Japan. Of course, the mastery of tasteful consumption appears to have operated as a crucial means of class distinction in modern capitalist societies

generally.[8] Nevertheless, in Japan certain forms of aesthetic mastery associated with traditional arts and crafts, and particularly with the practice of the tea ceremony, possessed an unusual degree of social prestige owing to their association with various old as well as new cultures of elite masculinity. This helps to explain the embrace of folk art by new middle-class groups during the 1920s and 1930s, when a rapidly industrializing economy, an expanding educational system, and the growth of cities and suburbs intensified the struggle to define modern bourgeois identity.

Aesthetics also proved useful to the Japanese state in its efforts to promote economic and political power abroad, as well as national integration at home. In this sense Japan's experience bears some resemblance to that of France. Like the nineteenth-century French state, the Meiji government deliberately sought to build upon the international reputation of Japanese decorative arts in order to increase exports and also as a means of enhancing its cultural and political authority.[9] By the early twentieth century, however, the elaborate and luxurious types of art-craft for which Japan was known in the West were becoming the relics of a bygone Victorian era. Costly and inefficient to produce and increasingly difficult to sell, luxury arts and crafts seemed more a liability than an asset—or ornament—to a would-be modern world power. The interwar years were a time of stylistic uncertainty for the Japanese state, therefore, when it was unclear how or even whether it would be possible to continue to capitalize on the idea of a native aesthetic tradition in promoting national goods and identity.

Chapter 4 argues that the prosperity and growth of the mingei movement during the late 1930s and early 1940s can be attributed at least in part to the active patronage of the state, which recognized in folk art the potential for an updated national aesthetic. Initially mingei appealed to bureaucrats concerned with national industry and trade as a design resource that was both modernist and Japanese and that might therefore revive export markets in Europe and the United States. More significant, however, was the favor folk art found with the "renovationist" or fascist officials and agencies who were determined to mobilize the entire nation, and indeed much of Asia, in the cause of Japan's total war. Government ideologues and propagandists embraced the arts and crafts of an idealized folk as a means of insisting on national, and also imperial, unity. For, as explored in Chapter 5, the folk aesthetic was also put to use as a means of integrating Japan's Asian empire. During the late 1930s and early 1940s, mingei activists worked in Korea, Okinawa, Hokkaido (among the Ainu), Manchuria, and Japanese-occupied

China to help construct a Greater East Asian culture of daily life. A judicious blend of native arts and crafts with Japanese technology and taste would produce, they hoped, a new lifestyle free of the yoke of Western commercialism and capable of joining Asians everywhere in the "coprosperity" promised by their Japanese rulers.

Readers familiar with mingei will be surprised, perhaps, to find relatively little discussion here of the most famous individuals associated with it. Some of the most distinguished artists of twentieth-century Japan spent all or many of their most productive years as leading figures in the Mingei Association. The internationally known artist-potters Hamada Shōji, Kawai Kanjirō, Tomimoto Kenkichi, and Bernard Leach were all closely associated with mingei, as were the dyer Serizawa Keisuke, the woodworker Kuroda Tatsuaki, the woodblock print artist Munakata Shikō, and others. The central theorist of mingei, the collector Yanagi Muneyoshi, was a prolific writer who early achieved renown as a public intellectual with expertise in literature, philosophy, and religion, as well as in art generally and folk art in particular. Yet while numerous biographies, memoirs, exhibition catalogues, and other studies and compilations dealing with these men and their individual achievements have been published over the years, there has been relatively little attention to the mingei endeavor as a larger, collective enterprise. Those relatively few studies that have ventured to treat mingei as a larger movement or project have tended to focus primarily on its contributions to the history of Japanese art; as a consequence, the lives and work of artist luminaries such as Kawai and Hamada, or of the presiding genius Yanagi, remain the dominant subjects of study.

I have sought instead to approach mingei less as a given genre of art and more as a changing cultural and social category that was created and negotiated by many more individuals, groups, and institutions than those enumerated by the standard narrative. This study focuses on the critical period between 1920 and 1945—which includes the often overlooked "dark valley" of the wartime years—to explore the role played in defining and promoting folk art not only by Yanagi and his artist friends, but also by a host of lesser known figures: provincial intellectuals and collectors, local artisans, government officials, merchants, magazine editors, and middle-class shoppers. I hope that what this book has given up in close attention to the biographies of the great men of mingei, it makes up in the alternative, broader perspective offered on the field of cultural production in modern Japan.

ONE. *The Beauty of Sorrow*

In the fall of 1914 Asakawa Noritaka, a Japanese schoolteacher in colonial Korea, paid a call on Yanagi Muneyoshi at his home in Chiba prefecture, outside Tokyo. Asakawa brought from Korea a Chosŏn-period ceramic jar, which he presented to his host.[1] The story has it that the twenty-five-year-old Yanagi fell in love with this object and that it helped to inspire in him a passionate interest in Korean arts and crafts generally. While Yanagi's fascination with Korean art persisted throughout his life, it was during the decade immediately following Asakawa's visit that he most avidly collected, appreciated, and promoted things Korean. Between 1914 and 1924, Yanagi made as many as ten trips to Korea, often staying for weeks at a time. In addition to building up his own celebrated collection of Korean ceramics and other objects, he devoted much of this period to writing a book and numerous articles on Korean art and related subjects, as well as giving well-attended public lectures in both Korea and Japan. He also joined with friends to organize several art exhibitions in both countries and led a widely publicized and successful campaign to establish a museum of Korean art in Seoul. The opening ceremonies for the Korean Art Museum (Chōsen minzoku bijutsukan), as it was rather daringly named, were held in April 1924.[2]

After 1924, Yanagi's focus shifted to the arts and crafts of his native Japan. Only two years later, he was at the center of a small group who declared themselves the champions of a category of objects they would name "mingei" (folk-craft).[3] Their April 1926 manifesto, a pamphlet titled "Prospectus for the Establishment of a Mingei Art Museum," is often taken to mark the

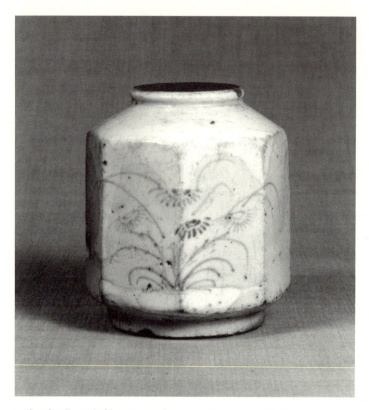

1. The Chosŏn-period jar presented to Yanagi by Asakawa Noritaka in 1914. It is often suggested that Yanagi's interest in Yi dynasty wares dates from his encounter with this object. Courtesy of Nihon Mingeikan.

establishment of the so-called mingei movement (mingei undō), a loose assemblage of artists, craftspeople, collectors, and others generally thought to have concerned themselves with the discovery and promotion of a rustic, artisanal, and, above all, Japanese aesthetic.

Yet even today, the Korean objects admired so extravagantly by the youthful Yanagi remain embedded within mingei ideology and practice. It has become a truism among chroniclers of the movement that Yanagi was led to discover mingei as a result of his enthusiasm for Korean arts and crafts. In a sense, the origins of mingei are acknowledged to be Korean. Moreover, the specific Chosŏn-period Korean objects Yanagi praised and collected continue to help define the mingei aesthetic. One room of the Japan Folk-Crafts Museum (Nihon Mingeikan) in Tokyo, established in 1936 under Yanagi's

direction, remains permanently dedicated to their display. For sale in the museum shop, as in all museum shops, are picture postcards of exemplary objects from the collection; almost always available are several reproductions of especially well-known Korean items. The curators of the museum actively maintain their status as experts on what is known in Japan as "Ri chō," or Yi dynasty.[4] For example, two glossy paperback guides to the collection and appreciation of Yi dynasty crafts were published in 1998; one was produced under the guidance of members of the museum's curatorial staff, who also contributed essays to both volumes.[5]

Korea also remains central to Yanagi's postwar status as a public intellectual. The reverence in which Yanagi's life and work are held by many both within and beyond mingei circles owes no small part to the reputation he gained posthumously, during the 1960s and 1970s, as a heroic defender of Korean art and culture against the once imperialist Japanese state. This reading of Yanagi's activism on behalf of Korean art was given influential expression by the well-known cultural critic Tsurumi Shunsuke, for whom Yanagi represented a rare instance of "gentle stubbornness" (odayaka na gankosa) in his resistance to wartime ideological mobilization. According to Tsurumi, Yanagi's attachment to Korean art, and his gently stubborn acknowledgment of a separate and honorable Korean cultural identity, were key demonstrations of his unwavering opposition to the imperialist militarism of the wartime Japanese state.[6] Even the Japanese Ministry of Education may be said to have promoted Yanagi's postwar identity as an advocate for Korean culture against Japanese colonial rule; a 1974 high school Japanese (kokugo) textbook approved by the Ministry included the text of an emotional essay written by Yanagi in 1922 protesting the projected destruction of a historic Seoul landmark by the colonial government.[7]

The postwar characterization of Yanagi as anticolonialist hero of Korean art has not gone unchallenged. During the mid-1970s, in particular, the publication of a Korean translation of Yanagi's 1922 book Korea and Her Art (Chōsen to sono geijutsu) was the occasion for a spate of critical writings in Korea on what the poet Ch'oe Harim, who wrote an essay for the translation, called Yanagi's "aesthetics of colonialism."[8] In the 1980s and especially in the 1990s, a number of Japanese scholars followed the Korean lead by developing further the arguments that Yanagi's approach to Korea and Korean art was flawed or somehow implicated in Japanese imperialism.[9] Yet for the most part these discussions stopped short of any consideration of how the colonialist or anticolonialist nature of Yanagi's Korean activities might be

related to the formation of mingei ideal and practice. Despite the close association—sometimes bordering on conflation—of Yanagi's life with the history of mingei activism, and despite the continuing importance within the folk-craft aesthetic of his Korean discoveries, the question of mingei's connection to Japanese colonialism in Korea or elsewhere has been little explored.[10]

By considering Yanagi's role in the emergence of Korean art, and especially in the emergence of the genre of Yi dynasty wares, it is possible to see that the categories of both Korean art and mingei were partly produced by Japanese colonial power in Korea. Yet the larger, if more diffuse workings of Western imperialism in Asia were also formative. During the Taishō era (1912–1926), Yanagi was only one among a number of cosmopolitan Japanese who partly turned away from Western high culture to celebrate the artistic and spiritual traditions ascribed to the "Orient" (Tōyō), a geocultural entity usually identified as comprising China, Japan, Korea, and India. The "return to the Orient" (Tōyō e no kaiki), as later scholars have referred to this fascination with the idea of an ancient Oriental civilization, represented a complex adaptation of Western ideas about the non-West. Yanagi and others accepted and employed Western systems of knowledge, including those mechanisms that, like the very idea of an Orient, implied Western superiority. At the same time, however, they sought to refute Western dominance by asserting indigenous Oriental value, and Japanese autonomy in particular.

The significance of the early-twentieth-century Japanese enthusiasm for Korean, Japanese, and other Asian objects must also be understood, therefore, within the context of a world increasingly dominated and defined by Western power. The discovery of Korean art, like the discovery of mingei, represented an effort to resist the controlling hierarchies and categories of Western knowledge. Yet the meanings and value that Yanagi and his cohort of collectors successfully attached to Korean objects were also instrumental in the reproduction of Japanese colonial power. The Korean art museum founded by Yanagi and his friends, for example, served ultimately to promote the legitimation and therefore the stability of the Japanese regime in Korea. More generally, the writings of Yanagi and his fellow enthusiasts of Korean art contributed to a larger body of colonial knowledge about Korea and Koreans. They praised Yi dynasty wares and the culture and people that produced them in terms that made Korea's status as a colonial possession of Japan seem both natural and inevitable.

*Canon Revision and the Uses of Colonialism*

Yanagi was certainly among the most prominent and active of those who took up Yi dynasty, or previously overlooked categories of Chosŏn-period Korean objects, during the early twentieth century. He was by no means alone, however. In addition to Japanese residents of Korea such as Asakawa Noritaka and his younger brother, Takumi, who helped to tutor Yanagi in the appreciation of Chosŏn ceramics, woodwork, and other wares, there were others based in Japan who, like Yanagi, were struck by the new aesthetic possibilities to be found in relatively humble objects of Korean provenance. An alternative narrative of Yanagi's discovery of Korean art, for example, suggests that he was introduced to it by his friends Bernard Leach and Tomimoto Kenkichi, artists who had both become ardent admirers of Chosŏn ceramics after viewing some examples at a colonial exposition in Tokyo in 1912.[11]

The young men who began to congregate in Seoul and Tokyo around their shared enthusiasm for later Chosŏn-period porcelain and stoneware were also linked by similar social and cultural station. As middle-class intellectuals—artists, writers, university students, teachers—they shared a somewhat precarious position as members of a cultural elite largely cut off from the monopoly capital that was rapidly producing a new haute bourgeoisie of industrialists and financiers.[12] Yet the opportunities opened up in Korea by Japanese colonial power gave Yanagi and his peers the means to contest the increasing sway of bourgeois economic elites in the cultural field, especially in the highly prestigious domain of art ceramics. By challenging the authority of the tea ceremony establishment in particular, Yanagi and other middle-class literati were able to revise the art ceramics canon in Japan to include the objects they had discovered in Korea. Through their success in promoting novel categories of Korean ceramics, they gained the cultural capital—or the status and authority—that enabled their campaign to promote mingei.

Korean ceramics have been highly valued in Japan for centuries. Certain types of Korean bowls produced during the Koryŏ (918–1392) and early Chosŏn periods, in particular, achieved iconic status during the late sixteenth century in the context of the elite practice of the tea ceremony. Over time there were vagaries in the popularity and status of Korean bowls relative to other, usually Chinese or Japanese teabowls. Nevertheless, the old tea maxim "First Ido [the most important category of Korean teabowl]; second

Raku; third Karatsu," which ranks Korean bowls above the two most famous types of Japanese teabowl, suggests the extent to which Korean ceramics achieved a preeminent position in one of the most influential aesthetic institutions of early modern and modern Japan.[13]

The importance of Korean bowls, many of them produced during the Chosŏn period, only increased during the early decades of the twentieth century, with the revitalization of the tea ceremony as a pastime for the very rich.[14] It may not seem surprising, therefore, that Japanese aesthetes and collectors of the early twentieth century were disposed to take an interest in the Korean ceramics rendered increasingly accessible by Japanese colonization. Indeed Yanagi himself often cited the aesthetic tradition of tea in explaining the importance he attached to Korean craft objects. He frequently expressed reverence for the creativity and sophistication demonstrated by the early tea masters who, in the early sixteenth century, first recognized the beauty of ordinary Korean rice bowls. Yanagi believed that the tea masters had thereby helped to form a special Japanese aesthetic in which his own discovery of Korean and, later, Japanese and other crafts shared.[15] He proposed that the regard in which he and other Japanese held the pottery and other arts of the Chosŏn period in Korea was an organic development of the Japanese aesthetic tradition and directly linked to the genius of Sen Rikyū, the most famous of the sixteenth-century tea masters.

Yet the enthusiasm of Yanagi and others for Yi dynasty ceramics, not to mention woodwork and other handicrafts, cannot be explained by the tea aesthetic alone. For one thing, the types of pottery and porcelain they helped to bring into vogue among Japanese dealers and collectors during the 1920s and 1930s were quite distinct from the older Korean bowls admitted within the tea canon. Many of the objects that would later come to epitomize Yi dynasty, such as white porcelain (hakuji) vases and other objects associated with Confucian ritual practices in Korea, or the small, whimsically shaped "water droppers" (suiteki) customarily used by Korean literati to wet their ink stones, had no function in the tea ceremony. Moreover, there was a difference between the way objects—Korean or other—were understood in the tea ceremony and the way they were approached by young Japanese collectors in colonial Korea. By the nineteenth century, the tea ceremony had become a site at which individual objects were appreciated as utterly particular and unique; to participate in the culture of tea was, in part, to accept a highly elaborated, semiapocryphal system of knowledge about a limited number of teabowls and other items. A cherished tea implement (cha dōgu), housed like

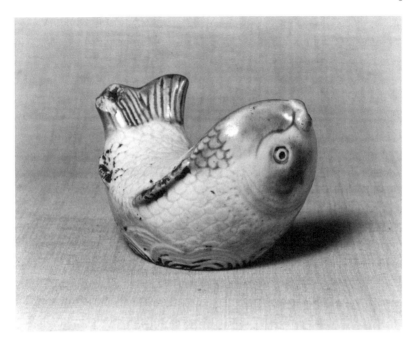

**2.** A Chosŏn-period "water dropper" (*suiteki*).
Courtesy of Nihon Mingeikan.

a jewel in layers of custom-made silk bags and inscribed boxes, was surrounded by an aura of iconic originality. Its value was produced largely by esoteric convention, which assigned it a name, a category, and a pedigree of origin, past ownership, and use.

By contrast, the middle-class intellectuals who browsed the antique shops and markets of colonial Seoul drew on a much more cosmopolitan, self-consciously modern fund of knowledge to evaluate objects. They used universalist standards associated with Western art and science to resist the parochial conventions of the tea world and to assert their own aesthetic authority. Yet at the same time they continued to rely on certain aspects of tea tradition to obtain legitimacy for their efforts to expand the field of collectible objects. Yanagi, for example, claimed that in promoting Yi dynasty ceramics (and, later, certain categories of Chinese, Southeast Asian, rural Japanese, and even English handicraft goods), he was reviving the true spirit of the early tea masters. Later followers of the first geniuses of tea, Yanagi charged, had fallen into an increasingly stylized and imitative formalism. He felt that the tea ceremony as practiced in his own day had lost most of its

originally creative character; it venerated the individual objects hallowed by centuries of tradition but failed to recognize the value that also existed in newer or otherwise unfamiliar things.[16]

Yanagi's characterization of the tea ceremony as an ossified, conservative set of persons and practices was not entirely fair. In fact, during the decades around 1900 the tea ceremony saw one of the more exuberant periods of change and creativity in its long history. Beginning in the 1880s and 1890s, tea was transformed from what had become a genteel, mostly private pastime for literary men into a highly competitive arena for the expression of power, status, and wealth by a variety of rising social groups.[17] Most conspicuously, during the economic boom associated with World War I, a new class of industrialists, particularly those connected with the Mitsui zaibatsu, or financial conglomerate, used their wealth to dominate the tea world with a lavish new style of tea that centered on the uninhibited acquisition and display of art objects new to the tea context.[18] Kumakura Isao, in his history of modern tea, argues that the new "zaibatsu tea" of late Meiji and Taishō manifested the capitalistic outlook of successful entrepreneurs reveling in their liberation from an earlier, Confucian suspicion of commerce and money. As a result, the style of tea promoted by these men was characterized by a hedonistic materialism. Spiritual or religious elements the tea ceremony had once incorporated were downplayed in favor of a frankly worldly concern with fabulously expensive tea implements, other art objects for display at tea gatherings, and the opportunities these provided for the negotiation of social status and power.[19]

In some ways zaibatsu tea brought a freer approach to tea practice and ideology in the early twentieth century. Its exponents brushed aside received conventions about the type of art suitable for display in order to introduce new categories of objects—namely, those of Buddhist art unconnected to the Zen sects or to tea practice—into the tearoom for the first time.[20] Yet at the same time zaibatsu tea reiterated and reinforced selected elements of the tea tradition, particularly as it concerned the canon of famous tea objects (meiki or meibutsu). The 1920s saw the publication of the Taishō meiki kan, an influential nine-volume photographic catalogue of pedigreed tea caddies and tea-bowls.[21] Its compiler, Takahashi Yoshio, a central figure in zaibatsu tea circles, intended the catalogue to provide a definitive modern accounting of objects belonging to the category of "celebrated tea implement." Yet with the Taishō meiki kan Takahashi actually managed to modify the existing canon even as he reestablished and buttressed its parameters.[22] In so doing, he

reinscribed a hierarchical ranking of ceramics from the perspective of a tea establishment newly invigorated by the infusion of monopoly capital.

Yanagi's critical attitude toward the modern tea ceremony may have had as much to do with the changing nature of the tea world as with its alleged inertia. Nor was he alone in such criticism. The luxurious hedonism that zaibatsu tea represented came to seem increasingly irresponsible and extravagant as the interwar Japanese economy slumped and social issues concerning the urban and rural poor acquired new urgency.[23] Moreover, the growing cachet of the tea ceremony as a form of conspicuous consumption drove the tea goods market to unprecedented heights, richly rewarding the captains of industry who already owned most of the "celebrated tea implements," but probably disgruntling aesthetes with more limited incomes. As Yanagi wrote in 1928, "Today such things as the making of tearooms with great refinement, at the cost of a thousand yen, must be called contrary to the true spirit of tea."[24]

For men such as Yanagi, colonial Korea offered special opportunities to counter the hegemony, reinforced by big money, of the tea tradition over the production and consumption of art ceramics in Japan. Perhaps the first to exploit these opportunities was Asakawa Noritaka, later known in Japan as the "patron saint of Korean pottery" (Chōsen tōki no kamisama). As noted earlier, it was Asakawa who is said to have first introduced Yanagi to Chosŏn-period ceramics. In 1913, three years after Japan's formal annexation of Korea, Asakawa moved to Seoul from his native Yamanashi prefecture, where he descended from a line of literary gentry, to take a position as an elementary school teacher. An aspiring sculptor and a tea aficionado himself, Asakawa was frustrated by his inability to afford the types of Korean ceramics favored by most Japanese collectors. Aside from the individual bowls hallowed by tea tradition, the Korean pots admired in Japan, as elsewhere, tended toward the impressive Chinese-style wares produced for ruling elites before the Chosŏn period. Writing much later of the magnificent pieces of old "celadon" he first admired in the Yi Royal Household Museum in Seoul, Asakawa described his frustration as it led to the discovery of a more accessible category of objects: "At that time I was only too sad. I wanted just one good piece, but they were too expensive for me. One night, passing in front of a Keijō dōguya [antique or tea implement store], I saw among the jumble of objects a white pot gleaming in the light of the streetlamp. I was drawn to this gently rounded thing, and stood looking at it for some time. This experience is even now stained deeply in my heart."[25]

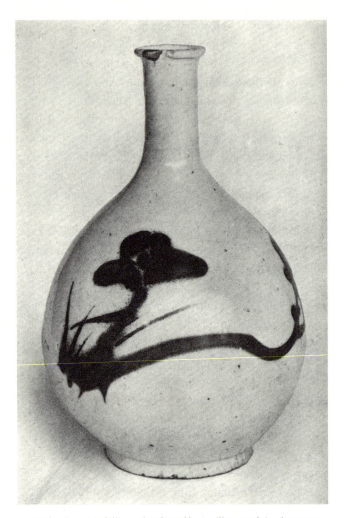

**3.** A Chosŏn-period liquor bottle (*tokkuri*), illustrated in the January 1932 issue of *Kōgei*. Yanagi wrote of the bottle, then in the collection of the Korean Art Museum, "The artisan was free. He was not limited by the intention of painting a beautiful design. He did not have consciousness of such things as 'this design is beautiful.'" From *Kōgei* 13 (January 1932): 22.

Asakawa identifies this moment as the point from which his career as an expert on Korean pottery began. (He quit his teaching job in 1919.) The pot was an example of a type of Chosŏn porcelain, distinguished by its milky whiteness, that later became especially popular in Japan.

Yi dynasty white porcelain, along with other types of Korean ceramics from the later Chosŏn period, was relatively cheap and plentiful. Asakawa and other Japanese with more taste and information than money—salaried employees of the colonial government or of private Japanese enterprise in Korea, scholars and writers, students, artists—took it up in part because they could afford it. Akaboshi Gorō, another authority on Yi dynasty, later wrote of his early days antique hunting in colonial Seoul (or Keijō, as it was called by Japanese) that he, like Asakawa, had at first been attracted to so-called celadon porcelain from the Koryŏ period but had been unable to pay the steep prices it commanded on the market:

> At that time it was Asakawa Noritaka who opened my eyes to the overlooked Yi dynasty things. I jumped at the opportunity to have him take me around to all the Keijō antique shops. What now seem astonishingly good pieces were lying around all over the place. Most of what I now own I obtained in Keijō. . . . In those days there were lots of [Japanese] antique dealers in Keijō. . . . In addition there were a great many Korean antique dealers, who mostly had junk shops and sideline businesses. I would be in front of a shop, and a *yobo* (a laborer) would come carrying a Buddha or a bronze piece or a pot wrapped in a cloth, and then he and the shop owner would begin to bargain. Finally the *yobo* would leave, and then the piece just bought would be priced at a hundred times the amount paid. Until I got used to it, I found this kind of thing truly unpleasant, but because it was clear that the objects would end up being sold somewhere, I had to buy them.[26]

Akaboshi offers here a glimpse into the colonial market relations that made it possible for him and other Japanese of relatively limited means to amass, despite the occasional pang of conscience, what later became extremely valuable collections of Korean art. Even at prices that returned large profits to Japanese (and some Korean) dealers, Japanese collectors found Korean art objects a good bargain.[27]

In addition to collecting ceramics, Asakawa devoted much of his twenty-odd years in Korea to the investigation of hundreds of old kiln sites in an effort to correct the errors of Japanese tea lore about Korean teabowls. His

challenge to the hegemonic ideology of ceramics purveyed largely by the tea establishment was not confined to the assertion of independent aesthetic authority that Yanagi appeared to find sufficient. Yanagi, already famous due to his close association with the influential *Shirakaba* (*White Birch*) art and literary magazine (published 1911–1923), through which he helped to introduce canonical elements of Western high culture to Japan, simply dismissed later developments in tea as formalist decadence. He suggested that his own preferences in art ceramics, like the genius of the early tea masters, drew on what he construed as a universal realm of aesthetic value to which he, as a recognized expert on Western art, had special access. Asakawa, a provincial schoolmaster, was perhaps less comfortable snubbing the aesthetic conventions of the rich and venerable. Instead, he bolstered his attack on tea knowledge with science. In 1934 Asakawa gave an address in Tokyo on the subject of his pottery investigations:

> Even when the [ceramic] objects that came [to Japan from Korea] in long ago times have written explanations attached to them, these are the judgements made from four-and-a-half mat tearooms by tea people. Because they did not actually know Korea, these judgements are nothing more than flights of fancy. They knew almost none of the facts. . . . If, first, [an object's] place of origin, the period when it was produced, and the conditions of its transmission become clear, then for the first time it will become a proper historical source. For example, when we talk of the Korean teabowl categories of Ido, Totoya, Soba, Katade, Gohon, these are all conventions derived from superficial observation; what is referred to as correct knowledge about these categories consists of the records made regarding individual bowls, and these are nothing more than conventions limited to the tea world. . . . In these days, which are liberated historically and geographically, I think that it is our job to investigate such things on the basis of a correct foundation.[28]

In this lecture Asakawa noted the special advantages of his time and place in colonial Korea. Although he expressed some irritation with the suspicion and passive resistance he encountered from Koreans during his excavating expeditions, he stated, "Ever since the annexation, everything [in Korea] has come to light, and things which were buried unused in the ground have appeared here and there; from the standpoint of research, this is the best of times."[29]

Asakawa's findings appear to have troubled the tea establishment. Takahashi Yoshio, when compiling the three volumes dealing with Korean tea-bowls in the nine-volume *Taishō meiki kan*, felt himself compelled to make repeated references to Asakawa's investigations in Korea and the new critical light in which they cast many of the received traditions of the tea world.[30] Takahashi resolved his dilemma by regretting that it was too late for him to fully assimilate Asakawa's contributions in the *Taishō meiki kan*: "Because I myself wish to go to Korea after the publication of this catalogue is completed, and do research there, for the time being I will base my commentary here on the past sayings of tea people, and hope to elucidate with regard to new facts such as those cited above at some other time."[31] However that elucidation may have been managed, the authority of tea ideology was gradually forced to retreat, in the face of empirical contradiction, from its original monopoly on the truth of Korean-Japanese pottery.

In their resistance to the authority of tea, and in their efforts to draw attention in Japan to previously overlooked categories of art ceramics, Yanagi and Asakawa joined a more general trend in ceramics appreciation. Scholarly groups like the Tōjiki kenkyūkai and the Saikōkai, whose leading members were attached to Tokyo Imperial University, and the Chōsōkai at Waseda University dedicated themselves to the scientific study and appreciation of old Japanese, Chinese, and other Asian ceramics. Their efforts were partly inspired by the example—and threat—of European and American scholars and collectors, whose access to certain types of Japanese and other Asian art treasures had only been facilitated by the narrow scope of tea taste.[32] At the same time they, like Yanagi and Asakawa, were often collectors of relatively limited means who sought to broaden the field of art ceramics eligible for legitimate appreciation.

But Asakawa, Akaboshi, Yanagi, and the other early collectors of Yi dynasty pottery and porcelain also used the advantages of their position in colonial Korea, in combination with the tools of Western-style knowledge, to force open the categories of collectible art in Japan. They became cultural heroes of a sort for establishing a distinct subfield in the appreciation of ceramics that was both independent of tea taste and yet partly informed and legitimated by it. As a measure of their success, Japanese demand for Yi dynasty grew rapidly during the early twentieth century, spreading from colonial residents and visiting cognoscenti in Korea to the metropolitan market in Japan. So popular did several types of the Chosŏn-period pottery and porcelain first collected by Yanagi and his peers become that there also

emerged a lively trade in Yi dynasty fakes, known sometimes as "Taishō Ri chō" (Taishō Yi dynasty).[33]

In successfully revising the canon of Japanese art ceramics, intellectuals and artists like Yanagi and Asakawa were able to wrest some of the leadership in the prestigious field of art ceramics from bourgeois economic elites, who were bidding for dominance from their new power position within the tea establishment. Colonial opportunities allowed middle-class literati to parlay modest investments into enormous returns in cultural capital. Although the highest prices continued to go to the older, rarer, and safely pedigreed objects of tea, the market value and cultural prestige of the late Chosŏn-period objects first bought cheaply in colonial Seoul climbed steadily, bringing both symbolic and actual wealth to many of its early collectors.[34]

## Solving the Korea Problem

The success of Yanagi, Asakawa, and others in revising the Japanese art canon to include novel categories of Korean objects owed much to the immediate and material opportunities opened up in colonial Korea to Japanese of even modest wealth. Especially after formal annexation in 1910, it was a relatively simple matter for Japanese like the Asakawa brothers and Yanagi to live, work, and travel in Korea, usually with the sorts of privileges monopolized by colonial elites everywhere. For Japanese in Korea, these included the freedom to seek out and appropriate Korean goods of all description at very low cost, and also to remove those goods—even rare or antique art objects—permanently to Japan.

But colonial power also produced other, less predictable opportunities for Japanese interested in shaping new meanings or identities. Yanagi and his immediate circle were especially active between 1919 and 1924, when Korean nationalist resistance opened up new spaces for negotiation and change within the colonial context. They used the relative fluidity and even instability of this period, when Japanese colonial policy and administration were under public review, to promote their own programs for cultural reform. By boldly engaging in the debate on colonial policy, Yanagi gained unprecedented publicity for his own definitions of art generally, and of Korean art in particular. He also succeeded in gaining significant public support in both countries for his various projects to improve Japan-Korea relations through the cultural "preservation" and "revival" of Korea. There was a critical edge to culturalist reform efforts like Yanagi's, which implicitly

or explicitly suggested the inadequacy and immorality of assimilationist colonial policy. Yet it is important to recognize that in Korea during the early 1920s, nationalist cultural reform was a means employed by governing authorities to produce legitimacy and stability for the Japanese regime. Korean art proved very useful to the colonial system that helped to define it.

Early 1920s Korea was the site for a widely acknowledged crisis in colonial relations. By 1919, a decade of oppressive, even brutal assimilationist rule had produced an uncontainable level of outrage and opposition throughout much of Korean society. The organized mass demonstrations that ensued on 1 March 1919, thereafter sacred to Korean nationalist memory as the March first movement (samil undong), terrified and infuriated colonial authorities, who called out the troops. Several weeks of mayhem and some thousands of Korean casualties later, it was clear to many in Japan as well as Korea that something had gone very wrong. Although mainstream Japanese opinion tended to blame Koreans, and also Western missionaries, for what were commonly described as "riots" and "insubordination" by "malcontent Koreans" (futei na Senjin), it was difficult to escape the reflection that Japanese colonial policy might also bear some responsibility. As a consequence, the "Korea problem" (Chōsen mondai) and discussion of its resolution figured large in both colonial and metropolitan publications for several years thereafter.

In this context, Yanagi was one of the few Japanese who dared to publish, repeatedly, opinion sharply critical of Japanese colonial policy. In essays and articles that appeared in newspapers and well-known journals from 1919 through 1924, he presented himself as a conscientious objector to the inhumanity and philistinism characterizing Japanese attitudes and policy toward Korea. As he put it in "Thinking about Koreans" ("Chōsenjin o omou"), an impassioned four-part article published first in a major Tokyo daily in May 1919, "If we wish for eternal peace between ourselves and our neighbors, then we must purify and warm our hearts with love and sympathy. But, unfortunately, Japan has dealt with the sword, and offered abuse. Can this possibly give rise to mutual understanding, or create cooperation, or produce union? Nay, all Koreans feel throughout their beings a limitless enmity, resistance, hatred, and separation [bunri]. It is an inevitable consequence that independence should be their ideal." Yanagi especially stressed the efficacy of art as a means of producing the mutual understanding and love necessary for improved Japanese-Korean relations: "I believe it is art, not science, that promotes congress between countries, and draws peoples to-

gether. . . . Only religious or artistic understanding can give experience of the inner heart, and from that experience create a limitless love."[35]

The extraordinary power Yanagi attributed to art—its capacity for social and political healing—derived from the Romantic philosophy he embraced, as did many of his colleagues in the so-called Shirakaba school. In this view, art was the key to a transcendent, mystic realm of natural and universal truth, beauty, and humanity. It was opposed, moreover, to the particularistic and divisive, unnatural modes of being associated with modern science and industry, politics, and nationalism. Raymond Williams has pointed out, in the case of the British Romantic poets, that the opposition they perceived between natural beauty and personal feeling on the one hand, and industrial civilization on the other, has often been misunderstood as a dissociation. But in fact the British Romantics, like the Japanese Romantics of the early twentieth century, were far from being indifferent to politics and social affairs. Rather, their commitment to art and love represented a direct criticism of modern state and society, which they hoped thereby to reform.[36] In this sense Yanagi, the author in 1914 of a massive study of William Blake, was simply extending principles long dear to him and many of his fellow "literary youth" (bungaku seinen) in proposing that the Korean problem might be understood and resolved best by means of art.

Yet by choosing to write regularly on so current and sensitive a topic, Yanagi also ensured that his definition of art generally, and of Korean art in particular, reached a much larger audience than he had ever addressed before. First in Japanese, then in English and Korean translations, his articles on the importance of a proper recognition of the value and meaning of certain Korean objects as Art circulated widely in both Japan and Korea. In a 1921 piece first published in Shirakaba and then translated into English for the Japan Advertiser, Yanagi wrote, "Who could look at this exquisite figure of Maitreya Buddha with its expression of profound meditation, or at this vase of ancient Korai [Koryŏ] work, and still remain cold toward the nation that could make such things. Art transcends frontiers and the differences of men's minds." Here Yanagi proposed relatively conventional candidates for inclusion in what he called the "universal realm of art."[37] Both ancient Buddhist statuary and Koryŏ-period ceramics were already acknowledged in Japan as valuable Korean art products. Elsewhere, however, he insisted that Chosŏn-period ceramics also qualified as "great art" (idai na geijutsu).[38] In his 1922 essay, "Korean Art" ("Chōsen no bijutsu"), he again reminded readers of the glories of ancient Korean Buddhist statuary before asserting, "But

people must not think that it is only in the distant past that Korea had art and culture. Is not the Koryŏ dynasty immortal for its ceramics? . . . Even from the Yi dynasty, which is thought to be decadent and therefore rarely considered, I have witnessed many immortal works. Some of its woodwork and porcelain are truly eternal."[39]

Yanagi did more than write. Early in 1920 he and his wife, Kaneko, a contralto who specialized in German Lieder, announced their intention to raise money through a series of benefit concerts in Japan. Their goal was to travel to Korea to give more concerts. These were part of a larger effort to prove that art and religion, rather than militarism or diplomacy, could effectively create harmony between the two countries.[40] At this point Yanagi seems also to have been planning the establishment of a literary magazine based on the cooperative efforts of Koreans and Japanese. In May of the same year Yanagi, Kaneko, and the British artist and potter Bernard Leach traveled to Seoul for three weeks of welcome parties, concerts, and lectures sponsored by various Korean and Japanese organizations. All concerned pronounced the entire venture to be a great success.[41] This was the first of many trips Yanagi and Kaneko, accompanied by various others, were to make to Korea during the next few years.

By the end of 1920 Yanagi had abandoned his plan for a literary journal in favor of a project to found a museum of Korean folk art, to be located in Seoul. Much of his activity (and that of his wife and friends) between 1920 and early 1924, when the museum finally opened, was devoted to this end. In addition to fundraising and promotional concerts and lectures in Korea and Japan, the museum project involved exhibitions of Korean pottery in both countries, a fundraising drive organized through Shirakaba, a stream of publications by Yanagi and his friends on Korean art, group art-collecting and kiln research trips in Korea, and complicated negotiations in Korea concerning the site of the museum.

After his death in 1961, Yanagi was eulogized by many Japanese as well as Koreans for championing Korean art and culture during the colonial period. His activist period in the early 1920s came in for special notice by those who held him up as an example of resistance to the imperialist Japanese state. Yet, as the historian Takasaki Sōji has noted, Yanagi's criticisms were directed largely against the heavy-handed militarism and assimilationism that characterized Japanese colonial policy before 1919 and that came in for general disapproval during the relatively liberal era of the early 1920s. It is significant that Yanagi's relations with the new colonial administration, brought in after

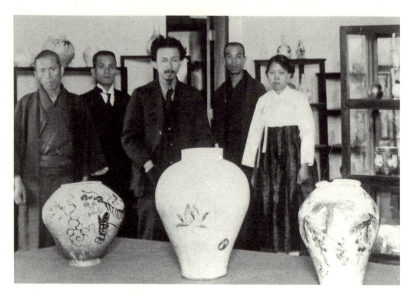

**4.** Yanagi (front center) and Asakawa Noritaka (far left) at a 1922 exhibition of Korean ceramics in Seoul. The three Chosŏn-period vases in the foreground all became celebrated pieces held in Japanese collections. Courtesy of Nihon Mingeikan.

the March first movement, were cordial.[42] Indeed, Korea in the early 1920s, under the new Saitō government, was highly receptive to Yanagi's special brand of cultural activism.

Many of the Korean organizers of the March first movement sought to make use of Woodrow Wilson's statements on the doctrine of national self-determination in order to attract international attention to the issue of Korean independence. There were even hopes that the Japanese government might be embarrassed into relinquishing its nine-year-old colony.[43] Korean efforts were partly successful: the independence movement, along with the violent countermeasures immediately taken by General Hasegawa Yoshi-michi, governor-general of Korea from 1916 to 1919, received publicity in both Japan and the West. In consequence, the Tokyo government felt in-creasing domestic as well as international pressure to review the evidently unsuccessful policy of military rule (*budan seiji*) that Hasegawa and his pre-decessor, General Terauchi Masatake, had implemented in Korea.[44] Some of that domestic pressure was applied by the few Japanese intellectuals who, like Yanagi, dared publicly to condemn the brutality of Japanese rule.

In August 1919 Prime Minister Hara Kei replaced Hasegawa with Admiral Saitō Makoto, who immediately undertook a more conciliatory "cultural" policy, thereby inaugurating the period of so-called cultural rule (*bunka seiji*; 1919 to approximately 1931) in Korea. But as Michael Robinson has argued in his study of Korean cultural nationalism during this period, Saitō's colonial policy was "a brilliant co-optative maneuver."[45] By expanding the arena of legally permissible political and cultural activity in colonial Korea, Saitō's regime was largely successful both in making Japanese rule acceptable to world opinion and in gaining increased legitimacy in the colony. At the same time, the Saitō administration strengthened the police control apparatus. The result was a split in the Korean nationalist movement between moderate or cultural nationalism, which flourished during the early 1920s, and a newer radical, leftist nationalism that came under increasing attack by the Japanese colonial state.[46]

During the early 1920s the museum was Yanagi's central preoccupation in Korea, but at the same time he continued to produce public commentary in both countries on the more general theme of Japanese-Korean relations. For the most part Yanagi settled down to write pieces urging cultural understanding and adjuring Koreans to focus on the development of cultural rather than political identity and independence. Although he could occasionally prove something of a gadfly to Japanese in Korea, on the whole his views and activities during the 1920s were as acceptable to the Saitō administration as they were to Korean cultural nationalists. Much like Yanagi, these Koreans considered political independence a remote goal predicated upon gradual, long-term cultural development. They focused on strengthening Korean identity through historical studies, education, a vernacular language movement, and cultural societies, and their programs were based on a policy of nonconfrontation with Japanese authorities.[47] One leading exponent of Korean cultural nationalism even wrote about his movement in 1922 that it was "untainted by politics."[48] This influential segment of elite Korean opinion welcomed and supported Yanagi's endeavors. The *Tonga ilbo*, a Korean-language newspaper founded and edited by prominent moderate nationalists such as Kim Sŏngsu and Chang Tŏksu, actively promoted Yanagi and his projects through articles and reviews as well as the sponsorship of lectures and concerts.

As for the government, Saitō's cultural policy corresponded in many ways to the proposals for Korean development outlined by Yanagi as well as many

Korean cultural nationalists. The actual reforms Saitō planned in Korea after 1919 were organized around precisely their concerns: the eradication of militarism in Japanese rule, increased educational opportunity for Koreans, freedom of speech, and general respect for Korean culture. In practice, of course, many of Saitō's promises were only half-kept. The gendarmerie was abolished, but only to be replaced by what became a much larger and more comprehensive civilian police force.[49] A civilian governor-general, though held out as a possibility, was never appointed. The public educational system was greatly expanded and the curriculum revised to include Korean studies, but it has been argued that the real beneficiaries continued to be the resident Japanese community.[50] Publication controls were relaxed, but only for relatively apolitical materials; socialist or otherwise radically critical opinion was suppressed.[51]

In this context, Yanagi's Korean projects met with approval and even active support from Japanese authorities. In early 1921 Yanagi met with Saitō, who offered to house the proposed Korean Art Museum in a building belonging to the government.[52] In 1922 the governor-general was among the twelve hundred who attended an exhibit of Chosŏn pottery organized by Yanagi and his friends in Seoul to promote the museum. On that occasion Saitō and his vice governor-general, Ariyoshi Chūichi, also donated a large sum of money to the museum fund.[53] It may have mattered that Yanagi's father had been an admiral in the Japanese navy, therefore once Saitō's superior, and that Yanagi's sister was married to a well-regarded bureaucrat in the Korean government. Yet these personal connections alone are not enough to explain the support Yanagi received not only from Saitō but also from the official government newspaper, the *Keijō nippō*, as well as other government organizations through the 1920s and beyond.[54]

For Yanagi the opening of the Korean Folk Art Museum in April 1924 marked the closing of a five-year period of public engagement in the politics of colonial Korean culture. After 1924 his activities in Korea took on a quieter, more conventionally philanthropic and educational cast. Supported by the colonial government, Yanagi and his wife made several more benefit lecture and concert circuits in aid of, in 1924, Korean victims of the massacre that followed the 1923 earthquake in Japan and, in 1925, victims of a Korean flood. But Yanagi's real interest had moved to Japan, where he was increasingly preoccupied with what would become a lifelong campaign to preserve and revive another culture—his own—against the assimilationist threat posed by Western-style modernization.

*Orientalism for the Orientals: Korean Art and the Reproduction*
*of Colonial Knowledge*

At the same time that Yanagi endeavored to relocate certain Korean objects within a universal category of world art, where they might take their place alongside such timeless monuments to human genius as classical Greek architecture, Russian literature, and French post-impressionist painting, he and others promoted the idea that Korean achievements also belonged in the category of Oriental art (*Tōyō no geijutsu*). By the 1920s, a wave of renewed interest in Asian, especially Japanese, artistic monuments and traditions had developed in Japanese literary and artistic circles.[55] Yanagi and other members of the Shirakaba set were quick to assimilate the various Japanese, Korean, and Chinese objects they admired within Oriental art, which they usually envisioned as a subset of the wider canon of universal or world art. They helped to promote the idea that Oriental art signified the greatest artistic achievements of the Orient, or *Tōyō*; this was a vaguely defined region comprising China, India, Japan, and Korea, which was often figured in terms that posited the centrality of Buddhism to a once great and unified ancient civilization.

In adopting the notion of Oriental art as a means of defining and celebrating not only Korean but also Chinese and Japanese ceramics, painting, and sculpture, Japanese collectors, artists, and writers were engaged in a complex interaction with Western, as well as Japanese, colonial power. By employing Western systems of thought, including Orientalist ideas that functioned to reduce and subordinate the non-West, they seemed to accept the often oppressive categories and hierarchies of a Eurocentric ideology. Yet some of the writers and artists who embraced the idea of the Orient did so partly to revise and even to resist the common sense about Asian cultures and especially artistic achievement that derived from the prestige of Western views. The result was an ambivalent form of colonial knowledge, mobilized in part to resist Western power but serving finally to reinscribe it.

Like many of his peers, Yanagi found his way back to non-Western, or indigenous, aesthetic value through an initial and abiding preoccupation with Western literature and art. His earliest efforts to promote Korean art were conducted, therefore, within the parameters of a highly Europeanized frame of reference. This was true in an institutional as well as an epistemological sense; Yanagi first wrote on Korean art in *Shirakaba*, a magazine that gained its celebrity and influence during the second decade of the twentieth

century in large part through its dedication to the goal of introducing European (and some American) high culture to Japan. It should not be surprising, therefore, that Korean art was introduced in Shirakaba in a manner shaped by several typically Western assumptions about the non-West. For example, the first Korean art featured in the magazine, for the February 1920 issue, was Buddhist sculpture dating from the eighth century and earlier—objects evoking the lost grandeur and mystic spirituality of a remote Oriental past.[56] This, as Yanagi put it in his editorial commentary, was a "second experiment"; the first had been conducted in July of the previous year, when Yanagi selected several details from ancient Japanese Buddhist paintings for reproduction in the magazine.[57]

In both issues, Yanagi considered himself to be introducing the readers of Shirakaba to Oriental art. In the first, he wrote at some length in defense of this innovation, which he expected would surprise and even offend the many readers who had "long adored Western art": "Just as we looked at the Occident with entirely new demands, so now we have begun to look at the Orient with eyes unlike those of anyone before. . . . We have begun to comprehend the Orient anew, but not from the fixed and academic viewpoint people have taken to date. Rather we comprehend the Orient in a universal sense; or, to put it differently, even though it is the Orient, we comprehend it in terms of universal value, and of truth that transcends the distinction between East and West."[58] Yet Yanagi's efforts to demonstrate the "universal" value and truth of Oriental art as it transcended the division between East and West relied on stubbornly Western categories. These included not only the central, unitary category of the Orient, and its irresistible associations with the past splendor of an ancient civilization, but also the category of art itself, as defined preeminently in terms of painting and sculpture.

Yanagi may well have chosen Buddhist sculpture in particular to represent Oriental art because it was already recognized both in Japan and the West as an important genre of native fine art, distinct from the lower orders of handicraft or industry.[59] Yet the art historian Kinoshita Naoyuki has shown that Buddhist artifacts were transformed into "artworks" only in the late nineteenth century, largely at the behest of government officials determined to effect Japanese "civilization and enlightenment" (bunmei kaika), or conformity to Western standards of cultural and social progress. In their search for an indigenous tradition of sculpture, one of the central genres of fine art in the European West, modernizing elites were quick to discover and promote carved Buddhist images. These seemed the closest counterpart to the monu-

mental statues and busts ubiquitous in the public spaces of nineteenth-century Europe and North America. At the same time, Buddhist objects satisfied Western consumers' touristic interest in the Japanese exotic, which Meiji officials could not afford to ignore. By 1900, therefore, the process by which many Buddhist artifacts were removed from temples, where they had functioned as sacred objects, and placed in museums (as well as private collections), where they became art objects in glass cases, was more or less complete.[60] Fifteen years later, Yanagi and other Taishō cosmopolitans found Buddhist sculpture readymade, by their Westernizing Meiji elders, as Oriental art.[61]

No less than Meiji-era modernizers, however, the young intellectuals who "returned to the Orient" in Taishō hoped to use Western means to resist aspects of Western hegemony. Yanagi suggested that by introducing Japanese to the magnificence of Oriental art, he might remind them that the West was not the exclusive province of value: "But for Japan today, which is in a strange condition, this sort of elucidation is both meaningful and necessary. For it is a fact that young Japanese are more familiar with things Occidental than with things Oriental."[62] Nor was Yanagi content to accept, uncontested, all of the implications of the Western categories and definitions he employed. For example, although the first Oriental numbers of Shirakaba featured painting and sculpture, it was not long before Yanagi had persuaded his fellow editors to let him devote an issue to Chosŏn-period ceramics, which, as he insisted at every opportunity, belonged to the category of "great art." Like the early modernists in Europe, of whom he was almost certainly aware, Yanagi resisted the conventional European distinction between "fine" and "decorative" or "applied" arts. Not only did such a separation imply and reinforce hierarchies of class, according to which the sculptor or painter occupied a position elevated far above that of the engraver or printer, but it projected those hierarchies onto the international stage. In this sense, the strong association of East Asian cultures with ceramic, print, and textile arts could only reinscribe Oriental inferiority.

Most important, Yanagi and his fellow celebrants of Oriental art lost no time in qualifying the essential uniformity implied by the idea of the Orient. In particular, they claimed for themselves, as Japanese, the capacity for active modern consciousness and aesthetic discernment normally monopolized, according to Orientalist thought, by the West. In this sense Japan, and especially modern Japan, was "different"; it was located both within and beyond the Oriental sphere. Of course, the idea that the hybrid nature of

Japanese modernity might give it a distinctive role relative to an Orient defined largely in terms of ancient art and spirituality was not new with the Shirakaba generation. In his 1903 book on Japanese art, *The Ideals of the East*, the art educator Okakura Kakuzō had already informed European and American readers that "Japan is a museum of Asiatic civilization; and yet more than a museum, because the singular genius of the race leads it to dwell on all phases of the ideals of the past, in that spirit of living Advaitism which welcomes the new without losing the old." Okakura concluded by suggesting some of the larger implications of Japan's singular genius: "The Chinese War [the Sino-Japanese War of 1894–1895] . . . arouses us now to the grand problems and responsibilities which await us as the new Asiatic Power. Not only to return to our own past ideals, but to feel and revivify the dormant life of the old Asiatic unity, becomes our mission."[63]

Both Okakura and Yanagi appear to have imagined an identity and role for modern Japan distinct from those of either Orient or Occident. In a sense, writers and artists of Yanagi's generation were able to go some way toward realizing Okakura's vision; the Korean museum that opened in 1924, for example, seems an almost uncanny expression of Okakura's notion of Japan's special curatorial role in the preservation of Asiatic civilization. However, Yanagi and his fellows, like Okakura, found it difficult to transcend the models and forms for international relations established by the West—even as they struggled to free themselves from the disadvantages of their own position in a Western-dominated world order. The very idea of a museum was borrowed from Western Europe, where its emergence and development were deeply involved in the history of modern imperialism.[64] In their voluminous writings on Korean material culture, moreover, Japanese collectors and critics of the 1920s and 1930s relied on rhetorical strategies of knowing and appreciation that had long been employed in the Western Orientalist literature on the non-West. As with the Korean museum, the result contributed to the reproduction of Japanese colonial power.

In 1922, Yanagi published his classic statement on Korean art, an influential essay which appeared in the magazine *Shinchō*.[65] In the essay he claimed that the art of any country reflects the psychology of its people, as formed by the natural environment and by history. Korea's geographic condition as a peninsula combined with Korean history, which Yanagi characterized in terms of instability, invasion, and subservience to foreign powers, to make the Korean essence lonely, sorrowful, and spiritual. In the same way Yanagi claimed that China's size and power had created a people and art defined by

strength and that the security and comfort of Japan's situation explained an essentially optimistic, playful character. Further, he proposed that each country's character is associated with one of the three key elements of art: form, color, and line. He argued that since the ideal form is stable, the ideal color bright, and the ideal line long, Chinese art is characterized by stable forms, which signify power; Japanese art by bright colors, signifying pleasure; and Korean art by thin, curved lines, signifying sorrow and loneliness.

In the essay Yanagi went on to explore the incompatibility of long, curved lines and stable forms. This was especially the case in pottery, which he saw as the apotheosis of the art of the curved line, that is to say, of Korean art. He pointed out, "All [Korean pots] are unstable because they are long and narrow, but in them the demand for the element of line is completely satisfied. How inappropriate and fragile the long, narrow part is in use. The people do not have worldly desires."[66] Yanagi proceeded to discuss what he perceived as the absence of bright color in Korean art and culture, and arrived at what has become his somewhat notorious theory of Korean "whiteness." He observed of Korea:

> As for the color of clothing worn, is it not, if anything, white? Or if not, then a pale blue. Why is it that old and young, men and women all wear the same sort of white clothing? There are many countries and people in the world, but one cannot observe this strange phenomenon anywhere else. . . . White clothing has always been for mourning. It has been the symbol of a lonely, reverent, and profound heart. The people, by wearing white clothing, are mourning for eternity. I think that the difficult historical experience of the people, who have suffered much, led naturally and inevitably to the clothing they wear. Is not the paucity of color true proof of the absence of pleasure in life?[67]

During this period the idea of an essential Korean sorrow brought about by a national history of unremitting disaster was of a piece with both scholarly and popular views in Japan of Korea. In his study of the Japanese historiography of Korea, Hatada Takashi has shown that during the early twentieth century Japanese scholarly discourse on Korea and its history centered on the theory of Korean "stagnation" (teitai). This notion persisted, Hatada notes, well into the postwar period and brings together several other themes central to the colonial-era Japanese study of Korea: the theory of the common origins of Japanese and Koreans (Nissen dōsoron), that of the original unity of Manchuria and Korea (Mansen ittairon), and the theory of Korean

subordination to other countries (taritsuseiron). In short, the basic argument promoted by the Japanese scholars who wrote on Korean history during this period was of the tragic impossibility of independent Korean development.[68] Publications on Korean art and culture by critics and collectors such as Yanagi contributed to a larger discourse that naturalized Japanese colonialism as a normal and even inevitable product of history, geography, and essential Korean identity.

In Yanagi's circle of fellow Japanese collectors of Korean objects, there were differences of opinion on various aspects of Korean art and culture. Nevertheless, the idea of sorrow or melancholy as an aesthetic principle of Korean culture was accepted by many. For example, Kurahashi Tōjirō, a publisher and collector who was part of Yanagi's circle in the 1920s, gave a lecture on Korean pottery in 1928 in which he claimed, "Another special characteristic [of Korea] is that for a thousand years it has truckled to stronger powers [jidaiteki] . . . standing for the most part between Chinese and Japanese might, and the fact of having been intimidated throughout, generally by China, has been included within the things created by Koreans. Their feelings did not turn outwards but rather went deeper and deeper inside, and as a result . . . Korean crafts call strangely to people, they are lonely, and this is why they were taken up by the [Japanese] tea people."[69] The potter Tomimoto Kenkichi was also an early enthusiast of Korean pottery, making trips on his own and with Yanagi to Korea during the 1920s. In writings on Korea from this period he too referred to the melancholy quiet of Korean pottery, and to its contrast with the "strength" of Chinese ceramics and the "prettiness" of Japanese pieces.[70] Kon Wajirō, the architect and folklorist, went to Korea in the early 1920s to survey minka, or folk houses, for a report commissioned by the colonial government. In the 1924 report Kon, ordinarily a careful and independent-minded observer, stressed what he saw as the decorative, free, natural quality of the Korean aesthetic. Still, even Kon prefaced his discussion with the statement, "It can be said that there is in the lifestyle of the [Korean] upper class a sad, delicate beauty such as has been recognized in the art of the Korean peninsula."[71] In 1933 Uchiyama Shōzō, another collector and Korean pottery expert, wrote, "When we contemplate Yi period wares, we realize that lonely people are indeed possessed of warm hearts."[72]

As suggested by Uchiyama's remark, many of those writing on Korean art during this period also imagined an identity between Korean objects and Korean people. For some the comparison between Koreans wearing white

and the white porcelain of the later Chosŏn period was irresistible. Kura-hashi concluded his preface to a 1932 book on Korean white porcelain with a typical flourish: "Those who travel in Korea are likely to see the scene of people in white clothing working slowly on the reddish-brown terrain. Those white-clad Koreans [Senjin] are, in sum, the white porcelain of the Yi dynasty."[73] The identity Kurahashi suggests between Koreans and Korean objects may be a poetic conceit, but it is one that recurs in a variety of Japanese texts written during this period on Korean material culture. It suggests the way Japanese writers regularly assumed the position of the colonialist master, or subject, whose consuming gaze rendered everything Korean—landscape, people, and things—into a unified aesthetic object. Often this maneuver was accomplished by means of the same rhetorical strategies that had long been employed in Western texts to subordinate non-Western (including Japanese) others. For example Asakawa Noritaka, the expert on Korean ceramics who with his brother Takumi introduced Yanagi and many other Japanese collectors to Yi dynasty pottery, published a poem called "Tsubo" (Jar) in 1922 that gave vent to a fantasy assimilating Korean women and ceramic objects. After comparing the shape of a Korean water jug to a girl's breast, "a form born to be loved," he went on to write in vaguely erotic terms of the Korean woman as a "walking Yi dynasty jar."[74]

Korea and Korean art and culture were often feminized, although the metaphorical gender relations that were elaborated from the initial premise of Korea or Korean culture as woman could go in a variety of directions. The writer and collector Aoyama Jirō, another member of the group around Yanagi, gave a lecture on Korean crafts that was published in the magazine Teikoku kōgei in 1930. Aoyama's main argument was that Korean culture had no real independent identity and that it was actually only a part of Chinese culture. As he put it, "Korea is that which is admiring, weak, timid, funda-mentally lazy and likes someone extreme; in short, a girl."[75] In Aoyama's account the "thoughtless," "irresponsible" man whom this "girl" emulates and is overwhelmed by is China. Yanagi, on the other hand, had a penchant for identifying Korean historical periods in terms of gender. For example, in 1922 he stated that the art of the Confucian Yi dynasty was masculine, whereas that of the preceding Buddhist Koryŏ dynasty was feminine.[76] Later, however, he reversed himself; for reasons about which one can only specu-late he decided that Koryŏ works were male, while those of the Yi were female.

The familiar metaphor of colonial object as woman could also make

room—sometimes even in the same text—for another familiar trope: colonial object as child. Asakawa's poem "Tsubo" includes the following verses:

> Koreans
> Do not know what intention is
> Rather than self-consciousness and reflection
> They have one instinctive way
> They make things with the pure heart of a child drawing a picture
> And that one feeling continues to the end
> An art in which feeling rather than rationality has won
> An art in which the same thing cannot be made twice
> Children's work made by adults
>
> One bows the head on seeing the drawings of children
> And feels astonished shame of one's own impurity[77]

The theme of the childlike Korean producing, all unconscious, masterpieces of art recurs in texts throughout this period. Yanagi used it, as did his friend the British potter Bernard Leach, who was still writing in the early 1950s, "The Coreans and their pots are childlike, spontaneous and trusting. We had something akin to this in Europe up to about the thirteenth century."[78]

Another comparison to Europe is apt here. Elisa Evett, in her study of the reception of Japanese art in late-nineteenth-century Europe, notes that critics in the West dwelled on what they saw as the childlike, unconscious, even primitive qualities of Japanese images, and by extension of the Japanese themselves.[79] In his 1898 *The Soul of the Far East*, for example, the astronomer Percival Lowell wrote that Japanese are "still in that childish state of development before self-consciousness has spoiled the sweet simplicity of nature."[80] These perceptions of the Oriental other were linked, of course, to ideas about the imperial European self; the decadent modern West had lost, irrevocably, the innocence and purity of the nobly savage state in which Japanese were still to be found.[81]

In much the same way, Japanese writings on Korean pottery helped to define and interpret not only the colonial Korean object but also the colonialist Japanese subject. In a sense, Korea offered an opportunity for critical reflection on Japan's modern development. For example, the childlike innocence and purity of Korea contrasted with the adult consciousness and impurity of Japan. Much as it had for Europeans and Americans contemplating the Far East, this metaphorical figure expressed the power relation between

two cultures while it evoked nostalgia for a lost, premodern past. Writings by Japanese critics refer to the "naturalness," "unconsciousness," and "traditionalism" of Korea, Koreans, and Korean objects. These were in explicit contrast to the artifice, self-consciousness, and Westernized modernity of Japan, which the authors generally deplored.

Asakawa Noritaka, for example, wrote in 1922 comparing Korean and Japanese ceramics:

> Much of Japanese pottery to date ignores natural laws and has a tendency to want to show off its own cleverness. Therefore it becomes something unpleasant. There is none of this in Korean things. First of all they always come out of nature; even [Korean] architecture is built to go with its surrounding lines and planes. If you look at it, the method is that of a swallow building its nest, and no matter how small the house, it harmonizes well with the lines of nature. I will even say that this is instinctive. Pottery methods too are truly not that of making something but rather of a swallow building its nest.[82]

Similarly, Yanagi wrote in 1931 of Japanese ceramics, "Production was poisoned by appreciation. Japanese bowls bear the scars of consciousness."[83] In the same vein, the potter Tomimoto Kenkichi wrote in 1925 of his disgust with the modern, Western-style architecture that Japanese had brought to Seoul, and mourned the resulting demise of indigenous Korean buildings and monuments, which were like "objects in nature" and "feel as though they have existed from before they were built."[84]

Yet Orientalist strategies of appreciating Korean objects also assigned great creative power and authority to Japanese consciousness, however scarred or impure. Almost every Japanese writing on Korean ceramics in this period stressed the importance and value of the Japanese discovery of Korean pottery in the sixteenth century and, by extension, of Japanese aesthetic discrimination generally. Occasionally it was even suggested that the Japanese genius lay less in art production than in art appreciation.[85] Moreover, that genius was in itself a form of production, and one that was perhaps of a higher order than that of simple manufacture. As Yanagi put it, "The Koreans made rice bowls; the Japanese masters made them into great teabowls."[86] The publisher and collector Kurahashi Tōjirō asserted that "the use of [Korean bowls] as tea utensils represented a discernment equal or superior to that of those people who made them."[87]

By claiming the power to discern Oriental objects, and even to create their

proper meanings and uses, Japanese intellectuals self-consciously ranged themselves alongside their Western counterparts as imperial authorities. In his first public reaction to the Korean independence movement of 1919, Yanagi suggested that just as the American writer Lafcadio Hearn had "understood Japan better than some of the Japanese," so might Japanese like himself be able to render "the labor of love for Korea" and fathom Korean "inner life as shown in religion and art." "There has been no Hearn for Korea yet," he observed.[88] Yet in claiming the type of authority over Oriental objects monopolized previously by Western subjects, Yanagi and his cohort were bidding for something beyond a mere power-sharing arrangement. They were explicitly engaged in an effort to resist the growing predominance of Western power throughout the world, and particularly in East Asia. As Yanagi wrote in 1923 of the Korean art museum he planned to open in Seoul, "It would be the greatest of pities if the introduction of the material civilization of Europe should lead to the extinction of our cherished Oriental handicrafts, as seems quite likely, so it is my earnest hope that the establishment of a gallery like this may not only serve to preserve the relics of the past, but also to provide a stimulus for new activities in the days to come."[89]

Like Okakura, Yanagi proposed that Japan respond to the Western challenge by means of a museum of past Oriental greatness that would also be, in some indefinite way, much more. In postcolonial retrospect, it is perhaps too easy to read imperialist intent into the vague, ambitious vistas opened by Okakura's 1903 mission to "revivify the dormant life of the old Asiatic unity," or even by Yanagi's hope some twenty years later of "new activities in the days to come." Certainly Yanagi's museum, which was made possible by Japanese colonial power in Korea and even helped to reproduce it, was both more concrete and ultimately more oppressive than the one Okakura only envisioned. Yet Yanagi belonged to a generation much more disillusioned than Okakura's with the imperialist modernizing project of the nineteenth-century nation-state. His aspirations for the future of Japan, Asia, and indeed the world were critical and utopian; only a few years later he looked toward a "Kingdom of Beauty" (bi no ōkoku) that promised humanity a quasi-socialist liberation from capitalist modernity.[90]

Even this brief survey of texts on Korean objects produced by the loose network of Japanese collectors and critics out of which the mingei movement later arose reveals some of the ways they not only reiterated but also amplified colonialist views of Korea, Japan, and the Orient generally. Al-

though areas of uncertainty and disagreement remained, particularly in connection with the problem of trying to accommodate Korean and Japanese difference within Oriental identity, a common discourse on the Korean object had been established by the end of the 1920s. Not only did that discourse affirm a more general understanding of Japanese-Korean relations prevalent during this period, but it helped to shape future encounters by Japanese with other cultures and their artifacts, whether these were located within national borders or without.

# TWO. The Discovery of Mingei

There is some disagreement as to when exactly Yanagi and his friends invented the word mingei, or folk-craft, and when they first began to discuss the idea of establishing a mingei museum. Was it on a train traveling through the Japanese countryside in the spring of 1925? Or was it on a visit Yanagi made with the potters Hamada Shōji and Kawai Kanjirō to a temple on Mt. Koya in January 1926? Authorities differ.[1] Though we may never know precisely when or where the idea of mingei first came into being, it seems clear that at some time in the mid-1920s a long-standing interest in rural handicrafts and concern about their preservation and reintegration into modern life crystallized among Yanagi and his closest associates in the neologism "folk-craft."

But the attempt to ascertain the precise moment and place that produced mingei is bound to fail in another, larger sense. In retrospect, the "discovery of mingei" appears as a discrete, unique event authored by a single agent. According to the conventional account, mingei was the accomplishment of a spontaneous, heroic moment of recognition by Yanagi alone—or, alternatively, by the mingei triumvirate of Yanagi, Hamada, and Kawai. It is important to see, however, that the naming of folk-craft was as much a process as it was an event and that the ideas eventually identified with mingei were produced by much more than individual inspiration. Over the late 1920s and early 1930s, a variety of individuals and groups, as well as texts and institutions, participated in the defining and redefining of mingei. In short, while Yanagi and his friends were central to the creation of mingei ideology, they

worked within a larger social and cultural context that must also be taken into account in explaining the rise of folk-craft.

Most important, mingei was discovered, defined, and promoted by networks of urban, middle-class, male intellectuals during a time of rapid and profound social change. Throughout the nineteenth century and into the early decades of the twentieth, certain forms of literary and aesthetic cultivation were strongly associated with a small minority of social elites. During the interwar period of the 1920s, however, urban literati found their cultural capital—and the social and economic privileges that accompanied it—steadily eroded by an array of new groups and forces. The rapid expansion of the higher educational system, the accelerating growth of the modern sector of the economy, and a rising tide of rural-urban migration were perhaps the most fundamental of a group of interrelated changes that helped to swell the ranks of a new, ambitious middle class. To established literary elites like Yanagi and his cohort, the aspirations of newly middle-class men and, increasingly, women represented both a threat and an opportunity. How would it be possible to defend their social and cultural position, built largely on aesthetic mastery, against groups fast gaining access to the conventions of taste on their own? On the other hand, rising middle-class groups offered older elites new scope for leadership and authority. The mingei project thus represented one of a range of efforts by literary men during the 1920s and 1930s to turn older forms of knowledge to new account.

Although class mobility and class anxieties were crucial to the rise of mingei, they were by no means the only factors at work. Also relevant was the increasing prominence of the countryside, both as the imagined site of native authenticity and as a very real and troubling place of economic and social distress. Again, it was primarily the efforts of a stratum of urban and suburban intellectuals who positioned themselves as intermediaries or translators between city and country that brought rural or folk culture to national attention in the 1920s. Folk-craft was only one, therefore, among a host of new rural objects of study, appreciation, and desire: folklore (minzoku), folk performing arts (minzoku geinō), folk architecture (minka), folk song (minyō), folk tools (mingu), and farmers' art (nōmin bijutsu), to name only the most conspicuous examples. Moreover, the move to recuperate indigenous forms of non-elite culture, and especially material culture, also represented a complex response to the encroaching West. Mingei activism was also shaped, therefore, by the impulse to find a place for Japaneseness

within a modernity that seemed in danger of being defined to an overwhelming degree by Western Europe and, especially, the United States. Ironically, of course, the urge to seek abiding value in the simple forms of popular, native daily life was at least partly informed by trends emanating from the industrialized West.

### Mokujiki Shōnin and the Double Return

It might be argued that Yanagi's primary concern in 1925 was not folk-craft, but rather the life and works of an obscure eighteenth-century Buddhist sculptor known as Mokujiki Shōnin. At least one of the train trips during which the word "mingei" is said to have been coined was actually undertaken by Yanagi and his friends as part of a series of investigations into someone they often called simply Shōnin, or "Holy Man." The standard narratives of the mingei movement always include, therefore, a brief but respectful excursus on Yanagi's work on Mokujiki Shōnin. Several of the sculptures Yanagi acquired for himself remain in the collection of the Japan Folk-Crafts Museum in Tokyo and are occasionally displayed. Yet the link between these pieces—bold, sometimes crude representations of Buddhist figures by an elderly self-taught ascetic—and the handicrafts now most commonly understood by the term mingei is not immediately obvious. Even though Yanagi defined mingei to include certain types of painting and other arts such as calligraphy and sculpture, in most cases these objects were anonymously produced. Indeed, the anonymity of their production was considered both an emblem and a condition of their status as mingei. Yanagi proposed that the individual, artistic producer of mingei appeared only in the modern period, as a sort of necessary evil. Thus the emphasis on the biography of Mokujiki Shōnin as heroic auteur, which has been inseparable from appreciation of his sculpture since the 1920s, only adds to the somewhat anomalous status of these objects at the margins of the mingei canon.

Nevertheless there are important links between Mokujiki Shōnin and mingei. Yanagi acknowledged some of these himself, and the tendency of many to conflate Yanagi's life with the history of the mingei movement has encouraged the inclusion of Mokujiki Shōnin in a narrative of folk-craft. Generally overlooked, however, is the pivotal position occupied by Yanagi's interest in Mokujiki Shōnin between his early enthusiasm for things Oriental and his discovery of Japan through folk art during the late 1920s. In 1924 and 1925, Yanagi's quest for Mokujiki Shōnin represented a literal return of

5. A late-eighteenth-century "smiling
Buddha" carved in wood by the itinerant
ascetic known as "Mokujiki Shōnin."
Courtesy of Nihon Mingeikan.

his interest to Japan, not from the conventional modern Japanese locus of estrangement from the native—the West—but from Korea. At the same time Yanagi continued to develop, first through Mokujiki Shōnin and then through folk art, his project to recognize anew the value of the non-Western. He returned from a youthful immersion in Western culture first to the Orient of Korea and of Buddhist art, then to Japan. In returning from both Occident and Orient, Yanagi and other Japanese intellectuals took part in a general shifting of cultural mood during the mid-1920s. Thus the small blaze of interest in Mokujiki Shōnin that Yanagi managed to ignite in 1924 and 1925 marked a moment of both connection and transition.

In April 1924, when Yanagi, his wife, and his friends finally celebrated the opening of the Korean Art Museum in Seoul, Mokujiki Shōnin was already in the offing. At the beginning of the year Yanagi had gone with his chief associate in the Korean museum, Asakawa Takumi, to Yamanashi prefecture to look at Komiyama Seizō's collection of Korean pottery. There he had been struck by two unusual Buddhist sculptures belonging to Komiyama. Yanagi later described this first encounter:

> The two sculptures were set in the front of the dark storehouse. . . .
> When I passed before them, my gaze rested upon them involuntarily.
> (If they had happened to be covered by a cloth Shōnin would probably
> have been concealed from me all my life!) My heart was stolen imme-
> diately. I was endlessly captivated by the subtle smile playing over their
> mouths. This was no ordinary sculptor. My intuition told me that this
> kind of thing could not have been carved by someone who had not had
> an extraordinary religious experience. . . . It was then that for the first
> time I heard the name, from Mr. Komiyama, of "Mokujiki Shōnin."[2]

From 1924 to 1926, in the interval between Korea and mingei, Yanagi energetically studied and promoted the life and work of this eighteenth-century itinerant monk. Mokujiki Gogyō Shōnin was born in 1718 to a farming household in a small village in central Japan. Originally named Itō, he began training as a monk of the Shingon sect of Buddhism, and at the age of forty-five took vows to eat nothing but raw vegetables (hence the title Mokujiki Shōnin, literally "holy man who eats the fruit of trees"). As part of his calling Mokujiki also embarked upon decades of almost constant travel throughout the Japanese islands. At the age of eighty-three he undertook a new form of ascetic practice (shugyō) which involved the carving of at least one thousand religious sculptures to leave behind at Buddhist sites through-

out Japan. Of the sculptures that Mokujiki produced during the last decade of his life (he died in 1810 at the age of ninety-three), about thirteen hundred identifiable pieces have survived.[3]

It was this sculpture that most interested Yanagi, and in 1924 he launched something of a Japan-wide treasure hunt for Mokujiki's "smiling Buddhas." Perhaps it is as much a testament to the sheer force of Yanagi's personality as to the significance of his subject that he was able to mobilize people and publications in various regions to participate in creating a small furor over the discovery of Mokujiki's long-overlooked genius. The scope of Yanagi's interest in Shōnin was not limited to the sculpture, but included his *waka* (classical Japanese poetry, of which Yanagi had a collection by Mokujiki published in 1925) and more generally the retracing of Mokujiki's travels.

In seeking to connect Yanagi's Mokujiki Shōnin phase to mingei, historians of the mingei movement have tended to stress the spiritual or religious component linking Buddhist sculpture and mingei. The art historian Mizuo Hiroshi, who occupies a semiofficial position as chief chronicler of the mingei movement's history, argues that Yanagi brought first to Korean pottery and later to folk art an insight into these objects as a form of spiritual expression. In Mokujiki's sculpture, the integration of religion and aesthetics that Mizuo claims Yanagi always sought above all, and which became more and more important to him toward the end of his career, was especially pronounced.[4]

Other links between Shōnin's sculpture and mingei proper might be cited. For example, Mizuo notes Yanagi's own 1925 acknowledgment of the rural, populist character shared by both Mokujiki's sculpture and the craft objects he would soon name mingei.[5] It is clear, moreover, that Yanagi used the travels he made in rural Japan tracing the movements of Mokujiki Shōnin as an early opportunity to investigate and collect craft objects.[6] The two years Yanagi spent investigating Mokujiki Shōnin were also a period of important institutional preparation for the mingei movement. It was through his interest in Mokujiki that Yanagi developed relationships with a number of provincial intellectuals and collectors such as Shikiba Ryūzaburō and the Yoshida brothers in Niigata prefecture, as well as the Kyoto scholar Jugaku Bunsho and others who were later to prove key figures in the Mingei Association. It was also in connection with the Mokujiki sculptures and research that Yanagi rehearsed the institutional lessons he had learned from his participation in the Shirakaba art and literature movement (1910–1923) and which he would later bring to his efforts to promote mingei. These included the

establishment of a central organization centered on a magazine (*Mokujiki Shōnin no kenkyū*, or *Research on Mokujiki Shōnin*) and the subscribers' association that financed it, supplementary traveling exhibitions and lecture tours, and the general aim of establishing a museum. Photographic reproductions were of key importance for publication (in periodicals, books, and also as postcards) and for formal exhibition, just as they had earlier been for Shirakaba and as they were to be for mingei.

In a significant departure from the Shirakaba model, however, both Mokujiki Shōnin and mingei enabled Yanagi to mobilize powerful networks of provincial elites around objects of local provenance. Whereas the fervent preoccupation with Western art, literature, and music exemplified by the Shirakaba movement had proved communicable in the provinces primarily to a class of educated youth, Mokujiki Shōnin (and later mingei) piqued the interest of a broader group that ranged from local officials and dignitaries to private scholar-collectors and Buddhist priests. The largest and most active such Mokujiki network formed in the city of Kōfu, the capital of Yamanashi prefecture. Mokujiki Shōnin was born in a mountain village in the Kai domain (later Yamanashi prefecture), and the special intensity of the "Mokujiki fever" in Kōfu reflected pride in a native son. By October 1924 about forty notables in Kōfu led by the chiefs of the security and educational sections of the prefectural government, the principal of the Kōfu middle school, and the collector Komiyama had begun to organize the Mokujiki Shōnin Research Group.[7] Not only did this group vigorously conduct its own activities, but it also served as the major source of funding for the various projects Yanagi undertook in the name of Mokujiki Shōnin.

Like mingei, records of Mokujiki Shōnin and the objects he produced were distributed all over Japan. As Yanagi and his friends moved about the hinterlands through 1924 and 1925 in search of Mokujiki's trail, local newspapers in those regions took up the cry. In December 1924 a piece in a Yamanashi newspaper remarked in playful consternation on the energy of Mokujiki enthusiasts in Kyushu; headlined "Mokujiki Research Also Popular at His Kyushu Resting Spot: We'll Be Outdone in Our Own Specialty If We Don't Take Care," the article began, "If you think that research on Shōnin is most advanced in our prefecture, which even has a Mokujiki Shōnin Research Group, you are greatly mistaken."[8] The note of regional pride and good-humored intramural rivalry was often struck in the extensive local coverage of the Mokujiki campaign. Accounts of new discoveries tended to

lay stress, as in the *Echigo taimusu* article titled "Kashiwazaki's New Place of Note," on the satisfaction of being put on the national map.[9]

Yanagi may have been sympathetic to this localistic sentiment—it was certainly very useful to him—but his own views on the meaning of Mokujiki Shōnin operated on a much larger scale. As such they found an audience in the nation's capital, where, for metropolitan cultural elites like Yanagi, the crucial referent lay beyond Japan. In an article he wrote for a major Tokyo daily in early 1925, Yanagi made his ambition clear:

> I believe that it can be said that Shōnin is the one indigenous Buddhist sculptor produced by Japanese Buddhism. We have to date looked back on Japan as the Japan of Buddhist art. Yet not one national treasure or masterpiece escapes Chinese or Korean categories. One wonders where the characteristically Japanese works are and, further, how that character can surpass theirs [those of China and Korea]. With the appearance of Shōnin, however, that hesitation is completely over-turned. Now Japan can face any country and declare "Here is a Japanese Buddhist sculptor." That is how original and ethnic [minzokuteki] his work is. Moreover these pieces are distributed all over Japan, and number over a thousand.[10]

Other writers took Yanagi's lead. The *Asahi gurafu*, a Tokyo pictorial weekly, ran a piece a month later titled "Buddhist Images Left by Mokujiki Shōnin, a Distinctively Japanese Buddhist Sculptor in Whom Pride Should Be Taken."[11]

In stressing the Japaneseness of the sculptures, Yanagi had found an important way to promote Mokujiki for national as well as regional con-sumption. The exhibition of sculpture and photographs which opened in Tokyo in April 1925 was a great success; attended by several thousand visi-tors over a five-day period and accompanied by the brisk sale of picture postcards, photographs, and copies of the magazine and a commemorative picture book, it surprised its organizers by actually turning a small profit.[12] Yet even if the distinctively Japanese character of Mokujiki's achievement was well-received, it was less clear what that Japaneseness meant, and to what it referred. If Mokujiki was characteristically Japanese, what was not Japanese? Was non-Japaneseness, as Yanagi suggested in his promotion of Mokujiki's sculpture, to be found in China and Korea? Or was it lodged in the more prominent Western "other"?

The apparent disparity in the attitudes of Yanagi and many of his peers as

to the relevant counterpart to the Japanese aesthetic represented by Moku-jiki's sculpture reflects the relative fluidity of notions of cultural and national identity in Japan during the interwar period. Whereas Yanagi urged a distinctive Japaneseness relative to China and Korea, others seemed more interested in an opposition with the West. According to an account of the Tokyo exhibition published in the Mokujiki Shōnin journal, the painter Nakamura Fusetsu commented on his visit to the show, "Today the blind belief in the white race's monopoly on art has been completely overthrown, and for us artists Mokujiki Shōnin gives vent to a strong feeling for the yellow peoples, and especially for Japan."[13] Even Shikiba Ryūzaburō, a young physician from Niigata who had moved to Tokyo and, deeply influenced by Yanagi, taken over the business of editing and publishing the Mokujiki Shōnin journal, seemed inclined toward "rivalry" with the West in his appreciation of Mokujiki:

> I love art. In the past I have loved the sculpture of Greece, Egypt, Michelangelo, Donatello, Rodin, Braudel, Maillol, and so on. But even though I have seen only a few of these in the original, I feel that I've had my fill. At least these are no longer "rivals." My interest moved to the Buddhist sculpture of such places as India, China, and Japan. But I didn't meet with anything that really suited me. Suddenly the work of Shōnin appeared before me. With each passing day my astonishment and love for its beauty increased. This was not just because it had been discovered by Mr. Yanagi.[14]

Like his mentor Yanagi, Shikiba had moved from an initial fondness for Western art to an interest in the art of Asian countries, and from there to Mokujiki Shōnin. But for Shikiba and many others at that time, the task of distinguishing clearly between Japan and other parts of Asia or, as it was often called, the Orient (Tōyō), seems to have been less pressing than for Yanagi. The interest in locating Japan within an Oriental cultural sphere appeared as early as the beginning of the century among segments of the Japanese intelligentsia, including Yanagi and his colleagues in Shirakaba; throughout the 1920s that interest blurred together with the beginnings of a cultural nationalism that is often summed up in the phrase "return to Japan" (Nihon e no kaiki). For most it was only later, in the 1930s, with the sharpening of Japan's appetite for imperial expansion on the Asian continent and the outbreak of war with China, that it became clear that an effective Japanese challenge to the West required a return to a Japan positioned within an

Orient from which it remained sharply distinct. This is not to say that most Japanese had not long assumed a distinction between Japan and the rest of Asia, nor that Yanagi did not remain highly conscious of the West as a location of alterity. Rather, people took positions along a range that attempted to identify Japan and Japaneseness in relation to various and shifting "others."

The links between Yanagi's work on Mokujiki Shōnin and on mingei include this theme of a double return to Japan from both West and East, or, alternatively, of a double challenge to both West and East. In early 1926 Yanagi wrote to his friend Yoshida Shōtarō, publisher of the *Echigo taimusu* newspaper and a fellow collector, of his hopes for his new project with mingei: "In coming years I want to labor on this [mingei] just as I have on the Mokujiki work, and when it's done I believe that I will be able to contribute a new wonder to the world and abundantly confirm Japan's existence as a land of art. In this field of *getemono* [mingei] for the first time Japan can show a challenge to China in terms of freedom and strength and charm. All the more will [mingei] show its superiority to Western things."[15] Implied in this passage is Yanagi's sense that mingei may prove an even more effective source of indigenous Japanese cultural identity than Mokujiki Shōnin. Although Yanagi claimed that Mokujiki's sculpture proved the existence of a Japanese Buddhist aesthetic independent of continental Asian Buddhism, it is clear that he expected mingei to present a more complete challenge—"in terms of freedom and strength and charm"—not only to Chinese culture but also to "Western things."

It is important, therefore, to acknowledge not only the links but also the discontinuities between the Mokujiki Shōnin and mingei projects. For Yanagi at least, if not for others, the significance of Mokujiki Shōnin lay primarily in the evidence his sculptures (and his life) provided of a distinctively Japanese Buddhist sensibility. Mokujiki had reassured Yanagi that within the Orient, or Tōyō, so often defined for Taishō-era Japanese intellectuals in terms of Buddhist civilization and particularly Buddhist art, Japan had held its own against India, China, and Korea. Yet however firmly Mokujiki might establish Japan's place within the Orient, his art availed little in the attempt to revise the relationship between Japan and the West. A Japanese identity derived from the sculptures and piety of an eighteenth-century Buddhist monk, however original, could only uphold the familiar couplet with which the reforming samurai statesmen of the Meiji Restoration (1868) had rationalized the changes brought to the material life of the nation: "Oriental

ethics, Occidental science" (Tōyō no dōtoku, Seiyō no gakugei). But by the late 1920s many Japanese were no longer content to cede the West all the credit for science or, by extension, technology and material culture generally. Mingei, a field of objects with indeterminate boundaries ranging from eighteenth-century Japanese clocks (watokei) to early-nineteenth-century paintings to handmade paper (washi) and textiles, offered new scope for cultural identity in a world increasingly defined by the mastery of things.

Folk art thus provided access to the modern in a way that Mokujiki did not. Although some members of the Mokujiki Shōnin Research Group in Kōfu asserted the relevance of Mokujiki's life and work to modern Japanese Buddhism, Yanagi's endorsement of such views tended to be vague at best. Mingei, on the other hand, soon suggested to Yanagi and others opportunities for an integration of the Japanese past with the Japanese present and future. Nor was the mingei group alone in its efforts to discover modern value in indigenous handicrafts. During the late 1920s and early 1930s mingei was defined and redefined in a context of multiple efforts to recuperate indigenous material culture for a Japanese modernity.

### "The Way of Crafts": From Getemono to Mingei

Yanagi and others came only gradually to identify a certain field of objects as mingei. The first phase of definition took place over a period of several years, between about 1925 and 1930, and the meanings that eventually developed continued to shift and proliferate even later. The instability of the category of mingei also reflects the fact that although Yanagi was certainly the central authorial figure in the process of definition, he was by no means a solitary genius. Mingei emerged as the result of a collective effort, through negotiation among the group of collectors, artists, and writers with whom Yanagi associated. It was also, of course, very much a product of its times, reflecting widespread new interest in non-elite—especially rural—society and culture and also in questions of daily life, modern design, and native value.

The gradual, collective nature of the discovery of mingei is suggested by the way the very word was invented and brought into use. The term—a compound of the Chinese characters "min" (people) and "gei" (art or technique) and a contraction of the phrase "minshūteki kōgei" (popular crafts)—is usually attributed to Yanagi. But it is possible that either Hamada Shōji or Kawai Kanjirō, potters to whom Yanagi grew close after his move to Kyoto in 1924, first suggested the word to refer to the old pottery, textile, and other

handicraft items in which all three shared a keen interest. "Mingei" was apparently put forward sometime in 1925 or early 1926 as an alternative to several other names by which the three young men and their friends referred to the inexpensive objects they had taken to hunting out in antique stores and flea markets.

Years passed before "mingei" effectively replaced the other phrases and terms in use. In particular, "getemono," roughly translatable as "low-grade things," was probably more commonly used by enthusiasts, including Yanagi and his group, throughout the 1920s. In the 1926 essay "Getemono no bi" (The Beauty of Getemono), written almost a year after "mingei" was probably first suggested, Yanagi even announced his intention of continuing to use the term "getemono" indefinitely. As he put it, "This is an unfamiliar slang term, but I know of no appropriate word to use in place of 'getemono.' Indeed once one grows accustomed to it, the word is highly suited, whether in terms of sound or form, to its meaning. It even has its own special flavor [ajiwai]. Because nothing would be better than for it to become commonly used, I will continue to use it myself."[16] As late as 1929, in the published transcript of a round-table discussion about crafts in which Yanagi, Kawai, and various others concerned with folk-craft participated, "getemono" and "mingei" were used interchangeably.[17] And yet not much later "mingei" was clearly the preferred term and "getemono" had fallen irrevocably out of favor. By 1942, when "Getemono no bi" was included in a collection of Yanagi's writings on what had come to be reasonably well-known as "mingei," he had revised it as "Zakki no bi" (The Beauty of Miscellaneous Wares) and replaced almost all references in the text to "getemono" with the rather vague term "zakki."[18]

The transition from "getemono" to "mingei" (or, at a pinch, "zakki") deserves more attention than it ordinarily receives. The process by which a small group of collectors named and renamed the objects of their interest was neither casual nor accidental. Yanagi himself offered an explanation for the abandonment of "getemono" that cited the uncontrollable nature of the word. In "Kyōto no asaichi" (The Morning Markets of Kyoto), a 1956 reminiscence of collecting folk-craft in Kyoto between 1924 and 1932, he described the origins of the term:

> Most of the sellers were old women, for whom the work was certainly an ideal sideline. Because the market was usually over by noon, the buyers would gather early. We too went often, and as a result got to

know the old women, who would do things for us like putting objects aside. Here I want to note that I first heard the slang terms "gete" and "getemono" from these women. Most of what we bought was, in their phrase, "getemono." Because we were intrigued by the unfamiliar term, and also because it clearly expressed the contrast with "jote-mono" [high-grade things], we thought it convenient to use the word ourselves. "Gete" indicated the very ordinary, inexpensive quality of these objects, and so corresponds to such terms as minki [popular wares] or zakki. I believe we were the first to write this slang down, and to explain its meaning. It was in "Getemono no bi," published in the 19 September 1926 edition of the Echigo taimusu, that I first used it in writing.[19]

In a sense, then, "getemono" too was a neologism for which Yanagi claims some of the credit. He goes on to describe the objections that gradually arose to the term.

But this slang word—perhaps because there is something strong in its tone, or because it has a certain bizarre quality—spread very quickly with each passing year, and now has gotten so that almost everyone uses it, and even dictionaries must include it. I believe the first to do so was Dr. Shinmura Izuru's Jien. Gradually, however, as this word spread throughout society, it overflowed its customary examples and became something very different from what we had originally meant; it was used mistakenly, and given outrageous meanings, and also employed in various ways to refer to amusements. For this reason our position was often misunderstood or distorted, causing us a good deal of trouble. So then we decided to avoid this slang term at all costs and, feeling the need to create some other word, finally settled on the two characters of "mingei."[20]

The nature of the misunderstandings or distortions to which "gete-mono" gave rise is suggested by the definition given in a standard, late-twentieth-century Japanese-English dictionary: "Simple ware; folk ware; an odd thing." One of the two example sentences refers to a male subject's taste in pottery, and the other reads as follows: "He must be a man of very strange likings that he should fall for that sort of woman" (Anna onna ni noboseru nante, yohodo getemono shumi da).[21] What Yanagi called the mistaken and even "outrageous" (tondemonai) associations that had accreted around "gete-

mono" linked folk ware to odd things and amusement in a manner that intimated a refined male taste for lowly, even voluptuous pleasures. What irked Yanagi and others may well have been the very accuracy of such a characterization of their predilections, particularly in the context of economic troubles and social unrest in the late 1920s and early 1930s, when frivolous pleasures had begun to seem distinctly irresponsible. By rejecting "getemono," Yanagi and the young men who had gathered around him sought to deny the private, hobbyist aspect of their interest in folk art. The new word, "mingei," with its etymological links to the "common people" (*minshū*) and to "craft" (*kōgei*), suggested far more weighty objects of concern befitting educated men of conscience in early Shōwa Japan: society and industry.

Yanagi's writings were central to this endeavor to define folk art in terms responsive to growing public concern about a mass society deeply troubled by rapid industrialization. "Getemono no bi" and especially a long series of articles published in 1927 and 1928 entitled "Kōgei no michi" (The Way of Crafts) stand today as the foundation of the early mingei canon; in these texts Yanagi formulated the basic framework of what was to become his theory of folk art.[22] In particular *Kōgei no michi*, which was revised and reissued in 1928 as a book and has been reprinted many times since, remains the classic statement of orthodox mingei doctrine.[23] But both texts are also remarkable for the urgency with which they press the case for mingei as a moral, social, and even national mission. Drawing heavily on Buddhist as well as Christian thought, on socialist arguments, and on the ideas of John Ruskin and William Morris, among others, Yanagi made clear that an interest in folk art was very far from being an esoteric, antiquarian pastime. As described in *Kōgei no michi*, mingei represented the critical utopia toward which Yanagi saw himself and his comrades actively engaged in leading Japanese (and possibly world) society.

The first step in disavowing elitist dilettantism was to assert the intrinsically social nature of mingei, and indeed of all manufacture—whether self-consciously "artistic" or not. In a sense Yanagi, along with many of his intellectual generation both within and beyond Japan, was renouncing the ideal he had only recently embraced, of culture as a high and separate realm of rare individual achievement protected from the pollution of the vulgar and the everyday. In the late nineteenth century this idealist neo-Kantian formula had been grafted comfortably (in a manner certainly not unique to Japan) onto older assumptions reserving supreme cultural value for the few. By

contrast, however, one of the fundamental arguments of *Kōgei no michi* was that culture and society are inseparable. Handicrafts were important in part because, produced largely for ordinary use by ordinary people, they exposed the falsehood of any attempt to distinguish sharply between the two. As Yanagi put it, "Craft beauty is social beauty." And further, "Ugly crafts are the reflection of an ugly society." In a discussion of the ideas of John Ruskin, whom he called a "great crafts theorist," Yanagi noted that it was inevitable that "his moral demands of beauty led him to demand an ethical order of society itself."[24]

Moreover, Yanagi claimed that it was precisely the "low" social origins of folk-craft, made by and for the laboring masses, that ensured its superior aesthetic and moral merit. This was especially true in comparison to the "high" craft or art produced for elite consumption. In both "Getemono no bi" and *Kōgei no michi*, Yanagi put forward the basic tenets of what became mingei ideology in terms that posited the superiority of premodern and early modern folk handicraft. That superiority was a consequence, he argued, of the conditions of handicraft production and consumption in plebeian society. True mingei (or getemono) was (1) functional; (2) used in the daily life of common people; (3) thus produced in large quantities; (4) therefore inexpensive; (5) produced in a cooperative or collective fashion; (6) handmade; (7) produced using natural, locally specific materials; (8) produced according to traditional techniques and designs; (9) produced by anonymous artisans without self-conscious, individualistic aesthetic intent; and the primary quality of the mingei aesthetic was (10) simplicity.[25] To the extent that objects produced according to these tenets were characterized by greater freedom, variety, strength, warmth, and naturalness, they were consistently more beautiful than most craft or art works manufactured under other circumstances.

Nor was it enough simply to appreciate this past beauty, however one understood it. *Kōgei no michi* is, among other things, a call to action. According to Yanagi, modern craft and society were suffering from a disease that demanded immediate intervention: "When I see the forms of distorted crafts, they look as though they will never recover from their fatal wounds. . . . I hear the fainting voices of these wares. They are asking why they are so ill. They curse this world, and also they plead for help. I cannot ignore them. My duty is not to attack their ugliness, but to ask why they became ugly. And then, if possible, I must work to return them once more to beauty." The causes of this tragic distortion were capitalism, the overreliance

on machines ("machine-ism" or *kikaishugi*), egotism (*shugashugi*), and intellectualism (*shuchishugi*). Yanagi compared himself to Ruskin and William Morris (whom he considered Ruskin's less talented successor) in his commitment to aesthetic and therefore social and moral activism in order to combat these ills: "In loving craft beauty, and in considering its past and hoping for its future, I cannot but discover my own purpose within theirs [Ruskin's and Morris's]."[26] This purpose, as described in *Kōgei no michi*, was to help bring about the socialist "Kingdom of Beauty" (*bi no ōkoku*) in which a true craft aesthetic, as exemplified by mingei of the preindustrial past, would be restored to the masses.

Yanagi's commitment to a socialist future was explicit:

> So there are two ways of looking at crafts. One is to affirm present-day society, and to give birth to crafts in its future. In other words, this is to look for new crafts on the basis of present-day social organization. But the second way is to try to develop future crafts on the basis of a reform of the present system. The former seeks the future of crafts based on continuation of the present, while the latter does so based on the construction of the future. One rests on capitalism, and the other enters socialism. Which path will guarantee the beauty of crafts? Naturally I, along with Ruskin and Morris, cannot hope for a bright future from the former.[27]

His critique of the ugliness of both craft and society under capitalism could be scathing. In the section titled "Ayamareru kōgei" (Mistaken Crafts), he mounted an eloquent attack on the greed, inequity, and misery that characterize capitalist production. No small part of this misery is due, he charged, to the inimical effects of capitalist machine industry on manufactures—both as labor process and as consumer product—and thus on the quality of daily life for the great majority. Observing that "it is true only that the unlimited use of machinery has not ensured modern happiness," he went on to state flatly, "There is no way to harmonize the present social system with beauty, because the system of capital itself exterminates beauty."[28]

Although many of Yanagi's statements in *Kōgei no michi* about social change were bold and even daring, they were made at a time when leftist social critique and activism had become almost commonplace among younger Japanese intellectuals. Few in the 1920s, which in Japan as elsewhere was marked by the irruption of the masses into public consciousness, could deny the importance of either urban or rural non-elite society and culture. And

most intellectuals in Japan, again like the intelligentsia throughout much of the world, had taken at least one large step to the left in the decade after the Bolshevik Revolution. In an era when the so-called Marx boy had become a familiar, even fashionable figure and the thirty volumes of the complete works of Marx and Engels were published in the mass-market *enpon* ("one-yen book") form, Yanagi's assertions of the value of "low" culture and the promise of a socialist future were hardly extraordinary.[29]

More distinctive in *Kōgei no michi*, perhaps, were the limitations to Yanagi's progressivism. His brand of socialism was strongly marked by an anti-modernist strain of communitarianism. Although his criticism of society and especially production and labor under capitalism owed a great deal to Marxist analysis, Yanagi was no Marxist. Instead, he subscribed to guild socialism, especially as propounded by the British architect A. J. Penty.[30] But Penty, who has been characterized by one historian as "an uncompromising medievalist, firmly localist in orientation, with a deep hatred of machine production," did not represent the mainstream of guild socialist thought, which accepted the necessity of adapting the guild ideal to modern industrial production.[31] Yanagi made clear in *Kōgei no michi* that it was precisely the medievalist spirit of Pentyian thought that appealed to him, and he repudiated the ideas of G. D. H. Cole, arguably the leading theorist of guild socialism: "I am dissatisfied with the assertions of Cole, who is also a guild socialist. He overlooks the fatal contradiction between the guild, which respects human liberty, and the machine system, which does not permit it."[32]

Moreover, Yanagi's definition of human liberty (*jinkakuteki jiyū*) was infused with an emphasis, articulated largely in Buddhist terms, on the greater social good as it transcended the selfish individual ego. In praising the medieval guild (which he translated into Japanese as *kyōdan*, or "cooperative group"), Yanagi focused on its role in preserving social order and unity. That order, he claimed, was reflected in the great medieval aesthetic, whether European or Japanese, just as capitalist disorder was manifest in the stylistic disarray of modern arts and crafts.

> When I visit people's houses, I cannot but feel the fractured nature of a period without unity [*tōitsu naki jidai*]. Going through a room, I see a Sung scroll hanging in the alcove. But in front of it stands a recently manufactured piece of copperware that I cannot bear to look at. The master of the house likes tea ceremony, and takes out of a gold-

encrusted bag an Ido teabowl. But the cup in which I am served plain tea is one of those cobalt things. And the sweets are on a colored plate decorated with an Art Nouveau design. . . . We, born into a divided era, have this division forced upon us in our daily lives.[33]

The conflict Yanagi found so distasteful in home furnishings was equally reprehensible in society, whether between individuals or classes: "All the ugliness that appears in craft is caused by a riven society. Therein is tyranny rather than mutual love. Slavery, not camaraderie. The denial of humanity, and not liberty. Antagonism, not unity. Class war, and not mutual aid."[34] Like many other Japanese in the interwar era, Yanagi was evidently more comfortable with the communitarian end of socialism than with the idea that conflict might be its means.[35] In this respect he parted company, again, with the mainstream of guild socialists, who were usually quite ready to admit to class war as a necessary evil in the construction of a better society.

Another equivocal note in Yanagi's otherwise progressive program for social and cultural reform was struck by his celebration of the hierarchical relations characterizing the medieval guild. The question of how to reconcile democratic ideals with the traditional distinctions between master, journeyman, and apprentice artisan had proved a source of discord in guild socialism, even as it became the target of criticism from without.[36] Yanagi embraced those distinctions without hesitation, however, as a natural and appropriate model for productive relations: "When we look back at the great [medieval] Age of Craft, there we see the mutual assistance of two forces. One is the common people, as craftsmen, and the other is the master craftsmen, who lead them. This union is especially clear in the medieval guild." So too in the present and future, Yanagi argued, should the people be led by a few enlightened individuals. These were usually identified as individual artists (kojin sakka).

> Just as the common people did not know how beautiful the things they made were, so they know nothing in the present of how ugly the things they make are. . . . Today, when beauty is lost, unless someone comes forward to show them an aesthetic goal, correct craft will never be revived. And yet it can never be created without the power of the common people. Thus there is only one path left open to us. Can crafts develop properly without the union of understanding individuals and the people, without labor assembled under good guidance?[37]

Although Yanagi stressed that, given proper conditions, the objects produced by the uneducated masses were vastly superior to anything the average artist could create, it was clear that he assumed a natural social hierarchy within which the latter retained a higher status: "If we look at them as human beings, how much greater the cultivated individual artist is than the uneducated artisan."[38] Nor did it seem likely, in his view, that this balance, and the roles it prescribed for artist and artisan in the production of "correct" crafts, could ever really change. In a 1929 round-table discussion, Yanagi expressed doubt that ordinary artisans could ever develop their own, independent consciousness of the mingei aesthetic. Kawai demurred, arguing that with greater access to education all artists and artisans would eventually work on the same level. Yanagi's response was noncommittal.[39]

Yanagi's habitual characterization of the relation between the craft object and its owner provides a striking further instance of his tendency to assume and even idealize inequity as a natural condition. A strong animistic theme runs through many of his writings on material culture; he regularly imagined consciousness and agency on the part of things, especially things he found beautiful. Occasionally he even asserted this as an article of belief. In "Getemono no bi," for example, he asks, "Even if they are objects, who can say that they have no spirit [kokoro]?"[40] Or, again, in Kōgei no michi: "Who can say that those wares have no spirit? But because they have been reared without human compassion, that spirit has become distorted. This is just the same as when an abused child loses its innocence."[41] The comparison to a child is telling. Craft objects are imagined to be, like children, vulnerable and dependent. Unlike most children, however, crafts also long to labor and serve:

> Wares always invite love. Their wish always to associate with us is visible. It's strange, but because their intent is to serve, they become even more beautiful when confronted by a master [nushi] who uses them well. . . . That beauty is the mark of their gratitude to one who uses them lovingly [aiyō suru mono]. . . . Just as people cannot live without the aid of wares, so too wares cannot live without the love of people. People are the mothers who rear wares. . . . The beauty of wares is planted in their service to people, and bears fruit in the love they receive from people.[42]

Craft objects are represented here and in other passages as childish servants, or servant children, who are fulfilled and made beautiful by a paternalistic (or maternalistic) relationship of loving exploitation.

This is a seductive but dangerous fantasy, especially when the distinction between people and things is blurred. It is possible to argue that Yanagi did sometimes blur that distinction, as he and others did between Korean people and objects, in his approach to Japanese folk-craft (folk/craft). For example, in "Getemono no bi," he wrote with what seems an almost studied ambiguity about the virtues of mingei as it lived a "life of the soil":

> Endurance and health and sincerity—these are the virtues within the heart of wares. These are wares that belong to the life of the soil. Those [*mono*, written as the character *sha*] who live properly the life of the soil are assured the blessing of heaven. . . . Because they are hard-working bodies [*karada*], they live modestly, dressed poorly. But contentment can be seen there. Do they not always greet morning and evening with health? . . . There is an alluring beauty in the fragility that trembles at the slightest touch (as in Kōrai [Koryŏ] pottery). But the figure that withstands, unmoving, a powerful blow is also astonishingly beautiful.[43]

The violence explicit in the last sentence of this passage helps to suggest to this reader, at least, what is jarring in Yanagi's claims to knowledge about the secret life of things.

Nevertheless, in general Yanagi's early writings on mingei communicate an urgent and activist commitment to the welfare of Japanese society as a whole, and to that of the "common people" in particular. He envisioned a "brilliant future" in which guild socialism ensured an abundance of beautiful, inexpensive objects produced and consumed communally by all. But to achieve this future, it was necessary that those with proper knowledge and consciousness take action. This meant, first of all, that Yanagi develop and promote his ideas about mingei and its significance. These ideas were, he insisted, simply truths or laws he had been taught by the objects themselves and to which his own intuition (*chokkan*) had given him direct access.[44] Next, it was essential that an educated elite adopt and implement these ideas so as to lead the unconscious people, much as the medieval clergy led the lay faithful, to their own betterment.[45] These leaders were artists, of course, but also critics and scholars, as well as consumers with the means to reject fashionable, mistaken goods in favor of "correct" wares.[46]

The apocalyptic, even messianic tone Yanagi occasionally adopted in these texts suggests that he considered the laws revealed to him to have universal validity. In the end, the Kingdom of Beauty was to be transnational. Nevertheless, part of the mingei mission Yanagi outlined—perhaps its pen-

ultimate goal—was the promotion of Japanese national identity and status within a competitive international context. "Getemono no bi" concludes with the following: "We cannot put our art before great China, or elegant Korea, without hesitation. But when we come to the realm of 'getemono,' we have arrived at the one rare exception. Therein is unique Japan. Certainty and freedom and creativity are found there in plenty. It is neither copy nor imitation. One can say unequivocally that here is a Japan that ranks with the works of the world. . . . For the glory of the Japanese people [minzoku], I must draw 'getemono' out from under its dust."[47] In his published writings Yanagi generally refrained from expressing what appears to have been his private conviction that getemono (or mingei) would not only challenge continental Asian art, but also show its "superiority to Western things."[48] He contented himself in Kōgei no michi, for example, by commenting only that someday Japanese mingei would receive due recognition from the "world," where it would create a "sensation."[49]

But Yanagi offered a more pointed nationalistic challenge to the West when it came to the question of who deserved credit for the aesthetic consciousness that made it possible to recognize the true value of mingei. He cited his Japaneseness in explaining his own decision to study craft, and its significance for society, from an aesthetic standpoint: "I cannot repress the realization that it is the glad duty given to us Japanese to pursue the aesthetic path. The craft beauty beheld by the first tea masters is, unquestionably, far more profound than that which Morris and his like saw. We, who inherit their blood, have the duty to enlarge our intuition and understanding of the problems they left behind—that is, the question of truth within craft."[50] Yanagi and his fellows, as Japanese, were thus peculiarly qualified not only to intuit the aesthetic truths of craft, but also to take the further step of understanding them. Conscious understanding, at once the blessing and the burden of the modern age, was what the Japanese tea masters of the sixteenth century had been unable to achieve.[51] By contrast, Ruskin and especially Morris, whom Yanagi praised for having been the first to develop such a modern consciousness of the social and moral import of the craft aesthetic, lacked the aesthetic insight native to the tea masters and to (some) modern Japanese.[52]

While Morris, even more than Ruskin, was to be commended for his craft activism, Yanagi also singled him out for the uncertainty of his aesthetic vision: "Look at the famous 'Red House' he built. What a weak [amai] building this is. It is nothing more than aesthetic play. Its form is clearly

modelled on medieval architecture, but was medieval architecture ever built with such weak sentiment? The 'Red House' is a painting and not a home, for the purpose of beauty and not use. In particular the interior decoration is a complete failure. I cannot bear to look at the patterns of that wallpaper."[53] Perhaps it is not surprising that, given remarks like these as well as the general drift of Yanagi's assessment of Ruskin and Morris, we find a certain asperity in the tone of some British scholars treating Yanagi and especially the question of his debt to Morris and the Arts and Crafts movement in England.[54]

Yet it is possible to read not only Japanese nationalism in Yanagi's denial of an Arts and Crafts origin to the mingei mission, but also a more generally modernist repudiation of the "weak sentimentality" of late-nineteenth-century aestheticism. The British Arts and Crafts movement is often acknowledged as one of the early sources of international modern design. Morris's emphasis on simplicity, functionality, and sound materials and workmanship—as well as his rejection of art academism and the cult of the fine artist—provided one of the wellsprings for the later development of such classic modernist institutions as the Bauhaus art and design school (1919–1933).[55] At the same time, however, British Arts and Crafts, like Art Nouveau in France and Jugendstil in Germany, also reflected a late-nineteenth-century cultural context within which the attitude of "art for art's sake," and the concomitant celebration of elaborate decoration and ornament, prevailed.[56] Fifty years later, the objects actually designed by Morris could only be repugnant to Yanagi, as to other arbiters of good design—whether in Tokyo, Amsterdam, or New York. By the late 1920s, the spare, functionalist aesthetic of high modernism was well on its way to setting design standards throughout the industrialized world.[57]

Of course, the mingei aesthetic was not shaped entirely by the imperatives of design modernism. The insistence on hand rather than machine production and the general suspicion of new technology voiced by Yanagi and his group pose the most obvious obstacles to any attempt to subsume mingei doctrine within modern design. It is important to recognize, however, the strong affinities between Yanagi's intuitively derived principles of beauty and what was fast becoming an international aesthetic orthodoxy. The confidence with which Yanagi could state that simplicity is the guarantee of all good art, or that only functional objects are truly beautiful, or that Gothic architecture and design of the European Middle Ages represent a pinnacle of human achievement, derived at least in part from the authority exerted by the

growing international consensus according to which these statements were (and for many still are) transparently true.[58] Even what might at first glance appear to be a rather "Japanese" or "Buddhist" criticism of Morris—Yanagi's accusation that his work was, in the end, fatally weakened by his individualism and his failure to transcend self-conscious "artistry" to achieve true, egoless "craftsmanship"—can be placed within an international context of 1920s design movements that rejected Romantic notions of self-expression in favor of egalitarian social ideals.[59]

### Early Experiments in Mingei Activism, 1926–1928

Yanagi was not alone in his ambition to supervise the construction of a beautiful new society. His writings on aesthetic and social reform in the late 1920s reflected the aspirations he shared with a number of like-minded collectors, artists, and writers. Between 1926 and the early 1930s, these collective aspirations were expressed somewhat more directly in a variety of group projects designed to promote mingei as both a means and an end of social and cultural change. In April 1926, for example, before Yanagi wrote either "Getemono no bi" or Kōgei no michi, a fundraising pamphlet titled "Prospectus for the Establishment of a Mingei Art Museum" was privately published and distributed. Although probably drafted by Yanagi, the document lists the potters Tomimoto Kenkichi, Kawai Kanjirō, and Hamada Shōji along with Yanagi as coauthors and concludes by naming the collectors Aoyama Jirō, Ishimaru Shigeharu, and Uchiyama Shōzō as fellow organizers.[60] The initial statement of intent concludes with the following:

> The beauty of nature lives, and the existence of the nation [kokumin no seimei] is reflected, within the beauty of mingei. The beauty of craft is that of warmth and vitality. Today, when everything has become marred by artifice and is drifting into weakness, when love is withering, do we not feel deep emotion upon savoring this correct beauty once again? Who can deny that a proper epoch is one in which beauty springs from nature, when beauty mingles with the common people, and becomes the friend of daily life? We commence this work of the "Japan Mingei Art Museum" in order to show that a proper epoch once existed in the past, and should exist again in the future.[61]

The seven signatories to the prospectus, along with some, if not all, of the friends and acquaintances to whom it was distributed, apparently shared

many of the convictions that informed later texts like *Kōgei no michi*. Folk art, far from being a novel category of antique collectibles, was testimony to "pure Japanese" national identity; it was the reservoir of a true, natural, and universal standard of beauty; and it offered a corrective to the ills of contemporary society.[62] The work of founding a mingei museum represented, therefore, a form of activism that was intended "at once to celebrate the past, affirm the present, and prepare for the future."[63]

Other forays into mingei activism, such as the 1927–1929 Kamigamo artisans' guild in Kyoto, the model house exhibited at the 1928 Tokyo Industrial Exposition, two short-lived retail operations in Tokyo, and another guildlike community planned in Shizuoka prefecture, offer additional evidence that a small but growing number of enthusiasts was persuaded that folk art was central to the betterment of an ailing society and culture.[64] It would be a mistake, however, to take the further step of concluding that these men and their activities constituted a fully organized movement, much less one identical to the so-called mingei movement as it got under way in the mid-1930s. The early experiments were conducted on a small scale, in a manner that might best be described as improvisational, by a loose and shifting network of individuals who embraced a variety of notions about mingei (or getemono) and its relevance to social or cultural reform.

Indeed, just as it was some time before the word "mingei" was firmly established, it was not until the mid-1930s that efforts to promote folk-craft began to have any real institutional or ideological coherence and efficacy. For example, *Kōgei* (*Craft*), one of two monthly magazines associated with the early movement, did not begin publication until 1931. (And even then, due to opposition from others, Yanagi and Hamada were unable to have the magazine named *Mingei*, as they wished.)[65] The other magazine, *Gekkan mingei* (*Mingei Monthly*), which was much more explicitly intended to serve as a movement bulletin, began to appear only in 1939. Nor was it until 1934 that the Mingei Association (Mingei kyōkai), an executive body that coordinated and helped to direct the various mingei-related endeavors and organizations that had sprung up in the early 1930s, was established.

Because of its manifesto-like air, the 1926 "Prospectus for the Establishment of a Mingei Museum" is often cited as evidence for the formal inauguration of the mingei movement.[66] It is worth noting, however, that the three-year program of action outlined by the "Prospectus" turned out to be quite unrealistic. Year 1 was to be devoted to the collection of all types of mingei from all parts of Japan, along with "reference pieces" (sankōhin) from Korea,

China, India, and other nearby countries as well as from the West. Year 2 was to be spent organizing exhibitions of mingei in Tokyo. Finally the museum itself, as a permanent showcase for the collection, was to be built in the third year.[67] Yet in fact it was fully a decade before a permanent mingei museum opened its doors in Tokyo; an earlier museum was attempted in 1931, in the Hamamatsu home of the collector Takabayashi Hyōe, but failed shortly thereafter.

The other early mingei projects were similarly impractical. None could be considered very successful, especially when measured against the hopes and expectations of those who undertook them. Thus experiments like the Kamigamo guild and the model house exhibited at the 1928 Industrial Exposition do not fit comfortably within a smoothly progressive narrative of the formation and rise of the mingei movement. Nevertheless, these endeavors merit attention, for they demonstrate that in the late 1920s, ideas about cultural and social reform through the production and consumption of indigenous handicrafts interested a number of thoughtful individuals. Although only a handful were roused to real action, their efforts received the support and favorable attention of many others—journalists, publishers, public intellectuals—who were in a position both to reflect and shape educated opinion.

Perhaps the most ambitious of these efforts to remake society in the name of mingei was the craft guild established in 1927 in Kamigamo, a northern section of the city of Kyoto. The Kamigamo Mingei Guild (Kamigamo mingei kyōdan), as it was called, began in the summer of 1927 and dissolved, for reasons Yanagi ascribed to "human moral weakness" (ningen no dōtokuteki chikara no yowasa), at the end of 1929.[68] During the nearly three years of its existence, the guild consisted of three, and then four young men (the eldest, and the leader, was the weaver, dyer, and schoolteacher Aota Gorō, who was twenty-nine in 1927) living and working together as artisans in a large rented house.[69] Despite the severe logistical, economic, and other difficulties which former members as well as commentators have cited for the guild's ultimate dissolution, the experiment was not without success.[70] In June 1929 a two-day exhibit and sale in Kyoto of the cooperative's products drew what was described as "record-breaking" attendance and sales, with visitors numbering nearly a thousand.[71] The guild is given credit also for having served as a formative training ground for the twenty-two-year-old woodworker and lacquer artist Kuroda Tatsuaki, who eventually won national recognition for his work.

By the standard of Yanagi's expectations, however, the Kamigamo Mingei

Guild was a disappointment. The true scope of the project as he first conceived it in another privately published and distributed pamphlet, "One Proposal Regarding a Crafts Guild," was nothing less than revolutionary. In the "Proposal," published in an edition of thirty in March 1927, Yanagi addressed what was already shaping into a key conundrum for his crafts theory: How could conscious, individualistic, modern craftspeople—having "eaten of the fruit of knowledge"—produce mingei, or objects comparable in aesthetic value to those created by the innocent, unconscious folk of the past?[72] The solution Yanagi urged was a re-creation of the medieval guild. It was only through a communal, cooperative mode of production rooted in a communal, cooperative way of life that "proper crafts" might still be produced in spite of the capitalist evils of modernity. Yanagi bolstered his proposal with guild socialist theory: "Guild socialists strongly assert that this path [of the guild] is the safest mode of economic life. As they say, this [path] safely escapes the evil influences of modern capitalism and machineism [kikaishugi] and will bring happiness to humanity."[73]

Yanagi felt that the quality of the objects produced by the Kamigamo guild validated his theory.[74] It was in its failure to survive and grow that the guild had fallen away from his plan. He had expected the guild to develop into a larger self-governing community: "Because it is a guild, it is inevitable that a village [mura] will be formed. As a result it will be possible to produce the fruit of an even deeper mutual love [sōai]. It will become a single unified self-governing body. (There are people who by reason of circumstance or character feel it difficult to live communally in a village. In this case, through the unity of fast belief, it is fine if they observe the spirit and regulations of the guild as one of its members.)" Yanagi could hardly ignore that he himself had no immediate intention of moving with his family to an experimental crafts commune. Nevertheless the "Proposal" concludes with the suggestion that in time this village-guild might grow to incorporate the labors of those who contribute to production indirectly, such as crafts historians and theorists, and that it might even expand to national dimensions: "Our guild will probably be criticized as being nothing more, after all, than a little cooperative, and they will say that it is far from the ideal of a national guild [kokkateki girudo]. However ripples emanate from one central point. What we are planning is indeed a true departure."[75]

Yet even if the vision of a mingei guild society was never realized, it had the power to inspire at least three thoughtful young men to several years of hard work. One senior guild member, Aota Gorō, a recent graduate of

Dōshisha University who taught history at the Dōshisha Middle School, had little or no artisanal background. Undaunted, he began studying weaving and dyeing, left his wife, and moved into the Kamigamo house, from which he commuted to work on weekdays. Nights and weekends were devoted to the painful trial-and-error process of mastering his art in the manner pre-scribed by Yanagi's emerging theory of "proper" craft. Kuroda Tatsuaki, as a trained artisan from a woodworking and lacquering household in Kyoto, had perhaps slightly less of an uphill climb. Yet he joined the guild in spite of opposition from his family and the complete absence of appropriate work facilities for his demanding and expensive craft. The third member, Suzuki Minoru, a Dōshisha university student struggling to study medicine, was engaged to assist Aota and to cook and keep house. The three were joined eventually by Aota's younger brother, another perfect novice, who ventured into metalwork under Kuroda's supervision.[76]

The guild members were all directly influenced by Yanagi's teachings and writings. In a 1928 newspaper article on the guild, the three expressed them-selves in terms that echoed Yanagi: "At this point the things we make will go out onto the market, but only by special order, as during the guild era. We are not at all interested in entering into the production system of present-day society." Their comments were tempered, however, by acknowledgment of some of the practical difficulties they had encountered in attempting to realize Yanagi's ideals: "Unfortunately, we simply cannot make the prices [of our products] low, unlike the things produced rapidly by machine power.... [But] as our group gradually increases, the prices will come down naturally."[77]

From start to finish, money was the hard reality that the guild vision never took adequately into account. Aota's schoolteacher's salary, along with the money Suzuki made as a private tutor (katei kyōshi), were hardly enough to cover the guild's expenses, which included a steep rent and the regular purchase of costly materials. Only toward the end of its existence did sales of the guild's products actually begin to bring in more than a paltry sum. As Suzuki noted in retrospect, the guild would not have survived without the financial support it received from outside. Most important were the efforts of Iwai Taketoshi, editor of the Kyoto edition of a major Osaka newspaper, who felt strongly enough about the guild project to devote much of his ener-gies to promoting and supporting it. Not only did Iwai organize a group of twelve or thirteen supporters to contribute money to the guild each month, but he saw to it that his newspaper sponsored the guild's successful 1929

exhibit and sale, as well as publishing promotional articles and announcements about the guild at every opportunity.[78]

As Iwai's activities suggest, the guild project was not quite so isolated or obscure a venture as is sometimes suggested. In his reminiscence, for example, Kuroda remarks that at the time, the guild members were treated as if insane, and no one paid any attention to the effort to promote mingei.[79] While most of those who were aware of the Kamigamo Mingei Guild probably did consider it eccentric and inconsequential at best, there was a significant number of others who, like Iwai, took it quite seriously. Like Iwai, moreover, these interested observers tended to be well-heeled men of culture whose opinions carried weight in society at large. Among the many visitors to the guild, for example, were such luminaries as the writer Shiga Naoya and the critics and collectors Kobayashi Hideo and Aoyama Jirō.[80] In a letter he wrote shortly after the guild had formed, Yanagi commented that "no one had any faith" in his guild proposal when he first made it.[81] Even if true, more than a few showed sympathetic interest once the project was launched.

The public impact of the Kamigamo guild was much smaller, however, than that of another mingei project: the "Mingeikan" or mingei model house exhibited at the 1928 Tokyo Industrial Exposition, held in Ueno Park in honor of the Shōwa emperor's accession. In an exposition widely heralded as the last and perhaps the biggest to be held in the once customary venue of Ueno Park, the Mingeikan attracted special attention as, according to one newspaper article, "the oddest entry" (ichiban kawaridane no shuppin) of all.[82] The opportunity to make this splash was provided, as was so often the case in the early years of mingei activism, by the intervention of another sympathetic and well-placed individual. Kurahashi Tōjirō, a publisher, collector, and mingei enthusiast, had been appointed the general chairman of the board directing the exposition. According to one account, he was concerned that the plan announced in 1926 to establish a mingei museum was "not proceeding as hoped," and he suggested that Yanagi, Hamada, Kawai, and the other figures central to the mingei art museum project submit something to promote it.[83] After much consultation it was decided that a house would be built and furnished in the park on a budget of 10,000 yen supplied by the exposition.

Yanagi later described the conditions the small group set for themselves: "It had to be a small house, and it had to be Japanese style [wafū] yet suitable for modern life. It had to aim at a middle-class family [chūryū no katei]. It had to be one-story, made of wood. The furnishings to be selected from mingei

objects produced at present in various parts of Japan. Whatever else was needed to be supplied from the works of the participants. Eighty percent of the budget to go to the building and 20 percent to the furnishings."[84] The more or less finished Mingeikan was first displayed to the public on 24 March 1928, when the exposition opened for a sixty-five-day run.[85] The preceding three months had been a frantic time for the mingei group, who traveled widely collecting craft objects, oversaw carpenters imported from the Shizuoka countryside ("because it was to be folk-house style, city artisans did not suit"), and struggled to produce pottery, furniture, and textiles for the house on time.[86] Three boxes of Korean items were sent from Seoul. Suzuki of the Kamigamo guild recalled taking weavings finished at the last minute to Tokyo on the overnight train.[87] Small wonder that at the moment of completion "everyone wept."[88]

Again, however, it is difficult to avoid the conclusion that the Mingeikan was less than fully successful. A permanent mingei museum, the establishment of which the Mingeikan was intended to promote, did not appear for another eight years. The Mingeikan was widely billed, moreover, as a model or prototype for what Yanagi called an "ordinary," "inexpensive," "middleclass" house. Yet the "two or three" inquiries from visitors interested in commissioning such a house were promptly declined. As Yanagi himself admitted, "Unfortunately [we] did not have the leisure, and it is not easy to collect and manufacture all the appurtenances."[89] Tellingly, after the exposition was over, this "ordinary" dwelling became the possession of yet another wealthy and cultivated mingei patron, the Osaka businessman Yamamoto Tamesaburō. Head of what was to become the Asahi Beer Company, Yamamoto had the building, renamed "Mikuni sō" (Mikuni Villa), taken apart and rebuilt on his Osaka estate, with the addition of some antiques plus consulting and custom work by Yanagi, Hamada Shōji, and others.[90] Nor did the structure ever serve as a family home of any kind; in the 1930s, Mikuni sō was written up in an Osaka periodical as an example of an up-to-date teahouse.[91]

And yet the Mingeikan did effectively introduce many of the ideas as well as the aesthetic embraced by the mingei activists to their widest audience yet. By the 1920s, the expositions begun by the government in the late nineteenth century to promote the nation's industry and educate its subjects had become increasingly gaudy sites for mass entertainment. Like their counterparts in Europe and North America, the big expositions in Tokyo drew hundreds of thousands of visitors and helped to form a rapidly developing

**6.** Parlor (ōsetsushitsu) of "Mikuni-sō," the model home originally exhibited as the "Mingeikan" at the 1928 exposition in Tokyo's Ueno Park. The table and chairs were made by the Kamigamo Guild member Kuroda Tatsuaki, as was the inlaid (raden) box on the table. Courtesy of Nihon Mingeikan.

**7.** Wife's room (*shufushitsu*, with *tatami* flooring) of "Mikuni-sō."
The lacquered table in the foreground, by Kuroda Tatsuaki, recalls
the Chosŏn-period furniture that influenced Kuroda during the late
1920s. Courtesy of Nihon Mingeikan.

consumer culture.[92] These visitors may well have paid special attention to the
Mingeikan, if only because it was so different from the exposition's other,
more standard attractions—crowd-pleasing spectacles and entertainments,
usually characterized by the liberal use of lights, color, and fantastic new
architectural forms. Many were doubtless puzzled by the contrast. In a two-
part article published in a Tokyo newspaper toward the end of the exposi-
tion's run, Yanagi took the opportunity to explain the Mingeikan to the many
readers who must already have seen or heard of it. He began by describing
the reaction of the average exposition-goer: "Visitors to the exposition at
Ueno will be likely to see a Japanese house surrounded by a bamboo fence
near the rear gate facing the exposition museum. Probably they will wonder
what possible relation it can have to the towering modern Western-style
buildings and the temporary exposition structures nearby. In front of the
entrance there is a signboard reading 'Mingeikan.' It is certain that many
will have difficulty even understanding this name."[93]

In the article Yanagi explained mingei, and the Mingeikan, in a simple,
straightforward way that avoided the guild socialist rhetoric conspicuous in

his other writings of the period. Even in the relatively liberal climate of 1920s Japan, one may presume that strident criticism of the capitalist status quo and the urging of wholesale cultural and social change would not have sat well with the editors (or censors) of a major Tokyo daily, particularly in the context of celebrations in honor of a new emperor. What remained discernible in Yanagi's comments, however, was discontent with aspects of the present and the insistence that mingei be employed to shape the proper future of Japanese daily life. Instead of social equity, however, Yanagi evoked nationalism in arguing for the significance of a revived folk-craft in modern Japan:

> Item: This mingei is the most conspicuous expression of national character. If it is not mingei, craft does not fully express a people's particular character. We have a duty to bring this to life and pass it on to the future.
>
> Item: Yet periods change and ways of life progress, and the objects of the past alone do not suffice for us. For example we must newly fabricate such things as Western-style desks, tables, chairs, bookcases, and tea things for black tea. But these must come forth not as copies of the West, but in a Japanese form.

Yanagi concluded his discussion by linking Japanese form to a larger Oriental destiny:

> Item: The reason why there is much Oriental tradition in both the form and spirit [of mingei] is that we are Orientals. That is inevitable, and not the result of will. It is a proud work to use this inevitability to bring the Oriental spirit to life in modern daily life.[94]

It is not clear how the Mingeikan or these calls for a distinctively Japanese Asian modernity in daily life were received by the general public. Yanagi later claimed, "Fortunately, because [the Mingeikan] was unlike the other submissions, it attracted attention and there was a tremendous number of visitors"; he went on to thank various members of the imperial family, government ministers, and "other celebrated persons" for their visits, and expressed his satisfaction with the favor many had shown the Mingeikan. It is also worth noting that the shop set up outside the Mingeikan and offering for sale many of the wares shown inside the house did what was thought to be a good business, selling more than half of its inventory.[95] On the other hand, fairgoers then as now were probably just as often critical or indif-

ferent. The writer and collector Aoyama Jirō managed the shop during the exposition. Later that year, he wrote a wry magazine piece in which he recorded some of the overheard reactions of Mingeikan visitors:

> Two drunks, moving toward the center of the exposition: "I've spent all my money, so it'd be best if we went someplace without anything."
> "Well then, let's go to the Mingeikan." (Overheard by Hamada Shōji)
> . . .
> A parent with child, entering: "This is what they call a house for poor people with taste."
> "It's really common but elegant." (Overheard by Yanagi Kaneko)
> A woman, entering: "Oh my, what a nice chair! Goodness, what a nice cushion! Oh dear, how difficult to sit on!" (Overheard by Miyamura).[96]

Yet there is no question that a number of opinion makers found the Mingeikan, and what they understood of its purpose, worthy of comment and even praise. The Tōkyō nichi nichi newspaper, one of the big Tokyo dailies, not only ran an admiring article several months before the exposition opened, but also gave the Mingeikan prominent billing—as "Quietness amidst the Storm"—in its exposition coverage, concluding, "This is one thing that certainly must not be overlooked."[97] The Mingeikan attracted especially keen notice from the world of Japanese design and architecture. Several architectural magazines featured photographs of it in their special issues dealing with the exposition.[98] Two periodicals went so far as to publish articles consisting of evaluations of the Mingeikan solicited from architects and designers. In the July 1928 issue of Kenchiku gahō (Architectural Graphic) fifteen individuals were canvassed for their opinions. The May issue of Teikoku kōgei (Imperial Craft), published by the newly formed industrial designers' association Teikoku kōgei kai, also devoted several pages to the reactions of eleven designers and architects to the exposition and more particularly to the Mingeikan.

Most of the reactions were mixed, and in several cases sharply critical. Three commentators, writing in Kenchiku gahō, even suggested that the Mingeikan was not worth attending to: "I don't go out sightseeing, so can't write about it," sniffed one professor of architecture. Another dismissed the Mingeikan with "Talk, talk, talk—what do popular things ever amount to, anyway?" The more specific criticisms that were offered tended, not surprisingly from a group of professionals, to draw attention to the amateurishness of the building and its layout. Noting the poor air ventilation, inadequate closet

space, and general inattention to practical problems evident in the Mingei-kan's plan, one engineer wrote, "All this fussing in newspapers and maga-zines about an amateur-built construction will end up confusing the public, so great care should be taken." Other criticisms expressed dislike of what was seen as an affected rusticity and antiquarianism that had little to do with modern life; several reviewers identified this tendency disparagingly as "tea taste."[99]

Nevertheless, almost everyone who had actually been to the house agreed that it was "interesting," if only in parts, and a number of commentators asserted that, "whether for good or ill," as one man put it, the Mingeikan was the most memorable exhibit of the exposition. More significant is the fact that the reviewers who were least equivocal in their praise reiterated Yanagi's call for the construction of a specifically Japanese modern culture. In *Teikoku kōgei*, one writer dismissed most of the exposition architecture as "copies of German style" and commended the Mingeikan because "we as Japanese wanted new experiments based on Japanese taste to which new foreign styles have been added." Nakamura Shizumu also deplored exposi-tion buildings for "not being symbols of modern Japanese culture and not showing the way Japanese architecture should proceed": "In this sense I am greatly in agreement with the Mingeikan. Even if it is insipid in many places, I felt inexpressible gladness that it is moving clearly in the right direction."[100] Even the disapproving engineer concluded that, despite the Mingeikan's many faults, "we cannot be too grateful that, built amidst a proliferation of stucco and cement, it has shown the public how appropriate this sort of [traditional] architecture is for the climate of our country, and in a spiritual sense how superior to new shallow things."[101]

The Mingeikan struck a chord among a broader segment of educated elites than did the Kamigamo guild or any of the other early mingei projects. Yanagi's ideas about folk art as the wellspring for a program of social and cultural change were developed within a small cohort of like-minded, often impecunious young men—writers, artists, collectors. Their efforts to realize aspects of this program, though largely ineffectual, generated the sympa-thetic interest and occasional support of another small group: wealthy, influ-ential men like the brewery magnate Yamamoto Tamesaburō, the Hama-matsu landowner Takabayashi Hyōe, and the publishers Kurahashi Tōjirō and Iwai Taketoshi, some of whom may have been attracted by the prospect of acting as patrons to budding artists as much as by the notion of promot-ing sociocultural reform. But the response to the Mingeikan, once built and

displayed in Tokyo, suggests that certain features of the mingei program of reform appealed to a larger group of professional elites. The idea of adapting native, Japanese forms to the material culture of modern daily life struck a number of these people as timely and appropriate. While their reasons varied, it seems clear that for most a nationalist rather than a socialist logic was at work. The indigenous aesthetic was most acceptable when framed in terms of Japaneseness, rather than international ideals of social justice.

*Desiring Folk: Mingei, Native Ethnology, and Middle-Class Taste*

In the late 1920s mingei or folk-craft was still relatively obscure. As Yanagi noted in 1928, few if any of the visitors to the Tokyo Exposition could be expected to have any idea what the term "mingei" even meant. But the fact that the mingei activists operated on a small scale—the obscurity, in other words, of their particular ideas and projects—is deceiving. Combined with the tendency to characterize the 1920s, in Japan as elsewhere, in terms of rather uncomplicated notions of internationalism and modernism and mass culture, it has helped to create the impression that efforts to promote mingei were the eccentric, even quixotic affair of a few free spirits thoroughly at odds with their times. This impression has only been deepened by treatments of mingei and the mingei movement that focus on its star individuals and the creative originality of their achievements. (It should be noted that in a sense these treatments only follow the lead of Yanagi himself, who insisted —in spite of his criticism of the modern cult of individual genius—that the discovery of mingei, like its very name, was both new and unique.)

As suggested by the response to the Mingeikan model house, however, ideas about recuperating indigenous material culture within modern, urban daily life had currency in early Shōwa Japan well beyond the mingei set. Most obviously, the example of the Mingeikan resonated among architects and designers, many of whom were already showing interest in the incorporation of native design elements and styles in modern buildings and interiors.[102] This reflected the restlessness they felt as members of the Japanese intelligentsia with the seemingly relentless Western monopoly on modern material culture. The question of how to make houses and furnishings both modern and Japanese had much more than superficial significance in a world that was being quite literally remade in the image of a dominant Western Europe and America. At the same time, those architects and designers who took note of the Mingeikan were also responding, as profes-

sionals dependent to some degree on market trends, to a more general rise of concern with a way of life associated with both the preindustrial past and the contemporary countryside.

One force behind the new interest in old-fashioned, rural ways and things was the economic boom caused by World War I. By the early 1920s, that boom had helped to spur the development of a small but increasingly influential population of educated urban and suburban workers: the members of what Japanese historians refer to as the "new middle class."[103] These men and (to a lesser but still significant extent) women began to appropriate and adapt formerly aristocratic forms of leisure activity which had long involved, among other things, the appreciation and consumption of an aestheticized vision of rural daily life. In part this was a process that had been under way for at least several centuries; the early modern antecedents of the mercantile "old middle class," for example, created a popular culture characterized in part by borrowings from the warrior aristocracy. But in the 1920s the process gained new celerity and scope, thanks to the rapid development of the industrial sector of the economy, massive rural-to-urban migration, and the expansion of the educational system, to name just a few of the deep structural changes under way during the first quarter of the twentieth century. The result was that a broadening stratum of men and women living not only in Tokyo and Osaka, but also in cities and towns throughout Japan, began to find satisfaction and pleasure in the idea as well as the artifacts of a rustic version of "traditional" Japan.

In developing these refinements of taste, urban consumers drew upon various sources of elite ideal and custom. Some, like the tea ceremony and its associated aesthetic of rural retreat, could be traced back to medieval origins.[104] Others, like the vogue for pastoral life that set in among literary networks in the early years of the century and spread to the upper reaches of the urban bourgeoisie during the 1920s, were much more recent and owed as much to influences from abroad as to native habit.[105] Of course, white-collar workers were generally not in any position to commission the Tudor- and Spanish Mission–style homes that became fashionable among the rich during the 1920s and early 1930s and that were arguably one conspicuous expression of the rise of a Westernized "rural taste" (inaka shumi).[106] Instead, in the 1920s the proto-"salaryman," to use the familiar Japanese term, and his family began their great migration out of urban centers into new suburban bedroom communities. Some of these, like Tokyo's now superaffluent Denenchōfu (literally "Garden Town"), which was developed by the indus-

trialist Shibusawa Eiichi in 1923, were inspired by British "garden city" theories of urban planning. From as early as the first decade of the century, policymakers and developers began to apply rural or pastoral taste to the problem of managing urban sprawl. Their vision of orderly, green settlements within commuting distance of city centers, where workers might restore themselves by contact with the healthful beauties of country life, was yet another factor in the dissemination of desire for the rural.[107]

Of course, city workers were not merely passive objects to be molded by urban planners. Nor did they simply ape the fashions of the rich and influential, whether Japanese or European and American. Instead, during the 1920s and 1930s, the literate, middling classes of urban Japan helped to create a new culture of recreational consumption in which older, once elite modes of consuming rusticity acquired new scope and significance. The rise of domestic tourism offers perhaps the most dramatic example of this transformation. As Constantine Vaporis has shown in his study of Japanese travel in the early modern period, the idea of travel as a form of edifying recreation for commoners as well as the aristocracy was not new.[108] Nevertheless, through the nineteenth century, the experience of domestic (and, after 1868, international) travel for pleasure remained the monopoly of a small, monied minority. Male literati, in particular, continued to control most of the meanings and images of recreational travel. By the 1920s, however, urban nonelites were gaining access to an expanding infrastructure of railway and shipping lines, inns and resorts, and informational bureaus and publications. The result was the rapid development of an incipient tourism industry and the concomitant transformation of all Japan (including its colonial possessions) into a giant, and of necessity largely rural, playground.[109]

In many ways the new travelers of the 1920s retained the forms and expectations of touristic pleasure that had been established among the privileged few. By the late nineteenth century and early twentieth, these included not only the conventional opportunities to demonstrate literary skills and aesthetic sophistication in the encounter with the rural landscape, but also habits more recently introduced by European and American tourists and residents, such as sea bathing, mountain climbing, hunting, golfing, and skiing. Yet there were also important changes. Perhaps the greatest of these, embracing more specific transformations, was the thoroughgoing commodification of all aspects of travel. Almost everything about the pleasure trip, from transportation and lodging to the "local color" (rokaru karaa) of regional sights and sounds and tastes, came to be assessed as a good,

available to anyone with cash.[110] Women, for example, came to figure promi-
nently as a local commodity for mass touristic consumption at the same time
that they became a growing category of tourists themselves.[111] In this pro-
cess the figure of the modern *ryokan* or inn maid became, along with the
pretty peasant, a recognizable social type, idealized, eroticized, and reviled in
a steady stream of touristic writings, both journalistic and literary.[112] On the
other hand, the increasing activity of women as tourists resulted in the
emergence of new forms of recreational travel, such as the newlywed trip
(*shinkon ryokō*) and the somewhat controversial phenomenon of solitary fe-
male travel.[113]

The commodification of travel also produced a slew of subsidiary com-
modities that were bought and sold as part of the touristic experience. One
travel magazine (itself such a commodity) advised would-be travelers that
the "Indispensable Travel Kit" included no fewer than twenty-one items; the
complete traveler carried, among other things, an inflatable pillow, pomade,
maps, and—to wear on the train—a bird-hunting cap (*toriuchi-bō*).[114] Not only
did men and women shop to travel, however; increasingly they traveled to
shop. Over the 1920s and 1930s, the Japanese tourist began to demand, in
addition to local services and experiences, large quantities of local objects. In
part this reflected the continuation of the much older travel-related custom
of buying presents and souvenirs (*omiyage*) to distribute upon returning
home.[115] Yet omiyage changed significantly in the modern period, as domes-
tic tourism expanded. For example, heavier and more perishable items, like
pottery or fresh produce and other foodstuffs, became omiyage, thanks to
new technologies of transport and communication; at the same time, re-
gions made accessible by those technologies provided new "famous local
products" (*meibutsu*) to add to the more familiar roster of items obtained
along the older highways and pilgrimage routes.[116]

Many Japanese tourists also began buying local products simply to keep,
rather than to give away or use in any conventional sense. Collecting, par-
ticularly the collecting of objects associated with the rural past, was another
form of once elite recreational consumption that gained popularity during
the 1920s and 1930s. Until the early part of the twentieth century, the collect-
ing of folk toys and other rustic curiosities (like getemono) was an anti-
quarian, esoteric pursuit restricted to small circles of gentlemen scholars. It
required uncommon amounts of money, leisure, and the nostalgic aesthetic
sensibility produced largely by urbane literary cultivation. With the advent
of modern tourism, however, growing numbers of middle-class men and

women in the big central cities and, later, in towns and cities throughout Japan acquired the taste for objects evoking the rural past. Folk toys (known from the 1930s most commonly as *kyōdo gangu*, literally "local toys") became especially popular; specialized periodicals and books, shops, and associations appeared in Osaka, Kyoto, Tokyo, and Nagoya even as the folk toy mania found its way into broader venues. In the late 1920s, for example, the Railway Ministry joined with local tourist bureaus to publish conveniently portable guidebooks to the folk toys of various regions. Not long after, the magazine *Ryokō Nippon* (*Japan Travel*) began putting out a folk toy appendix to each issue.[117] By the 1930s it was not unusual to find articles on folk toys and folk toy collecting in a wide range of publications.

The discovery of mingei, then, must be understood within the context of a larger discovery of the rural aesthetic made by a new and growing segment of the population—the urban and suburban middle class—during the first half of the twentieth century. The agrarian picturesque appealed to middle-class consumers in part because its appreciation evoked the habits and tastes of established elites. But it would be inaccurate to suggest that the nostalgia felt for the countryside and its artifacts by newer members of the urban bourgeoisie was wholly emulative. For one thing, in the 1920s most Japanese in cities and towns were relative newcomers, whose sense of attachment to the villages they or their parents had left behind was still quite strong. For another, during this period there was a growing sense that the way of life associated with the old-style rural community was rapidly disappearing. Given the remarkable pace of modernization throughout the nation, it is not surprising that folk ways and things began to gain value—much as they had already in other industrialized parts of the world—as the poignant vestiges of a simpler time.

Observers of the Japanese countryside looked back to a past that seemed not only simpler but also, perhaps, better all around. By the mid-1920s, the post–World War I recession, along with financial straits aggravated by the 1923 Kantō earthquake, had combined with the consistent state habit of promoting industrial growth at the expense of agriculture to create palpable social as well as economic distress in the countryside. To many, the dramatic rise in organized tenant-farmer activism and the steadily increasing rate of rural-to-urban migration by cash-starved agrarian workers were two of the most obvious signs that village Japan was deteriorating. The rise of urban admiration for "traditional" features of the rural landscape and rural society

therefore also reflected anxiety about the future of a countryside—and, in-deed, of a country—that seemed increasingly subject to disruptive change.

Mingei activists were only one among several groups of Japanese intellec-tuals who led the way during the 1920s in praising folk culture and in sounding the alarm about its imminent extinction. Indeed, the discovery of mingei must also be understood in relation to the almost simultaneous emergence of a set of alternative approaches to the folk, and particularly folk artifacts, often loosely grouped within the category of "native ethnol-ogy" or "folklore studies" (minzokugaku). Yanagita Kunio, the patriarchal figure whose lifework as a scholar of Japanese folklore remains central to the quasi-academic field of native ethnology, began shaping his program for the study of rural Japan as early as 1910. While his focus remained the non-material elements of rural culture—such as folklore, language, custom, and belief—several younger men associated with him began, during the 1920s, to specialize in the study of rural material culture.[118] Kon Wajirō, perhaps best known in English-language scholarship for his ventures into an idiosyn-cratic brand of urban studies he dubbed "modernology" (kogengaku), is also celebrated as a pioneering scholar of folk architecture (minka).[119] Kon dis-covered his interest in rural built structures in the early 1920s when, as a young professor of architecture at Waseda University, he joined a group organized around Yanagita and dedicated to the investigation and preserva-tion of village architecture.[120] Shibusawa Keizō, who also found his way into Yanagita's orbit in the early 1920s, developed a long-standing fascination with rural artifacts into a career as an influential scholar of what he named "folk implements" (mingu).[121]

There is some acknowledgment, in retrospect, that the various endeavors emerging in the 1920s to define, investigate, and promote folk culture were probably linked and should be considered together as parts of some larger project.[122] Nevertheless, to date there has been very little effort to explain the nature or causes of that larger project.[123] Instead, most treatments of the mingei movement, folklore studies, or minka and mingu studies, tend to follow more or less uncritically the lines laid down by participants, which suggest two distinct lineages descending from Yanagi and Yanagita, respec-tively. The native ethnologists, in particular, have been anxious to emphasize the distinction between their own discipline, with its claims to scientific rigor and objectivity, and the aesthetic system of social morality and even reform espoused by mingei adherents.[124]

While clear differences separate the various approaches to folk culture denoted by the two categories of mingei and native ethnology, the similarities that link them are at least as striking. Most obviously, all were efforts to promote a broader recognition within and beyond Japan of the value of indigenous rural culture. All took some degree of inspiration from similar trends in the West.[125] All arose or gained momentum in the 1920s, and all were spurred by the perception that "traditional" Japanese society and culture, as represented by the nineteenth-century village, were at risk. Less obvious is that the mingei and the native ethnological ventures alike emerged from the same elite male subculture of shumi, or the playful exercise of aesthetic taste. Moreover, in seeking public authority as experts on folk culture, Yanagita, Yanagi, Kon, and others felt a similar need to distance themselves from shumi, which was increasingly characterized in terms of frivolous and effete consumerism. At the same time, however, almost all of the 1920s projects to study and promote folk culture were also shaped by a shared inability to fully repress hobbyism.

Just as the taste for objects later called mingei developed first among networks of literary collectors, so too the study of folk custom and folklore initially emerged as a gentlemanly pastime among groups or clubs of urban collectors in the late nineteenth century and early twentieth.[126] In some ways Yanagita, like Yanagi, conformed to the profile of the typical shumisha, or cultivated dilettante, who made up these groups. The product of a scholarly family and a first-class Tokyo education, Yanagita brought to his study of folk culture a highly literary sensibility, as expressed not only in his famously dense prose style, but also in his own youthful efforts to write poetry and his participation in various literary groups.[127] At the same time, he did not fully belong among the aesthetes and collectors who constituted the mainstream of folk culture enthusiasts at the turn of the century. One reason for this may be sought in the fact that he grew up in the countryside, as the sixth son of a learned but unprosperous Shintō priest and doctor, and rose to the ranks of the nation's cultural elite only by dint of hard application, first as a student and later as an agrarian technocrat in the Ministry of Agriculture and Commerce (and also, it might be added, as adoptive son-in-law or muko to the influential Yanagita family).

During the first two decades of the twentieth century, therefore, Yanagita participated in a number of the groups specifically concerned with rural culture but, he later claimed, with significant reservations about their frankly recreational overtones. In 1954, for example, he commented on the early folk

culture groups in a way that suggests some alienation, and perhaps even social anxiety, caused by their emphasis on collecting:

> Long ago, when *fōkuroa* [folklore] was called names like *dozokugaku*, among our group there were inevitably hobbyists who often traveled and came to meetings, and who talked with most enthusiasm about collecting. In groups such as the one called Shūkokai [Association for Collecting the Old], these types had the upper hand for a long time, and they looked down on those of us who didn't own things, and who only felt interest in observing or in thinking about and investigating origins and distribution—they called us "the great ones" [*oeragata*]. It was they who made the strange term "folk toys" [*dozoku gangu*] popular, and who gave over any number of special issues of the magazine *Tabi to densetsu* [Travel and Legend] to toys.[128]

By the 1950s, when Yanagita made these remarks, things were very different. Recreational travel (or tourism), tasteful collecting, and private literary activity were all well on the way to becoming forms of mass leisure and had long lost their former status as markers of elite male identity. By contrast, Yanagita's commitment to observation and investigation, or science, had made him the dean of an entire field of national scholarship—truly a "great one" in postwar Japan. The contempt of the hobbyists for what Yanagita represents as his innate preference for research over touristic shopping could only appear, in retrospect, shortsighted.

The social and cultural changes that would make once elite forms of male recreation into middle-class and, increasingly, female leisure activities were already under way in the 1920s. Emerging within this context, native ethnology's commitment to scientific dispassion and the mingei group's emphasis on reform activism appear as two alternative and linked, rather than opposed, strategies to translate genteel taste into professional authority. The point is less that one group reached for the legitimacy of science and the other for that of social reform than that all the men seeking to become authorities on folk culture felt a common need to distance themselves from what was becoming the contamination of frivolous consumerism. It is suggestive, in this regard, that at least one prominent figure associated with the scientific or native ethnology camp—Kon Wajirō—regularly chose to justify his travel, reading, writing, and "collecting" (in the sense of collecting research materials, especially his celebrated sketches) in terms of social activism rather than science.[129] Also suggestive is the folk toy scholar Saitō

Ryōsuke's account of the efforts by leading aficionados of folk toys to gain greater public standing during the 1920s and 1930s; Arisaka Yōtarō, for example, struggled to establish *kyōdo gangu* as at once a scientific field of study and a reformist program to direct the production of new toys (*sōsai gangu*). Saitō concludes that these efforts failed largely because the hobbyist element remained too powerful.[130]

The mingei group and especially the native ethnologists had more success in transcending their amateur beginnings. Nevertheless it proved impossible for them to repress shumi, or playful connoisseurship, altogether. It was, after all, a constitutive element of personal identity for cultivated men who grew up, as did all the major folk studies exponents, in the decades around 1900. Moreover, it was central to the social networks that not only produced folk studies in the first place, but also continued to serve as an important source of support thereafter. Even Shibusawa Keizō, who of all the native ethnologists was perhaps most uncompromisingly scientific in his methods and goals, began his career as a folk implement scholar by amassing an enormous collection of folk toys.[131] And it is difficult to imagine that shumi considerations were entirely absent from the occasion in 1930 when Shibusawa had a troupe of folk festival dancers brought from the countryside to celebrate the renovation (*niimuro hokai*) of his Tokyo mansion, where they performed for a select audience of friends and acquaintances. Shibusawa danced one of the parts.[132]

Perhaps most important, the shumi sensibility persisted because it was crucial to the wider appeal of folk culture among growing numbers of educated urban and suburban Japanese. Folk art, folk architecture, and folklore became popular—and men like Yanagi, Kon, and Yanagita gained influence and income—in part because middle-class consumers acquired a taste for taste (shumi). However sternly the folklorists and others repudiated the hobbyist consumerism that had characterized their own early engagement with folk culture, they relied on sales of their books and magazines and articles in a market driven by the spread of shumi, or hobbyist consumerism. Shibusawa, as grandson and heir to the fabled industrialist and financier Shibusawa Eiichi, could afford to take a rigorously scientific approach, regardless of its lack of popular appeal, in ways that most other folk culture experts could not. Someone like Kon, for example, who came from a modest professional background (his father, like Yanagita's, was a provincial doctor), could gain authority for his views only by courting an audience. It is reported, for example, that Kon so disliked the hobbyist enthusiasm that

dogged folklore studies and especially the study of folk houses that in the 1930s he tried in vain to drop the term *minka* (folk house, folk architecture) in favor of the more severe *nōson jūtaku*, or "agrarian-village housing."[133] Nevertheless, he owed much of his status as an expert on folk houses to the popularity of his first book, the 1922 *Nihon no minka* (*Folk Houses of Japan*). Illustrated by Kon's charming drawings, this book—a somewhat impressionistic collection of descriptions, often written in rather lyrical style—went through three editions; the second, published in 1927, was an especially handsome object bound in a striped woven cloth that can only be described as folk arty.

The recurrence of *shumi* is pointed out more easily and uncontroversially of the folk-craft group than of the native ethnologists, whose achieved status as social scientists, or men above taste and consumerism, remains largely intact today. Yet even though Kon and Yanagita, unlike the mingei leaders, never sought to sell home accessories, during the 1920s and 1930s they and their writings were deeply involved in the same markets. By the 1930s, both men wrote regularly in a range of popular periodicals, and in women's magazines in particular, as experts on not only folk culture and native tradition, but also urban daily life and consumption generally.[134] Indeed it might be argued that both Kon and Yanagita became, like leading figures in the folk-craft group, not only authorities on tasteful consumption but also themselves models of tasteful consumption—even, perhaps, objects of tasteful consumption—for middle-class consumers. The December 1932 study (*shosai*) issue of the architecture and design magazine *Jūtaku* (*The Home*), for example, featured pictorials on the personal studies of both Yanagita and Kon. The article on Yanagita's study concluded with the observation that Yanagita kept Stone Age artifacts on bookshelves and a small table, along with some dolls—that is to say, some folk toys.[135]

In sum, the folk culture experts who emerged in the 1920s were able to achieve a paradoxical sort of authority for themselves and their ideas about rural Japan. They were exponents of an older, elite subculture of connoisseurship, or good taste, which regarded aspects of the rural landscape with particular favor. Their pronouncements on folk art, folk architecture, and folk custom had special cachet, therefore, among the growing numbers of middle-class men and women who aspired to consume as tastefully. At the same time, however, Yanagi, Yanagita, and other folk culture authorities enhanced their status by claiming to reject the *shumi* stance of private, playful connoisseurship. Instead, they defined themselves as social reform-

ers, scholars, and scientists who transcended the petty, selfish gratification of frivolous consumption. They were concerned with the greater goods of knowledge and truth and the well-being of Japan as a society and a nation. One result was that, during the 1920s and 1930s, leading mingei activists and native ethnologists were able to develop careers as experts on the folk, or rural society, as well as on urban consumerism.

Science and social reform served similar and linked functions in legitimating the claims of the folk culture experts to special authority over both rural and urban society. Yet it made a difference that some chose to identify themselves primarily as scientists, whereas others gravitated toward the role of the social reformer. The latter—namely, Yanagi and other promoters of folk-craft, but also several native ethnologists such as Kon—were drawn almost ineluctably into active reform efforts from which the scientists tended to remain aloof. As recession deepened into full-blown depression during the late 1920s and early 1930s, and the troubles afflicting rural Japan loomed ever larger, members of the mingei group began to find new scope in the countryside for their ambitions to help remake society and culture. As a result, the definition and meanings of mingei shifted yet again.

# THREE. *New Mingei in the 1930s*

> Miyamoto was interested in pouches, and whenever he saw a shop that specialized in them he would go up to the window and intently scrutinize the display. "You're still interested in such things, are you?" Kensaku asked. "Of course I am," Miyamoto replied. Then he proceeded to give a discourse on the subject. The intricate ones, he said, the sort made by true artisans, were necessarily old and thus weren't very clean. After all, you had no idea who might have had them before. But there was a lot to be said for the kind made for common use by the less pretentious peasant craftsmen. You could buy them new, they were therefore clean, they were also cheap, and there was something appealing about their honest simplicity. Besides, you could always throw them away without compunction. "I bought quite a few of them around Kyoto this time," he said. "I'm thinking of visiting Korea soon, you know. They've got very nice ones there."
> —Shiga Naoya, *A Dark Night's Passing* (1921–1937)

During the 1930s, mingei, or folk-craft, began to gain public recognition and interest. The rise of mingei can be explained most immediately by the changes that occurred in the nature and scope of mingei activism. A few core members of the original group of collectors and artists began to preside over a movement to organize rural producers, along with provincial and metropolitan elites, around new definitions of mingei. The production of "new mingei" (*shin mingei*), as it was then called, led to marketing efforts centered

on the expositionary forms and institutions of prewar Japanese consumerism. The result was the increasing visibility of a redefined mingei, as it became a fashionable item of consumption among not only men but also women of taste. The changes in the production and consumption of mingei must also be understood, however, in the context of larger changes in Japanese society and culture over the 1920s and 1930s. The economic troubles afflicting the countryside in particular during this period, the rise of nationalist ideology along with international conflict in the 1930s, and the emergence of new roles and identities for educated, middle-class women underlay the new attention to native handicraft techniques and products.

## Producing New Mingei

The bold idea of directing the actual production of new mingei, or newly made handicraft objects that revived the essential qualities of "old" mingei, seems to have come to Yanagi in the late spring of 1931. The occasion was a trip he took to western Japan in late April and early May for the purpose of investigating handicrafts production in northern Kyushu and in the northwestern region of Honshu known as San'in. Before his departure, Yanagi referred to the trip in terms that suggest he had little intention of doing more than seeking out more of the "buried crafts" of regional Japan; as in the past, he was hunting for overlooked treasures to discover, collect, and promote.[1] Nor was he disappointed in his quest. As he wrote upon his return, "There were many extremely good things everywhere, in hidden places. My room is now full of the objects I brought back."[2] Yanagi's discoveries included, perhaps most famously, the Onta ware (Onta-yaki) produced in the Kyushu pottery village of Sarayama, near Onta.[3] But he also brought back to Kyoto a startling new sense of the potential scope of mingei activism. In the San'in region, he learned that it was possible not only to discover mingei, but also actively to shape it.[4]

### "WHEN THE WORLD WAS A BAD PLACE": NEW MINGEI
### AND THE DEPRESSION IN THE SAN'IN REGION

In a sense, the core group of getemono enthusiasts, especially Yanagi, had been casting about for years in search of some project of social and cultural reform that might employ their love of "low-grade things." Yet while none of Yanagi's craft-related reform initiatives of the 1920s can be said to have

failed outright, none had really taken off. The Korean Folk Art Museum, the Mokujiki Shōnin campaign, the Kamigamo cooperative, or the Mingeikan model house—not one had achieved anything close to the momentum and influence of the Shirakaba group to which Yanagi had devoted his early youth. In early 1931 he and his closest associates embarked on yet another venture: the publication of a monthly magazine called *Kōgei* (*Craft*), dedicated to the discovery and promotion of previously overlooked genres of handicraft, and more generally to the goal of aesthetic education.[5] Until his trip to San'in, Yanagi seemed more or less content to envision the mingei mission in primarily educational terms; he hoped that *Kōgei* might serve, like the enormously influential *Shirakaba* he had helped to edit a decade earlier, to communicate new "aesthetic standards" (*bi no hyōjun*) to Japanese society.[6]

In San'in, Yanagi was introduced to the idea of a far more interventionist relation to mingei by two local acquaintances: Ōta Naoyuki, the director of the Chamber of Commerce and Industry in Shimane prefecture's capital city of Matsue, and Yoshida Shōya, a physician in Tottori city, the capital of Tottori prefecture. Ōta, a noted poet and the scion of an eminent local family, had earlier encountered Yanagi and the mingei philosophy through his elementary school classmate, the potter Kawai Kanjirō. Yoshida's connection to Yanagi dated back to his student days, when he had been so devoted a reader of *Shirakaba* that he had sought out Yanagi's acquaintance and kept up with him ever since. In their different ways, both men were keenly interested in the possibility of reviving certain forms of handicraft industry peculiar to their respective localities. Ōta's concern was linked to his official position in charge of prefectural industry. Yoshida, for his part, had developed a more private interest in folk art largely under Yanagi's influence. When he returned to his hometown of Tottori in 1930, after some fifteen years of schooling in eastern Japan, it was almost inevitable that he would become curious about the mingei to be found locally.[7]

Upon his arrival in Matsue, Yanagi was swept up in a flurry of activities and events that Ōta had organized and that helped to establish a pattern for new mingei activism as it developed over the next several years. In an account of Yanagi's May 1931 visit published later that year in *Kōgei*, Ōta noted that because he had long been troubled over how best to guide artisanal production, Yanagi's visit represented an opportunity. He took Yanagi on a brief tour of the prefecture to have him conduct what Ōta dubbed a "crafts examination" (*kōgei shinsatsu*; the term "shinsatsu" implies medical examination for diagnosis). Objects surveyed were divided into three categories: those

that were "healthy," those that might become healthy again, and those for which there was no hope. Ōta had the trip and Yanagi's favorable judgments publicized in the local press and organized a series of talks by Yanagi on the theme of "correct craft" to audiences of artisans and others. The result, Ōta claimed, was that "an unexpectedly great stimulus was given to the crafts-people of the prefecture, such that even in the craft circles of Izumo, which I had thought the most degraded of all, we were able to create a surprisingly ardent, sincere spirit of awakening." Further, Ōta had the happy thought of lending some pots by his old friend Kawai to several local potters, along with a "few words of advice." Inspired by the "astonishing" improvement thereby effected, Ōta later asked Yanagi and Kawai to assemble and lend him a collection of about sixty "reference items." Over the summer of 1931, Ōta had these objects shown several times in different parts of the prefecture as the "Correct Craft Exhibit." He also put on a show of Kawai's work in Matsue and arranged opportunities for both Yanagi and Kawai to advise and correct crafts production in the region. "In this way," Ōta concluded his essay for *Kōgei*, "I have sown the seeds of a crafts movement through the entire prefecture."[8]

Yoshida Shōya's project of craft reform in neighboring Tottori prefecture began on a much smaller scale but proved even more influential in helping to define new mingei, and particularly the model of "guidance" or "direction" (*shidō*) that became central to mingei reform. Yanagi timed his visit to Tottori so as to witness the opening of an experimental firing at the Ushinoto kiln, where Yoshida had been engaged in guiding production for several months. Yoshida's interest in Ushinoto, a large kiln in a mountain village south of the city, had begun shortly after he moved back to Tottori in late 1930. Intrigued by several Ushinoto teabowls he came across in a local shop, he went to see the kiln and meet Kobayashi Hideharu, the young potter who had inherited the ailing business from his grandfather. Yoshida dismissed most of Koba-yashi's recent work as misguided efforts to imitate modern, Western-style objects, but found much to admire in the older Ushinoto wares Kobayashi showed him in a storeroom. Yoshida praised the old things and persuaded Kobayashi to make a batch of pieces selectively reviving some of their forms, glazes, and patterns. In addition he asked Kobayashi to reproduce aspects of other objects chosen from Yoshida's own collection of getemono.[9]

Although the results of the first effort were mixed, Yanagi and Yoshida both agreed that the experiment showed great promise. Yanagi bought a number of items on the spot and wrote enthusiastically in *Kōgei*, "As a first

trial, one may say that it was better than good. . . . There are hardly any other kilns presently producing things at this level." "I have a special interest in this work . . . ," he added, noting that "it has shown us a good point of departure for the development of correct mingei."[10] For his part, Yoshida claimed, "As a result of this Ushinoto experiment, I learned that so long as the materials, artisans, and methods are good, the application of good model pieces will surely lead to the birth of good things."[11] He and Kobayashi immediately set to work toward the next firing, which occurred in July. During the summer and fall of 1931 Yoshida also began to apply his newly discovered formula to other branches of handicraft industry; he enlisted a number of Tottori artisans—woodworkers, metalworkers, weavers, dyers, and lacquerers, among others—to produce goods to his specifications.[12]

Yoshida's success in persuading Kobayashi as well as dozens of other Tottori craftspeople to begin working under his direction requires explanation. What induced independent artisans to alter their methods and take instruction from strangers? Frequently they found that Yoshida's suggestions involved abandoning what they knew best in order to undertake arduous experiments with unfamiliar materials, designs, and techniques. For mingei reformers went well beyond merely selecting what they considered the best of old, indigenous objects and methods for artisans to preserve or revive. Yoshida, for example, was inventive in his suggestions for the production of altogether new items. He asked Kobayashi to make a variety of the often Western-style utensils that were beginning to show up on urban, middle-class dining tables: plates, coffee and tea cups with saucers, sauce boats, pitchers, soy sauce dispensers, and more. To Kobayashi, as to most other rural Japanese in the 1930s, these were unfamiliar objects of little use in their own households. He later recalled that the Western-style handles required on coffee cups and pitchers posed a number of technical problems that were resolved only in the mid-1930s, when Bernard Leach visited the kiln and gave Kobayashi personal instruction.[13] Yoshida also had local carpenters and woodworkers make such exotic items as gentlemen's canes, salt and pepper shakers, cigarette and match boxes, chairs, and desks. An "old woman" (baasan) was hired to weave specially spun and dyed thread into cloth for such novelties as curtains, neckties, cushions, and Western-style clothing.[14]

In an oral history transcribed in the 1970s, during the last decade of his life, Kobayashi addressed the question of why he had agreed to undertake mingei production. He insisted that his 1931 "conversion" (tenkō) had not

**8.** Covered rice bowl (*meshi chawan*) produced under Yoshida Shōya's direction at the Ushi-noto kiln and illustrated in the October 1931 issue of *Kōgei*. Yanagi commented of the bowl that originally its painted design had been used by the kiln on plates alone, but that "now this design is being applied to various things" (presumably at the behest of Yoshida and Yanagi). He added, "While rice bowls are the items most used in daily life, none of those produced today are really good. You can't find anything this good at any other kiln." From *Kōgei* 10 (October 1931): 72.

been motivated by financial considerations: "I didn't enter the mingei move-ment for gain [*soroban zuku de*]. At that time, you know, those teachers [Yoshida and Yanagi], they encouraged me and I heard from them how precious the work of my forefathers was. So, out of that excitement. I en-tered the movement out of excitement, not for gain."[15] The pleasure of hear-ing Ushinoto wares—ordinary objects of daily use for farming households—praised by great men from the city was doubtless a factor in Kobayashi's willingness to attempt mingei production. Nevertheless it is difficult to ig-nore the probability that he also hoped to alleviate a desperate financial situation.[16] Kobayashi was facing bankruptcy in 1931, when he first met Yoshida. Explaining why he had converted in 1930 to the Buddhist sect of Daihonkyō, Kobayashi told his interviewer: "[That time] was the worst pe-

riod for me, in pottery-making. Social conditions were bad. It was a bad recession, different from recession nowadays. Because it was the kind of time when you worked and worked, and no matter how hard you tried, there was just ruin ahead. . . . It was a time when the world was a bad place, in that terrible recession."[17]

By 1931, the world depression was reducing much of the rural population in Japan to dire economic straits. In particular, the collapse of the silk thread market in the United States after 1929 brought almost instant calamity to already hard-pressed rural communities increasingly dependent on sericulture for income. By 1930 about 40 percent of all farm households grew silk cocoons, and their sale accounted for 12 percent of farm income. As prices for cocoons as well as rice and other agricultural products plummeted, and as rising unemployment in the cities caused village populations to swell with jobless returnees, shortfalls of income grew acute.[18] For small-scale producers of traditional handicrafts, who had already been contending for some years with waning demand as inexpensive, mass-produced, "modern" goods were introduced into the rural market, the depression produced often insuperable difficulties.[19] As Ōta put it, describing the situation in Shimane, cash-starved provincial artisans in 1931 were like "hungry ghosts chased by demons from hell, manipulated by the poisonous hand of the wholesale merchant [tonya]."[20] Thus many craftspeople may well have been receptive to any scheme that, like the mingei experiments in the San'in region, held out the real possibility of generating new markets.

Certainly the San'in artisans who did "join the movement" in the lean years of the early 1930s soon found new and profitable venues for their products. In late 1931, a special issue of Kōgei was devoted to "new crafts from San'in" and brought out to coincide with successful exhibition sales of San'in crafts in Kyoto and Tokyo, and later in Osaka. Organized by the leading mingei activists and sponsored by major consumer institutions such as the Osaka Mainichi newspaper, Takashimaya department store, and the cosmetics company Shiseido, the exhibits sold well and were so favorably received that they became regular events repeated annually.[21] In addition, the new mingei produced in San'in found regular outlets not only in regional shops but also in a growing number of both small and large Tokyo and Osaka retailers.[22] By 1933 San'in producers were even contending with competition in the marketplace from imitation new mingei.[23]

Of course it was not only crafts producers who suffered in the depres-

sion, or who stood to gain from the return of local industry to economic viability. The vigor of the efforts of local elites like Ōta and Yoshida and the alacrity of the response from Yanagi and other metropolitan mingei activists must also be understood against the backdrop of national socioeconomic distress and the pervasive atmosphere of crisis and reform that it engendered. The special San'in issue of *Kōgei* began with an article by Ōta on "The Future of Provincial Crafts," in which he described the benefits he hoped the new craft movement would bring to the provinces, where "capital and human talent are drying up." Provincial crafts, he declared, were "the best means of aiding, purifying, and bringing happiness to ordinary society," which was suffering from "the many defects that can be said to be the subsidiary product of capitalist economic organization."[24] Ōta focused less on the aesthetic and quasi-spiritual advantages of revived rural craft production that Yanagi and Kawai tended to stress, and more on the possible gains to his own locality; for example, he urged the use of local pottery by local restaurants and inns as a way of highlighting regional identity for consumption by tourists.[25]

Nor did Yanagi ignore the implications a successful revival of rural industry might have for a society in the throes of economic crisis. In *Kōgei*, he noted, "There are various projects now trying to aid impoverished farm villages, and among these crafts are one of the most important." He went on to summarize a lecture he had given recently in San'in, in which he had argued that handicrafts were a solution to the problem, caused by mechanization, of surplus labor in the village.[26] It is worth noting, however, that the interest of Yanagi and his nearest associates in the new crafts movement in San'in may well have reflected the impact of the depression in another, more personal dimension. Never especially affluent, Yanagi supported himself by writing, teaching, lecturing, fundraising for his various projects, and the occasional antiques-dealing coup. Indispensable income was brought in by his wife's busy professional life as a concert singer and voice teacher. In correspondence from 1930 and 1931, he complained bitterly of straitened finances and his consequent inability to travel or collect, and he commiserated with the money troubles of many friends.[27] The crafts movement in San'in provided Yanagi as well as fellow mingei activists Kawai, Hamada Shōji, the textile dye artist Serizawa Keisuke, the weaver Tonomura Kichinosuke, and others with numerous invitations and paid opportunities to travel, speak, publish, evaluate crafts, and organize exhibition sales during a difficult period.

## DIFFERENCE AND SAMENESS IN THE
## PRODUCTION OF NEW MINGEI

The success of the new mingei movement in the San'in region, and later in other parts of Japan, is only partly attributable to the impact of the world depression. Another reason new mingei production so rapidly gained the support of local elites and the institutions they controlled, as well as that of artisans and their communities, is that in many ways it represented a very familiar approach to the very familiar problem of generating and increasing local revenues.[28] Yet mingei reformers added a novel twist to their enterprise by insisting on the native, local authenticity of the objects produced under their aegis. Yanagi, Yoshida, Ōta, and others claimed that their efforts to reform and rehabilitate handicraft production, unlike those of most other groups and organizations, were guided by a recognition of the unique value of local design, materials, and technology. There is a certain irony here. Although new mingei was justified in part as a means of conserving regional specificity, in fact it might well be argued that the mingei reformers actually managed to encourage the development of a relatively homogeneous aesthetic at the expense of genuine local diversity. From another perspective, however, it is also true that the mingei reforms helped to breathe new life into local handicrafts production, thereby probably preventing their extinction outright. Moreover, the claims of new mingei to a peculiar degree of indigenous authenticity helped it to find a special consumer niche in the metropolitan markets of Tokyo and Osaka, which only increased the appeal of new mingei production to local artisans, officials, and merchants.

The new mingei movement of the 1930s drew on networks, organizations, and attitudes created by relatively recent experience. In the early twentieth century, the idea of handicrafts reform was linked not only to efforts to increase revenues, whether local or national, but also to national concern about rural communities and a growing public sense that rapid modernization was jeopardizing their welfare and integrity. Indeed, the world depression was especially catastrophic in rural Japan because it followed more than a decade of economic hardship for the agrarian sector, which had long been forced to finance Japan's industrial development. The burden on farming communities increased in the 1920s due to the post–World War I recession, and specifically as a result of government policy after the 1918 Rice Riots to hold down the price of rice.[29] As a consequence, by 1930 various Tokyo-based as well as local organizations and programs directed at the amelioration of rural socioeconomic ills were already in place. These included

numerous efforts to encourage and reform handicrafts production, which could serve both as a form of low-cost "subsidiary industry" (fukugyō) in farm villages and as a source of enhanced local commercial identity through the creation and promotion of "famous regional products" (meisanhin or meibutsu). Public initiatives to improve and expand the handicraft industry were launched both by agencies of the central government, such as the Ministry of Agriculture and Forestry and the Ministry of Commerce and Industry, and by provincial government offices.[30] In addition, there was at least one privately sponsored rural handicraft reform project, the farmers' art movement (nōmin bijutsu undō), that achieved national renown in the 1920s. It was joined by numerous smaller-scale private handicraft reform efforts at the regional and even village level.[31]

In San'in's Shimane prefecture, the new mingei movement was clearly founded on the experiential and organizational base of previous handicrafts reform efforts. By 1931 Ōta Naoyuki, the local figure most responsible for inciting "mingei fever" in Shimane, had presided for some years already, as director of the Matsue Chamber of Commerce, over numerous projects in cooperation with national initiatives to develop the production and consumption of local crafts. In 1927, for example, the Chamber subsidized a study tour for local potters, led by Ōta, of advanced ceramics-producing regions such as Kyoto, Seto, and Nagoya. Related activities in the late 1920s included an exhibition and sale of souvenir gift items (omiyage) from all over Japan for the purpose of improving the quality of local counterparts; a competition for prefectural omiyage; an exhibition and sale of national "special products of subsidiary industry" (tokusan fukugyō hin); and an exhibit of artcrafts (bijutsu kōgei) featuring items borrowed from the Ministry of Commerce and Industry as well as several other prefectures, along with old and new examples of local handicraft. In 1929 Ōta also formed the Matsue Craft Society with a membership of thirty-two local artisans and crafts dealers; the Society undertook to organize lecture meetings and exhibitions, to submit works to national juried exhibitions, and to conduct study tours.[32] It is hardly surprising, therefore, that Ōta was able to mobilize local networks of artisans, officials, journalists, and merchants with such facility two years later, when he began to promote the cause of new mingei.

Yet the success of new mingei owed as much to the pains mingei reformers took to distinguish their projects from other handicraft reform initiatives as it did to the example and legacy of those other groups and agencies. Mingei activists claimed above all that the new objects fashioned

under their guidance were authentically local and traditional; somehow, the coffee cups and neckties and cigarette boxes San'in craftspeople learned to make were still mingei, as Yanagi and his circle had defined the term in the late 1920s. By emphasizing the native character of new mingei, and by criticizing their rivals for ignoring the value of indigenous forms and methods, the leaders of the new mingei movement were able to differentiate themselves in an increasingly crowded field.

One of the most obvious targets for criticism by Yanagi and other mingei leaders was the so-called farmers' art movement. In 1919, the well-known woodblock print (hanga) artist and art educator Yamamoto Kanae (1882–1946) began training young men and women from farming households in Nagano prefecture to produce hand-carved wooden dolls, embroidery, and other mostly decorative items for exhibition and sale. Inspired in large part by a trip to Russia in 1916, where he had been impressed by folk art produced by peasants and children, and especially by a school for peasants organized by Tolstoy, Yamamoto hoped to develop artistic consciousness among rural Japanese while providing struggling agrarian communities with additional income. "Farmers' art" sold well in metropolitan markets throughout the 1920s, and Yamamoto's training and research center in Nagano soon expanded as it received support from both local and national government agencies, and also from private donors. By the mid-1920s, farmers' art had developed into a genuinely national initiative; thanks to official endorsement by the Ministry of Agriculture and Commerce, prefectural governments throughout the country were calling upon Yamamoto and his research center for advice and aid in organizing production of their own farmers' art.[33]

To the extent that the success of Yamamoto's rural handicraft initiative helped to develop general interest in folk material culture during the 1920s, the advent of getemono and, later, mingei and new mingei clearly owed farmers' art a significant debt. Nevertheless, mingei activists resented the unsurprising tendency of casual observers to confuse mingei with the earlier established farmers' art, especially since getemono or mingei had been defined partly in reaction against it. As Yanagi pointed out as early as 1927, much farmers' art, unlike true getemono or mingei, was based on folkloric Russian or other European models chosen by Yamamoto and other artists for reproduction by rural craftspeople.[34] In a 1935 article written to establish once and for all the difference between mingei and farmers' art, he condemned farmers' art roundly as "something that a Western-style artist [yōgaka] fond of foreign countries had Japanese country youth make in

9. An example of farmers' art (nōmin bijutsu), produced in the 1920s or 1930s. The doll represents a man in rural Japanese dress, skating. Courtesy of Municipal Yamamoto Kanae Museum, Ueda City, Nagano.

imitation of the objects he thought beautiful and selected from among foreign farmers' art." Unlike mingei, according to Yanagi and his cohort, farmers' art was nothing more than a Westernized bauble produced at the whim of urban intellectuals; it reflected none of the regional, functional character of "purely Japanese," "purely agrarian" objects "born" rather than "made" in the countryside.[35]

Similarly, advocates of new mingei criticized the official handicraft reform initiatives launched throughout the country for their tendency to ignore indigenous tradition in favor of alien, often Western-style innovation. As Ōta put it, "Because [artisans'] childish brains and their habit of 'revering officials and despising common people' lead them to place too much faith in governmental supervisors and to follow their guidance blindly, they . . . produce nothing but Westernized [battaa kusai] objects in bad taste."[36] Yanagi's comments were even more pointed; in one Kōgei editorial from late 1931 he described several government projects he had encountered during a brief trip to Tōhoku, including one that encouraged Tsugaru and Nambu villagers to weave cotton flannel rather than the hemp cloth that had long been a local specialty, and accused "those persons called officials and engineers" of irresponsibility and lack of understanding or consideration for the regions they ostensibly served. Because cotton, unlike hemp, did not grow easily in northeastern Japan, cotton cloth manufacture forced dependence

on cotton imported from outside the region. Similarly, flannel could be woven only on "large machines" brought in from industrial centers. Yanagi claimed that new mingei production, by contrast, sought to employ local resources in a natural manner responsive to the needs and circumstances peculiar to a given region and its people.[37]

Non-mingei craft reform projects, in short, were held to be insensitive to the specificity of Japanese regions. Mingei reformers complained of thoughtless, arrogant urban intellectuals and bureaucrats who promoted unnatural and impractical modes of production, which resulted in ugly, nonfunctional, Westernized goods and the eradication of valuable local heritage. And yet mingei reformers, themselves urban intellectuals and even government bureaucrats, were not entirely immune from similar charges. In retrospect, certainly, it is possible to see that over the decades mingei activism helped to create a rather standardized genre of its own throughout the crafts-producing regions of Japan. A 1980 guide to the kilns and pottery of the San'in region, for example, identifies mingei as one of the four main types of local pottery production and comments that due to the impact of mingei reforms, "the characteristic designs and methods of the folk kilns in various areas were lost, and it cannot be denied that a species of mingei style became stereotyped."[38] Nor did critics in the early 1930s fail to notice the paradoxically homogenizing influence of reforms in the name of distinctive local character. In Okayama prefecture, where local elites in the city of Kurashiki began to promote new mingei production in the early 1930s, one kiln responded to an instructional visit paid by Yanagi and the potter Hamada Shōji by turning out large quantities of pottery in imitation of works by Hamada. Criticism arose to the effect that the kiln was simply "licking the leftovers" of individual artists like Hamada, and that its pottery was losing its specifically regional character.[39]

The emergence of a characteristic mingei style in ceramics, woodwork, textile, and other handicraft production supervised by mingei reformers owed a great deal to their reliance on the use of models or exemplars (tehon). Thanks to his work in Tottori, Yoshida Shōya soon gained a reputation as a particularly effective director (shidōsha) of provincial artisans seeking to produce new mingei. As he repeatedly explained, the basic method he used, and the secret to his success, was simply to give craftspeople good models to imitate.[40] In the case of the Ushinoto kiln, Yoshida explained that he gave the potter Kobayashi some models, which included "good pieces from Ushinoto's old work, as well as a few pieces of getemono I had collected from

various regions, along with work by Kawai, Hamada, Tomimoto, and so on."[41] Since, for most mingei enthusiasts, good models tended to derive from the same basic groups of objects, it is not surprising that new mingei was often conspicuously uniform in style.

Ultimately, the often homogenizing results of mingei reformers' work with rural craftspeople derived from the steep hierarchies of class, geography, and gender that shaped the way Japanese in the 1930s understood themselves and their proper social roles and relations. For urban intellectuals like Yoshida, Yanagi, and others of their cohort, it was very difficult to imagine that a barely literate village artisan might be capable of much more than responding to the directives and models provided by his or her betters. Although mingei ideology exalted the aesthetic achievements of the provincial craft producer, such achievements were always attributed to the unconscious workings of custom and community—a force sometimes assimilated to the Buddhist concept of tariki, or salvation through faith in powers outside the self. This denial of individual capacity among rural artisans made especially good sense to urban male elites when, as was very often the case, crafts producers were female. Commenting in 1932 on the admirable designs painted on Mashiko teapots by the experienced female artisan Minagawa Masu, Yanagi felt compelled to write, "Tradition works in interesting ways. It leads both those with artistry [egokoro] as well as those without to the same heights. . . . [In the world of craft] there are no heroes. There are crowds of people. And yet beauty lives."[42] Yoshida wrote of the young women who manufactured neckties for him in Tottori: "One is constantly amazed at the beauty of the new necktie patterns that innocent [mushin] weaving girls come up with; this too is thanks to the way of tariki, and we know by it the virtue of mingei."[43]

Thus in spite of the loving respect for regional identity and variety that informed mingei theory, in practice mingei reformers often imposed their judgments and standards upon rural crafts producers in a manner that produced more sameness than difference, and that was occasionally more than a little reminiscent of the high-handed ways of the very "officials and engineers" Yanagi deplored. Descending upon village workshops in their automobiles and Western-style clothing, mingei activists freely dispensed instruction, advice, and models—occasionally even Western models—in their mission to preserve and revive authentic Japanese handicrafts for a new age.[44] Moreover, mingei reformers confidently distinguished between those elements of older, preindustrial handicraft production they considered valu-

able, and those they did not. Their judgments could be sweeping. Ōta reported in 1931, for example, that after evaluation by Yanagi and Kawai, it became clear that pottery from the Izumo area had always been "mistaken" in method, and therefore "thin and cold."[45] Yoshida eventually declared, "In Tottori there was almost no mingei object that could be reproduced just as it had been of old; putting it even more strongly, in the case of the Ushinoto kiln, everything with the exception of the Gorohachi teabowl had to be newly conceived."[46]

Nevertheless it is important to recognize that mingei production, even if imposed from above in arbitrary and even contradictory ways, did hold a special appeal to many artisans beyond the economic opportunities it offered. Like the Ushinoto potter Kobayashi, rural craftspeople were gratified to hear the older work of their parents and community praised. For many, moreover, it was a relief in a time of economic distress and anxiety about the advent of mass production and increasingly more sophisticated technologies to be told on good authority that the old, local ways and materials and tastes they had mastered were more than adequate. The Shimane papermaker Abe Eijirō, who would eventually be named one of Japan's "living national treasures" (ningen kokuhō), recalled his own 1931 encounter with Yanagi gratefully: "When I met Mr. Yanagi, it was at the time when Western-style paper [yōshi] had begun to be made extensively in Japan, and Japanese-style paper [washi] and Western-style paper were competing. I, who had been born into a poor papermaking family, stood at a crossroads, wondering and agonizing about which direction I should take. Mr. Yanagi told me then that I should travel the one road of Japan's handmade paper."[47]

## THE EMERGENCE OF A NEW MINGEI MOVEMENT

By shifting their focus to new mingei and the countryside in 1931, mingei activists finally discovered a formula for success. Almost immediately, their efforts to reform rural handicraft industry in ways claiming to respect indigenous tradition and identity attracted favorable attention and support; local artisans and elites of the San'in and its neighboring regions were the first to join the cause, but before long new mingei and its leading promoters were gaining adherents in the metropolitan centers of Kyoto, Osaka, and Tokyo, as well as in other parts of the country. Indeed, by the mid-1930s, Yanagi and his closest associates were the leaders of what might fairly be called a movement. In 1934 the Mingei Association (Mingei kyōkai) was formed to enlist the growing numbers of those individuals and groups participating in new

mingei production and its promotion and distribution. The Mingei Association also acted as publisher, taking over the publication of the magazine *Kōgei*, as well as of a growing stream of books by Yanagi and others. Moreover the Association served as a sort of umbrella agency to coordinate the other mingei institutions that sprang up in the 1930s, such as the retail and wholesale shops Takumi in Tottori and Tokyo and the mingei museum (Nihon Mingeikan, or Japan Folk-Crafts Museum) in Tokyo.

Yet it is worth emphasizing that the central notion of mingei around which the movement formed and rallied in the early 1930s was quite distinct from the ideas about getemono, or mingei, that first animated the small group of young men who collected and promoted their temple-market finds in the late 1920s. Most obviously, the shift to new mingei represented a turning away from old mingei, or the antiquarian focus of much earlier activity. The objects first named mingei were the rustic artifacts of a pre-industrial past, and before 1931 the practices most closely associated with those objects had been basically appreciative and curatorial. Although central figures within the mingei group, such as the potters Hamada, Kawai, and Tomimoto, were productive artists, and although certain of the mingei projects of the late 1920s sought to expand the realm of mingei activism beyond antiques collecting, until 1931 the mingei mission was understood primarily in terms of demonstrating new aesthetic standards through the celebration of an overlooked category of antiques.

The success of the new mingei initiatives set in motion a process by which the shift away from hobbyist antiquarianism finally gained real momentum. In the early 1930s, a redefined grouping of mingei activists embraced very different forms of practice around very different kinds of objects. In addition to directing the production of new handicraft goods, for example, they began to travel widely and systematically about the hinterlands of Japan in search of ongoing crafts production and active crafts producers. Beginning in 1933, it became common for small groups of leading mingei figures to undertake investigative buying trips for weeks at a time. While these trips certainly retained a strong element of the playful aestheticism that had long attached to both travel and collecting for cultivated men, their primary stated purpose was both reformist and commercial: the goals of the travelers were to find "buried" or "hidden" crafts production and producers eligible for reform, occasionally to undertake guidance of artisans on the spot, and also to buy handicraft goods for exhibition and sale in urban centers.[48] As they become involved in coordinating and negotiating local

craft reform initiatives, moreover, mingei activists began to work closely with hitherto unfamiliar groups and agencies—not only rural artisans but also a wide range of local powers, including the very state-sponsored experimental stations (*shikenjo*) and crafts guidance institutes (*kōgei shidō jo*) that Yanagi and other mingei leaders so often criticized. And finally, the success of mingei reform projects was inextricably intertwined with the success of new mingei in the urban marketplace. Inevitably, therefore, mingei activists also busied themselves with the campaign to sell new mingei—an undertaking which brought them into increasing contact with such institutions of mass consumption as department stores, newspapers, and women's magazines.

As the meanings of mingei and mingei activism changed, so too did the composition of the core group of mingei activists, along with the nature of their association. The numbers of *dōjin*, or those enthusiasts most closely involved in managing mingei projects and institutions, grew steadily over the course of the 1930s. Yet there was also a degree of attrition; certain members of the original group of collectors and artists were alienated by the changes of the early 1930s, and their defection from the cause of new mingei helped to accelerate its ascendancy among a new and expanding coterie of activists.

One problem pointed out almost immediately by critics both within and outside of mingei circles was that of the aesthetic quality of new mingei. The work of San'in artisans simply could not compare, they complained, either to old mingei objects or to the work of craft artists like Kawai and Hamada. Perhaps the first to make this observation publicly was Yanagi's family relation Ishimaru Shigeharu, a scholar and collector who had been one of the seven cosigners of the 1926 "Prospectus for the Establishment of a Mingei Art Museum." In a short essay published in the December 1931 issue of *Kōgei*, he confessed his disappointment with the new San'in mingei he had seen at an exhibition sale. He had gone to the show fully expecting to buy something, but ended by leaving empty-handed, convinced only of "what a difficult thing is craft made under supervision." Ishimaru wrote that all he found was notably inferior imitations of work by artists such as the woodworker Kuroda Tatsuaki and the potters Kawai, Hamada, and Michael Cardew, and he went on to speculate on the theoretical impossibility of recreating getemono in the present as either art or craft.[49] Ishimaru's comments, though clearly unwelcome to Yanagi and others committed to the production of new mingei, were difficult to ignore.[50] Indeed, they pointed to

a problem that has continued to vex mingei ideology and practice ever since: the knot of contradictions posed by the effort to define mingei so as to include on more or less equal terms not only old and new mingei, but also the works produced by individual artists such as Hamada and Kuroda.[51] More immediately, Ishimaru's criticisms stung because they were echoed repeatedly by others, and because even the most loyal partisans of new mingei could not but admit their truth.[52] The usual response was that it was unfair to judge new mingei harshly, as its production was still immature.[53]

The problem of the quality of new mingei was linked to a more general restiveness felt by some of the earlier collectors and promoters of old mingei, who resented the repudiation of antiquarian dilettantism that seemed increasingly necessary to Yanagi and others bent on industrial reform in the countryside. The tensions between the older culture of *shumi*, or taste, and the newer drive for greater social relevance were particularly clear when it came to the appreciation of ceramics, especially antique ceramics. Thanks in large part to the institution of the tea ceremony, ceramics collecting and connoisseurship formed one of the most venerable and prestigious forms of elite male recreation in Japan. Most of the earliest members of the mingei group had been brought together by their shared interest in antique pottery and porcelain, and in particular by their experience as pioneers in the collection and appreciation of Chosŏn-period Korean ceramics. Not surprisingly, therefore, antique folk pottery loomed large in the early years of getemono and mingei enthusiasm, as did patterns of playful sociability centered on its acquisition, celebration, and display.

While Yanagi never gave up his own private interest in old mingei and particularly old ceramics, by the early 1930s he was regularly expressing public impatience with pottery-centered antiquarianism. As he observed in *Kōgei* in early 1931, "Antiques-hunting is fun, but there is much greater significance in searching out good new things."[54] Thus even though the January 1932 issue of *Kōgei* was a special number devoted to Chosŏn-period Korean (Yi dynasty) ceramics, Yanagi made it clear in his editorial comments that this was largely a concession to the wishes of others.[55] Later, he was even more direct; in a 1935 issue of *Kōgei* he expressed regret that too many issues of the magazine had been devoted to pottery and that "there are quite a few who buy only the pottery numbers of this magazine." These people, he added darkly, "are not our true friends."[56] By the mid-1930s Yanagi's criticisms of the antiquarian, shumi sensibility among mingei enthusiasts had become entirely explicit. In a 1936 issue of *Kōgei*, he publicly reprimanded a

group of collectors in Kyoto who were in the habit of mounting an annual exhibition of their old mingei: "It feels wasteful simply to repeat these shows of old things. . . . I am told that this is just something light, for your pleasure, and that's fine—but from the viewer's perspective it is also possible to take this as a kind of narcissistic rapture [jikō tōsui], or even as a competitive vanity show." He went on to recommend that the group engage in activities that were more "progressive" and had "greater social significance," such as scholarly investigations into Kyoto-area mingei, or efforts to promote the production and distribution of new mingei.[57]

Yanagi's increasingly authoritative tone reflects the changing constitution of the core group of leading mingei activists. By the mid-1930s he had clearly emerged as the unchallenged leader of a larger and much more hierarchical organization openly dedicated to social and cultural reform. His dominance, and the dominance of the reformist agenda, were fully achieved only after several key figures of the early mingei initiatives—such as Ishimaru, and also the wealthy ceramics connoisseurs Aoyama Jirō and Kurahashi Tōjirō—had departed the scene.[58] They withdrew from the inner circles of mingei activism largely because they found the new emphasis on directing and promoting new mingei production in the provinces uncongenial. As Ishimaru noted, the championing of new mingei required aesthetic compromise; more generally, the reformist impulse was clearly at odds with the conventionally literary, urbane, and cosmopolitan inclinations of Tokyo aesthetes like Kurahashi and Aoyama.[59]

It is also possible, however, that Yanagi had difficulty working cooperatively with men who considered themselves his intellectual and social equals, and that at least some of his former cohort were alienated by his autocratic tendencies.[60] In January 1932, the writer Hata Hideo attacked Yanagi at length in an article published in the ceramics magazine *Chawan* (*Teabowl*) for what he described as Yanagi's numerous "contradictions" and weaknesses. Hata claimed that Yanagi now snubbed his old companions Aoyama Jirō (along with Aoyama's elder brother, the art critic Aoyama Tamikichi), Ishimaru, and Kurahashi because they perceived Yanagi's failings. Hata predicted that ultimately Yanagi's craft movement would be diminished by his refusal to work with true peers and by the egotistical "stink" of his preference for "fans" (fuan) and followers who "worshipped" him.[61]

The degree to which Hata's partisan fulminations should be credited is open to question. Nevertheless it is clear that as some of Yanagi's earlier associates distanced themselves from mingei activism in the early 1930s,

their places were taken by a new cadre of men whom an ungenerous observer might well call "fans" and "followers." Yoshida Shōya may be taken as a representative figure: a provincial doctor with modest literary inclinations, he commanded status and rank decidedly inferior to those of the Tokyo collectors and aesthetes. Much less could he be considered on the same level as someone like Yanagi, a nationally known, Tokyo- and Kyoto-based intellectual approximately ten years his senior. Like many of those who joined the inner circles of new mingei activism during this period, Yoshida first encountered Yanagi and his ideas in print, during his student years; along with legions of "literary youth" in the provinces, he had been a devoted and admiring reader of the magazine *Shirakaba* and later of Yanagi's publications on folk art. Other new mingei activists with similar backgrounds were Ōta Naoyuki, a local official; Morinaga Jūji, a Waseda-educated, Shimane landlord whom Yanagi persuaded to become a weaver; Takeuchi Kiyomi, a salaried employee of provincial industry; Mitsuhashi Tamami and Shikiba Ryūzaburō, two more provincial doctors; and Tonomura Kichinosuke, a Christian minister in Shizuoka prefecture also persuaded by Yanagi to take up weaving.[62]

Thus even as the shift to new mingei tended to marginalize those earlier champions of folk-craft whose primary interest remained the collecting and appreciation of antiques, it made possible the expansion of mingei networks outside the insular literary and artistic circles of the major urban centers. The new attention in a time of national economic crisis not only to the old mingei of regional Japan, but also to the possibilities of its revived production generated support from a wide variety of provincial sources. The most active participants in mingei reform activism tended to be drawn from the ranks of local elites; they were the professionals and landed gentry whose interest in folk art, and in Yanagi, derived partly from their own commitment to the literary culture of taste and aestheticism that defined at least one version of elite Japanese masculinity across the nation. But the newest mingei reformers were also motivated, in contrast to the earlier group of collectors and artists, by strong localist sentiments of regional pride and interest. They were often connected to local industry and to local branches of the state in ways that encouraged further expansion (as well as adaptation) of new mingei initiatives. In the Okayama city of Kurashiki, for example, interest in new mingei production on the part of local notables led to several projects in the early 1930s undertaken by Yanagi, Hamada, and the textile dye artist Serizawa Keisuke in collaboration with a floor-covering manufacturer (Nihon

Engyō kabushiki gaisha) and also with a local industrial school (Kurashiki Jitsugyō Gakkō).[63]

## Marketing New Mingei

Until 1931, the collectors and artists and writers who congregated around getemono or mingei formed only one of the numberless small literary and artistic groups that lay scattered across the Japanese cultural scene. Like most such groups, the mingei coterie incorporated a strong element of elite male sociability and play, and its most noteworthy collective activities (occasional publications, exhibits, and efforts to establish a museum) were generally funded privately, out of the pockets of participants for whom it might be said that such activities represented a form of leisure. As key figures within the mingei group turned to the production of new mingei in 1931, however, they were drawn almost ineluctably into very different sorts of financial arrangements. New mingei production could not be sustained exclusively by private largesse or the eccentric tastes of literary collectors, especially since the wealthier among mingei enthusiasts preferred old things to new. Consequently, the campaign to find outlets and markets for the flow of newly manufactured folk-craft out of the San'in and other regions led mingei activists to develop relationships with key institutions of urban consumerism.

Despite an often professed unworldliness about money matters, Yanagi and his closest associates were remarkably successful in pursuing a variety of opportunities to market new mingei; over the 1930s, mingei activists established several retail shops, as well as temporary and, by the late 1930s, permanent venues for sales in major department stores. There were also regular and profitable exhibition sales in both central and provincial cities, and ties were formed to such important agents of popular consumerism as newspapers, women's magazines, radio, and film. By the mid-1930s, mingei was becoming distinctly fashionable. The result was not only the generation of income on a hitherto unprecedented scale for many of those associated with new mingei production, but also an entirely new level of publicity and influence for mingei activists in an unexpected role: as experts on tasteful bourgeois consumption.

### SHOW AND SELL

The marketing of new mingei was structured by what might be called an expositionary logic. In the context of a nascent consumer market, new min-

gei first made its appearance by means of exhibitions or displays intended to educate and entertain, as well as sell. In this respect, new mingei was introduced to urban and suburban Japanese much as were many other new commodities during the late nineteenth century and early twentieth. The expositionary form, which developed out of the interaction of a native tradition of commercialized spectacle with the influence of the great international exhibitions in Europe and the United States, was first employed by the Meiji state to train both producers and consumers to participate in a national economy. Later, private capital took it over as a central device in the formation of domestic consumerism. During the 1930s, therefore, urban Japanese consumers encountered new mingei through what had by then become a familiar device of assimilation: the exhibition sale.

In seeking to sell new mingei, folk-craft reformers and activists at first relied almost exclusively on exhibition sales sponsored by major newspapers or department stores, or sometimes by the two in combination. In October 1931, for example, the Kyoto edition of the Ōsaka mainichi newspaper sponsored a three-day show-cum-sale in Kyoto, at the Osaka Mainichi Hall, of new mingei produced by San'in artisans.[64] Six months later, the Ōsaka mainichi joined with another major daily, the Tōkyō nichi nichi, to put up a juried all-Japan exhibition and sale of new mingei at the Shirogiya department stores in Osaka and then in Tokyo.[65] Also in the spring of 1932, Takashimaya held a large exhibition and sale of new mingei from the San'in region at its Osaka store, the first of a series of similar show sales put up at the various Takashimaya stores in Osaka, Kyoto, and Tokyo semiannually over the next five years.[66]

While newspapers, especially the Ōsaka mainichi, remained important sponsors of new mingei exhibition sales, increasingly it was the department stores that provided the most regular and successful opportunities for showing and selling new mingei. Takashimaya was perhaps the first of the major department stores to commit itself to marketing new mingei in this manner, but during the 1930s it was joined by the Tokyo-based emporia Mitsukoshi, Matsuzakaya, and Shirogiya, along with Hankyū in Osaka and Daimaru in Kyoto. At all of these stores, typically a section or sometimes the entirety of one of the upper floors devoted to home furnishings and art or craft objects would be given over to the temporary exhibition and sale of mingei. Show sales usually took place in the spring or fall, never lasting more than a week at a time. Normally they required the active participation of the mingei

activists, who were often responsible for supervising various aspects of the event. For their part, the department stores provided funding, staff, promotional services, and, of course, the cachet, publicity, and clientele associated with their status—well-established by the 1930s—as palaces of bourgeois consumption.

The reliance on exhibition sales sponsored by newspapers and department stores came about most immediately and obviously as a result of personal connections. The Kyoto edition of the Ōsaka mainichi newspaper, for example, was headed by Iwai Taketoshi, an old friend and patron of the mingei potter Kawai Kanjirō. A collector himself, during the late 1920s and 1930s Iwai donated his own time and money, as well as the resources of the newspaper he managed, to various mingei-related undertakings, such as the Kamigamo guild experiment. And it was Kawai again who provided the link to the department store Takashimaya through his friendship with Takashimaya's general director, Kawakatsu Ken'ichi. In early 1932 Yanagi referred in several letters to his efforts, evidently successful, to press Kawai to negotiate with Kawakatsu for Takashimaya's first exhibition sale of new mingei, which took place in April of that year.[67]

But there were also larger structural and institutional forces at work which, by the 1930s, made the temporary exhibition sale an established means of promoting commodities to a nascent mass market. Yoshimi Shun'ya, in his study of expositions (hakurankai) in nineteenth- and twentieth-century Japan, has demonstrated the central role of the exposition—the spectacular, temporary display of manufactured goods—in the formation of Japan's early mass consumer culture. The first self-consciously modern industrial expositions of the late nineteenth century were directly inspired by the great international exhibitions held in London, Paris, Vienna, and Philadelphia. Sponsored by the state, the domestic versions of the international exhibitions were intended primarily to encourage the development of domestic industry, to help prepare Japanese submissions to the international expositions, and to introduce the public to the improving influence of Western-style displays of manufactured goods. As in Europe and the United States, however, the novel forms of commodity display and mass spectacle associated with the industrial expositions soon began to inform the development of a new culture of urban consumerism promoted increasingly by private capital rather than the state. By the 1920s, newspaper companies, railway lines, and department stores had largely replaced central or local government agencies

as the leading sponsors of the dozens of lavish expositions that feature so prominently in the annals of Japanese urban recreation throughout the first half of the twentieth century.[68]

Japanese department stores, in particular, had a complex relation to the exposition form. It has often been observed that the department store in Japan, as in Europe and North America, grew out of the exposition, and in a sense represented the most immediate adaptation of a permanent version of the exposition form to consumer capitalism.[69] Yet in Japan the exposition in more or less its original mode, as a temporary, autonomous, primarily exhibitionary event often located on a sprawling outdoor site, continued to have a lively existence through the 1930s and beyond. Even as department stores became perpetual expositions of a sort, they along with private rail lines and especially the major newspaper companies persisted in sponsoring and participating in the earlier type of temporary, free-standing expositions. Moreover, department stores themselves became the sites of almost constant mini-expositions of varying scale where, again, the emphasis continued to be as much on transient event and spectacle as it was on the actual sale of the commodities displayed. Indeed, as the historian Hatsuda Tōru has noted, the early Japanese department store differed from its Euro-American counterparts in the extent to which expositionary elements prevailed; in particular, he points to the emphasis in Japanese stores on facilities and spectacles—such as art exhibitions or dining rooms or rooftop amusement gardens—that were only indirectly related to the selling of things.[70]

One explanation for the persistence of expositionary forms in Japanese department stores, and in urban consumerism generally, may be that they remained a useful way to do business in the context of a relatively small and undeveloped consumer market.[71] Given the low purchasing power of the vast majority of urban Japanese consumers, it made sense for department stores to concentrate resources on spectacles or dining facilities or other attractions that might at least draw paying visitors, if not buying customers.[72] Further, the exposition was an effective means of educating potential consumers. Visitors to a show or show and sale of art objects, furniture, travel goods, or children's educational toys were often being introduced to unfamiliar commodities for which demand was as yet only very weak.

It is also significant that commercialized forms of spectacle were by no means a new feature of urban Japanese culture. The popular enthusiasm for expositions in the late nineteenth century owed at least as much to the existence of a vigorous native tradition of fairs, shows, exhibitions, and

exhibition sales as it did to Western example.[73] Similarly, it might be argued
that the persistence of the exhibition sale in the department store and other
retail establishments of the 1920s and 1930s reflected the persistence of a
nexus of meanings and practices associated with elite male consumerism
and dating back to the early nineteenth century, if not before. Especially
relevant are the exhibitions of pictorial art and calligraphy, or *shogakai*, which
were initially restricted to circles of connoisseurs and held at private sites, but
by the mid-nineteenth century had become more public and more frankly
commercial affairs. Another type of late Tokugawa exhibitionary practice
that may be considered pertinent is that of the *bussankai*, the displays of local
products, which were initially organized by scholarly men for the edification
of their peers but also showed a tendency to become increasingly commercial
and heterogeneous over time.[74] Perhaps it is in this context that we should
interpret the often cited finding by Kon Wajirō, who conducted informal
studies of Tokyo department stores in the late 1920s and early 1930s and
noted the surprising preponderance of educated men—"gentlemen" (*shinshi*)
and students—among their clientele. Slightly over half of the visitors to the
Mitsukoshi store in Ginza during a thirty-minute period one Sunday after-
noon in 1928 were men, and approximately half of these appeared to be either
gentlemen (30 percent) or students (20 percent).[75] Kon attempted to recon-
cile his numbers with the already well-established assumption that most
shoppers at department stores were female by hypothesizing that men were
overlooked because they tended to spend shorter periods of time in the store
and wore less conspicuous clothing than did women. Alternatively, he pro-
posed that many were simply accompanying their wives. Perhaps, however,
we might also look to the history of elite male involvement with commodity
display, both in the early modern period and as it developed over the course of
the late nineteenth century and early twentieth.[76]

It is not surprising, then, that new mingei was first marketed in a pri-
marily expositionary manner by newspaper companies and especially de-
partment stores. Moreover, the special character of new mingei as a class of
commodities made it particularly suitable for the exhibition sale format. Its
status as the product of a more or less traditional form of native industry
placed it squarely within a category of objects central to modern Japanese
expositionary practice. Thanks in part to the highly favorable reception of
Japanese arts and crafts exhibited at the international expositions through-
out the late nineteenth century, and to the ensuing European and North
American demand for Japanese manufactures conforming to the standards

of "Japonisme" or "Japan taste," the Meiji state took the lead in actively promoting handicraft production and reform throughout the country. One of the key means employed by both the central and local governments was the public industrial exhibition or exposition. Thus by the early 1930s the edifying display (and, secondarily, the domestic sale) of exemplary items of local handicraft production was a practice established by some fifty years of precedent, particularly in the provinces, where it had also spawned an institutional infrastructure of industrial museums, local products display halls, and other such permanent exhibitionary venues very welcoming to new mingei show sales.[77]

There were several other aspects of new mingei which suited it for introduction to the major urban markets by means of the exhibition sale format in particular. One was the lingering association of folk-craft with the hobbyist predilections of literary urbanites. Even though new mingei provoked suspicion and even disdain from some of the literary aesthetes who had originally taken up old mingei in the 1920s, it was still seen by many (to the frustration of Yanagi and his associates) as belonging to the general category of rustic curios fancied by men of taste and leisure. Thus the display and sale of new mingei at exhibitions in department stores and other downtown sites in the early 1930s drew on a tradition that continued to attract a certain type of urbane gentleman, along with those who emulated his style and habits.

The association of new mingei with a long, commercialized, urban tradition of exhibition by and for literati was strengthened by one other aspect of new mingei: the fact that as a category it also included, however awkwardly, the work of celebrated craft artists such as the potters Kawai Kanjirō, Hamada Shōji, and Tomimoto Kenkichi. By virtue of their leading roles as mingei activists, and their apparent commitment to the aesthetic and socioethical principles articulated by Yanagi, these artists were understood to be producing new mingei too. Clearly their works were distinct from the new mingei objects produced by the rural artisans they and other mingei activists supervised in the San'in and other regions. But the question of just how that distinction was to be understood remained problematic, at least within mingei circles. In his statements of mingei philosophy, Yanagi consistently emphasized the superior aesthetic-moral value of objects produced once upon a time by "nameless craftspeople." In theory at least, modern, conscious, individualistic artists like Kawai were valuable primarily as guides, who might direct the postlapsarian present to a restored "Kingdom of Beauty" in

which the folk would once again become the true producers of aesthetic value. Yet this ideal of the artist as tutor and servant to the superior genius of the folk was contradicted, at least in the short term, by the far greater value that was ascribed by most of Japanese society to the production of the former. By 1931 Kawai, as well as his fellow potters Hamada, Tomimoto, and to some extent Leach, were all rising stars in the firmament of the Japanese art world. Over the course of the 1930s several other artists closely associated with the mingei movement came to share their success, most notably the textile dye artist Serizawa Keisuke and the woodblock print artist Munakata Shikō. Their works were shown and sold regularly in a variety of contexts, but perhaps most conspicuously in department store exhibition sales.

Finally, new mingei appealed to the organizers of as well as many visitors to exhibition sales because much of it was also useful in the home. The fact that mingei pots, textiles, and furniture could also serve as implements of daily life only added to their marketability. Thus new mingei's ambiguously compound character—at once art, folk curio, a form of native industrial manufacture, and a type of household good—increased its potential for commodification within the exhibitionary forms of the urban Japanese market. Indeed, a kind of commercial synergy developed, whereby each of new mingei's several modes helped to promote the others, as well as the category as a whole. The various institutions that became involved in showing and selling new mingei all found ways to employ this synergistic effect. In the spring of 1934, for example, the Tokyo department store Matsuzakaya held two pottery exhibition sales concurrently. One, a show of ceramic objects by ten well-known artist-potters, included the works of Kawai, Hamada, Leach, and Tomimoto. The other, an enormous show and sale of over nine thousand objects produced anonymously by artisans at "folk kilns" (minyō) in various parts of Japan, was assembled and curated by Yanagi, Kawai, Hamada, and other mingei activists, and was advertised in conjunction with the art-ceramics exhibit.[78] In early 1937, one of the Hankyū department stores in Osaka established a mingei salesroom (mingeihin uriba) on its third floor.[79] Although the salesroom was permanent, offering new mingei to customers year-round, Hankyū also promoted it as a site of regular exhibition sales, which were usually organized around individual mingei artists and their works or certain genres of new mingei (such as handmade paper or ceramics from folk kilns in a certain region). Occasionally one of each type of exhibition sale was held at the same time.[80]

A similar dynamic informed the nature of another sort of retail establishment that sprang up in tandem with new mingei in the early 1930s: the mingei shop or boutique. Three shops opened in 1931 and 1932 expressly to sell new mingei. The first, called Mizusawa, was opened in Tokyo in early 1931 by a young scholar inspired by Yanagi's theories of folk-craft; it seems to have failed not long after. The second, Minatoya, was started at the end of 1931 in Tokyo on a stronger financial basis provided by the wealthy Hamamatsu collector and mingei patron Takabayashi Hyōe, and managed to stay in business for some years thereafter. The third, Takumi, eventually became the official retail outlet for the mingei movement. Established in 1932 by Yoshida Shōya in the city of Tottori as the local retailer for new mingei produced in the San'in region, Takumi opened a branch shop (later the main store) in the fashionable Ginza section of Tokyo at the end of 1933.[81] All three stores relied on a combination of frequent exhibition sales along with regular, standing displays of new mingei. At both Takumi and Minatoya, store layout itself came to reflect the importance of exhibition sales. The Takumi in Tokyo, for example, was renovated several months after opening to create a second-floor gallery space; in its first year or so the shop held exhibitions of washi and shawls, as well as of works by the textile artist Serizawa Keisuke, the potters Funaki Michitada and Bernard Leach, and the weaver Morinaga Jūji. In 1934 and 1935 Minatoya also put on exhibition sales of new mingei; there were shows of works by the weaver Aota Gorō and Serizawa, as well as of generic hand-woven and hand-dyed textiles. At the end of 1935, Minatoya too opened a room on an upper floor to be devoted to exhibitions and also to gatherings of various kinds.[82]

The overlap between new mingei as aesthetic object and new mingei as a piquant brand of household good helped to promote it not only in department stores and various other retail establishments, but also in other major institutions of what might be called Japan's "exhibitionary complex": the academic art exhibition and the museum.[83] As early as 1927, the mingei group acquired an institutional foothold at the Kokuten, one of several major annual, juried art exhibitions that dominated the Tokyo-centered art world.[84] Initially founded in 1918 by a group of Kyoto painters dissatisfied with the management of the official Monten (renamed Teiten in 1919) art exhibition, in 1927 the Kokuten added a crafts section under the direction of a new member, the potter and mingei enthusiast Tomimoto Kenkichi.[85] In 1929 Hamada and Kawai joined Tomimoto as members of the Kokugakai, which organized the Kokuten. From that time until 1937, when a quarrel

10. Exterior of the shop Takumi in the Ginza neighborhood of Tokyo
(1933). Courtesy of Tottori Mingeikan.

**II.** Interior of the shop Takumi. The items displayed in the fore-
ground are men's neckties. Courtesy of Tottori Mingeikan.

between Tomimoto and Yanagi precipitated the withdrawal of the mingei
contingent from the Kokugakai, the crafts section of the Kokuten became
something of a showcase for new mingei.[86]

While the Kokuten at first showed new mingei only in the sense of new
works produced by mingei artists, in the 1930s it became common for
visitors to the exhibition to find displayed the other new mingei as well:
utilitarian objects produced by rural artisans under the direction of mingei
activists. In her study of the mingei movement, Chiaki Ajioka suggests that it
was Yanagi's insistence on the inclusion of the humbler sort of new mingei
in the Kokuten that probably served to alienate Tomimoto from him and
from the mingei group generally.[87] Certainly any misgivings Tomimoto may
have felt about the joint display of both types of new mingei were shared by
others. As one critic wrote in a review of the crafts section of the 1935
Kokuten:

> In one section we see a magnificent highbrow white porcelain jar. In
> another, a woven straw bag and a casual everyday kimono from Tottori
> are placed in a jumble, as if in the shop-front of Takumi. I admit, of
> course, that each of these works has its own charm and taste. But I
> cannot understand why these ordinary objects are placed solemnly and

pretentiously at an art exhibition. Some may say that they are there because they are good, or beautiful. But I feel offended to see them placed side by side with works by Mr. Tomimoto or Mr. Hamada.[88]

Nevertheless, Yanagi and his cohort were able to continue exhibiting "ordinary objects" at the Kokuten until 1937, when they left the Kokugakai for the independent mingei venue of the recently opened Japan Folk-Crafts Museum. Their success in introducing and then keeping the disputed straw bags and everyday kimonos from Tottori in a major art exhibition was at least partly due to larger, modernist currents within the academic art world. By the mid-1930s, it was no longer self-evident that a sharp distinction could or should be drawn between art-craft objects and more ordinary, utilitarian, even industrial sorts of items. Indeed, in 1936 the official art exhibition, the Teiten, underwent temporary dissolution due to a rift between two major art-craft factions over, among other issues, the question of whether the Teiten's craft section would be receptive to new—that is, modern, Western-influenced, more utilitarian—crafts. There was no Teiten in 1936; instead, a group calling itself the Real Craft Art Association (Jitsuzai kōgei bijutsu kai) formed and, proclaiming the unity of utility and beauty, put up an exhibition that was considered by many an attack on the traditionalist aestheticism of the Teiten. In addition to conventional art-craft items such as flower vases and incense holders, the Real Craft Art Association's exhibition featured a model room submitted by the Matsuzakaya department store, a set of verandah furniture from the Mitsukoshi department store, and such relatively utilitarian objects as handbags and parasol handles.[89]

Commercial considerations were also relevant to the blurring of distinctions between art and artifact. The more ordinary sort of new mingei was not only displayed, but actively marketed at the Kokuten. Beginning in 1933 the exhibition included a folk-craft sale section, where visitors could buy objects similar to those displayed.[90] The success of this innovation, which was reported to have had better sales than the exhibition sales at department stores, helped to convince Yoshida Shōya that a specialized mingei shop might do well in Tokyo. The following year, the newly opened Takumi handled the sales of mingei at the Kokuten.[91] Those who profited from this arrangement included not only the producers and promoters and merchants of new mingei, but also the Kokugakai itself, which received a 20 percent commission on all sales of mingei at the Kokuten.[92]

The expositionary logic that structured the marketing of new mingei was

also evident at the Nihon Mingeikan (Japan Folk-Crafts Museum), which opened in Tokyo in late 1936. Like most museums, the Mingeikan was based on a permanent collection. Much of the collection consisted of examples of folk art collected by Yanagi and other core mingei activists, but there was also a steady stream of objects donated to the museum by collectors and dealers. While the majority of the exhibitions mounted at the Mingeikan displayed objects either chosen from the collection or loaned to the museum by private collectors, there were also occasional exhibition sales. In the summer of 1937, for example, the Mingeikan put up a show of about two hundred examples of kogin, a type of needlework produced in northeastern Japan. As an advertisement for the exhibition noted, most of the items shown were provided by two collectors, one of whom offered his pieces for sale.[93] Moreover, at the end of the Mingeikan's first year, Yanagi announced that due to popular demand, exhibition sales (sokubaikai) of new mingei by both artisans and artists would be held every spring and fall.[94] The commodity nature of the objects to be viewed in the museum was further emphasized in several other ways. The mingei shop Takumi coordinated its inventory and advertising with Mingeikan exhibitions, much as it did with major exhibition sales at department stores. "We are showing and selling items similar to those in the [Mingeikan's] new works room," began a Takumi ad that appeared in Kōgei when the museum opened. The ad copy continued: "Also, it is possible to order the interior furnishings used at the Mingeikan."[95] Thus even the furniture, lighting, and window treatments of the museum were commodities on display. And of course the museum itself sold things. While it would be some decades before the Mingeikan had a true museum shop, visitors in 1937 could purchase thirty-seven different color postcards of exemplary pieces from the collection, along with a selection of Mingei Association publications.[96]

## THE GETEMONO FAD OF THE 1930S

Who actually bought mingei, and for what purpose? How was mingei received? The historian, like the marketer, finds the actual identity and behavior of consumers an elusive quarry. Nevertheless there is enough indirect evidence to suggest that mingei did become fashionable in the 1930s among new segments of the urban and suburban bourgeoisie. In particular, the taste for folk art seems to have spread from its original locus among middle-class male cultural elites to a broader, more distinctly bourgeois, and in-

creasingly female population. While the mingei activists-turned-marketers welcomed the growth in sales and publicity, they were more ambivalent when it came to the identity and especially the apparent motivations of the new consumers of mingei. Instead of finding its way into the homes of "ordinary people" or even the "social masses," where it might help to effect a revolution in aesthetic consciousness and everyday life, mingei was taken up by rich men and women as an item of personal adornment or home decor testifying to cultivated tastes. In short, the new consumers of mingei behaved like the old consumers of mingei, and for many of the same reasons.

The expositionary show-and-sell structure effectively introduced folk-craft to a wider audience and market, but mingei reformers realized that exhibition sales alone were not enough to ensure increased demand. They felt that if mingei was to become something more than a mere curiosity or ornament for occasional appreciation by the few, it was also necessary to redefine the objects shown and sold and to propose new ways of consuming them. From as early as mid-1931, therefore, Yanagi and his closest associates strove to emphasize the utility as well as aesthetic value of new mingei. Increasingly, new mingei was promoted as a category of beautiful but also necessary, useful, relatively inexpensive goods that ordinary people (ippanjin) might employ in their daily lives. Writing in 1931 of a projected (and never realized) scheme to distribute new mingei tableware to "every home" (kaku katei) through the magazine Kōgei, Yanagi concluded that it would be "extremely convenient for those persons who want the works of individual artists but find them too expensive to purchase, and yet are sick of the things sold around town."[97]

The language is vague; who were these discerning yet cost-conscious householders Yanagi and other mingei activists had in mind? Perhaps the clearest indication is offered by the objects themselves, which suggest that to some extent the mingei reformers were still thinking of themselves: educated men of relatively modest means who took a tea-inflected interest in the aesthetics of the everyday and enjoyed an up-to-date, Westernized style of life. From the beginning, many new mingei items were clearly designed to appeal to a gentlemanly trade. For example, one of the earliest and greatest successes of new mingei production was the hand-woven necktie. Other items which might be considered part of the same "product line" included gentlemen's canes, homespun (an English-style cloth typically used for Western-style men's suiting and much favored by Yanagi himself in his own

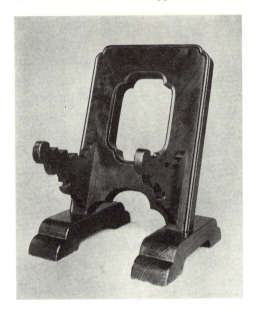

**12.** A plate stand (*saratate*), manufactured in the village of Yasugi, in Shimane prefecture, and illustrated in the October 1931 issue of *Kōgei*.

wardrobe), another cloth declared suitable for men's dress shirts (*waishatsu* or "white shirts"), banded Panama hats, and belts with buckles designed by Kawai Kanjirō.[98]

Many of the new mingei items directed at gentlemanly consumption were relatively inexpensive, practical goods intended for everyday use. Even if artisanal new mingei was at first consumed mostly by the familiar figure of the man of taste (*shumisha*), he was expected to consume it differently, in a way that supplemented rather than replaced his consumption of mingei antiques or mingei art. Not only might he wear or carry about town his new mingei purchases, as he would not be likely to wear or carry an antique piece of embroidery or a Tomimoto pot, but he was to use new mingei at home in a manner distinct from, if related to, his use of mingei collectibles. For example, one of the first items of new mingei featured (with prices) in the magazine *Kōgei* was a wooden plate stand. Manufactured in the Shimane village of Yasugi, the plate stand represented an adaptation of the design for an older, more familiar object: a mirror stand.[99] But unlike a mirror stand, which normally functioned as a dowry good and was destined either for storage (as a valuable) or for use in private, feminine zones of the home, a plate stand evoked masculine pursuits and spaces: the collecting of ceramics and their modern, Western-style display in, most likely, the more public and male-coded reception room (*zashiki*) or study.[100] Other new mingei objects

**13.** A study designed by the potter Kawai Kanjirō and exhibited in May 1938 as one of several model rooms featuring mingei, at the Hankyū department store in Osaka. Illustrated in the October 1938 issue of *Kōgei*. A plate stand is in use at the far right, in front of the window. As suggested by the presence of a table set with cups and saucers, as well as an ashtray, a gentleman's study might also serve as the site of male sociability.

apparently intended for ordinary use by the gentleman at home were literary accessories such as bookends, ink stands, and special decorative boxes for back issues of *Kōgei*.[101]

Yet, as is suggested by the frequent use of the word "household" (*katei*) in their efforts to promote new mingei, the folk-craft reformers hoped to appeal not only to bookish men of taste, but also to their female kin.[102] Again, the actual objects are telling. The mingei shops Takumi and Minatoya offered, in addition to neckties and homespun, such ladies' sundries as handbags, shawls, *obi* (kimono sashes) designed by Tomimoto and Serizawa, and obi cords.[103] Moreover much new mingei fell into the category of those household goods normally associated with elite female domesticity. While the male household head (especially one fond of ceramics) might well take an interest in the pottery used in his home, as well as in the furnishings and ornaments of his study and the formal spaces of the parlor or reception room, by the early twentieth century much of the home and its ordinary management were understood to constitute a sphere governed by female authority. In particular, the modern Japanese housewife probably considered

**14.** Three *obi* cord clasps (*obidome*), illustrated in the October 1938 issue of *Kōgei*.

herself in charge of all domestic cloth goods, as well as kitchen imple-ments.[104] Thus the prominence in new mingei production and marketing of such home textile items as napkins, tablecloths, table runners, lampshades, hand towels, curtains, and cushions clearly implied an expectation of female consumer interest.[105]

New mingei was often presented as appropriate for acquisition by ordi-nary people.[106] However, the types of objects produced, their recommended uses, and especially the prices at which they were sold all strongly suggest that by ordinary people mingei reformers actually meant a small and privi-leged segment of society. Nevertheless, there is evidence that folk art re-formers genuinely aspired to sell new mingei to a much broader market. In part, of course, their wish was purely pragmatic; the more new mingei sold, the better for the artisans and other local interests, as well as the big and small urban merchants, with whom mingei reformers' fortunes were in-creasingly tied. Yet the goal of distributing mingei to every household also reflected a continuing preoccupation with the possibility of using folk art to effect social reform through a revolution in taste. A 1934 round-table discus-sion sponsored by the magazine *Kōgei* on "aesthetics and the social," for example, began with a lengthy disquisition by Yanagi on the need to dissemi-nate artisanal craft products to the "social masses" (*shakai taishū*), so that beauty might escape its monopoly by the few to become truly the property of

society at large.[107] The question of how exactly the masses might learn to want mingei beauty in their daily lives was unclear, although the ever inventive Yoshida Shōya had some ideas. In 1937 he proposed a mingei coffee shop in which everything, from the building and interior furnishings to the utensils and even the clothing of the waiters, would demonstrate the virtues of folk-craft in use; similarly, he imagined mingei cafeterias, mingei apartment buildings, and mingei rental houses. By such means, Yoshida hoped, new "users" (tsukaite) of mingei might be reared.[108]

As it happened, new urban users of mingei did emerge over the course of the 1930s, and in numbers that assured its market success. However, they were not precisely the consumers mingei activists had originally envisioned. Nor did they seem to view or use mingei in the ways, or for the reasons, Yanagi and other reformers thought entirely appropriate. To begin with, mingei—both new and old—began to find favor among a broader spectrum of bourgeois elites. The "taste for the rural" (inaka shumi) of the 1920s had developed, by the mid-1930s, into a wide variety of practices and fashions. Among the very rich, these included a fad for country houses built in the vernacular style of the Japanese farmhouse, or minka. For some, the full effect of rustic chic was achieved only by furnishing the minka, or minka-style building, with authentically folkish interiors and objects. One observer, the art critic Tanabe Kōji, posited in 1936 a direct link between the minka fashion and what he described as a degeneration of mingei's popularity into a "baroque" decadence: "Things are being collected that are extremely shabby and sordid, or that cannot be considered healthy craft, or that have no modern function, simply because they once belonged in a farmer's home; some of these [refurbished farmhouses] have literally become, therefore, museums of low-grade things [getemono no hakubutsukan]." Tanabe also deplored the effect on the mingei market; according to him, not only had old mingei become absurdly overpriced, but demand for it had led to the flooding of the market with newly made mingei that was "highly unnatural and unhealthy" and that "ignore[d] regional character."[109] Mingei activists probably disagreed with Tanabe's assessment of new mingei, but they shared his disapproval of the minka fad. Noting in 1937 the "recent fashion for buying farmhouses and making them into summer homes or sticking them in a corner of the garden," Yanagi commented, "In many cases they [the purchasers of farmhouses] have 'folk' [gete] renovations done, or even damage [the buildings] slightly in 'tasteful' ways. Many are thus toying with them, instead of living in them honestly."[110]

Eventually even more important to mingei's success was the emergence of a market for both new and old mingei among elite women. But again, the nature of that market differed from the expectations of it held by mingei reformers. Instead of using mingei "honestly" as hardworking implements of daily life, the women who admired and began to buy folk art in the late 1930s appear to have been more interested in its value as a fashionable item of personal adornment or home decor. This, at any rate, was how magazine editors expected women to understand mingei. In the upscale women's monthly Fujin gahō (Ladies' Graphic) and the highbrow Fujin kōron (Ladies' Review), mingei was first promoted as a category of tasteful kimono and dress fabric.[111] From the mid-1930s mingei also began to appear in home and lifestyle magazines like Jūtaku (House) and Seikatsu to shumi (Daily Life and Taste) as a type of home accessory and a style of interior decoration.[112]

More generally, mingei appealed to women of the upper and, increasingly, the middle classes as both an expression and a means of self-cultivation. Beginning in the late nineteenth century, one of the most important features of elite female identity in Japan was education beyond the compulsory elementary level in the small but growing number of girls' higher schools (jogakkō). These institutions helped to promote and also to revise the Meiji ideal of femininity centered on active management of the home and family and identified by the phrase "good wife, wise mother" (ryōsai kenbo). One key moment of revision occurred during the 1920s, when educators influenced by liberal ideologies began to emphasize individual development and creativity; in particular, there was new attention to the cultivation in bourgeois young women of aesthetic sensibility, or taste (shumi). Tea ceremony, for example, was introduced into many girls' higher schools in the late nineteenth century as a form of etiquette training; in the Taishō period, however, it was reformulated as an aesthetic discipline intended to produce good taste as well as good manners.[113] Yet at the same time, most well-bred women were still expected to apply themselves—and their cultivated aesthetic sensibilities—exclusively within the context of home and family. Thus even at a liberal new girls' school like Hani Motoko's Jiyūgakuen (literally, the Free Academy, founded in 1921), the emphasis was on the union of art and daily life (seikatsu), with special attention to embroidery and other womanly handicrafts (shugei).[114]

By the 1930s, the elite ideal of a good, wise, and also tasteful wife and mother was reaching a growing audience through the rapid increase in the numbers of girls attending higher school, and also with the dissemination

of women's magazines directed at higher school students and graduates.[115] It is not surprising, therefore, that educated women were inclined to take up both new and old mingei, which offered new possibilities for the domestication of a sophisticated aesthetic. At the same time, mingei—unlike many household goods associated with the tea ceremony or with celebrated artists —was relatively affordable. It was within the reach of the growing proportion of magazine readers and girls' higher school graduates who belonged to the new middle classes of urban and suburban Japan. In a 1936 article in *Daily Life and Taste* on "tasteful" pottery produced at the mingei pottery village of Mashiko, it was noted that the works of well-known artists like Hamada Shōji and Bernard Leach were too expensive for the "ordinary middle class." The author concluded, "Today, when so-called *getemono* is so popular, Mashiko pottery—with its chunky shapes and understated [*shibui*] colors and patterns—will be ever more in demand for ordinary use in the home."[116]

For men of taste, the idea that women might pretend to comparable levels of aesthetic cultivation and autonomy could be difficult to countenance. A 1935 editorial in *Nihon shumi* (*Japan Taste*), a small magazine catering to the gentleman aesthete, sneered at both mingei and its female admirers: "Until the year before last, Tokyoites would have needed explanatory notes to understand what *getemono* meant. But nowadays even young women in western clothing fuss over soot-covered farmhouse pot hangers and the like, saying 'Oh, how interesting [*Omoshiroi wa ne*].' Can young women really find blackened, dirty things beautiful?"[117] Mingei activists were more ambivalent. There were those who probably agreed with one Yamauchi, who wrote with some asperity in *Kōgei* that women had once been properly diligent producers of mingei, and thus "on a completely different level from girls nowadays, who reflect credit on themselves by sponging on their parents and nattering on about girls' higher schools and self-cultivation [*shūyō*]."[118] Others, of course, had counted on some degree of female consumer interest in mingei. Nevertheless, even they may have gotten more than they bargained for. Hamada, writing in 1933 of a recent exhibition sale of his pottery in Kurashiki, remarked, "Even the lady visitors were quite active, choosing [pots] and asking questions without depending on anyone."[119] As an artist in lean times, Hamada could only welcome potential buyers, regardless of their sex. On the other hand, he could not help registering some surprise upon encountering provincial women bold enough to select art objects and quiz artists without (male) advice or protection. For him as for other mingei reformers, the expectation may have been that women would confine

themselves to buying the less expensive, more obviously useful domestic or feminine goods produced by artisans and sold at retail establishments like Takumi and the department stores; art objects and antiques, as well as the knowledge to fully appreciate them, were high-status commodities most appropriately consumed by men. Yanagi wrote several times from the University of Hawaii, where he had gone in 1933 to teach a summer course on Oriental art, of his surprise at finding that most of his students, as well as the audiences for his public lectures, were women.[120]

Yet the mingei activists, like many other men of culture in interwar Japan, discovered that the ungovernable appetite of growing numbers of women for information and goods pertaining to tasteful consumption also presented them with new opportunities for influence and income.[121] Yanagi's writings were anthologized in girls' higher school textbooks, and the Mingeikan became a popular destination for girls' higher school field trips. Leading members of the mingei movement also wrote with increasing regularity for the women's press, where they even began to figure as celebrity tastemakers whose lifestyles and persons were as salable as their opinions or art production.[122] When Bernard Leach returned to Japan for an extended visit in 1934 after a fourteen-year absence, he discovered his old friends engrossed in their new mingei endeavors. To Leach's bemusement, his association with them, and therefore with mingei, meant that even he was pressed into service as an occasional expert on ladies' tasteful consumption. During a 1935 visit to Tottori, Leach was maneuvered by Yoshida Shōya into giving an impromptu address to "upwards of one thousand silent, kneeling, blue uniformed girls" at the local girls' higher school; he later wrote that he felt "inane" but "talked of home-cooking and dressmaking, and of the home in general as opposed to the shop." Yoshida also had Leach give a cooking class to local matrons; although Leach wrote of having felt "considerably 'broody' about this unexpected programme," he also reported with some pride that he successfully supervised the preparation of a menu that included rice curry with twelve condiments, asparagus salad, and banana ice cream.[123]

The mingei activists found that they could not control who bought mingei or why. Mingei was successful in the 1930s urban marketplace, but not because Japanese housewives—much less the masses—appreciated its everyday utility, or the "healthy" nature of a lifestyle based on the folk-craft aesthetic. Instead, mingei became fashionable among affluent, educated urban consumers in the 1930s for many of the same reasons it had first

appealed to gentlemen hobbyists and collectors in earlier decades: because it was affordable and decorative, because of the authenticity that attached to its association with the rural, native past, and because its appreciation signaled sophisticated tastes. The fact that mingei was first admired by male cultural elites provided a further reason for its cachet among bourgeois men and women anxious to establish their credentials for cultural mastery. The men of mingei may have been disappointed by the gap between their ideal of wholesale lifestyle reform for the masses and the reality of mingei as bour-geois trinket, but they were practical enough to adapt themselves and their wares to existing market conditions. Yanagi disapproved of rich men using folk-craft to decorate their minka summer homes, but Takumi opened a summer outlet in the elite vacation region of Karuizawa nonetheless.[124]

And yet mingei also owed its growing visibility over the 1930s to another factor, one that would eventually help to give mingei activists wider scope to reform everyday life. According to the craft critic Tanabe's 1936 analysis, the fashion for mingei derived not only from Yanagi's theories, Kurahashi Tō-jirō's efforts to promote Korean craft, and the resurgent popularity of the tea ceremony, but also from "the calls for Japanese spirit, based on nationalist thought, over the past year or so."[125] Indeed, nationalism had become in-creasingly prominent in all areas of Japanese society and culture from as early as 1931, in the aftermath of the Manchurian Incident.[126] In the fields of art and design, the nationalist fervor that accompanied the escalating war in China took the form of renewed interest in indigenous styles and traditions, a trend often referred to as "Japan taste," or Nihon shumi. While it was not always entirely clear what constituted Japaneseness and thus where Japan taste began and left off, by the mid-1930s there had emerged a strong asso-ciation between the folk aesthetic of mingei and Japan taste in its rustic mode. As a result, the mingei movement began to attract interest and ap-probation from official agencies of the wartime state. With the advent of total war in 1937 and the state's concomitant concern for ever greater levels of national mobilization, mingei activists found new relevance for their vision of folk-craft as a beautiful and native technology of daily life.

FOUR. Mingei and the Wartime State,
1937–1945

The war years of the late 1930s and early 1940s were a period of unprece-
dented influence and activity for the mingei movement. By late 1937, Japan's
unannounced war with China had lurched from its beginnings in the so-
called Manchurian Incident of 1931 to full-scale and escalating conflict. As
systematically underprovisioned and brutalized Japanese troops marched
through China, finally sacking the Nationalist (Guomindang) capital in the
infamous Nanjing Massacre of December 1937, the central government in
Tokyo began putting into place the institutional mechanisms necessary to
mobilize the nation for total war.[1] It was at this juncture that mingei began to
attract serious new attention and support from a variety of state agencies.
Officials first in the Ministry of Commerce and Industry and the Ministry of
Education and later in such organizations as the Cabinet Information Bu-
reau and the Imperial Rule Assistance Association fastened on the potential
of mingei activism and ideology to help manage the home front. For their
part, mingei activists eagerly embraced the opportunities afforded them by
state approbation; for the first time, they glimpsed the exhilarating pos-
sibility of realizing their visions of social and cultural reform based on the
folk-craft aesthetic.

Yet the dream of leading a societywide revolution in taste remained, like
so many of the heady visions of the wartime years, largely unfulfilled. In the
end, specific initiatives such as those to reform the lives of impoverished
Tōhoku villagers, to create a new ethos of daily life for urban elites, or to help
design a new factory culture came to very little. What, after all, could survive

the demands of a ravening military machine in the last stages of a hopeless war? Nevertheless the mingei movement's various wartime projects warrant close examination. Mingei activism between 1937 and 1945 was important for the continuing development of the movement. By about 1940, mingei and its central institutions (the museum in Tokyo, the Mingei Association and its two periodicals) had achieved a semiofficial status that contributed greatly to the broad dissemination of an orthodox version of mingei ideology. One consequence was growth; the first regional branches of the Mingei Association, which would continue to spread throughout Japan after 1945, were established in 1942.² Another major consequence was added prestige and authority for the leading proponents of mingei and for their particular views on Japanese handicraft. That prestige and authority survived Japan's defeat in 1945, despite the collapse and subsequent vilification of the regime with which mingei was initially associated. Indeed, mingei's establishment in the second half of the twentieth century as a venerable yet arrestingly modernist national icon owed a great deal to its collaborations with the wartime state.

The relationship that developed between the Mingei Association and the state during the Fifteen-Year War also compels attention for the insight it offers into the question of Japanese fascism. In their attempts to help define and realize a "new order of daily life" (seikatsu no shintaisei), mingei activists participated in an official campaign of national regeneration inspired by fascist Italian and especially Nazi German examples. As in other nations dominated by fascist or fascistic regimes, such as Vichy France, as well as Italy and Germany, folk culture and particularly folk art were assigned great importance and value owing to their association with an indigenous, pre-industrial, agrarian past. Mingei was taken up by a Japanese state that, like its counterparts in Europe, was intent on mobilizing for war a national and imperial identity founded on blood (race) and soil (land).³

Thus study of the official favor accorded folk art in Japan during the years of total war provides another angle from which to consider the problem of Japanese fascism. For some decades, European and especially North American scholars have persisted in dismissing the idea of a Japanese fascism. While the mainstream of postwar Japanese historiography in Japan has generally operated on the assumption that the central structures as well as ideology of rule in wartime Japan were recognizably fascist, the North American scholarship which dominates postwar Japanese studies outside Japan has tended to proceed instead from the conclusion that Japanese militarism

or ultranationalism produced a form of government fundamentally different from the fascist regimes of Italy and Germany.[4] Yet, as Andrew Gordon has pointed out, many of the Western critics who reject the fascist label for Japan are vulnerable to charges of "an implicit Eurocentrism and an explicit nominalism"; they rely on European cases, usually Germany, to generate a list of characteristics indispensable for fascism. To the extent that Japan lacks such features as a charismatic dictator, takeover by a mass fascist party, or genocidal domestic policies, it is said to be disqualified for fascist status.[5] However, Gordon has argued persuasively that despite clear differences, "we can find similarities in the historical contexts to the rise of fascist systems in Italy, Germany, and Japan, the ascendant ideas that justified the new order in each society, and the programs that resulted."[6]

The history of mingei helps to illuminate, in particular, fascist aspects of Japanese cultural policy during the early 1940s. Most discussions of Japanese fascism have focused on political institutions and movements or on economic policy. There has been some study also of fascist ideology and literature.[7] A consideration of folk art makes it possible, however, to begin to assess the crucial question of the role played by aesthetics in fascist policy-making. As has long been stressed in the scholarship on European fascism, aesthetic considerations were central to the fascist project. Not only were fascist politics characterized by the deliberate manipulation of spectacular new forms and symbols, such as architecture, film, mass festivals and rallies, posters, and uniforms, but the fascist renovation of society and the state was framed in explicitly aesthetic terms.[8] In Japan as well as in Germany, Italy, and France, one of the central goals of fascist thinkers, bureaucrats, and politicians was to create a beautiful new society in which individuality and difference could be both exalted and sublated by the exquisite discipline of national unity and sacrifice. This vision had very concrete uses in mobilizing national subjects and resources for wartime labor and privation, but it was also held out as an end in itself. The ideal of "one hundred million hearts beating as one," one of the most often quoted slogans of wartime Japan, was presented as a source of aesthetic gratification, as well as of virtue and strength. For Japan as for all fascist polities, folk art was useful as an impeccably indigenous aesthetic resource that evoked the social harmony of premodern communal forms.

The changing uses of mingei during the late 1930s and early 1940s also reveal some of the peculiarities of fascist aesthetics as they took form in an especially late-developing nation. The constraints of belated industrializa-

tion are also relevant to the particular ways the state expressed interest in folk art. It is sometimes suggested that the relative absence in Japan of monumental architecture of the sort designed by the Nazi architect Albert Speer is evidence that the wartime state was not fascist.[9] Yet it ought to be remembered that Japanese planners were hampered to an unusual degree by the shortage of resources; the demands of total war against the Allied powers left little for supplying even the daily necessities of life, let alone for erecting grandiose monuments to national glory.[10] The relative prominence of folk art and folk art activism in the planning of several key government agencies suggests some of the other ways Japan's backwardness inflected its fascist experience. The preoccupation of the Ministry of Commerce and Industry, for example, with increasing exports and with the possibility that mingei might help to improve national industrial design reflects the special pressures that attended Japan's efforts to achieve the status of a fully modern power. Somewhat like their counterparts in Italy under Mussolini, Japanese intellectuals both in and out of government circles were keenly aware of the importance to an international power they had not yet fully gained—whether political or economic—of creating a distinctive national style and taste.[11] Japan, like Italy, occupied a marginal position among the great powers; it is no coincidence that in Japan too, therefore, the uncertainty of the national aesthetic was seen as a handicap in international markets and also as a source of anxiety and shame.

The uses to which mingei was put at home in the effort to create wartime national unity were also distinguished by Japan's particular circumstances. One consequence of the rapid, relatively delayed process of modernization in Japan was the existence of an unusually high degree of social and economic unevenness. There was a large agrarian sector, for example, in which the majority of the population led very unmodern lives. Thus the campaign to mobilize the home front required, among other things, overcoming the significant obstacles to political integration posed by the growing rift between farm and factory or country and city. The aesthetics of a daily life modeled on an idealized, and rationalized, vision of the farm household became Japan's way to create the fascist harmony and unity that would produce total victory in war.

*What Becomes an Export Most? Mingei and the State before 1937*

The early years of mingei activism passed in the almost total absence of official attention of any kind. Only with the advent of the new mingei reform initiatives in the early 1930s did a few bureaucrats in those government agencies concerned with regional industry begin to take some notice. Even then, however, official reaction was slight, sporadic, and ambivalent. The 1932 comments of Kunii Kitarō, the director of the Ministry of Commerce and Industry's Industrial Arts Research Institute, may be considered representative. In an editorial published in the institute's magazine, Kunii remarked that both the mingei and the farmers' art (*nōmin bijutsu*) movements were welcome evidence of growing national interest in crafts (*kōgei*) and brought "unbearable gladness" to those of "us who have been calling for the industrialization of our country's crafts." Mingei and farmers' art were also laudable as efforts to call attention to native manufactures: "Needless to say, because most of that which is called our country's industry has made great strides on the basis of the importation of European and American culture, we have fallen into the bad habit of thinking highly of imported manufactures and, from an insufficient recognition of crafts, of making too much of science. We have rarely turned back to consider crafts, the special talent peculiar to our country." Even going so far as to mourn the passing of preindustrial self-sufficiency and authenticity, Kunii praised the objects promoted by both movements. Yet in conclusion, he criticized farmers' art and mingei for having failed to integrate modern science into their modes of production. He also warned, pointedly, "From a manufacturing point of view, if objects are only those things likely to please a limited number of connoisseurs, or if they are nothing more than imitations of medieval things, then they are very weak and will not have staying power as commodities."[12]

Kunii's mixed reaction to mingei reflected the evolving position of the Ministry of Commerce and Industry (MCI), which was still working out its views and policies on those domestic manufactures belonging to the category of crafts. The MCI was formed in 1925 out of the former Ministry of Agriculture and Commerce as a consequence of the lobbying of agricultural groups who demanded their own ministry. The fledgling Ministry began its rise to prominence by aggressively promoting a policy of "industrial rationalization" in response to the steadily worsening economic conditions of the late 1920s. One of the primary goals of the rationalization movement,

which involved a variety of U.S- and German-inspired measures to integrate industrial policy and improve industrial efficiency, was to relieve Japan's international balance of payments deficit by increasing exports of manufactures. Inevitably, the drive to stimulate trade drew MCI's attention to the small-scale manufacturers who provided the lion's share of Japanese exports. As Chalmers Johnson notes in his study of the MCI (or MITI, the Ministry of International Trade and Commerce, as the ministry was later renamed), it was the MCI bureaucrat Yoshino Shinji who was one of the first to realize that "medium and smaller manufacturers of sundries such as bicycles, pottery, enamelware, canned goods, hats, silk textiles, and so forth were contributing from 50 to 65 percent of all of Japan's exports," and that due to general inefficiency "they were losing money doing it."[13]

The establishment by the MCI of the Industrial Arts Research Institute (Kōgei shidō jo) in 1928 may be seen as part of the general campaign to rationalize the world of smaller-scale manufacturing.[14] It also represented a more specific resolve to bring modern science and technology to crafts (kōgei) production in particular.[15] As Kunii made clear in a statement he published in 1928, the institute's primary aim was to "industrialize" Japan's traditional "art crafts" (bijutsu kōgei). He envisioned something he called "industrial crafts" (sangyō kōgei), which would use science and modern technology to mass-produce inexpensive yet aesthetically appealing household commodities. Kunii expected that by integrating modern industrial rationality with the artistry of Japan's native handicraft tradition, such manufactures would perform well in both domestic and foreign markets.[16] Accordingly, throughout the 1930s the institute endeavored to improve and modernize regional production of wood, metal, bamboo, ceramic, and textile items of household use. Under Kunii's direction, the institute organized numerous, regular juried exhibitions of objects in various regions as well as in major cities. Training workshops were held at the institute every year for artisans selected from all over the country in fields relating to woodwork, metalwork, and lacquerwork, and exemplary objects from the institute's collection were frequently loaned to the various official and semiofficial crafts guidance organizations that formed in almost every prefecture and that put up their own exhibitions. The institute also employed a stable of engineers and designers expert in various fields of crafts production who circulated the country giving lectures and advising on the manufacture of crafts.

Not surprisingly, the newly established institute regarded the budding mingei movement with some skepticism. To the extent that institute engi-

neers and officials took any notice at all of new mingei activism in the early 1930s, they were bound to be unfavorably impressed by the inefficient, "medieval" technologies and materials employed in the manufacture of folk-craft. Far from introducing the principles of industrial rationality, mingei reformers were bent on preserving many of those aspects of handicraft production that could only strike MCI analysts as embarrassingly premodern. The result, as any advocate of industrial rationalization might have been able to predict, was expensive goods produced erratically and in small quantities for a narrow market. Institute disapproval was palpable in a 1934 review of a mingei pottery exhibition sale at the Matsuzakaya department store. While the reviewer conceded that the objects shown were beautiful, he criticized the various folk kilns for all making the same types of things, adding, "Efforts to increase the use value of water jars or mixing bowls by employing them as braziers [hibachi] lack healthy thinking about application." The review concluded, "In seeking to transmit a refined taste by means of crudeness and an antique flavor, [the exhibit] merely offers up, uselessly, cartoonish materials."[17] Even as late as 1940, when mingei had acquired much more official legitimacy, institute employees freely criticized mingei and mingei ideology for its anachronistic "sentimentality" and "utopianism."[18]

Yet Kunii and his underlings at the institute could never dismiss mingei altogether. To begin with, one of the institute's founding objectives was to aid the development of viable "subsidiary industries" in the struggling agricultural sector. It was for this reason that the institute was initially located in Sendai, the most important city of the perennially impoverished Tōhoku region, where local government and private interests had already put into place an array of initiatives directed at the reform and revival of crafts production.[19] Even if institute technocrats disagreed with mingei activists in principle on how rural industry ought to be developed and promoted, they could not ignore the relative success of the new mingei projects in the San'in and other regions. Nor were all industrial policymakers necessarily ill-disposed to the mingei approach to local manufacturing. One of the central figures in the mingei movement of the 1930s was a midlevel MCI bureaucrat named Mizutani Ryōichi. On occasion Mizutani was instrumental in generating informal as well as more official types of MCI support for mingei projects, including, in 1934, a successful campaign to reform washi (Japanese-style paper) production in Saitama prefecture, where a friend of

Mizutani's had just been appointed the new director of the prefectural Office of Commerce and Industry.[20]

During the mid-1930s it became clear to institute planners, moreover, that mingei was a valuable aesthetic resource to be exploited in the increasingly urgent campaign to promote exports of Japanese manufactures. From the outset, Kunii had asserted that stylistic or aesthetic reform was a central goal of government crafts policy. In his 1928 statement on the purpose of the institute, for example, Kunii emphasized the importance of finding efficient ways to manufacture inexpensive, useful consumer goods without compromising their "artistic flavor." Beauty, he asserted, was essential to sales of crafts, that is, most of Japan's consumer manufactures, in both domestic and foreign markets.[21] In the early 1930s, the institute's commitment to improved aesthetic quality only deepened with the advent of the world depression, as it became increasingly difficult to find markets for Japanese exports. The rise of international trade protectionism combined with mounting domestic military expenditures to aggravate Japan's trade deficit and growing need of foreign exchange.[22] In a 1932 editorial for the institute magazine, Kunii was explicit about the role he expected a commodity aesthetic derived from the native crafts tradition to play in promoting national interests in an increasingly competitive global context:

> Even in the manufacturing industries, we have scientific production methods that are hardly inferior at all to [those of] the advanced nations, but today in this time of intense economic world war, each [nation] must proceed in the direction of its own special character if it is to plan on victory. In this sense the future path of our country's industry is to put all its might into *producing craft goods for the masses that are based on our unique craft techniques to which have been added modern spirit and modern science*; in other words, to raise the value of commodities by adding the aesthetic element missing from our industrial goods which have [otherwise] made such great strides since the Meiji Restoration.[23]

The advantages of a specifically Japanese commodity aesthetic in the trade wars of the 1930s were underscored when Kunii undertook a six-month tour of Europe and the United States in 1933 and discovered what he claimed to be the growing popularity of the Japonesque style (*Nihon shumi*). He wrote of seeing many "craft commodities," including metalwork, ceramics, and textiles for women's clothing, that adapted the "spirit of Japanese design" as

extrapolated by Western designers from Japanese painting, kimono, and tea ceremony goods. He quoted a Japanese trade official in Berlin: "Recently the countries of the West have wearied of scientific, or materialist [busshitsuteki] lifestyles, and feel a sort of longing for the spiritual culture of the Orient, and this is stimulating artisans to employ Japanese craft techniques in items of daily use, and so buyers have come to desire commodities with Oriental, Japanese designs."[24]

Yet as Kunii and others concerned with promoting Japanese exports were well aware, the Japonesque or Oriental style was by no means a fixed, clearly defined category. Not all indigenous design necessarily corresponded to the ideas of Japaneseness fashionable in Europe or North America (or indeed in Japan) at any given moment. In their efforts to determine which Japonesque items might actually sell, institute officials were attentive to evidence suggesting that 1930s Western consumers particularly favored rustic handicraft goods like mingei. There was much comment, for example, when a 1934 exhibit of Japanese village handicrafts in Paris was so well received that the Printemps department store placed a large Christmas order for baskets, trays, lacquerware, and toys.[25] The craft artist Fujii Tatsukichi, who was critical of what he perceived as the institute's Westernizing bias, noted wryly that it was only "because reviews have been good in France and Germany, and so lots of orders have been placed, that the peasant crafts or local crafts of Japan are being reevaluated [in Japan]. . . . How sad that the worshipful custom continues of praising nothing that has not been praised by foreigners."[26] Here Fujii may also have had in mind another Western influence on official attitudes toward the popular handicraft tradition: the German architect Bruno Taut (1880–1938), who worked as a consultant to the institute between 1933 and 1936.

Taut's brief career in Japan began abruptly in early 1933, when he and his companion sought refuge there from the newly empowered Nazis. As a well-known expressionist architect with strong leftist leanings and affiliations, Taut was distinctly persona non grata in Hitler's Germany.[27] In Japan, by contrast, he was tolerated by the authorities—particularly when it became clear that he could be put to use as a foreign expert on industrial design. Taut appears to have obtained his position as consultant to the institute at least in part because his emphatic views on export goods recommended him to Kunii. In a journal entry dated 5 September 1933, Taut wrote, "I saw the MCI's Sendai Industrial Arts Research Institute's exhibit at Mitsukoshi [department store] in Nihonbashi. There were some things of good quality—but

very few, about two or three. The rest was sloppy and makeshift. From first to last, these were sketchy imitations of European and American [objects] for 'export taste.' The institute director Kunii asked for my frank opinion, so I criticized [the exhibit] freely."[28] Kunii must have been pleased. He had just published his article on his travels abroad, in which he concluded that the new Western interest in Japonesque commodities made it imperative that Japanese production for export cease to imitate Western goods and "return to [Japan's] true, characteristic spirit and unique technology."[29] Taut's critique of the exhibit was promptly published in the September issue of Kōgei nyuusu (Craft News), the institute magazine; in it he stressed the value of traditional Japanese techniques and patterns as used in designs that remained true to function. He urged the institute to "borrow and collect old Japanese masterpieces—craft objects that are national treasures—to keep close at hand, and labor to create things that surpass or at least do not fall below them."[30] Taut began his employment at the institute two months later.[31]

Taut's admiration for "old Japanese masterpieces" and his conviction that the design principles they embodied had modern relevance were apparently heartfelt. Indeed, he achieved an enduring celebrity in Japan thanks to books and essays in which he praised the timeless genius of such monuments of premodern Japanese architecture as the Ise Shrine and the Katsura detached palace.[32] Many of the buildings and objects Taut admired in Japan belonged to the aristocratic past, but he was also effusive in his appreciation of the folk architecture and handicrafts he encountered in the countryside. He did not entirely agree with the mingei program, which he considered unrealistic, but he maintained cordial relations with Yanagi, Hamada, Kawai, and other mingei activists and went on record as a supporter of their basic mission to preserve and promote Japanese folk-craft.[33] At the institute, he designed prototypes of such items as sandwich and melon baskets, magazine racks, egg cup sets, pipe stands, cigarette boxes, and parasol handles; many of these objects were clearly inspired by the techniques and materials of rustic Japanese handicrafts.[34] Indeed, Taut himself made some effort to revive the "peasant handicrafts" (nōmin tekōgei) of the Takasaki region during his time at the institute.[35]

Taut's enthusiasm for folk material culture suggests another reason why mingei rose in the estimation of institute officials during the late 1930s and early 1940s. Not only did Taut's interest seem to confirm the idea of a Western market trend favoring the rustic Japonesque, but it also raised the possibility, in a time of increasing nationalism, that mingei-type objects

might offer indigenous access to international modernism. In her study of Japanese architectural ideology, Jacqueline Kestenbaum observes that Taut's assertions about the modernism inherent in traditional Japanese structures such as the Katsura detached palace were not especially original; Japanese authors were making similar arguments as early as the late 1920s. Ironically, Taut's ideas about a native Japanese modernism were influential because of the authority they received from his status as a celebrated European modernist.[36] In the case of traditional Japanese handicrafts, Taut's opinion was corroborated by several other European design experts hired by the institute to consult on export goods. For example, the German interior decorator Tilly Prill-Schloemann, who was retained by the institute in late 1939, visited the Mingeikan and the mingei shop Takumi and later pronounced "mingei, handicraft-type things" as the most appropriate Japanese goods for export. She added that old Japanese objects were distinguished by a timeless, "correct" modern quality.[37] The noted French designer Charlotte Perriand, during her stint at the institute in 1940–1941, was even more enthusiastic about the modernist potential of mingei and proceeded to create interiors and furniture, including a bamboo version of the famous chaise-longue she designed in 1928–1929 with Pierre Jeanneret and Le Corbusier, both directly and indirectly inspired by mingei.[38]

Institute personnel were not entirely receptive to the idea that modern Japanese industrial design should take its cue from indigenous folk art; they were particularly sensitive to the patronizing implications of such advice when given by Europeans. A 1941 institute round-table discussion with Perriand developed a distinctly combative tone as she defended herself against accusations of using mingei-type design elements to exoticize Japan. One of her interlocutors, the designer Katsumi Masaru, was especially prickly:

> First of all, we ourselves want to make use of the splendid wisdom of our ancestors, and have no need to be told to do so by foreigners. However [that wisdom] must be filtered through modern, scientific rationality. If, instead, we complacently swallow those things that express the exoticizing view [monomezurashii ki na metsuki] of foreigners, then the future of our Japan will be imperilled. Because the thorough dissemination of science is still necessary in Japan, it is a great nuisance to healthy intellectuals when this is ignored and a small minority of those with a taste for nostalgia [kaiko shumi sha] is catered to instead.[39]

Nevertheless, the basic idea that the modernist aesthetic embraced through-out the industrialized world had always been inherent in the most ordinary artifacts of the Japanese past was appealing. As Kunii wrote in a 1940 edi-torial for *Kōgei nyuusu*, "We must reflect deeply on the anti-ornamentalism advocated by the Bauhaus after the last great war; in fact the attitude that creates limitless beauty in undecorated objects of necessity is characteris-tically Oriental."[40] Only a few months after the contentious round-table with Perriand, moreover, mingei-type ideology as well as objects were promi-nently featured in several issues of the institute magazine. In a two-part pictorial on "Technologies of the Nation," "local crafts" (*kyōdo kōgei*) "well-ing up from the daily lives" of villagers were presented as appropriate for use in modern Japanese life. They were praised for having a "simple flavor" and for "overflowing with the beauty of their materials." The caption for a photo of a "shopping basket" hand-woven of vine read: "It's so much sturdier and more beautiful than ones in the city as to be beyond compare."[41] The in-stitute's endorsement of mingei was made fully explicit in late 1941, when the Mingei Association was invited to submit a display to the MCI's much publicized Exhibit of National Daily Life Goods.[42]

The institute's late embrace of folk art as a "national daily life good" did not represent an abandonment of its original mission to rationalize smaller-scale crafts production and to increase exports of manufactures. Rather, the institute took up mingei in a pragmatic effort to adapt its basic aims to the context of escalating, global war. As both international trade competition and Japan's need for foreign exchange intensified, institute designers and their supervisors became more open to the possibility that mingei might serve as a design resource in the campaign to shape a distinctively Japanese, modern, and above all salable national style for consumption abroad. By the early 1940s, however, the MCI along with much of the rest of the central government was at least as preoccupied with the related, and more imme-diately accessible, goal of managing domestic consumption. It was here, in the wartime campaigns to mobilize the home front to consume less and produce more, that mingei and mingei ideology came to seem truly useful.

## Mobilizing the Home (Front)

It is a measure of the official favor that mingei activists were beginning to enjoy that in April 1939, the Mingei Association launched a second monthly magazine, titled *Gekkan mingei* (*Mingei Monthly*). Both of the maga-

zines put out by the Mingei Association were allowed to continue pub-
lication without apparent interference until late 1944.[43] Only a very marked
complaisance on the part of responsible agencies—the powerful Cabinet
Information Bureau and the Ministry of Commerce and Industry—could
have ensured the survival of not one but two folk art magazines from
the same small organization during a period when forced consolidations
and even outright dissolution drastically reduced the number of periodicals
published.[44]

The hope that mingei might help Japanese manufactures to perform well
in overseas markets was doubtless a factor in the official calculus that pro-
duced such preferential treatment. As the authorities grew increasingly pre-
occupied with the problem of mobilizing the nation for an unprecedented
level of war effort, however, mingei activists were able to win goodwill from
the state primarily by demonstrating the relevance of folk-craft to a wartime
"daily life" (seikatsu) that enshrined the values of native productivity and
thrift. Part of the value of the mingei program to the wartime state derived
from its apparent versatility; during the late 1930s and early 1940s Yanagi
and his closest associates were active in reform efforts in the countryside—
notably in the Tōhoku region, which had become a national icon of rural
misery and backwardness—even as they continued to promote mingei ob-
jects and ideology to middle-class urban audiences. Not only did the Mingei
Association's wartime projects thereby suggest the capacity of mingei to
reform households throughout Japan, whether impoverished and rural or
affluent and urban or suburban, but they also held out the possibility of a
new lifestyle that would actually help to resolve and submerge pronounced
differences of class and region at a time when national unity was of utmost
concern.

Thus, by examining mingei reformers' efforts in both country and city
between 1937 and 1945 it is possible to see that they were involved in a larger,
state-sanctioned campaign to shape a home front—indeed, to shape the lives
of Japanese at home—for total war. Further, study of the connections be-
tween wartime mingei initiatives in Tōhoku and those addressed to con-
sumers in the nation's capital and other major cities helps to illuminate the
nature of official campaigns to mobilize daily life. Like the mingei projects,
the state's interest in seikatsu or daily life was driven partly by an ambition to
translate an idealized vision of rural productivity into a style of living that
might be adopted by all Japanese.

SNOW COUNTRY

Tōhoku, or the Northeast, is the region comprising the six northeastern prefectures of Japan's main island. It had been recognized by mingei collectors from as early as the 1920s as a treasure house of undervalued handicrafts, particularly in the categories of woodwork, weaving and embroidery, and metalwork.[45] Beginning in 1937, the Mingei Association embarked on a new phase of interest and activity in Tōhoku at the invitation of a quasi-governmental organization headquartered in the city of Shinjo in Yamagata prefecture. In August 1937, the director of the Snowfall Region Farm Village Economic Survey Institute (Sekisetsu chihō nōson keizai chōsajo) formally requested that Yanagi visit in September to investigate local mingei and take part in a conference with several dozen local "mingei researchers." Yanagi's visit was to form part of a larger project, which he had already agreed to undertake for the institute, to "investigate the mingei objects of the Tōhoku region."[46] In fact the agronomists of the Snowfall Institute wished to ascertain whether mingei-style handicraft production might be developed into a viable form of off-season industry for struggling local villages. Accordingly, Yanagi traveled to Yamagata, where he supervised the first investigations of Tōhoku folk-craft in Mogami county (gun). Visiting villages and examining such household items as work clothes, straw raincoats (mino or, in this part of Tōhoku, kera), baskets, and winnows, Yanagi convinced his companions from the Snowfall Institute that by drawing on traditional materials, designs, and techniques, the local manufacture of new mingei might indeed be developed profitably as a winter by-employment. Over the next five years the collaborative efforts of the Mingei Association and the Snow Country Association (Yukiguni kyōkai), a subsidiary group organized by the institute, produced a steady stream of increasingly well-publicized exhibitions, competitions, round-table discussions, and other events in both Tōhoku and Tokyo.

The Tōhoku mingei projects must be understood within a larger context of growing local and national concern about rural conditions generally, and Tōhoku in particular. Indeed, the very origins of the Snowfall Region Farm Village Economic Survey Institute (hereafter, the Snowfall Institute) suggest some of the outlines of the history that produced a groundswell of Tōhoku-related activism in the 1930s. The Snowfall Institute was established in 1933 by the Ministry of Agriculture and Forestry to help direct plans for the economic revitalization of Tōhoku villages, and more particularly to guide

efforts to reduce economic losses caused by the heavy snowfall characteristic of northeastern Japan. The institute was most directly the result of the so-called snow damage movement (setsugai undō) begun in the late 1920s by Matsuoka Shunzō, a national Diet representative from Yamagata prefecture. According to the usual account, it was during a hospitalization for pneumonia one winter in Yamagata city that Matsuoka was first struck by the idea that the snow country of Tōhoku was climatologically handicapped relative to the "southern countries" (nankoku) of the rest of Japan. Matsuoka is said to have invented the term "snow damage" (setsugai) to account for the high number of children with cold-related illnesses whom he observed in the hospital. He went on to build a popular campaign for the further investigation and, eventually, state redress of the various types of snow damage that afflicted his constituency.[47] Matsuoka quickly gained widespread local support for the movement, especially for his proposal that land taxes levied by the state be reduced in "snow-damaged regions." Although the central government did not make concessions on this point, in 1933 the Ministry of Education allocated additional funds for the support of compulsory education in the Tōhoku region, in explicit acknowledgment of the burden of snow damage.[48] In the same year, the Snowfall Institute was established in Shinjo, a small city in central Yamagata, under the jurisdiction of the Ministry of Agriculture and Forestry. Its first director, Yamaguchi Hiromichi, was a young bureaucrat from the Ministry's agricultural administration department (nōseikyoku).[49]

The snow damage movement had its roots in the agricultural depression of the 1920s, whereas the somewhat delayed response of the central government can be understood within the context of the world depression and the national sense of rural socioeconomic crisis it brought about in the early 1930s. Both were also part of the gradual development of a consciousness among both natives and outsiders of the special immiseration of Tōhoku and of the need for aid and reform efforts directed at this region in particular. A series of poor harvests due to cold weather drew national attention to the problem of economic and social "backwardness" in Tōhoku as early as 1900, leading to the formation of several private and official organizations and movements beginning in 1913 dedicated to Tōhoku development (Tōhoku shinkō).[50] Much of this development effort was focused on generating and reviving Tōhoku industry and helped to bring about, among other things, the 1928 decision of the MCI to set up the Industrial Arts Research Institute in Sendai, Tōhoku's largest city. Matters only went from bad to worse with

the economic downturn for agriculture in the 1920s, followed by the catastrophe of the world depression. In Tōhoku the impact of the world depression was greatly aggravated and prolonged by two disastrously bad harvests in 1931 and 1934. Not only did these circumstances lead to the expansion of the various development projects and campaigns already in place, but the plight of famine-stricken Tōhoku farm villages became a subject of urgent national concern. Stories of starving children going to school without lunches or even staying home to help their families gather barely edible wild plants vied in the national press with accounts of desperate farmers selling daughters into prostitution or other forms of indentured servitude. These helped to generate popular as well as governmental relief schemes at the same time that they reinforced a general perception of Tōhoku as a place of want and misery.[51]

In many ways the collaborative efforts by the Snowfall Institute and the Mingei Association to promote new mingei production in Tōhoku participated in the larger culture of 1930s reform efforts directed at the blighted northeast in particular, and at rural society in general. Like so many of the initiatives generated both within and outside the region (including the mingei campaigns of the early 1930s in the San'in region), the mingei projects were intended first and foremost to boost the productivity of farming communities by an expansion and rationalization of low-cost cottage industries. By more fully exploiting off-season labor, reformers hoped to provide cash-starved farm households with additional sources of income. At the same time, efforts to promote mingei production in Tōhoku villages were also meant to help bolster local morale. An internal report produced in 1938 by the Tōhoku Region Farm Village Industrial Guidance Association, which worked with the Snowfall Institute on the initial mingei investigations, concluded, "Because in Mogami county there are many excellent mingei objects and the farmers possess superior manufacturing skills, there exists in all likelihood the possibility that with some guidance [these objects] will make inroads into central markets, and also that the manufacture of mingei will not only revive the farm village economy but will also aid greatly in the uplift and enlightenment of the farming people's spirit."[52] As Kerry Smith notes in his study of a depression-era Tōhoku village, one of the central goals shared by 1930s rural reformers was precisely such uplift and enlightenment. In his words, there was a broad sense of crisis that "had been triggered by the collapse of the rural economy but was also driven by the belief that the fabric of rural society was itself in need of repair." The state-sponsored Economic

Revitalization Campaign directed at farming villages throughout Japan between 1934 and 1941, for example, was intended to develop not only the agrarian economy, but also "farmers' spirit" and "village culture."[53]

In Yamagata prefecture in 1938, the Snowfall Institute—with Yanagi and other mingei activists acting as consultants—pursued both economic and spiritual recovery by working out a method to promote the local manufacture of new mingei through a system of juried exhibitions. In early 1938 letters were sent to the approximately forty village heads and agricultural cooperative directors of Mogami county announcing the Snowfall Institute's plan to develop mingei (defined as "handmade things, excluding toys, manufactured as of old by farm households for their own use or for sale") as a subsidiary industry. The villages and cooperatives were requested to submit folk-craft objects for a competitive exhibit to be held at the Snowfall Institute. Cash prizes were to be awarded to makers of objects designated "select" and "special select," and the institute also offered either to buy or to arrange the sale of prize-winning items.[54] The institute director Yamaguchi, who had anticipated about a thousand entries, confessed himself disappointed by total submissions of fewer than two hundred—a result he attributed to the "incomplete diffusion of the term 'mingei.'" Nevertheless, in May the objects were shown in Shinjo as promised, along with a companion exhibit of Korean mingei and other "reference items" recently acquired by the Snowfall Institute. The shows were planned to coincide with a convention of Yamagata industrial cooperatives, which helped to boost attendance; about one thousand visitors were reported over a two-day period.[55]

A year later, in early 1939, the Snowfall Institute was able to generate much more interest and attention for a second, larger exhibition of locally produced mingei. This time the objects were produced by the youth groups of the entire Shōnai region of Yamagata prefecture. Yanagi and Yamaguchi were among the judges, and special prizes were donated by such big-name organizations and individuals as the Tōkyō nichi nichi newspaper and Matsuoka Shunzō, Yamagata's Diet representative and one-time snow damage movement leader. With a total of two thousand submitted objects and about eight thousand visitors, the event exceeded the expectations of its planners.[56] During the next several years the Snowfall Institute continued to organize juried exhibitions of mingei in different parts of Tōhoku, in collaboration with various central and prefectural state agencies, including, eventually, a semigovernmental corporation called the Tōhoku Industrial Development Company (Tōhoku kōgyō kaisha). In a larger-scale version of the plan first

devised in 1938, this corporation undertook to buy all the mingei objects commended by the judges of the various exhibitions for resale to urban dealers and also for possible export.[57]

By the late 1930s even the most afflicted regions of Japan had largely recovered from the worst of the depression crisis. After 1937, however, a new national emergency was at hand: what had begun as yet another local "incident" in China between Japanese and Chinese troops escalated rapidly during the late summer and fall of 1937 into the full-scale war that would end only in 1945, with Japan's collapse. After 1937, therefore, schemes to revitalize the countryside began to shade by often imperceptible degrees into schemes to mobilize rural resources for the war effort.[58] The mingei projects in Tōhoku were no exception. Efforts to increase the output of farming households through low-cost, labor-intensive by-employments were entirely consistent with both the mainstream of depression-era rural reform, which emphasized farmers' self-help, diligence, and thrift as the keys to recovery, and the wartime state's demands for ever greater levels of productivity and sacrifice. Similarly, the "spiritual uplift and enlightenment" it was hoped new mingei manufacture might encourage could be seen as a factor in both economic revitalization and war mobilization. In 1939, for example, the Yamagata politician Matsuoka Shunzō took the opportunity of the youth group exhibition to present a memorial to the Diet on the "Support and Encouragement of Tōhoku Farm Mingei." As he put it, government aid in the development and marketing of Tōhoku mingei would "truly [kill] three birds with one stone." If Tōhoku farmers could be persuaded to stay at home and manufacture mingei during the winter instead of going to cities to seek work, then urban unemployment problems would be reduced, the deteriorating influence of urban ways on "pure local customs" and "family affections" averted, and national wealth increased.[59] Here Matsuoka articulated a version of the earlier reform perspective, which sought to address rural economic distress in part by protecting villages from demoralization by out-migration and urban influences. The same exhibition was hailed by Snowfall Institute representatives as a contribution to the ideological dimension of the war effort: "The creation of intimacy between young people and mingei, and their total mobilization for mingei exhibitions, brings forth the fruit of national spiritual mobilization [kokumin seishin undō] concretely, materially, through the world of things."[60]

The ambiguous overlapping of the goals of recovery and mobilization can be seen also in the effort by Yanagi and others to use the mingei projects to

revise Tōhoku's image as an impoverished, backward hinterland. In a 1939 lecture Yanagi, for example, proposed an alternative perspective that focused on Tōhoku's cultural bounty:

> The region of Tōhoku gives everyone the idea of a poor land. But even if this is true, a defect of outlooks to date on Tōhoku has been that they overlook one aspect of its abundance. With a changed viewpoint, Tōhoku appears before us as an astonishingly rich land. It is probably well to think also of its poverty, but there is even more significance in thinking of its wealth. And rather than the negative viewpoint of aiding that poverty, is not the positive attitude of seeking to make that wealth flourish far better? One must be glad of the recent trend to recognize the value of such things as the language and folklore [of Tōhoku]. Also I think that there are many splendid elements that we must study in terms of the correctness and simplicity of its way of life, the quality of its material substance, and its characteristic practices. Here one recalls Ryūkyū, but I think that in future the Tōhoku region will be seen as Japan's most important cultural property.[61]

Yanagi's ideas were quickly taken up at the Snowfall Institute. In 1940, Morimoto Shinya, an institute employee, commented, "Until recently we, who saw Tōhoku farm villages only in terms of their economic condition of lack of money and looked to revival in this aspect alone, had overlooked Tōhoku's wealth and high level of culture, and had not even tried to see these." But Morimoto had come at last to understand that "Tōhoku is the most Japanese place, and also the place with the highest culture of daily life [seikatsu bunka] in Japan, and we must deeply admire its possession of a rich culture."[62] Yamaguchi also attested in 1940, "I have come to consider the daily life of Tōhoku farmers, which until now I had seen only in terms of poverty, as the original, correct daily life of the Japanese. What is Japanese culture? Is it modern urban culture, or is it this Tōhoku culture—Tōhoku, which has only had its faults pointed out? But can we not point out even greater faults in modern urban culture?"[63]

In one sense, these were ideas that had been associated with rural reform for at least a decade. The notion that rural recovery required that the farming population come to a new appreciation of the value of country life relative to city life was very much a part of reform ideology as embraced throughout the 1930s by Tokyo bureaucrats and local activists alike.[64] Moreover, the importance of cherishing a distinctively rural lifestyle had already been communi-

cated directly to many in farming communities by such means as the mass-market monthly *Ie no hikari* (*Light of the Home*), which was aimed at farm households and achieved a peak circulation of 4 million in 1938—the largest of any magazine at the time.[65] The editors of the magazine, which was linked to the Ministry of Agriculture and Forestry through its publisher, a national semiofficial organization of rural cooperatives, strove throughout the 1930s to promote the construction of a revitalized village culture free of the decadence of urban consumerism. In her analysis of the content of *Ie no hikari*, Itagaki Kuniko shows that over and over, readers were advised that the cause of rural woes was in good part the misguided attempt to ape urban ways. Instead, they were urged to reconstruct and celebrate the healthy, self-sufficient, cooperative and beautiful lifestyle unique to rural Japan by spending less and producing more. In an early 1930s campaign to persuade rural people to replace the consumption of imported fibers such as wool and cotton with locally produced hemp and (waste) silk, for example, *Ie no hikari* emphasized the idea of a special rural aesthetic associated with clothing manufactured at home of hand-woven and hand-dyed textiles.[66]

Nevertheless, in its regionalist and also nationalist emphasis the mingei approach to Tōhoku in the late 1930s represented something of a departure. First of all, even if assertions of the value of a revitalized, specifically rural culture were not uncommon by the late 1930s, rarely was it suggested that some regions of Japan (much less Tōhoku) were more likely sites for such a culture than others. Yet not only did mingei reformers claim that Tōhoku was home to the "richest" and "highest" way of life in Japan, but they also proposed that Tōhoku culture was most authentically Japanese. The insistence on regional distinctions and hierarchy and the repeated invocations of Japaneseness both reflected and endorsed the intensified wartime preoccupation with national identity and consciousness. Regionalism is often conceptualized as a force in opposition to national integration, but, as has been shown in the case of the Shinshū region in the late nineteenth century, modern Japan also provides examples of a complementary relation between localist sentiment and nationalist sacrifice.[67] In Tōhoku especially it might be speculated that a regional history of persistent underdevelopment in the context of national modernization created the potential for ideological as well as material obstacles to the levels of mobilization required by total war. By offering the region a new identity framed in terms of cultural wealth and exemplary Japaneseness, along with some modest forms of material relief, the mingei initiative in Tōhoku may have helped to prepare some of

Japan's poorest farming people for even greater sacrifices in the name of national interest.

Yet the revision of Tōhoku was intended for another audience as well. For the leaders of the Tokyo-based Mingei Association in particular, interest in the local impact of the Tōhoku mingei projects always vied with a more centrist, metropolitan orientation. Their efforts to promote Tōhoku mingei and the way of life it represented were directed less at Tōhoku farmers than at the urban middle-class groups to which they themselves belonged. In addition to the various events organized in Tōhoku, the mingei projects were publicized in Tokyo and other urban centers by a slew of lecture meetings, exhibitions, and exhibition sales. Both of the Mingei Association periodicals ran regular stories and features about Tōhoku mingei, and the rise of metropolitan interest in Tōhoku folk-craft was also chronicled and heightened by regular articles in the national press.[68]

In one sense the campaign to promote Tōhoku mingei to city dwellers was, like the campaign to promote new mingei production among Tōhoku farmers, nothing new. Much as they had done in the early 1930s with new mingei from the San'in region, Yanagi and his associates endeavored to market Tōhoku handicrafts as accessories for a modern, urban existence. In his explanatory comments to the photographs in a 1942 issue of *Kōgei* devoted to Tōhoku, Yanagi repeatedly pointed out ways in which certain items might be used or modified for use in "city homes." He wrote of a woven rice container, "This is something that would be fine in any household; things sold in Tokyo recently do not have this much quality or beauty." A small broom was pronounced vastly superior to those "mediocre" varieties used in "many Tokyo homes." Yanagi admitted that a winnow was nothing more than a farm tool, but he argued that the materials and techniques of its manufacture might be adapted to produce such amenities of the modern household as wicker trunks, chair seats, and charcoal scuttles: "In any case it would be a shame to leave these techniques and materials for regional things alone."[69]

Yet the marketing of Tōhoku material culture also operated in new ways that resonated with the goals of the wartime state. For one, by the late 1930s and early 1940s the changed political climate was enough to cast in a newly patriotic light the idea of buying home accessories derived from, and evoking, the Japanese countryside. Most immediately, "buying Japanese" represented compliance with the official wartime campaign to increase foreign exchange by reducing dependency on imports. Also, by choosing to decorate

with "Japanese country," householders could demonstrate their commitment to an evolving national style that emphasized the modern relevance of native tradition. In April 1940, for example, the women's magazine *Fujin gahō* ran a special feature on the suburban Tokyo home of Shikiba Ryūzaburō, editor of *Gekkan mingei*, to demonstrate how mingei objects might be incorporated in the sort of modern, semi-Westernized existence that most educated, urban Japanese either led or aspired to lead. Photographs showed the exterior and interior of a large house built in a style adapted from the Japanese farmhouse, or *minka*. As the captions pointed out, each of the (Western-style) rooms was filled with mingei from various regions of Japan, including Tōhoku, and also from Korea and China. The Shikiba family were shown happily eating off mingei earthenware, wearing mingei fabrics, and sitting amid a clutter of mingei lamps, chairs, cushions, mats, rugs, knick-knacks, and bedspreads. An accompanying article concluded by urging readers to look again at the photographs of "purely Japanese," "beautiful," and "powerful" pottery, curtains, and cushions: "When we think about it, the discovery of this mingei represents nothing less than the reconstruction of Japanese culture, and the embodying of its great power. It will eventually give direction to Japanese culture in the future, and it will become a brilliant new daily life movement."[70]

It was also new for mingei activists to insist to an urban audience on the exemplary Japaneseness of Tōhoku folk-craft in particular. They thereby helped to promote national integration at a time when internal division or contradiction was becoming anathema to the state. By revising the image of Tōhoku in terms of authentic Japaneseness rather than impoverished backwardness, mingei activists and others used the rhetoric of a common national identity to bridge the widening gap between city and country. It became something of a shibboleth among mingei writers beginning in the late 1930s that the most authentically Japanese things and ways were preserved at the northern and southern ends of the nation, since these regions were farthest removed from the hectic pace of modernization and Westernization at the center. Yanagi wrote in 1939 of a Tōhoku mingei exhibition at the Folk-Craft Museum, "Here we can see an unadulterated Japan," and he warned, "If [these things] are discarded for being countrified, then Japanese things will not come to life."[71] The idea that Tōhoku mingei evoked an original Japanese identity was taken up and elaborated elsewhere. One newspaper review of the exhibition proposed that Tōhoku mingei reminded a city audience of the familial bonds of an ancestral national community: "Even

though [Tōhoku] is part of this country, when we see the craft objects of this overlooked region gathered in one place, they give us an exotic feeling [ekizochikku no kan]. However when we approach the individual display objects, whether an obi or a bamboo sieve or a bandori or a piece of embroidered quilting, and when we take them in our hands, nostalgia for the image of our distant ancestors comes oozing forth."[72]

Not surprisingly, the Mingei Association's Tōhoku projects both in and outside of northeastern Japan quickly gained government support. The versatility of the projects, which sought to improve rural industry and morale at the same time that they addressed questions of national consciousness and lifestyle for city as well as country, explains much of their appeal to a variety of state agencies. The six Tōhoku prefectural governments were joined by the Ministry of Education and of Agriculture and Forestry in sponsoring exhibitions, exhibition sales, and other events organized to promote Tōhoku mingei not only in Tōhoku, but also in such urban centers as Tokyo and Osaka.[73] In 1939, the minister of education even decided to devote an entire room of his official residence in Tokyo to the permanent display of mingei produced by Yamagata youth groups.[74] After 1940, moreover, Tōhoku mingei —and the Mingei Association and its activities generally—began to attract the interest of several newer agencies even more centrally associated with the effort to mobilize the home front: the Imperial Rule Assistance Association and the Cabinet Information Bureau.[75] The collaboration of the Mingei Association with bureaucrats in these "renovationist" organs of the wartime state led to a new focus: the creation of a so-called culture of daily life (seikatsu bunka) for all Japan and even for all Asia.

### TOWARD A NEW DAILY LIFE CULTURE

Between 1940 and 1945 the Mingei Association survived, and even thrived, by participating in the effort to redefine modern Japanese consumer practices in ways that promoted the aims of the wartime state. During these years the leading figures of the mingei movement produced a constant stream of publications as well as art and craft objects, and they also engaged in a busy round of public activities: organizing exhibitions and exhibition sales, judging in competitions, participating in nationally publicized round-table discussions, giving lectures, and the like. Much of their work was intended to demonstrate the relevance of mingei objects and ideology to an officially endorsed conception of the home front often referred to as the "culture of daily life" or "daily life culture" (seikatsu bunka). Daily life culture remained

throughout the war years an ill-defined phrase used most often to legitimate, vaguely, the sorts of war-related privation that characterized everyday existence for ever larger numbers of Japanese subjects. But daily life culture was more than empty rhetoric; it also denoted a fascist vision of social and cultural transformation that was put forward in the early 1940s by influential intellectuals and government bureaucrats and that embraced the so-called high-defense state and even total war as necessary features of the revolutionary, world-historical changes presumed to be under way. Not all the leading mingei figures subscribed to the entirety of the "renovationist" program, as it was sometimes called, connoted by the idea of daily life culture. Nevertheless, the energetic efforts of certain key figures, such as the *Gekkan mingei* editor Shikiba Ryūzaburō, combined with the more passive acquiescence of others, such as Yanagi, to identify the Mingei Association as an active participant in the daily life culture movement. The result was a brief but intense period when it began to seem as if the mingei activists' early ambitions to lead a national and even international program of social reform might be realized at last under the fascist New Order of the early 1940s.

It is worth exploring the origins and significance of the ideology of daily life culture as a means of gaining insight into the wartime efflorescence of the mingei movement as well as into the nature of the renovationist program that gained ascendancy in government circles during the early 1940s. Contemporary sources often point to the playwright Kishida Kunio, director of the Cultural Section of the Imperial Rule Assistance Association (IRAA) from 1940 to 1942, as the source of daily life culture thought.[76] Certainly he made the phrase one of his watchwords during his time at the IRAA. However, it seems likely that the idea of daily life culture as developed in the early 1940s owed at least as much to the thought of the philosopher Miki Kiyoshi (1897–1945). A central figure in the Shōwa Research Association, a national policy research and planning group—a brain trust, as it is often called—for Prime Minister Konoe Fumimaro, Miki exerted real influence on the New Order policies of the second Konoe cabinet (1940–1943). It was he who recommended the formation of the IRAA's Cultural Section and also the appointment of Kishida as its first director.[77] Moreover, the gist of the daily life culture concept was entirely consistent with Miki's cultural theories; indeed, daily life culture received its most lucid exposition in a 1941 essay he published in the magazine *Fujin kōron* (*Ladies' Review*) as "Daily Life Culture and Daily Life Technology."[78] For Miki, the concept of daily life culture was central to a larger vision he had been working out in the 1930s, of a transfor-

mative change in society that would resolve the many contradictions and difficulties brought about by its modern, capitalistic development. He hoped that by appreciating daily life culture and, further, by undertaking its reform, Japanese state and society would be able to ensure a new type of progress that would at once draw on the strengths of native tradition while implementing the rationality and technology associated with modern science.[79]

In defining daily life culture (seikatsu bunka) Miki relied, as did almost all other commentators on the subject, on its opposition to the well-known phrase "culture life" (bunka seikatsu).[80] "Culture life" was first used by social reformers during the early 1920s, when it referred to a new, Westernized ideal of modern domestic life. Educated women, in particular, were the targets for a modest campaign to promote culture life, or notions of scientific management as well as bourgeois family ideology, in the middle-class home. From this small beginning, culture life rapidly became an element of popular culture, where it circulated widely as an increasingly commercialized conception of an up-to-date, cosmopolitan (i.e., Westernized) existence. A fashionable ideal briefly associated with elite lifestyles, culture life was soon cheapened by its association with the emerging mass market; by the late 1920s and early 1930s, it had become inseparable from the ubiquity of a whole range of shoddy commodities hawked for their "cultural" attributes: "culture houses," "culture pots," "culture knives," and so on.[81] By the late 1930s, culture life had the shopworn, tawdry air of superannuated fashion, making it an easy target.

Miki began his 1941 essay on daily life culture by locating the distinction between it and culture life first and foremost in the meaning of culture. Whereas much of the glamour of culture life had been obtained from a notion of culture as a high realm of art and music and literature, daily life culture referred rather to the "absolutely everyday," "ordinary" things such as language, cooking, and walking which, as Miki stressed, were also crucial aspects of human culture.[82] From this basic distinction flowed the other important ways daily life culture differed from culture life. For example, daily life culture was created by all humans and therefore belonged to all, regardless of gender or class. Perhaps Miki's consciousness of his essay's audience —the readership of a prestigious women's magazine—encouraged him to observe that "women have an intimate relation to daily life culture" and that "when one considers the importance of daily life culture, one understands that women, who have until now been thought to have no connection to culture or cultural activities, have an important relation to and even a respon-

sibility for culture."[83] Culture life, by contrast, was predicated on an under-
standing of culture as the product of rare, presumably male genius. As Miki
noted, culture life belonged only to the cultured few who could create "high"
culture, or to those who could pay for it.[84]

The exclusive and elitist definition of culture that underlay culture life was
related to the tendency to overlook "the beauty of Japanese things, tradi-
tional things" in favor of Westernization.[85] As Miki implied, and other critics
of culture life spelled out, from the late nineteenth century elite culture in
Japan had come increasingly to be identified with imported, European ideas,
practices, and goods.[86] Unlike many other wartime critics of culture life,
however, Miki was careful to distinguish the Westernizing excesses of the
1920s from what he considered the real value of Western civilization and also
from the potentially great usefulness of its selective adaptation to the end of
Japanese development. As he put it, "The true depth of Western things was
not grasped, and in the name of culture life there appeared a colonialist
culture." Instead of the superficial, ignorant, and slavish mimicry entailed by
culture life on the one hand, or "narrow-minded and dogmatic xenophobia"
on the other, Miki advocated the study and adoption of worthy aspects of
Western daily life culture so as to shape a new daily life culture "from our
own, autonomous standpoint."[87]

Daily life culture was also distinguished from culture life by its transcen-
dence of Western-style liberal individualism in favor of a cooperative, com-
munal ethic focused on production rather than consumption. According to
Miki, people had been drawn to culture life because "they sought a free
lifestyle for the individual that was liberated from the various feudal ele-
ments of daily life in the past." In his progressivist, quasi-Marxian scheme of
history, it was both good and inevitable that the fetters of the feudal past be
thrown off: "To the extent that it was necessary for the development of our
nation's daily life culture that feudal remnants be overcome, the so-called
culture life had an important meaning."[88] However, Miki held that true free-
dom and individuality were achieved ultimately by "the union of the particu-
lar and the general" within a cooperativism (kyōdōshugi) and a totalism (zen-
taishugi) that somehow managed to avoid the pitfall of anti-individualist
"standardizationism" (kakuitsushugi).[89] Miki's discussion of consumerism
and productivism followed a similarly dialectical logic. He suggested that
while consumerist activities such as "playing records, listening to the radio,
reading books, and watching movies" were not absolutely wrong in and of
themselves, culture life entailed an excessive preoccupation with this sort of

consumption. The consequences were divisive and exclusionary: cultural consumers were divided from cultural producers, culture became a luxury available only to those with money, and culture was separated from the routines of home and ordinary daily life. Daily life culture, by contrast, resolved these contradictions by integrating consumption and leisure within a primarily productive mode of being. Quoting Goethe to the effect that "only productive things are true," Miki insisted that "culture must be that which, in a variety of senses, makes the nation productive."[90]

As suggested most obviously by Miki's emphasis on cooperativism and national productivity, the ideology of daily life culture reflected and affirmed the basic domestic policies of the wartime state. In his discussion of cooperativism, for example, he explicitly endorsed neighborhood associations (tonarigumi), an oppressive device employed intensively by the Home Ministry beginning in September 1940 to control and mobilize urban residential districts.[91] He was less specific in his treatment of productivity, which seemed to refer primarily to the idea that all humans were (or could become) culturally productive or creative in the context of fashioning their daily lives: "Whereas the so-called culture life takes the stance of receiving culture made by a small number of artists and scholars, in daily life culture all persons deepen their consciousness of the fact that they participate in the creation of culture, and everyone must stand in a productive or creative rather than merely receptive relation to such things as art and science." Nevertheless, Miki made clear that the production of daily life culture was also related to the more specifically material sorts of productivity so important to Japanese planners in 1941. He asserted the inherently progressive nature of daily life culture, which improved constantly through the creative use of new technology, and added, "Our daily lives at present see unavoidable retrenchments which are providing a catalyst to new daily life technologies, and by means of the production of a new daily life culture not only must scarcity be compensated for, but it must be made into abundance."[92] In other words, the privations forced on civilians by total war offered an opportunity for innovation and even greater productivity at the household level.

More generally, Miki's exposition of daily life culture revealed it as a component of the so-called renovationist vision shared by many intellectuals as well as key policymakers in the late 1930s and early 1940s. Renovationism (or "reformism" or "revisionism") is a vague and ambiguous label; in the broadest sense it refers simply to a commitment to sweeping domestic reforms for the purpose of increasing national strength, and as such might

be said to have characterized the views held by a wide variety of groups and individuals across the 1930s political spectrum. In terms of usage, it is most often applied to an influential group of career bureaucrats (the "new" or "renovationist bureaucrats," shin kanryō or kakushin kanryō) who became prominent in the years after 1932 and especially after 1937. Even among this group individuals held various, sometimes contradictory views and positions, yet there seems to have been a degree of consensus on the need for greater control by the state over the economy in particular, and on the importance of achieving an autonomous and "Japanese" solution to what was widely seen in the 1930s as a national impasse or crisis. These ideas were shared by a number of military men, as well as others in a position to affect or make policy.[93] The type of renovationism for which Miki himself, as a leading member of the Shōwa Research Association, was an influential exponent elaborated on the basic theme by proposing a particular view of world history. It was argued that an age of liberal individualism originating in Western Europe and associated with capitalism had come to Japan with the Meiji reforms of the late nineteenth century. That epoch of untrammeled private interest was ending, however, and with it the gross inequities created between classes as well as between nations and world regions. Japan, along with Germany and Italy, belonged to a small group of nations that were dismantling the old order through domestic reforms as well as innovative foreign policies and that were thus on the verge of ushering in a new global era defined by a more cooperativist principle of social and economic organization. War was one important means by which the necessary transformations both within and between nations were to be achieved.[94] In Miki's formulation, the establishment of a new daily life culture was another.

Renovationism of the sort promoted by Miki and other members of the Shōwa Research Association became especially important in 1940, when it provided the ideological underpinnings for a movement launched by the Konoe cabinet to establish a domestic New Order (shintaisei). Determined resistance from business interests and the political parties, among others, prevented full realization of the New Order, which was originally intended to facilitate mobilization for war by instituting radical, fascist reforms of the market economy and the parliamentary system.[95] Nevertheless, elements of the New Order—most notably the IRAA, a large-scale organization initially dedicated to replacing the principle of parliamentary representation with that of direct, state-managed mass support or "assistance" for the imperial regime—were put into place and remained active for several years. It is

possible to understand the New Order as part of a larger fascist transformation of Japan through not only those institutional changes specifically sought by Konoe and his renovationist supporters in mid-1940, but also earlier reforms such as those successfully engineered by the Home Ministry in the late 1930s to ensure greater control over labor through the elimination of unionism. Indeed, it has been argued persuasively that between 1937 and 1945 Japan saw the fundamental changes necessary to warrant its classification as a type of fascist regime.[96] Even if the New Order movement of 1940–1941 was unsuccessful, the basic renovationist goal that drove it—of promoting national power by restructuring the Japanese polity and economy along capitalist, yet antidemocratic lines—was largely achieved.

The ideas associated with daily life culture were very much part of the New Order movement and became especially prominent in the programs and rhetoric of the Cultural Section of the IRAA, which was dedicated to the mission of improving daily life culture. (Indeed, the very existence of a Cultural Section reflected the views of Miki and others on the importance of recognizing culture as a necessary and integral aspect of popular daily life, and therefore as a central concern for the state.)[97] Daily life culture ideology was conspicuous in all of the Cultural Section's undertakings, which included a "factory culture movement" and a "national health movement" as well as a major campaign to establish IRAA-affiliated "regional culture movements" in the provinces. According to the historian Kitagawa Kenzō, by 1944 approximately four hundred provincial organizations or movements had been launched under the auspices of the Cultural Section. While many of the movements were organized by provincial artists and literati to promote their own activities as well as to disseminate various forms of what might be considered high or elite culture to the masses, a good many focused explicitly on improving local daily life culture through means ranging from amateur theatricals to the establishment of day care centers and the practice of cooperative cooking.[98] The regional culture movement in general was promoted by Kishida and his subordinates at the Cultural Section in terms of daily life culture. Like Miki, they endorsed daily life culture as a long overlooked native resource in the lives of ordinary Japanese, characterized by an innate cooperativism and productivism very different from the elitist consumerism and individualism connoted by culture life. The regional culture movements, and the activities of the Cultural Section as a whole, were explicitly intended to develop and mobilize the resource of daily life culture for total war.[99] As the Cultural Section's assistant director Kamiizumi Hidenobu proposed in an

address delivered at a regional culture conference in late 1941, it was a mistake to understand culture as a superficial piece of decoration, like a necktie. Culture was as essential to daily life as clothing: "At a fire, fire-fighting clothes are necessary. In wartime, one must have military wear. This is the true nature of culture. At a fire, a necktie is a nuisance, and it is even worse to be naked."[100]

Mingei was soon recognized and endorsed by New Order bureaucrats as an appropriate element of the new daily life culture. In August 1941, for example, the women's magazine Fujin gahō published an article titled "The New Daily Life Aesthetic and the Way of Mingei" by Hata Ichirō, an official attached to the Cultural Division of the Cabinet Information Bureau. The article began with the requisite discussion of the "great difference" between daily life culture and culture life. Whereas the phrase "culture life" was said to evoke the "skin-deep imitation of superficial Western culture," "daily life culture" referred to "the new aesthetic daily life, the moral daily life that is built on the truth and aesthetic consciousness found in such ordinary, every-day things as a teacup." The new daily life culture, according to Hata, was the foundation for the powerful new national culture that was emerging in the "present time of great historic and cultural change, in the era that the high-defense state is striving to form." At the heart of the article was the assertion that mingei, defined as "inexpensive handicrafts made for the masses and combining a racial beauty with a healthy functional beauty," was essential to the new daily life culture of urban Japanese. As evidence, Hata pointed to the recent success of Tōhoku mingei in department stores. He also noted, ap-provingly, the extent to which native handicraft production was officially encouraged in Nazi Germany. He observed that Hitler's mansion as well as other official buildings were furnished and decorated with German craft objects: "This indicates that involvement with handicraft production, first, elevates racial consciousness, second, rears a spirit that discards petty ego-tism and is in accord with the cooperative, and third, by employing the nation's resources is highly effective in terms of economic policy." Hata concluded with the hope that in future, city ladies would select their "every-day items" (nichiyōhin) "from the countless mingei objects still buried like treasure not only in Tōhoku but in villages throughout Japan." By using mingei objects and by "infusing them with a new urban 'sense,'" towns-women would not only revive a "diseased" urban culture, but would also help to create a "vital driving power" through the exchange with "regional culture."[101]

Mingei was also officially recognized as a feature of the culture to be encouraged in the countryside. In an article on regional culture published in the IRAA newspaper in early 1941, it was proposed that because "the correct tradition of Japanese culture exists more today in the regions than in the culture of the center, which has developed under the influence of foreign culture," a properly revived regional culture would form the basis of a new national and East Asian culture. Mingei was named one of three categories of traditional regional culture to be preserved and developed.[102] The IRAA Cultural Section directors Kishida and Kamiizumi both went on record stating that the preservation and "healthy development" of mingei were necessary to the reconstruction of regional culture.[103] The official endorsement of mingei was tempered, however, with some uneasiness about its residual associations with hobbyist nostalgia and consumerism. In their discussions of traditional regional culture, both Kishida and Kamiizumi made a point of warning against the dangers of reactionary antiquarianism, which Kishida associated with "dilettantes" (kōzuka) and the playful exercise of taste (shumi), and Kamiizumi laid specifically at the door of mingei collectors: "For example, it is often to be seen among such people as collectors of mingei, that they do no more than discover the excellence of regional culture, and neglect its further development."[104]

For their part, the leading figures in the Mingei Association sought vigorously to dispel any lingering suspicions of shumi and instead asserted mingei's central place in the project of lifestyle reform for a nation at war. Shikiba Ryūzaburō declared in 1939, shortly after he began to edit the new Mingei Association periodical Gekkan mingei, "We want to avoid making this into a partisan organ for the Mingei Association, or a hobby magazine." Rather, he envisioned something "broad and general" that would help to bring about a "new daily life movement."[105] Over the next several years, Shikiba and other writers for the magazine repeatedly rejected the association of mingei with frivolous consumerism. As he put it in a 1942 editorial, "The mingei movement, which to date has been thought of as private activity taken up as a hobby by a small group of dilettantes, has come at last to understand its true mission. . . . If there are persons who now despair, saying that mingei is no good in wartime, then that is evidence that they like shumi and play; the time has come for mingei to exhibit its true essence, to prove itself as the seasoning and the support of a daily life pushed to its limits [giri giri no seikatsu]."[106]

The regular reiteration of announcements to the effect that now at last the mingei movement was free of hobbyism suggests that in fact it was difficult to purge mingei activism entirely of the playful, antiquarian connoisseurship from which it had originally emerged. Nevertheless, on the whole the mingei reformers were successful in their efforts to represent folk art, and their interest in it, as part of the deadly serious work of mobilizing the home front. Their campaign began in earnest in the late summer and fall of 1940, when the government seemed poised on the verge of instituting a radical, fascist transformation of both state and society in the name of total war.[107] One tactic employed by mingei publicists was simply to claim that mingei objects and ideology were already perfectly appropriate for wartime daily life. In a sense, they suggested, the circumstances of war were finally bringing about proper recognition of the basic principles they had long advocated. Shikiba and others wrote along these lines in response to the antiluxury legislation promulgated by the Home Ministry in July 1940, on the third anniversary of the so-called China Incident. As Shikiba put it in a piece for the women's magazine Katei (Home), "The edict forbidding luxury goods has further heightened the value of mingei for us. We have been blessed with an ideal opportunity to ponder healthy craft items."[108]

However, Mingei Association leaders went well beyond simple assertions of mingei's relevance to wartime daily life culture. They strove to overcome the handicap of mingei's origins in shumi by becoming actively involved in a variety of projects and initiatives intended to demonstrate that folk art, far from being a marginal or decadent form of hobbyism, properly belonged at the center of the movement to renovate Japanese culture and society. These projects and initiatives ranged from efforts to help the IRAA's Cultural Section to reconstruct "work culture" or "factory culture" for laborers in Japan (discussed in the next section), to various undertakings intended to reform daily life culture for the populations of Japanese-controlled Asian regions such as Manchuria and North China (treated in chapter 5). Like so many of the plans proposed during these years, those of the Mingei Association seem never to have been fully realized. Nevertheless they served what may have been their true purpose after all. The projects devised by leading association figures helped to publicize an activist, gritty, even industrial image of mingei and its capacity to renovate Japanese daily life, and as such they contributed to the continued survival and even growth of the mingei movement in the context of intensifying national crisis.

*The Beauty of Labor: Mingei and Factory Girls*

One particular daily life culture project undertaken by the Mingei Association is worth considering in some detail as a case study in the interaction between mingei activism and fascist cultural policy. The project, which sought to reform the dormitory life of female workers at a spinning factory, suggests the extent to which leading figures within the mingei movement were willing to adapt their program in service to such wartime goals as increased industrial productivity. Despite an earlier stance sharply critical of machine industry, mass production, and the lifestyle associated with these for both workers and consumers, now even Yanagi seemed to support the idea of mingei work in the modern factory.[109] Yet the factory girl project is also intriguing for the further insight it offers into the significance of daily life culture in the context of Japanese fascism. The effort by organizations such as the Mingei Association to employ aesthetics in the wartime rationalization of factory labor highlights the existence of yet another important set of ideas and programs linking Japan in the late 1930s and early 1940s to the fascist regimes of continental Europe. At the same time, however, the association's factory girl proposal, and the interest it elicited from various governmental and semigovernmental agencies, makes it possible to see that the ideas about managing workers' daily life culture put forward by Japanese planners in the early 1940s were in fact quite distinctive. In their special emphasis on the aesthetics of a self-sufficient domestic creativity, New Order officials and their collaborators sought to adapt fascist practices and ideals to the circumstances peculiar to Japan.

Beginning in late 1940, the leaders of the Mingei Association eagerly embraced the premise of a New Order for Japan—announced in August by the Konoe cabinet—as an opportunity to promote their organization and ideology and to demonstrate mingei's relevance to Japanese society and culture in the broadest possible terms. The October 1940 issue of *Gekkan mingei* was devoted to the theme of "The New Order and Mingei" and opened with a proposal for the establishment of an official organization to encourage regional handicrafts. This agency, in which the proposal's authors envisioned the participation of various government ministries (Agriculture and Forestry, Education, Commerce and Industry), was to represent an expansion and recognition of the association's work of the past decade.[110] The October issue also included a long article by Yanagi, "The New Order and the Question of Craft Beauty," a discussion of German handicraft organizations

by Graf von Dürckheim, and the first mention of a new project on the dormitory life of female workers at a spinning factory, to be the subject of a special issue of the magazine only a few months later. "It is just this sort of problem, of a social nature, that the true mingei movement takes on," commented the reporter.[111]

Although the factory girl project was first mentioned in October 1940, planning by Mingei Association leaders seems to have begun in the summer of that same year, possibly during meetings in July with the factory owner, Ōhara Sōichirō.[112] It soon eclipsed other initiatives. In early 1941, the special magazine issue devoted to the project opened with a statement declaring that the "problem of the daily lifestyle of female laborers" represented the mingei movement's first major undertaking since it had begun, the previous fall, to become a powerful new cultural movement "for the purpose of construct-ing a new cultural order, by means of actively integrating with aspects of present-day society."[113]

And yet the project, which centered on the construction, furnishing, and use of a special dormitory, appears never to have been realized. Even in the pages of the special issue itself, the editor, Shikiba Ryūzaburō, expressed doubt that the project would ever be anything more than a paper plan. (He was quick to add, however, "We have grasped a truth," and "I believe the day will come when this material is put to use in some way.")[114] Nevertheless, the mingei proposals for the reform of factory girl dormitory life offer a vivid example of how mingei activists sought to demonstrate mingei's relevance to the wartime state in terms of its capacity to overcome contradictions between the farm village and the industrial city, or premodern handicraft and modern machine manufacture. By aestheticizing the seikatsu—or the objects, architecture, gestures, and routines of dormitory life—for teenage girls working at a nylon-spinning factory, the Mingei Association proposed not only to resolve the basic contradictions underlying the fascist ideal of Japanese society, but also to ensure the managed hyperproductivity that was arguably its ultimate end. In this context, seikatsu bunka became a way to suggest a beautiful, native discipline of maximal production and minimal consumption that would smoothly integrate city and country, industry and agriculture, work and leisure, as well as women's roles as wage laborers and as wives and mothers.

The most immediate concern addressed by the mingei plan was that of potential conflict between "farm village culture" (nōson bunka) and the cul-ture of the urban factory. The nylon-spinning plant studied by the associa-

tion, one of several large factories owned by the Kurashiki Silk Company, was located in the city of Kurashiki in Okayama prefecture. A survey conducted by the association of about half of the approximately nine hundred girls and women working at the plant (out of a total worker population of over two thousand in 1940) revealed the unsurprising fact that the vast majority, about 85 percent, hailed from farming households in rural villages.[115] The association stressed the importance of their finding that well over half of 359 female workers who had left the factory had done so to return to life in farming villages.[116] One goal of the proposed reform of dormitory life, therefore, was to reduce the presumed shock of the factory girls' reentry into small-village farming life.[117] This was only part of a larger, related problem, however. The opening statement published in the special issue of *Gekkan mingei* devoted to the factory project noted that a national initiative was under way to disperse urban factories to rural locations, and that "even now we can see the great and intractable confusion to lifestyles that will occur in future. . . . Indeed, it is our urgent duty to plan for the contact between modern factory culture and traditional farm village culture, and to establish a path for their integrated development."[118]

Dormitory architecture and furnishings provided one obvious point of integration. The dormitory planned by the Mingei Association, and handsomely illustrated in *Gekkan mingei* by Serizawa Keisuke's woodblock prints, was modeled on the Okayama farmhouse, or *minka*. In what was claimed to be the characteristic Okayama style, the building was to be one story, with a gabled roof, and it was to be surrounded by a well-tended hedge "such as is often seen in Okayama prefecture." Inside, the dormitory—scaled to house approximately ten workers at a time—was to be organized around two central rooms: a main common room, or *hiroma*, immediately accessible from the earth-floored entrance, along with a combined kitchen and dining room. The rest of the plan comprised two sleeping rooms for the workers, the matron's room, a guestroom, and a bathroom. Most of these, except for the kitchen/dining room, which was envisioned with a wooden floor, were to be *tatami* (mat-floored) rooms (the tatami of Okayama manufacture).[119]

By building the dormitory in farmhouse style, and also by furnishing it with a broad assortment of mingei objects—from the cushions the girls were to sit on, to the bowls and plates they used at mealtime, to the altar shelf (*kamidana*) in the main room—association planners expected to instill in workers an appreciation of the culture of daily life of rural Japan generally, and of their own specific farm villages in particular. As they put it, "The

藝民刊月

**15.** The cover of the March 1941 issue of *Gekkan mingei*. Pictured are workers at the nylon-spinning factory in Kurashiki, where the Mingei Association planned to build a dormitory. Photo courtesy of Fine Arts Library, Harvard College Library.

**16.** Woodblock print by Serizawa Keisuke, depicting the exterior of
the planned dormitory. From *Gekkan mingei* 3, no. 3 (March 1941):
12–13. Photo courtesy of Fine Arts Library, Harvard College Library.

family-style dormitory [*katei ryō*] we have planned chooses its furniture and
fittings, as well as utensils and other small items, from the mingei presently
extant in the various regions of Japan. We want thus to establish the facilities
and the guidance that will give female workers, when they return to their
villages and begin their lives there, the knowledge that will enable them to
identify the things of their own village comparatively with respect to the
mingei of other Japanese regions, and also so that they themselves under-
stand the value of the culture of daily life in their own village."[120] It is worth
noting here that the mingei from "other Japanese regions" included stencil-
dyed cloth (*bingata*) from Okinawa, which was to cover cushions in the
matron's room, Korean flooring (*ondoru*) paper for the sliding doors of the
guest room, as well as various other items in the "Korean style."[121] Thus a
reformed culture of daily life might serve to integrate not only farm and
factory, but also colony (or semicolony) and metropole.

The mingei aesthetic was to shape not only the housing and furniture of
the female workers' afterwork lives, but also the way they passed their time.
The reformed culture of daily life imagined by association planners would
integrate not merely the material culture of the Japanese periphery into its
metropolitan center, but also the rhythms of rural productivity into the
industrial leisure created by factory time. For example, it was noted with
disapproval that the many girls at the Kurashiki plant who chose to spend
some of their earnings and leisure time on needlework tended to favor

間　土　I

間　廣　II

**17.** Woodblock prints by Serizawa Keisuke, depicting dormitory interiors. At top is a view of the earthen-floored entryway (*doma*). Below is a view of the common room (*hiroma*), which opens off the entryway. From *Gekkan mingei* 3, no. 3 (March 1941): 14. Photo courtesy of Fine Arts Library, Harvard College Library.

**18.** Two examples of *sashiko* embroidery, also known as *kogin*. From *Gekkan mingei* 3, no. 3 (March 1941): 82. Photo courtesy of Fine Arts Library, Harvard College Library.

French-style embroidery. And yet, the authors of the initial report pointed out, there still existed in Japanese farm villages a beautiful style of embroidery known as *sashiko*, which had developed as a means of reinforcing clothing. The implication was that somehow factory girls could and should be induced to take pleasure in the useful native art of sashiko rather than in foreign furbelows.[122]

By offering to replace decadent, consumerist, Westernized tastes and habits with an active appreciation for the homely arts of rural Japan, the Mingei Association proposal advertised the disciplinary and educational as well as integrative potential of mingei. Not only would workers be protected by reformed dormitory life from the urban and foreign influences that boded ill for their reacclimation to the village, but mingei would train them to become more useful, productive farmwives. By learning how to mend and

strengthen work clothes in an austere if attractive indigenous style, factory girls would develop a skill that enhanced farm productivity, rather than one that diverted them (as well as scarce cash resources) with colored silks and urban fancies. Similarly, the authors of the proposal bemoaned the common practice of attracting rural workers to factories by promising such urban amenities as Western-style dormitories and after-hours cooking classes in kitchens equipped with gas lines and electric burners.[123] By contrast, the reformed dormitory would serve as a rustic classroom where factory girls would learn how to perform household chores—cooking, cleaning—in a manner and setting more appropriate to their final destinations. Along the same lines, the dormitory grounds were to include facilities for kitchen gardening and animal husbandry: a vegetable garden, a chicken coop, and a pig sty. Female workers would receive training at these sites in the "subsidiary industries" appropriate to the farm household and increasing its self-sufficiency.[124]

Yet there was a certain ambiguity about the ends to which after-hours training was to be put. Was it only after leaving the factory, back on the farm, that mingei-inspired discipline and productivity would be useful? The culture of daily life promoted by mingei reformers is notable for a degree of surveillance and bodily discipline that, while meant to suggest the orderly harmony of the preindustrial household, has somewhat more dystopic implications in the context of what was, after all, an industrial labor camp. Tanaka Toshio, a young journalist and textile researcher involved with the Mingei Association during the late 1930s, was one of the chief planners of the factory project and the probable author of the initial report. In it, and also in the zadankai (round-table discussion) published in Gekkan mingei, he expressed concern that those female workers who lived in company dormitories—by far the majority at the Kurashiki plant—ordinarily spent as many as four hours a day as they pleased, without guidance or observation. He imagined that, by contrast, the minority of female workers who commuted to the factory were never left to their own devices when at home. Instead, "as soon as they return home and open the door, they are monitored in the way they open and close the door, in the way they take their coats off, in how they make their greetings, how they put down their parcels, how they sit, how they stand up, and in such ways an entire training in daily lifestyle occurs."[125] This was the sort of training that ought to occur, Tanaka asserted, in the reformed, mingei dormitory:

If a girl were at home, then for example to take a teacup, her parent might talk during mealtime about where the teacup was made, or teach her about whether it was good or bad. Or she would be taught how to hold the teacup, and how to eat, and further how to wash and dry it after the meal, and how to put it away. And then after eating, if she was sprawling about [nesobette ireba], she might be reprimanded, and even warned about opening and shutting doors. Well, I think this is the kind of education in living that is missing in factory dormitories at present, and that would be conducted at the family-style dormitory.[126]

It is unclear whether or not Tanaka was interested in the obvious advantages to factory managers and owners of a workforce under the constant, paternalistic surveillance he admired. But other Mingei Association members were readier to acknowledge the relation between reforms they proposed and enhanced factory productivity. Shikiba, for example, the editor of Gekkan mingei, reported the results of an elaborate questionnaire on daily life he and another leading association member composed and distributed among 362 female workers at the Kurashiki plant in January 1941. In his commentary on that section of the questionnaire dealing with music, Shikiba suggested that radio music and songs might be used in the factory to increase productivity. Noting that "Germany and other 'musical nations' are skillfully making use of industrial music," he wrote, "I think it would be good if at this factory as well, songs were selected appropriate to the various work stations, and [workers] were made to sing them or listen to them while working."[127]

Shikiba's questionnaire also included a section dealing with the topics of romantic love, marriage, and menstruation. The questions subsumed under these categories, and particularly Shikiba's discussion of them, suggest that at least some of the mingei planners also sought to address one of the most difficult conflicts inherent in the fascist social model. Female factory workers were a particular node of anxiety in New Order Japan, as they were in Nazi Germany and fascist Italy, because of the threat they posed to a social ideology that claimed to value women first and foremost as a means of social and racial reproduction. Women were to be wives and mothers in the home, not laborers in the factory. And yet female labor was increasingly indispensable to industrial productivity, particularly in the context of total war and the military mobilization of ever growing numbers of men.[128]

The mingei proposals for dormitory reform, with their explicit intention

of training the factory girl for a contented and productive life in a farming household, downplayed the contradiction by emphasizing the relative brevity (about five years) of the average factory girl's term of employment and the near inevitability of her fate as a village bride.[129] Nevertheless, Shikiba's questionnaire reveals worry about the possibility that the industrial labor experience might compromise the smooth fulfillment of feminine destiny as wife and mother. For example, he commented on the (alleged) paucity of the girls' experience of romantic love and their inability or unwillingness to describe an ideal marriage partner.[130] He blamed these responses, which he believed to reveal the belated development of love (aijō), on the infrequency with which factory girls watched movies and also on the rigid segregation of the sexes imposed by factory dormitory regulations. While he conceded the importance of guarding against "immorality," he insisted on the need for some education in sex and a "proper love life." As he put it, "At present, when early marriages are being encouraged, an environment that is overly indifferent to romantic love and marriage is not good." There was further, if implied, criticism of the factory experience in Shikiba's discussion of menstruation. An active and well-known psychiatrist who specialized in gynecology, Shikiba wrote with authority on the subject: "Most of the young girls at this factory [first menstruate] at the age of 16, and this is close enough to the Japanese average. But it is dreadful that as many as 22 are so delayed as not yet [to be menstruating] at the age of 17, nor even at 18, 19, and 20, and this is something that must be attended to."[131]

Perhaps Shikiba's attention to what he considered the low level of factory girls' interest in their own appearance should be understood in this context of concern about their reproductivity. In his commentary on the final section of the questionnaire, which dealt with the issue of clothing, Shikiba deplored the fact that the majority of respondents (sixty-six) expressed a lack of desire for any particular dress. He wrote, "As a rule, for women there is no such thing as too many dresses. Especially for young women. How sad this lack of desire is, then! . . . A diminished interest in clothing is certainly not a good thing." Elsewhere, in commenting on responses to questions about the purchase and use of cosmetics, he expressed similar worry about what he perceived as an unusual lack of interest in makeup. The solution, he opined, was to educate workers on the nature of simple yet feminine beauty. He concluded, "It is important that [workers] be plain, and yet that they not be permitted to lose their womanly flavor [onnarashii nioi]."[132]

Some of the education Shikiba called for to remedy the inadequate femi-

ninity of factory workers was to be provided in the context of classroom instruction. At the Kurashiki factory, workers were supposed to spend an hour most evenings in Youth School (shōnen gakkō). It may be presumed, however, that like other mingei planners he expected life in the family-style dormitory, with its watchful matron, carefully chosen furnishings, and round of homely farmhouse chores, to give workers a much more pervasive educational experience. The simple beauty of a reformed culture of daily life would teach workers femininity as well as discipline and productivity, thereby helping to ensure the reconciliation of their labor function with their biological function. Shikiba wrote with approval of the sight of workers after they had returned to the dormitory at the end of the workday and had changed out of their Western-style uniforms and into "colorful" kimono: "At last their femininity comes forth, giving the viewer a sense of relief." He added in conclusion, "The rooms and the uniforms are too colorless, too cold. Shouldn't there be more color in the life of young women?"[133]

By proposing to aestheticize the "daily life," or life before and after the factory shift, of female industrial workers, Mingei Association leaders hoped to demonstrate the broadly useful potential of mingei in New Order Japan. They worked to show that the mingei aesthetic, far from being the plaything of urbane antiquarian dilettantes, was an authentically indigenous tool that might serve to help integrate, manage, and finally increase factory production, farm production, and social reproduction. It is in this sense that, even if the proposed dormitory was never actually built, it nevertheless managed to serve the mingei movement quite well. Certainly the increasing tempo of collaboration in 1941 between the Mingei Association leadership and various official and semiofficial agencies was at least in part a direct outcome of the project. Several months after the special factory girl issue of *Gekkan mingei* came out, a round-table discussion was held at the Folk-Crafts Museum in Tokyo, with official participants from the Cabinet Information Bureau, the Cultural Section of the IRAA, the Ministry of Agriculture and Forestry, and the Industrial Patriotic Organization (Sangyō hōkoku kai). Most of the discussion revolved around the possibility that the mingei organization might aid the state in helping to design worker housing, and more generally a new lifestyle for factory laborers.[134] Two more round-table discussions of worker housing and culture were sponsored by the association during the summer of 1941; government officials were conspicuous at both.[135]

The factory girl project, along with the discussions and further proposals about worker housing and worker culture to which it gave rise, provides

insight not only into the nature of the relationship that developed between mingei activism and the "high-defense state," but also more generally into the cultural policies that were shaped by various participants during the late 1930s and early 1940s. In particular, the project offers further evidence of both official and nongovernmental interest in a specifically fascist resolution to what had come to be known throughout much of the industrialized world as the "problem of worker leisure."

By the 1930s there had emerged in the United States and western Europe a variety of movements to organize and manage the leisure time created by the widespread adoption of the forty-eight-hour work week. However, only in Mussolini's Italy, and later in Germany and other European right-wing dictatorships, was the effort to manage leisure first initiated, and then largely controlled, by the state through large agencies designated for that purpose.[136] Fascist Italy and Germany, in particular, pioneered efforts to enhance productivity by means of national, state-directed institutions dedicated to the authoritarian organization of mass leisure.[137] As the historian Takaoka Hiroyuki has pointed out in his study of managed recreation in Japan, it was the European fascist model that would become particularly influential in Japan from the late 1930s.[138]

Beginning in 1938, the hodgepodge of recreational organizations and movements that had already emerged in some of Japan's larger cities and industrial plants—hiking clubs, the youth hostel movement, factory sports programs, and so on—were brought together under the Japan Recreation Association (Nihon kōsei kyōkai), which had been created by the newly established Welfare Ministry (Kōseishō).[139] The initial impetus driving the formation of the Recreation Association (and, arguably, the Welfare Ministry itself) was military alarm about the poor physical condition of the nation's youth and the wish to combat—largely through exercise and outdoor activities—what was perceived as the particularly deleterious effects of city life and factory work on Japan's war effort in China. As the conflict in China escalated into the all-consuming total war of the late 1930s and early 1940s, however, the Recreation Association along with several other state-directed agencies became concerned not only with the physical health of military recruits, but also with the larger goal of managing and systematizing leisure throughout Japanese society. There was special worry in the late 1930s about the need to curb excess consumption and frivolity on the part of urban workers, who were using their relatively high wartime wages to help create what authorities considered an "unhealthy" consumer culture in the cities;

and there was special interest in the possibilities offered by emulation of the Italian and German examples.[140]

Yet the discussions of worker housing and culture organized by the Mingei Association in 1941 illustrate some of the problems as well as the attractions associated with the effort to rationalize factory leisure according to established, Western models. One difficulty concerned the content of the various entertainments and activities commonly used to divert workers and to raise their morale. The Italian and German programs for worker recreation prominently featured modern, even American-style forms of mass entertainment, such as movies, jazz revues, and tourism. Japanese efforts to improve worker morale and productivity—both the earlier initiatives in individual plants and the later, more coordinated programs directed by semi-official agencies—also relied heavily on traveling theatricals and revues, movies, and other types of modern mass entertainment. Participants in the mingei round-table discussions worried, however, about the impact of such materials upon workers, many of whom were presumably impressionable teenagers from rural villages. Tanaka Toshio, one of the chief planners of the Kurashiki dormitory, complained of the practice of having cabaret-style revues performed at provincial factories: "I heard of one nylon-spinning plant where they brought in a group from the Takarazuka. The result was that the workers decided to put on their own theatrical, [singing] in strange voices and performing an imitation revue. They've stopped this, and I do think that theatrical groups are a very good thing, but isn't there also a danger?"[141] Yamamoto Shōzō, a representative from the Japan Technological Education Association, asked, "When you suddenly bring into the dull existence of the factory dormitory a bunch of pretty girls to perform a revue, then doesn't that factory life become even more unbearable [to workers]? I think it's very dangerous simply to give them entertainment culture [goraku nari bunka], and especially strange, urban culture."[142]

One of the highest-ranking government bureaucrats present at the round tables was Kamiizumi Hidenobu, assistant director of the Cultural Section of the IRAA. He concurred with the criticism of the entertainment approach to worker recreation, noting that "officials in the Welfare Ministry" see only the immediate gains in productivity that seem to result from giving workers entertainments: "But I think that we will pay for it in two or three years, or in five years, or ten. They don't consider this, and use these methods to ensure labor power in the moment. We must revise this way of thinking." Kamii-

zumi went on to suggest that the true consequence of the entertainment approach was simply to increase workers' desire for escapist leisure.[143]

Kamiizumi's comments reveal a more fundamental dissatisfaction with the very premise of a separation or opposition between work and leisure. Not only were conventional factory-sponsored diversions disturbingly exotic and perhaps decadent, but they encouraged workers to find labor hard and dull. In other words, not only was the usual sort of organized worker recreation alien, but it was alienating. Kamiizumi noted that until recently the Cultural Section of the IRAA had been preoccupied with the rural culture of farming people, and had only just come to recognize that the culture of factory workers needed to be considered on a separate basis. His characterization of the difference between farm and factory work is revealing: "People in factories think that they work in order to conduct their daily lives [seikatsu], that they work in order to eat, and that their work in no way enters into their daily lives. But people in farm villages consider their own work to be a pleasure. That is very different from factory workers. People who work in factories and mines do not think that way. . . . I believe that work must be integrated within daily life."[144] Unlike farming, industrial labor was somehow conducive to a fragmenting of life experience, and as a result factory workers found themselves leading an existence divided between labor and "daily life." The goal, Kamiizumi suggested, was to find a way to reintegrate work and leisure for factory laborers in a manner comparable to that of farm workers.

Kamiizumi's views reflected the position on "work culture" (dōrō bunka) associated more generally with the IRAA and the Cabinet Information Bureau, as distinct from the Welfare Ministry's Recreation Association or the Recreation Section of Sanpō, the Industrial Patriotic Organization. While the latter agencies, which had undertaken to organize and direct worker leisure since the late 1930s, tended to define an appropriate work culture in terms of ordinary forms of recreation and relaxation, the more radical, renovationist vision promoted by officials in the Information Bureau and the IRAA during the early 1940s was of a new, "healthy" culture actively created by workers themselves in a manner that would integrate and "clarify" their daily lives. Takaoka Hiroyuki has shown that the latter view came to prevail in the early 1940s, replacing the previous emphasis on recreation with a new campaign to have cultural "specialists" guide factory workers in the spontaneous creation of new types of music, theater, or literature that would "renew worker daily life."[145]

In one sense the objections to the recreational approach to worker lei-
sure, and to the opposition between work and daily life apparently promoted
thereby, represented an impulse to break away from the Western, specifically
Italian and German models of leisure management. Yet it is also true that the
ideal of integrating work and leisure in a more organically unified daily life
was very much a part of the National Socialist program for industrial labor in
Germany. Indeed, as Shelley Baranowski points out in her study of Strength
through Joy (Kraft durch Freude, or KdF), the directors of KdF criticized the
Italian program of worker recreation for seeking only to manage workers'
time off the shop floor, and they insisted that "leisure unconnected with
work would result in mindless entertainment rather than the 'elevation of
personality.' "[146] It was precisely for the purpose of demonstrating KdF's
commitment to the integrated whole of workers' lives that the organization
showcased a Beauty of Labor office, which was dedicated to aestheticizing
the work experience itself through improvements in plant architecture and
layout, the provision of specially designed furniture and decorations for
canteens and recreation rooms, the organizing of cultural events for work
breaks, and more.[147]

It is clear that many of the Japanese who occupied themselves with the
question of a properly managed worker culture were favorably impressed by
the efforts of KdF, and particularly of Beauty of Labor. Admiring references
to the German example, and specifically to Beauty of Labor projects, were
scattered throughout the discussions sponsored by the Mingei Association.
Taniguchi Kichirō, for example, of the Tokyo Industrial College, spoke at
enthusiastic length about the model barracks constructed in 1934 by Beauty
of Labor for construction workers on the autobahn, or national highway
system. Apparently Taniguchi had toured the barracks during a visit to Ger-
many; he dwelled on the hygiene and recreational facilities provided and
noted with approval that workers marched in lines from recreation hall to
canteen, "singing songs and beating a drum." He concluded, "I think they
are giving workers a degree of guidance in their daily lives that is extremely
rational, culturally."[148] At another round-table discussion, there was ani-
mated talk of the desirability of the joy in work that one speaker insisted was
experienced by German workers at a machine company.[149]

And yet the Kurashiki dormitory proposal and the discussions hosted by
the Mingei Association suggest that even as Japanese embraced the ideal of a
managed leisure that was somehow seamlessly integrated with work, and
that might produce the sort of regimented, communitarian joy prized in

Nazi Germany, there were those who gravitated toward a somewhat different model of integration. For some Japanese planners the emphasis seemed to fall less on the effort to aestheticize the industrial work experience than on the notion of a more beautifully productive daily life—by which they meant the space and time occupied by laborers when they were not at their work stations. Rather than seeking to integrate leisure or recreation into work, in other words, they sought to integrate productive work into leisure. Thus, for example, Mingei Association leaders and their supporters were primarily interested in the possibility of "guiding" a new worker culture through the design and furnishing of worker housing, whether dormitories for single men and women or individual homes for families.[150]

The preference among at least some Japanese for a means of managing workers that focused less on the factory and more on the home may help to explain why Japan never saw the full development of anything like Strength through Joy or the Italian National Organization of Afterwork (Opera Nazionale Dopalavoro). Recent research has shown that the Recreation Association attached to the Welfare Ministry, along with the Recreation Section of the Industrial Patriotic Organization, were larger and more effective in their efforts—which were often explicitly modeled on the Italian and especially the German examples—than has previously been acknowledged. Nevertheless it remains true that the Japanese agencies committed to managing work culture received little direct state support and never achieved anything approaching the scale and influence of their European counterparts.[151]

A variety of factors contributed to the failure or unwillingness of Japanese policymakers to rationalize worker leisure in the manner of the European fascist regimes. The political philosopher Maruyama Masao has argued in a classic essay that the relative absence in Japan of anything like Strength through Joy revealed the much greater influence of agrarianism in Japanese fascism and the comparative weakness in Japan of the proletariat and the "democratic movement" "prior to the fascist structure." It was also connected, as Maruyama noted, to the lesser degree of capital accumulation in Japan.[152] Moreover it seems likely that opposition from private industry to any significant interference with labor management was too great for the state bureaucracy to overcome.[153] In the round-table transcript published in the special factory girl issue of Gekkan mingei, the Kurashiki spinning factory owner Ōhara Sōichirō expressed his own objections to the German and Italian models quite forcefully. Arguing that the European systems entrusted all welfare and recreation functions to state agencies, thereby leaving the

individual company and its managers little responsibility for guiding work-ers' "healthy daily lives," Ōhara asked rhetorically, "Isn't it the case that if all recreation functions are left to some agency, then the true, integrated, cul-tural mission of the company as a social being will be impossible?" He went on to argue that the nature of the leisure activities promoted in "for-eign countries," which involved individual workers leaving the company to "travel, or go to the theatre, or engage in sports," was inappropriate for Japan, whose "special circumstances" included the accommodation of the great majority of female workers, especially, in factory dormitories.[154]

But another possibility suggested by the mingei dormitory project, and the discussions about worker culture and housing to which it led, is that the rationalization of leisure in New Order Japan was not so much thwarted or neglected as it was pursued somewhat differently, by means of an emphasis on the beauty of a daily life culture that, while authentically native and non-Western, was as regulated and productive as modern, industrial labor. The German historian Anson G. Rabinbach has written that the historical func-tion of Nazism "was to exorcize the traditional patterns of culture which conflicted with modern modes of production."[155] Studying the Beauty of Labor office, Rabinbach found that during the late 1930s, a cult of produc-tivity and efficiency eclipsed an earlier emphasis on preindustrial, völkisch forms and modes to give mature Nazi ideology and culture a distinctly modernist cast. In Japan, however, preindustrial folk forms and modes were not so much eclipsed as they were transfigured, to create a culture of daily life that was both non-Western and modern in its managed productivity. Faced with the challenge of mobilizing an only partially industrialized econ-omy and by the ambivalent associations of modern industry with the racist West, Japanese fascists made a virtue—or rather a beauty—of necessity.

# FIVE. Renovating Greater East Asia

Nostalgia cannot be sustained without loss.
—Susan Stewart, *On Longing*

During the war years of the 1930s and early 1940s, mingei activism became increasingly interventionist not only in the home islands of Japan, but also further afield, in the various colonial and semicolonial territories of the rapidly expanding Japanese empire. The process began in Korea. Beginning in the mid-1930s, the leaders of the new mingei movement in Japan worked with collectors and officials in Korea to discover, produce, and promote new Korean handicrafts. They turned away from Yi dynasty antiques and sought instead to introduce Japanese consumers to new categories of Korean commodities: inexpensive, useful, yet also tasteful household goods manufactured by hand. To some extent, the shift from Yi dynasty antiques to new Korean handicrafts was driven by changes in the definition and treatment of Japanese mingei. As the antiquarian dilettantism of getemono was laid aside in favor of the social reform connoted by new mingei, so too in Korea mingei reformers downplayed the private appreciation of old pottery and began instead to seek out the ongoing production of indigenous arts and crafts.

Yet an increased emphasis on social reform within depression-era Japan does not fully explain the impulse to find, develop, and market new Korean folk art, nor does it explain why mingei activists later made similar efforts in other parts of Japanese-controlled Asia. Beginning in the late 1930s, the mingei movement expanded to include groups and activities in North China

(Hokushi), Manchukuo (Manshūkoku), and Taiwan. An account of mingei activism in Asia must also consider, therefore, its relationship to the shifting nature of the Japanese imperialist project, which changed dramatically after 1931. The army's seizure of Manchuria in 1931 and 1932 inaugurated a new era of expansion, in which the older effort to operate within the frameworks of international law and practice established by the Western colonial powers was largely abandoned. Instead, Japanese policy came to embrace the ambitious new goal of carving out an autonomous East Asia under exclusive Japanese control. The mingei reformers, in their new emphasis on using Japanese expertise to manage the raw, artisanal productivity alleged to be latent in Korea, China, and other regions, took part in the general drive to construct a self-sufficient, non-Western empire—or "coprosperity sphere"— directed by Japan.

Prasenjit Duara has pointed out that Japanese policies toward Asia during the 1930s were shaped by the increasing global illegitimacy of imperialism and colonialism as practiced by the great powers before World War I. During the interwar years, instead, "nationalism [became] the driving force of expansionism." In purveying an ideology of pan-Asian fraternity, and in founding the new, multiethnic state of Manchukuo in 1932, Japanese policymakers—like their Chinese, Indian, and Soviet counterparts—worked antiimperialist nationalism into new political forms which nevertheless "held the potential of developing into new forms of domination," or imperialism.[1] Duara's insight helps to explain why Japanese wartime imperialism in Manchuria and China took the particular, "informal" trajectory that it did.[2] The paradoxical role played by an anticolonialist, yet expansionist, nationalism in Japan's wartime empire also helps to explain the particular nature of the Mingei Association's cultural projects abroad, as well as the links between those projects and wartime mingei activism in the "inner territories" (naichi) of imperial Japan. For example, Yoshida Shōya and other Mingei Association members in the occupied territories of northern China and in Manchuria sought to manage there the creation of what they called a new daily life culture (seikatsu bunka). In envisioning a selective adaptation of indigenous handicraft traditions to new types of domestic goods, to be produced and consumed in new ways, mingei activists in China as well as in Japan imagined a transformation of Asia. That transformation included the reform of Japan itself and was intended ultimately to form a modern, geographically and culturally integrated entity capable of resisting the imperialist West. Thus the mingei projects on the Asian continent were linked to the daily life

culture reform initiatives, such as the factory girl plan of 1941, undertaken in Japan.

Similarly, the rise of anticolonialist nationalism during the interwar period, and its role in shaping Japanese territorial expansion after 1931, lent special urgency and credence to the mingei activists' preservationist approach to cultural and ethnic difference. In a sense the officially multicultural and multiethnic state of Manchukuo, with its slogan of harmony among the "five races" (Japanese, Chinese, Korean, Manchu, and Mongol), represented a validation of the antiassimilationist posture long held by Yanagi and his friends and followers. In the occupied territories of China as well, where the Japanese army set up administrations modeled on that of Manchukuo, there was little effort to institute the sorts of assimilationist policies normally associated with wartime Japanese imperialism.[3] Even in Taiwan, the oldest of Japan's "formal" colonies, there was an interwar and wartime shift in attitudes and policies toward the indigenous tribal peoples known collectively as "Takasagozoku" and also toward the majority population of Chinese immigrants. Although the most draconian form of wartime assimilationism, or kōminka (literally "imperialization"), took place in Taiwan as in Korea, it coexisted into the 1940s with Japanese and Taiwanese attempts to preserve and celebrate native culture.[4]

Yet if the preservationist approach to cultural and ethnic difference was tolerable and even useful in the further reaches of Japanese-controlled Asia, it was more problematic when closer to home. In the late 1930s and early 1940s, mingei activists tried to champion Okinawan and Ainu culture at the extreme southern and northern ends, respectively, of the home Japanese islands. Their endeavors resembled the work they had already undertaken with modest success first in Korea, and later in China and Manchuria. As in China and Manchuria, moreover, the celebration of alternative ways and things among Okinawans and the Ainu was linked to renovationist prospects for a new daily life culture. However, the Okinawan campaign, in particular, encountered unexpected obstacles. In what has come to be known as the "Okinawan dialect controversy" (Okinawa hōgen ronsō) of 1939–1940, the Mingei Association faced energetic local resistance to their calls for a more appreciative, less assimilationist treatment of distinctively Okinawan culture.

In a sense mingei activists lost the fight in Okinawa. Assimilationist policies directed at the modernization and Japanization of Okinawa gained momentum during the early 1940s, and Yanagi and his group were forced to

beat a retreat back to Tokyo. And yet from their headquarters in the metropolitan center, leaders of the Mingei Association continued to promote very effectively their view of Okinawa as an exotic, premodern paradise that was both distinct from and valuable to modern Japan. That view even received the tacit endorsement of the state. How then can we understand the coexistence of what have been called "policies of ethnic negation" by the modern Japanese state toward minority groups such as the Ainu and Okinawans and the persistent tendency to celebrate their cultural and even ethnic difference?[5] In part, of course, the dissonance was produced by the simple fact that different groups voiced different views, both within and beyond the halls of state. But by considering the tension between assimilationism and preservationism within the larger context of Greater East Asia, we can see that it also reflected important fault lines in the larger, more or less shared goal of an anti-imperialist, yet expansionist nation-state.

## Managing Korea's "Splendid, Instinctive Power"

During the early 1930s Yanagi and his closest associates were preoccupied with the redefinition of folk-craft in Japan. Their efforts to make mingei objects and ideology more conspicuously relevant to contemporary Japanese society cast certain of their earlier concerns into shadow. Notable among these was Korea. A passionate interest in Korean antiques, particularly the ceramics and woodwork of the Chosŏn period, had brought together many of the early mingei enthusiasts in the early decades of the century. The position of Yanagi and his circle at the vanguard of what was to become a new Japanese tradition of appreciation for Korean pottery helped to lend authority to their later efforts to promote mingei. Yet that authority, along with the popularity of Yi dynasty art objects to which it was linked, was mostly confined to a narrow segment of elite, urban male society. Influential and prestigious though the cultivated male world of art and especially ceramics collecting continued to be, during the 1920s and 1930s it began to occupy an increasingly marginal position within a developing mass society. By venturing into the production and marketing of new Japanese folk art in 1931, mingei activists made what turned out to be a successful gamble for influence in a much wider field. At the same time they distanced themselves and new mingei, at least publicly, from the insular antiquarian circles in which Chosŏn-period ceramics had become a kind of fetish.

Another, more personal factor that helped to alter the valence of antique

Korean objects for Yanagi in particular was the death in early 1931 of Asa-kawa Takumi. Like his older brother, Asakawa Noritaka, with whom he helped to introduce Yanagi to Korean objects and culture, Takumi was a Japanese resident of Korea and a connoisseur of Chosŏn-period arts and crafts. He also became one of Yanagi's closest friends and served as his collaborator in all things Korean. Yanagi felt the loss keenly. For several years his interest in Korea was reduced to largely private, memorial activity; he made brief trips to Seoul on the anniversaries of Asakawa's death and saw to it that various writings by Asakawa on Korean objects were published posthumously. For a time it seemed that Asakawa's death had drawn to a close an era of youthful enthusiasm for Korean art; Yanagi went so far as to write in the April 1932 issue of *Kōgei*, "The range of Korean things is narrow, and for the most part it's already been surveyed, and I don't think new fields will be opened up."[6]

During the early years of immersion in the effort to promote the produc-tion and consumption of new mingei in Japan, Yanagi did little more than refer occasionally to his wish for similar work in Korea. He usually put this in terms of his expectation that Asakawa Takumi, if alive, would have under-taken the "revival of Korean provincial crafts."[7] Nevertheless the novel idea of seeking out—or even helping to develop—new and useful, rather than antique, primarily decorative Korean craft objects gradually developed into a second phase of more active engagement with Korea. The November 1932 issue of *Kōgei*, for example, was devoted to ordinary Korean stonework. Yanagi wrote, "People know about Korean stone Buddhas, and pagodas, and pillars, and bridges. But there are also a great many beautiful things in the stonemasonry more closely associated with everyday, household life." Among the photographs of ink stones, brush holders, braziers, bowls, and headrests that illustrated the issue were several of Korean stonemasons at work that had been taken by Hamaguchi Ryokō, a Japanese collector who lived in Seoul. Yanagi remarked, "My heart is drawn to these photographs. These are scenes I would like to have photographed for various types of craft. . . . In Korea, things are being made in the old ways even now."[8] As it had a few years earlier for new Japanese mingei, the curiosity about ongoing artisanal production soon joined with the impulse to actually direct the manufacture of Korean crafts. Another issue of *Kōgei*, in March 1935, fea-tured new straw work from Korea; a number of the mats and baskets pic-tured had been made by a Korean artisan in Japan, under the supervision of the potter Kawai Kanjirō.[9] In the summer of the same year Yanagi traveled to

Korea for several weeks of sightseeing and shopping with Bernard Leach; it was his first such trip to Korea in years. He reported with some excitement of happening unexpectedly on a provincial market: "Many of the wares [sold] were traditional Korean tools of daily life [mingu]. Pottery, bamboo goods, iron pots, linen, carvings, mats, etc, and also various sorts of foods, seaweeds, firewood, charcoal, bamboo, etc. etc. How valuable this sort of market day is for Korean daily life, how much it aids provincial industry, and eases daily life, and warms sociability, and enlivens the city! The quickest way to come and know Korea is the market day."[10]

Among the leading mingei activists, the shift of interest from old to new Korean artifacts became fully explicit in the late 1930s. In 1936, and again in 1937, Yanagi, Hamada, and Kawai took extended trips to Korea for the purpose of investigating new handicraft production. Previous visits to Korea by mingei collectors and other Japanese interested in acquiring Korean art had consisted largely of shopping in Seoul and, to a lesser extent, Pusan and other major cities, where a profusion of antique shops (dōguya) run by both Japanese and Koreans catered to a mostly Japanese clientele. However, the 1936 and 1937 trips, which were organized around the exploration of the Korean countryside, or, as the mingei group called it, the "interior" (okuchi), represented a conscious departure from this pattern. An essay in Kōgei about the 1937 trip, coauthored by Yanagi, Kawai, and Hamada, began by asserting:

Many visit Korea, but we are probably the first to have gone with our purpose. Even though there are people who seek old things, never has anyone looked for new things. However in Korea, which preserves old customs well, beautifully artless [muzōsa] objects from the past are still being made here and there. If one wants to see the long ago Korea, there is nothing like seeing Korea now. We wanted to see more of what there is of objects that continue to be made even now. Further, we wanted to trace the roots of those kinds of things, [and see] what kind of environment and feeling they were born of. In order to see an unadulterated [majirike no nai] Korea, one must enter the interior.[11]

The trips to Korea, along with the activities and projects that flowed from them, were clearly shaped by the earlier experience of promoting Japanese new mingei production and consumption. As in the early 1930s, the explorations of provincial handicraft industry also served as an opportunity to accumulate objects for display and sale at exhibitions at department stores, the shop Takumi, and other metropolitan venues. As with new mingei in Japan,

the trips and exhibits were followed by special promotional issues of Kōgei; two numbers devoted to "Present-day Korean Mingei" were published in 1936 and 1937. But it is also clear that the idea of venturing into the Korean countryside in search of freshly produced handicraft objects was connected not only to earlier developments in mingei activism, but also to the changing nature of Japanese colonialism during the 1930s. At the same time, the new Korean mingei initiatives drew upon habits of colonialist thought and practice that had marked earlier Korea-related endeavors by Yanagi and his circle. For example, the emphasis on Korean conservatism and traditionalism in the passage just quoted echoed—as did the earlier appreciations of Korean crafts by Yanagi and other Japanese collectors—a more general discourse portraying Korea as a static, stubbornly premodern society. The notion of a Korea mired in the past was connected, of course, to the idea that Japanese rule was necessary to effect Korea's passage to modernity. Also the idea of an "artless beauty" inherent in Korean objects reiterated a related complex of associations Japanese writers had made during the 1920s between Korea and childlike, premodern unconsciousness on the one hand, and Japan and adult, modern consciousness on the other.[12]

And there were other ways in which the burst of Korean activity beginning in 1936 was shaped by certain colonialist continuities. Yanagi's celebrated public criticism of Japanese colonial rule in Korea and his efforts to resolve the "Japan-Korea problem" (Nissen mondai) through cultural activities during the early 1920s had been acceptable and even useful to the relatively conciliatory "cultural" regime put into place in Korea after 1919. Accordingly Yanagi's various Korean projects and visits in the 1920s received both direct and indirect support from the government in Korea. In the mid-1930s as well, the mingei activists were able to rely on the colonial administration in Korea. For example, during the nine days Yanagi, Kawai, and Hamada spent in May 1937 traveling in southern Korea, they were given banquets, full-time guide-interpreters, the use of cars and drivers, and other forms of active support and hospitality by Japanese and Korean officials in the region.[13] Matsumoto Iori, the governor of Zennan (South Chŏlla) province, organized a public round-table discussion in Kwangju at which the trio, along with their Seoul-based collaborators Hamaguchi Ryokō and Doi Hamaichi, were asked to give their views on Korean products and lifestyle.[14]

The mingei group spoke of the things and people they found in the Korean interior in much the way many Japanese had written about antique Korean art objects a decade earlier. In the 1920s Yanagi and other collec-

tors discovered an ineffable beauty linking Chosŏn-period ceramics to the Korean landscape, Korean clothing, Korean shoes, girls, rooftops, spoons, and even music—thereby rendering much of Korea into an object for appreciation by the discerning Japanese subject. In the mid-1930s Yanagi and his colleagues simply extended this vision to the ordinary sights and sounds of the contemporary countryside. The travel essay published in *Kōgei* summarized their statements at the round-table discussion:

> How many splendid works still remain in Korea. How deeply their beauty is rooted in daily life. How difficult it has become to produce good objects in the inner territory [*naichi*, i.e., Japan], which has lost that kind of strength. Therefore how splendid are those characteristic things which have not been influenced by the inner territory. However, if changed just a little and used in daily life now, how large the work of the future will be. . . . In the end we were simply repeating "It's great, anyway it's great" [*Taishita mono da, nanishiro taishita mono da*]. Our cries of pleasure in the objects and also the daily life were such that people laughed. But this pleasure was probably communicated.[15]

Yet the extension of that aestheticizing vision beyond conventionally pleasing objects and sights to include the homely details of daily life in rural Korea—from the earthy proverbs found in a child's schoolbook to the stink of fermenting fish sold at a public market—also represented a change.[16] It was a change, moreover, that reflected key developments in the way many Japanese thought about the "inner" and "outer" territories (*naichi* and *gaichi*), as Japan and its colonies were often designated.

In 1931, with the invasion of Manchuria and the creation of the Japanese puppet-state of Manchukuo, Japan's so-called outer territories began to take on a new, visionary aspect in the Japanese imagination. Korea, for example, began to be figured less as a recalcitrantly premodern society to be guided only gradually into the light of the twentieth century, and more as an organic part of a modern Asian whole to be actively reconstructed by Japanese leadership. The integrated, even symbiotic new relationship proposed between colonies and metropole was fueled by the growing urgency of Japan's war effort; the outer territories were to provide raw materials, markets, labor, and military support for prudent administration by Japanese, who were rich in managerial skills but poor in natural resources. The shift in mingei reformers' attention from old to new Korean mingei resonated, therefore, with a fundamental shift in the nature of the Japanese imperial project. Much

in the way that military and government planners imagined themselves developing Asian resources for an industrialized future prosperity, mingei activists focused increasingly on the potential they saw in their own management of Korean artisanal productivity.

The new focus on manageable productivity was accompanied by a marked change in the rhetoric employed to describe the aesthetic properties of Korean objects. Leading figures in the mingei movement of the late 1930s began to write about Korean (and later Manchurian, Chinese, and Southeast Asian) material culture in ways suggesting that it was both the product and symbol of a kind of "strength" Japan no longer possessed, but might adopt and adapt for the future. The Korean objects and lifestyle Yanagi, Kawai, Hamada, and others celebrated beginning in 1936 were no longer "sorrowful" or "melancholy" in any way.[17] Instead they were characterized repeatedly in terms of "power" (chikara), "health" (kenkō), the "natural" (shizen), "simplicity" (soboku), and "freedom" (jiyū). It was suggested that these were qualities related to Korean fidelity to the past; the "strongest," most "unerring" shapes and customs were those that the mingei activists identified as having been passed down, unchanged, from long ago times.[18] By contrast, Japan was frequently denoted as a place where this ability to "give birth" to "good" shapes and designs had deteriorated and become corrupted with modernity.[19] As Yanagi, Kawai, and Hamada put it in their essay on the 1936 trip: "When we encounter new Korean products, we feel keenly how much we have lost; even as we exult in the name of civilization and culture, how greatly we are actually defeated. What have the world's artists suffered for, and what must they suffer for next? It is for nothing else. It is to retrieve the splendid instinctive power [honne no chikara] that these Korean people possess."[20]

As in much of the writing produced by admirers of folk art everywhere, there was a distinctly elegiac undertone to the essays, commentaries, and editorials that appeared on new Korean mingei. Not only did the excellence of Korean objects remind many Japanese of their own lost, premodern past, but they feared for the survival of the virtues of Korean premodernity. Traditional artisans were elderly and techniques were dying out; demand, corrupted by the influx of Japanese and Western commodities, was falling off; misguided Japanese intervention was said to be destroying characteristic Korean design.[21] Yet it was in part to address this creeping blight that the mingei activists had taken up the cause of new Korean handicrafts in the first place. The emphasis in their writings was less on loss and the nostalgic appreciation of an inevitably vanishing excellence than on the importance of

finding ways to revive and adapt the virtues of the Korean handicrafts tradition for the Japanese as well as Korean present and future.

Although mingei promoters promised vague future benefits to Korea as a result of the preservation of Korean handicrafts, they seemed primarily interested in the contribution a revived Korean material culture could make to Japan. Yanagi, Kawai, and Hamada concluded the account of their 1936 trip by criticizing the attitude of most Japanese residents of Korea, who, "while living in Korea, do not even try to eat Korean-style food or learn Korean" and who "want to return quickly to the inner territory." As they put it, "Even though there are many things to be gained [uketoru] from Korea, it is truly unfortunate that few people gain them." In contrast to their shortsighted compatriots, the mingei collectors "were able to gain many things from Korean lifestyle and products."[22] Consequently they had many specific suggestions for ways that Korean objects, occasionally with some adaptation, might enhance Japanese daily life. The commentaries Yanagi wrote to accompany the photographs of Korean objects in both of the new Korean mingei issues of Kōgei were scattered with ideas of this nature. Various vessels and implements were recommended for use in the Japanese home or on the Japanese dining table.[23] Large water jars might be used as braziers (a favorite mingei adaptation), religious items might serve as furniture, and a brass object of undetermined function made an ideal ashtray.[24] It occurred to Yanagi and others that an especially sturdy type of handmade paper, customarily used to cover the heated floors of Korean rooms, was suitable for use in book binding. This application was demonstrated by the covers of the October 1937 issue of Kōgei.[25]

Gains to Japanese daily life were stressed, of course, in the exhibition sales of new Korean mingei held in the spring and summer of 1938 at the Takashimaya department stores in Tokyo, Osaka, and Kyoto. Although the statements by Kawai, Hamada, and Yanagi which appeared in Takashimaya's promotional pamphlets concluded with the hope that "these [objects] become a means for the deepened understanding of Korea and build a new way of thinking with regard to the future of [Korean] crafts," the main theme of the shows was perhaps better expressed by the assertion that "there are many things that can be made use of in our daily lives."[26] As the introductory statement for one pamphlet put it, "You will find of interest the over 10,000 items, in 800 different categorics, and we believe that if you approach them with the spirit of the great tea masters of old, and consider their uses, there are great finds here."[27]

Thanks to the enthusiasm of individuals such as Soma Teizō, an energetic Mingei Association member who lived in the Tōhoku city of Hirosaki, show sales of new Korean mingei were also held in various provincial cities. Yet it is difficult to know to what extent Japanese consumers were convinced by the mingei shows and publications to incorporate contemporary Korean hand-icraft objects into their daily lives. There is evidence that the Tokyo craft shop Takumi as well as other mingei sales outlets in Japan continued to funnel some new Korean objects to their clientele.[28] After all, the Korean baskets, straw sandals, and pottery sold in Japan were relatively inexpensive and featured the handmade, rustic aesthetic that became increasingly fashion-able during the 1930s. At the same time they, along with the handicrafts of other Asian colonies and even of relatively remote parts of Japan like Oki-nawa and Tōhoku, offered an exoticism legitimated by the ideal of national-imperial unity.

Nevertheless, there is also evidence to suggest that despite the efforts of the Mingei Association, the interest that Japanese consumers took in Ko-rean handicrafts was not entirely amenable to direction from above. Just as middle-class men and women tended to appropriate Japanese mingei in a manner influenced more by the actual practices than by the teachings of Yanagi and other cultural elites, so too they tended to approach Korea and Korean material culture in ways that were perhaps more emulative than obedient. For example, there was steady growth during the 1930s in the popularity of Yi dynasty, or the types of Chosŏn-era ceramics and furniture first celebrated in 1920s Japan by members of the early mingei circle. Even though Yanagi sought in the early 1930s to repress the preoccupation with Yi dynasty, which he criticized as unhealthy, antiquarian fetishism, Yi dynasty continued to gain cachet not only as a category of collectible antiques, but also as a fashionable style of interior decor. One of the model rooms created for a Matsuzakaya department store exhibition of "New National Furniture," and then featured in the March 1935 issue of *Jūtaku to teien* (*House and Garden*), was a "Japanese parlor appointed in the Yi dynasty style."[29] The center-piece of the room was a low wooden table of the sort first admired in Japan by collectors like the Asakawa brothers and Yanagi. Indeed Chosŏn-period wooden tables attained something of an iconic status among the Japanese who first collected Yi dynasty and who later went on to celebrate mingei. Among Asakawa Takumi's few publications on Korean arts and crafts were a book and several articles about Chosŏn-period tables. The woodworker Kuroda Tatsuaki, a member of the Kamigamo guild experiment in Kyoto and

later a celebrated artist in his own right, became known for his tables in the Yi dynasty style; the antique Korean table was an almost inevitable element of interior decor for mingei activists in their own homes. Tellingly, the new Korean mingei sold at Takumi and elsewhere soon came prominently to feature reproductions of Chosŏn-period tables, which were manufactured by Korean artisans under the direction of the collector and association member Hamaguchi Ryokō in Seoul.[30]

Although Yanagi and his associates liked to imagine new Korean mingei as a wellspring of healthy, vigorous utility that might be channeled into Japanese homes, consumers in Japan were apparently more interested in Korean material culture as a source of art objects and sophisticated home decor. They also seem to have been inclined to regard Korea as an exotic source of touristic pleasure—again, much in the way that the leading mingei activists, along with Japanese cognoscenti generally, had come to do. It is suggestive that new Korean mingei was often displayed in department stores along with photographs of Korean scenes.[31] According to the advertising pamphlet produced by the Takashimaya store in Kyoto, the photographs were part of a "Korean Tourist Panorama" (Chōsen kankō panorama) that had been appended to the show sale of handicrafts. In addition to several dozen photographs, the panorama included a "georama" (jiorama) that depicted "one part of the daily life" of a Korean woman. Visitors were promised that they would "embrace the sensation of disporting themselves in Korea."[32] While it is unclear to what extent mingei activists were involved in planning and assembling such panoramas and georamas, they did cater to Japanese touristic curiosity about Korea in another way, through their writings about their travels. The vividly descriptive travel essays published in Kōgei (and excerpted in the department store pamphlets) with yet more photographs might also be seen as providing readers with a vicarious tourist experience. Few Japanese could afford to actually travel for pleasure to Korea, Manchukuo, or Taiwan during the 1930s, but the rapid growth of domestic tourism combined with Japanese imperialism to bring these "outer territories" within the realm of general touristic longing. That longing was both stimulated and partially assuaged by such activities as visits to department store exhibition sales, Korean or Manchurian or Taiwanese pavilions at expositions, the purchase of souvenir items, and the reading of travel books and articles written by those Japanese with the means to travel the further reaches of the empire.[33]

Popular Japanese curiosity about Asia as well as other parts of the world

flourished from well before the 1930s, but the development of mass con-
sumerism helped to give that curiosity a newly material, acquisitive cast,
particularly with regard to Japan's colonial possessions. As described for
Japanese readers, the Korean travels of Yanagi, Kawai, and Hamada in 1936
and 1937 resembled nothing so much as extravagantly consumerist pleasure
tours. This was especially true of the second trip, which was financed in part
by the Takashimaya department store.[34] Outfitted with cameras and appar-
ently unlimited funds, the mingei group careered about the Korean coun-
tryside in what almost seems a caricature of modern tourism, hunting for
authentically Korean sights, experiences, and, above all, things. Each day
was punctuated by several bouts of large-scale shopping at local markets,
shops, and artisanal workshops. The buying of objects so mediated the
perceptions of the Japanese group that they could not pay a visit to a Ko-
rean's home without seeing something—a cushion, a kitchen tool, a piece of
furniture—they wished to purchase. Their hosts usually obliged them. Dur-
ing a visit to a Buddhist monastery they even persuaded a monk to sell them
a bag he carried.[35]

Nevertheless, it seems that by the mid-1930s even tourism and the discov-
ery of new Korean consumer commodities could generate only limited inter-
est in one of Japan's older colonies. Beginning in 1931, with the outbreak of
fighting in Manchuria, the focus of Japanese public attention moved north to
Manchuria and China, where it stayed throughout the decade. As Kan Donjin
has pointed out in his study of the treatment of Korea in Japanese news-
papers and magazines during the period of colonial rule, after 1931 there was
a remarkable drop in the number of articles and editorials published on the
subject of Korea. Kan notes, further, that what little that did appear during
the 1930s and early 1940s was concerned almost exclusively with Korea's role
in the continental war effort.[36]

The mingei movement, in some ways the product of an earlier, more
intense Japanese interest in Korea, continued to maintain its various Korean
concerns and connections. Nevertheless, these too shifted and ultimately
receded in importance. In a sense the campaign to promote new Korean
handicraft goods from 1936 through 1938 represented an effort to revise the
meaning of Korean mingei in accordance with changing conceptions of
Japan and its place in Asia. By taking up new rather than old objects, and by
locating those new objects in the context of contemporary Korean daily life,
mingei activists moved toward a definition of Korea that placed it in a com-
plementary, rather than antithetical, relation to modern Japan. Just as the

new Korean things, in contrast to the antique objects collected and appreciated as art, were to be actively incorporated within the daily life of the Japanese household, so Korea was no longer a melancholy museum of past Oriental beauty, but rather a productive field from which Japan might harvest premodern Asian "strength" and "health." By the 1930s, moreover, Korea had become a relatively stable colony, offering little of the overt, organized resistance to Japanese rule that had attracted so much Japanese and also international attention in the early 1920s. As such it was increasingly assimilated into imperial Japanese identity, though in a distinctly subaltern position.

### North China and Manchukuo: A Greater East Asian Culture of Daily Life

It was in China and Manchuria that the Mingei Association came most fully to an accommodation with the larger goals of Japanese wartime imperialism. Beginning in the late 1930s, leading mingei activists worked in regions of China occupied and controlled by the Japanese army. There they undertook a number of disparate projects, ranging from efforts to direct the manufacture of new Chinese mingei and to establish museums of Chinese and Manchurian folk art, to the investigation and reform of the daily life culture of Japanese colonists. Again, much of the work undertaken by mingei reformers in China and Manchuria represented an extension of earlier endeavors to produce and promote new mingei in Japan and in Korea. Yet there were also significant changes, as Mingei Association members both in Japan and in China adapted the rhetoric, goals, and methods of mingei reform to the exigencies of a precarious and highly militarized new sort of territorial expansionism. Like the various mingei projects undertaken within Japan proper in the early 1940s, the Chinese and Manchurian initiatives were also distinguished by their consonance with the explicitly renovationist domestic policies of the wartime state.

#### MINGEI AND THE MILITARY

One of the most striking features of mingei activism in occupied China was that it occurred with the active support and even sponsorship of the Japanese military. At the same time, the mingei projects in China, as well as in Manchukuo, were shaped in ways that served specifically military goals. The close imbrication of military interests and even so apparently pacific an endeavor as handicraft reform was almost inevitable in occupied China, and

to a lesser degree in Manchukuo. Although hundreds of thousands of civilian Japanese resided along the "points and lines" (that is, in the major urban centers and in the smaller settlements along railways) in Manchuria and northern China that were under Japanese control, and although ostensibly civilian, native governments had been instituted in Manchuria and in the three occupied regions of northern China, real power belonged to the various Japanese army authorities on the ground.

A survey of the wartime career of Yoshida Shōya, the Tottori physician who helped to organize and lead the new mingei movement in the San'in region beginning in 1931, and who went on to lead the efforts in North China, serves to illustrate how important and necessary a role was played by the military in any Greater East Asian cultural reform project. In 1938, Yoshida was called up to serve as a military doctor for the Japanese army in North China (the North China Area Army). Several years later, Yoshida wrote an essay in which he commented, "In going to the front, I secretly hoped that if I went to the Chinese continent there would be lots of mingei objects and that these would give me pleasure in the intervals of war." Although Yoshida claimed that he had been disappointed in this hope—that North China, unlike Japan and Korea, had little to offer in the way of mingei—he made a name for himself during his two years of active duty by publishing a steady stream of articles in Japanese newspapers about his experiences as a soldier interested in Chinese folk art.[37]

In early 1940, at about the same time that many of these articles were collected and published as a book in Japan, Yoshida was discharged (with decorations) in Japanese-occupied Beijing.[38] At that time he was appointed a "pacification officer" (senbukan) in Beijing and given a commission by the Special Affairs (Tokumu kikan) section of the North China Area Army to oversee matters relating to both industry and medicine.[39] (The Special Affairs section had been formed in 1937 as an intelligence bureau and to manage the administration of the occupied territory.) In connection with his work for Special Affairs, Yoshida also seems to have become attached to the central executive office of the People's Renovation Society (Shinminkai in Japanese, and Xinminhui in Chinese), a mass organization centered in Beijing that might be described as the ideological wing of the Japanese army–controlled Provisional Government of North China.[40]

The Japanese army, and particularly its Special Affairs section, was instrumental in establishing the People's Renovation Society shortly after the founding of the Provisional Government in late 1937. The society was set up

as a binational institution, modeled on the Concordia Society (Kyōwakai) in Manchukuo, intended to generate support for the new regime. Relations between the Japanese army, the government, and the People's Renovation Society were complex; as one American observer put it in 1939, "The Provisional government is the wife and the Hsin Min Hui the concubine of the Japanese."[41] One of the primary goals of the People's Renovation Society was the "renovation"—with help from Japan—of China's premodern, indigenous Asian spirit, which was said to have become sullied by contact with the West.[42] Thus activities sponsored by the society included the revival of Confucian rituals as well as the promotion of Chinese art. At the same time the society was concerned to demonstrate to Chinese the concrete advantages of Sino-Japanese unity; Japanese and Chinese functionaries attempted to put into practice the idea that "the only way to secure the livelihood of the people is to develop the resources of China with Chinese manpower and Japanese capital and technique" through a wide variety of educational, agrarian, relief, and other projects.[43]

Whatever Yoshida's other responsibilities were, he as well as his associates in the Mingei Association in Tokyo appear to have understood his mission in China primarily in terms of reviving the production of mingei. Shikiba Ryūzaburō, editor of *Gekkan mingei* and a former classmate of Yoshida in medical school, wrote in a 1940 editorial of his hopes of Yoshida's new status: "The fact that Chinese mingei will be investigated by an official agency is deeply significant. I hope that this will become the spark for the establishment of a Chinese Mingei Museum in Beijing, and that it will create the opportunity for the export to foreign countries by Japanese of new Chinese mingei. There has been joyful word from Yoshida that the day has come for the realization of the dream he wrote of in an earlier issue."[44]

By mid-1940 Yoshida had already published a number of articles in *Gekkan mingei*, but it was in a piece that appeared a year earlier, in the magazine's first issue, that he articulated most clearly his dream for Chinese mingei. Yoshida placed mingei, and particularly the production and marketing of new mingei, within a larger framework of war between East and West: "I believe that today's holy war [seisen] is one of chasing out of the Orient the Westerners who have corrupted Asia [Ajia] with the commercialist machine industry that arose from the industrial revolution, and of enriching human life by means of correct handicrafts. I think that Japan, through proper and ethical machine industry, and Korea and China, through handicrafts, should eradicate the products of commercialism." More specifically, Yoshida noted

that although he had not seen very much mingei in Beijing, Tianjin, or Hebei, "the world of handicrafts, and cotton and wool materials are rich, and I thought that if we had a new mingei movement [here] it would be truly splendid." He concluded, "I want to dream that production [seisaku] will be in the Orient and markets will be of course in the Orient but also in the West."[45]

Yoshida's references to a corrupting Western form of industrial commercialism or capitalism, to the more humane and ethical alternative that it was Japan's mission to provide (through war) in Asia, and to the eventual marketing of Asian manufactures in the West reflected an uneasy amalgam of military, commercial, and mingei ideology. Leading factions within the Japanese army on the Chinese continent had long nurtured a brand of anti-capitalist, anti-Western idealism in their visions of a Japanese-controlled, autarkic Asian economy.[46] Yet the policies and plans of the military tended to focus, unsurprisingly, on wartime economic self-sufficiency, rather than on the prospect of continued trade relations with the West. As Louise Young has pointed out, the business community which underwrote Japanese expansion and development on the continent concentrated instead on trade opportunities; while wartime autarky in East Asia certainly offered new and profitable scope for trade and investment, Japanese business interests understood the advantages of the so-called yen bloc within the larger context of global commercial integration, wherein a peaceable trade relationship with the West was indispensable. Similarly, it might be argued that Yoshida's idea that China and Korea, rather than Japan, become sites for Japanese-managed handicraft production was an adaptation of military policy to mingei thought. One of the army's more radically innovative undertakings on the northeastern Asian continent was to promote there the development of heavy industry—a course of action that overturned the conventional pattern of colonial economic development and that many domestic Japanese industrialists and manufacturers regarded with dismay.[47] Yoshida's proposal that Japanese concentrate on developing and managing handicraft production in China and Korea rather than in Japan bears a certain resemblance to army policy regarding strategic industries, even as it draws upon mingei ideas about the toll taken by modernization on Japanese creativity.[48]

Yet Yoshida also noted a distinction between China and Korea. Unlike Korea (or Japan), North China appeared to lack much in the way of surviving mingei production. Yoshida speculated that causes might include the destructive impact of Western imperialism in China, as well as Chinese geo-

graphical features facilitating communication and therefore the homogeni-
zation of material culture.[49] He claimed, therefore, that North China offered
only a past tradition of handicraft techniques, along with plentiful raw mate-
rials such as cotton and wool. Confronted with this absence, Japan's role, as
Yoshida began to formulate it during 1939 and 1940, was to reconstruct
Chinese mingei production. He considered various possible methods, such
as the training of selected Chinese artisans in Japan or, alternatively, the
"transplantation" of dying Chinese handicrafts to Japan, where they might
survive for eventual reintroduction to China.[50] Ultimately he decided on a
course of direct action that drew upon his experience a decade earlier in
Tottori. He and mingei artist-craftsmen would supervise the production of
new folk-craft in China.

In the summer of 1940 Yoshida invited several of the younger generation
of mingei artist-craftsmen to join him in China. Yanagi's nephew, the weaver
Yanagi Yoshitaka, as well as the dyer Okamura Kichiemon, who had been
trained by Serizawa Keisuke, left Japan for Beijing that fall. Over the next two
years they were joined by two young potters, Kawai Takeichi, nephew and
apprentice to Kawai Kanjirō, and Yoshida Teizō. Writing in the 1990s of his
experience in China, Okamura pointed out that the 1939 wartime restrictions
imposed in Japan on the use of a wide range of materials necessary for craft
manufacture had made his work as a dyer difficult to continue. As he put it,
"Half in despair I went to China and entered Yoshida Shōya's Chinese [Ka-
hoku] Mingei Movement."[51] For young, ambitious Japanese hampered by an
increasingly constricted wartime economy, China may have seemed a rela-
tively open field of opportunity. As Earl Kinmonth suggests in his study of
the education and employment of middle-class Japanese youth in the late
nineteenth century and early twentieth, one important advantage of imperial
expansion on the Asian continent was the employment opportunities it af-
forded to an oversupply of educated young men during the 1930s.[52]

Okamura and Yanagi Yoshitaka arrived in China to take semiofficial posi-
tions with the North China Area Army's Special Affairs section and the
People's Renovation Society.[53] Directed by Yoshida, they immediately set to
work organizing the production of Chinese mingei. Okamura and Yanagi
spent some time investigating handicraft manufacture in various regions of
North China, but their primary responsibilities concerned the management
and direction of several factory workshops and People's Renovation training
centers for the production of woven, dyed, and embroidered goods. The

condition in which they believed they found Chinese mingei—degraded, despised, and nearly extinct—required that they reinvent it almost completely.

After a brief visit to China in the fall of 1940, Shikiba wrote an article describing this process of reconstruction and its attendant difficulties. One of the tasks given Yanagi Yoshitaka and Okamura was the reform of wool rug making in the region of Shunde, where the rugs "were dyed vulgar colors using chemical dyes, and designs also had become bad." After collecting large quantities of vegetable dye materials from various regions, Yanagi and Okamura went to a People's Renovation dyeing and weaving craft training center on the outskirts of Shunde, where they began training "14 or 15 Chinese youths" to make vegetable dyes and to dye rug yarn.

> It was no simple feat to make these youths, who had over a long period become accustomed to easy cheating methods, learn this kind of true work. Adding the language difficulty, it was no ordinary labor to put them, with their stubborn character and opposition in their hearts, on this new path. But this labor was rewarded. The work flowered. When this foundation was laid, work was begun at a dye shop and a weaver in the town. They were given new designs and shown models made here [in Japan], and began making things that were completely different from the previous, vulgar rugs. Finally about 30 weavers entered the Special Affairs guidance center and began to work. They are acquiring skills and comprehending the spirit [of those skills], and when they are sent out to towns and villages, the rugs of all Juntoku [Shunde] will change completely into beautiful things.[54]

Shikiba had flown to China in October 1940 along with the elder Yanagi, Hamada, and Kawai at the invitation of the Special Affairs section. They went on the occasion of a two-day exhibit in Beijing of the early results of the efforts of Yoshida, Okamura, and Yanagi Yoshitaka. Sponsored by the People's Renovation Society and Special Affairs, the "Exhibition of Public Welfare Industry [kōsei sangyō]) of the Sekimon [Shimen] District" featured about three hundred examples of pottery, weaving, embroidery, and rug making, and reportedly caused a "sensation" (senseishon) among Beijing officials.[55] Sensational or not, the show seems to have been favorably received; over the next several years, Yoshida and his associates received continuing official (military) and private support in their efforts to develop the production and also consumption of mingei in North China.

**19.** The "Exhibition of Public Welfare Industry of the Sekimon [Shimen] District," held 18–20 October 1940 in the Beijing Hotel, in Beijing. From *Gekkan mingei* 1, nos. 2–3 (January–February 1941): 28. Photo courtesy of Fine Arts Library, Harvard College Library.

As the name of the exhibit suggests, the mingei project in China was subsumed within a more general campaign sponsored by the Japanese army and the Provisional Government to promote Chinese "public welfare" (*kōsei*). Handicraft production was considered a suitable means of helping Chinese farmers and others whose livelihoods had been destroyed by war.[56] Accordingly, Yoshida even proposed that the new handicrafts produced in China be called "People's Welfare Crafts" (*kōmin kōgei*) rather than mingei. People's Welfare Crafts were intended to improve the lives of Chinese producers as well as consumers. Those who made the objects would take pleasure in their work and also make money, and those who used them would improve the quality of their daily lives. Yoshida pointed out that the term "mingei" was liable to misinterpretation because it retained hobbyist associations from its origins in antiques collecting. By contrast, the objects produced under Yoshida's supervision in China were entirely new: "Mingei began by looking back at the past. However I want to turn my eyes now to the present and future."[57]

Yoshida and the Mingei Association members who followed him to China seem earnestly to have desired that their work aid ordinary Chinese. No doubt there were also those in the Japanese army who genuinely wished to alleviate hardship among the Chinese civilian population. Nevertheless it is also clear that the public welfare campaign of the Japanese army promoted specifically military goals; in addition to serving as a form of pro-Japanese propaganda, the success of any low-cost means, such as the mingei project, of providing unemployed rural youths with gainful occupation could only aid in the effort to control an extremely unstable region wracked by guerrilla warfare.[58]

Mingei activism in China and especially in Manchuria was shaped by the goals of the Japanese military in other ways as well. One special area of concern for the Japanese army, and consequently for mingei reformers in the region, was the lifestyle and morale of Japanese settlers on the continent. Given the strategic importance of Japanese settlements, which were intended in many cases to serve as a first line of defense against not only the Chinese enemy but also the possibility of attack by the Soviet army, it was of no small concern to the authorities when it became clear that Japanese colonists were failing to thrive. There were any number of factors that militated against the success of ill-prepared, underequipped, isolated communities of Japanese farmers settled on land expropriated by force from Chinese cultivators.[59] Nevertheless, some Japanese observers focused on the inappropriateness and inefficiency of the everyday objects or customs that these colonists retained in environments very different from those they had left behind.[60]

Here, then, was another opening for mingei activism on the continent. In 1942 the Mingei Association became involved in the official celebration of the tenth anniversary of the founding of Manchukuo by helping to organize an exhibition at the Tokyo Mitsukoshi department store in April of new mingei produced by Japanese colonists in Manchuria. A special Manchurian issue of *Mingei* was brought out the following month.[61] In the September issue of the same year it was reported that officials from the Manchukuo Settlement Central Office (Manshūkoku kaitaku sōkyoku) and the Manchurian Railway (Mantetsu) had visited the Folk-Crafts Museum in August to discuss future plans, which revolved around issues of "constructing and guiding" the daily life of Japanese settlers or colonists, as well as the establishment of a Manchurian mingei museum.[62] Immediate results of the discussion appear to have included a plan devised by the Mingei Association

concerning new pottery production in Manchukuo and a trip taken to Man-
chukuo and North China by Muraoka Kageo, an increasingly active associa-
tion member, in September.[63] At the end of the year the Folk-Crafts Museum
put on an exhibit of the leather handicrafts of the Oroqen, a tribal people
from the mountainous northern region of Manchukuo.[64]

All of the escalating Manchurian activity reached a high point in late
summer of 1943, when a group that included the Mingei Association lead-
ers Hamada Shōji, Tonomura Kichinosuke, and Shikiba Ryūzaburō went to
Manchukuo for nearly two months.[65] According to Tonomura, who repub-
lished his journal of the trip as a book in 1983, this group visit was organized
by Yanagi in response to requests made by the semigovernmental Man-
chukuo Immigration Association (Manshū ijū kyōkai) and the Manchukuo
Light Industry Group (Manshū ken kōgyō dan), an association of Japanese
concerns in Manchukuo. Partly funded by these two organizations, par-
ticularly the Wakamoto pharmaceutical company, the group was sent to
investigate and also supervise the production and distribution of objects of
daily use in Manchukuo, and also to collect mingei in preparation for the
founding of a Manchukuo Folk-Crafts Museum (Manshū mingeikan).[66]

As described in Tonomura's journal, the group traveled throughout Man-
chukuo, sightseeing and shopping furiously at antique stores, markets,
kilns, artisanal workshops, department stores, museums, and industrial
expositions in most of the major cities of the region. They endeavored to
collect objects produced by the different groups that formed the officially
multiethnic nation of Manchukuo. Tonomura noted, "At the beginning of
the trip we had hoped for approximately equal amounts of craft objects by
Chinese, Mongolians, Manchurians, and Russians, but the result was a pre-
ponderance of Chinese things, with little by Manchurians or Russians, and
only some by Mongolians." He added that the group had been surprised by
the unexpectedly large quantity of Korean handicrafts encountered. Japanese
things, however, were "yet to come."[67] The objects purchased, about three
hundred in all, were sent back to the group's base at the Wakamoto head-
quarters in Shinkyō, the capital of Manchukuo. In September these objects
were exhibited in Shinkyō as a sort of interim report on the progress of the
Manchurian mingei venture. According to the invitation to the show, it was
hoped that "the simple, healthy wartime daily life of Manchukuo be beau-
tified by means of these locally produced folk-craft objects, and by the manu-
facture of craft objects of daily life that learn from them."[68]

Several members of the group devoted much of their time in Manchukuo

to the effort to manufacture mingei-inspired "craft objects of daily life." In September the potters Hamada, Kawai Takeichi, and Ueda set to work at the large modern facilities of the Manchukuo Ceramics Company (Manshū tōki kaisha) at Kōryūsan kiln on the outskirts of Shinkyō. Originally a local concern, the kiln had come under the control of Japanese capital and was attempting to begin the manufacture of Japanese-style tableware (washokki) for consumption in Manchukuo. It was at the behest of the company's Japanese directors that the mingei potters supervised the largely Chinese staff of artisans in the experimental production of over a thousand pieces of pottery meant to serve as prototypes for the machine production of teabowls, covered rice bowls, covered dishes, tea cups (for black tea), milk pitchers, and tobacco implements. These objects were designed to adapt the shapes and patterns of a type of indigenous folk pottery known as "Nazuna te."[69] As Shikiba explained in a 1944 article in the magazine Kaitaku (Settlement), ceramics produced and consumed by Japanese in Manchukuo ought to "exhibit the special character of Japanese resident in Manchukuo by using Manchurian materials and taking advantage of its techniques."[70]

CRAFTING A GREATER EAST ASIAN CULTURE OF DAILY LIFE

Mingei activism in China and Manchuria was also distinguished from earlier efforts to promote new mingei, whether in Japan or Korea, by the prominence it gave to the goal of a transformation of daily life culture (seikatsu bunka). The phrase "daily life culture" recurs regularly in mingei writings of the early 1940s, as it does in Japanese publications generally during this period. To some extent, the ubiquity of public references to daily life culture reflects little more than its status as an official slogan associated with the mobilization of civilians for total war. Yet leading members of the Mingei Association, along with those parts of the government committed to the renovationist program elaborated by intellectuals such as the philosopher Miki Kiyoshi and the directors of the Cultural Section of the Imperial Rule Assistance Association, sought to imbue the concept of a culture of daily life with more concrete significance. In the ideology of daily life culture, a classically fascist preoccupation with ethnonational unity and rationalized productivity was linked to a campaign to reform household consumption.[71]

Yet the activities of Yoshida and other Mingei Association members in China and Manchukuo suggest that renovationist ideas about daily life culture were considered to have relevance beyond the "inner" home front of the main Japanese islands. Moreover, continental Asian seikatsu bunka was to

aid in the creation of Japanese seikatsu bunka. Mingei activists hoped that their efforts to discover, develop, and reform continental Asian handicrafts would create a new culture of daily life for native Chinese and Manchurians, as well as for Japanese colonists; they also aspired to use their work in China to reform daily life within Japan proper. Thus mingei activism in China offers insight into just what was signified by official rhetoric about the construction of a Greater East Asian culture (dai Tōa bunka no kensetsu), in which indigenous Asian strengths were to be managed by Japan toward the creation of a new world culture.[72] It also shows that the wartime campaign to renovate Japanese culture and society interacted with imperialism in ways that affected not only the nature of Japanese colonialism, but also that of Japanese fascism.

Several specific mingei projects demonstrate the interaction between wartime colonialism and domestic renovationism. For example, by 1942 the three Mingei Association members in North China had developed a special concern with the role of clothing in the new Asian daily life culture they hoped to help shape. The interest in dress stemmed in part from a discomfort and even shame that Yoshida, Okamura, and Yanagi Yoshitaka seem to have felt in connection with the appearance of many Japanese in China. Writing in late 1941 of the problem of what Japanese should wear in China, Okamura commented, "It can be said that the occasional sight of [Japanese] walking the streets looking slovenly to a degree that cannot be seen even in the Japanese home territory is truly a national disgrace." He argued that Japanese-style dress (wafuku) was inappropriate to the continent, and that "thoughtful persons must reform as soon as possible the wearing of Japanese-style dress so slovenly it makes your face sweat [to see], and this is the duty of we Japanese in the field."[73] Yet neither Okamura nor Yoshida thought that Japanese should wear Chinese-style dress (Shinafuku), at least not as Chinese wore it. In 1942 Yoshida deplored the fact that Chinese dress, which he disliked because the men's version resembled the women's, was worn by some Japanese. He noted that only Western missionaries looked good in Chinese dress; he attributed this to the way "their cultivation refines Chinese dress and creates something new."[74]

Implied in Yoshida's rejection of Chinese dress was a concern that Japanese were not as successful as (cultivated) Westerners in overcoming the putative effeminacy of traditionally Chinese male costume. And as suggested by Okamura's objections to the sight of Japanese in "slovenly" kimono, a related motive behind the quest for dignified, masculine garb was an anxiety

about colonial prestige and distinction. It was important to many Japanese that Japaneseness be embodied on Chinese (and Manchurian, Korean, and Taiwanese) streets in a manner that confirmed the legitimacy of Japanese rule, rather than undermining it. Yet the familiar colonialist imperative to present the natives with a clean, potent, and civilized self was modified in two significant ways for Japanese in wartime China. First, the impulse to invent a new type of costume was also informed by the renovationist campaign to reform dress within the Japanese metropole. Second, the reform of daily life culture was also intended to distinguish Japan—together with Japanese-controlled Asia at large—from the West. The new look that mingei activists hoped to create was ultimately to garb Chinese as well as Japanese and to demonstrate a pan-Asian modernity to the rest of the world.

Beginning in the late 1930s, various ministries and government agencies became interested in the possibility of designing standardized clothing to be worn by civilians in Japan. After several false starts, a committee formed by the Army and Welfare Ministries produced in early 1940 several designs for a regulation "national dress" (kokuminfuku) for men. These designs were officially promoted for general use by a "national dress edict" (kokuminfuku rei) in the same year. Unlike the "standard dress" (hyōjunfuku) designs put out later for women by the Ministry of Welfare, national dress designs seem to have been adopted widely. By the early 1940s, surveys conducted in Tokyo and Osaka suggested that over 10 percent of urban men were choosing to wear national dress. Government planners were clearly anxious to promote national dress and standard dress as a means of controlling the consumption of increasingly scarce civilian goods. For military officials, moreover, it was desirable that civilians acquire the habit of wearing standardized outfits suitable for military activity; not only would such clothing be useful in the event of civilian mobilization for military duty, as substitutes for regular army uniforms, but its regular use would promote the sort of social unity and regimentation essential for total war. The actual clothing designs reflected these priorities. National dress and standard dress were carefully designed to save cloth; the formal version of national dress for men dispensed with the formerly de rigueur waistcoat and necktie, for example, and the kimono version of women's standard dress stipulated a narrower obi (belt) and sleeves than was customary. All of the designs were intended to promote physical mobility, and they were to be produced and worn in cloth of "national defense color," or military khaki. Yet as Inoue Masahito argues in his study of national dress, the campaign to come up with a new,

standardized form of dress cannot be explained solely in terms of economic or military imperatives. Also important was the desire shared by many private groups and individuals, as well as government officials, to invent a new costume that was both modern and non-Western. The elimination of the necktie and its replacement by a wrapped "Japanese-style" collar, for example, was touted not only as a way of conserving cloth, but also as a modern application of Japanese rather than Western tradition and design.[75]

By late 1942, the mingei activists in China had come up with designs and prototypes for new Asian outfits that strongly resembled national dress. One Mingei Association member, Muraoka Kageo, visited Beijing in September 1942 to find Yanagi Yoshitaka at work at the central committee office of the People's Renovation Society attired in "apparel of his own design." Muraoka praised the outfit, which he described as "dark blue in color, of handmade cotton material, in pattern resembling the Concordia Dress [Kyōwafuku] of Manchukuo or National Dress No. 2 [Kokuminfuku otsu go] of Japan, but with a removable collar." Muraoka pronounced it an improvement over both of the latter. During the same visit he also described Yoshida's design for the summer version of a costume called the "Asian Development Dress" (Kōafuku). This was essentially a Western-style suit of jacket and trousers (as were all versions of national dress), but with a lower, looser removable collar, that had been selected as the 1943 summer uniform for members of the People's Renovation Society. Muraoka ordered one suit for himself and expressed the intention of wearing it in Japan to promote its use there as well.[76]

The adoption of Asian Development Dress as a People's Renovation Society uniform meant that it was worn, at least in theory, by a fair number of prominent Chinese as well as Japanese throughout northern China. (According to one official estimate, the People's Renovation Society numbered five thousand leaders and more than three and a half million members in 1944.)[77] Yoshida sought in other ways as well to promote a daily life culture, and specifically modes of dress, to be adopted by Chinese as well as Japanese. As he put it in 1941, "[Clothing] is one of the problems of our culture of daily life in North China, and it is the first thing we have taken up, as it is near at hand. Of course this is for Chinese, and it is also for Japanese living in North China."[78] At official exhibits in 1941 and 1942, new textile handicrafts produced under the supervision of Yanagi Yoshitaka and Okamura were displayed along with signs in Chinese with such slogans as "Wear cotton clothing in North China," "Simple beauty is Asian development beauty

[Kōa bi]," and "Let us cast out of North China Western fashions and clothing with a corrupt beauty that causes incorrect luxurious sensations."[79]

Mingei activists in Tokyo, as well as in China, hoped that their work on the Asian continent might aid in the construction of a new and genuinely pan-Asian culture of daily life. As indicated by occasional comments to the effect that the clothing designed by Yoshida and his subordinates in China ought to be worn in Japan, leading members of the Mingei Association seem to have imagined that Japanese in the inner territories could and should adopt a new Asian daily life culture combining Japanese and non-Japanese elements.[80] Shikiba was forthright in his editorial notes for a 1942 issue of Mingei: "Yoshida's pieces will be published serially beginning with this issue. [These will deal with] the problem of clothing for the new age, and of food and housing, and also with welfare [kōsei]. They will give concrete form to the new Japanese daily life culture in which Asian tradition is employed, and Western ways are eliminated, and should be attended to closely. The era of discussion is over. Our ideals may well be realized first in North China."[81]

There is some evidence that Yoshida was successful in having his views on clothing and an "Asian daily life culture" taken up beyond the relatively narrow circles of the Mingei Association, by other influential Japanese-controlled organizations in China. In the tourist magazine Hokushi (North China), for example, a photo feature on the "welfare crafts" produced under Yoshida's aegis stated simply, "One may view here the form of a new Asian culture in which Japanese knowledge and feeling have been combined with Chinese resources and tradition." Pictured were several cups, some woven and embroidered cloth, and a woman wearing a short-sleeved, knee-length dress with a mandarin collar.[82] In 1943 the People's Renovation Society established a North Chinese Welfare Industries Guidance Center which incorporated and expanded the handicrafts projects initiated by Yoshida and his colleagues; according to Yoshida, one of the four founding principles of the Center, announced at its opening ceremony, was "to cleanse Asia of the daily life implements which are the products of the free commercialism brought from the West, and to exalt the new Asian daily life culture."[83]

The ideas of Yoshida and his supporters should be understood within a much broader context of renovationist thought, according to which Japanese expansion on the Asian continent was to serve as a means of promoting reforms within Japan proper. The view that Japanese culture and society should change so as to conform more closely to those of Asian territories

under Japanese control—the idea, as it were, of "assimilating" Japanese to non-Japanese culture—was by no means widely shared. As Komagome Take-shi has argued, the basic policy followed (with some variation) by the war-time state in all of the northeast Asian regions subject to Japanese control was of cultural assimilation and political differentiation. Non-Japanese were to learn Japanese, and even in some instances to take Japanese names and worship at Shintō shrines; yet their non-Japaneseness, which was inscribed more or less permanently in the household registry system of identifying an individual's original domicile (honseki), destined colonial subjects to system-atic political disenfranchisement.[84] Nevertheless significant factions within the Japanese military and government, along with influential individuals and groups outside officialdom, envisioned a somewhat different relationship between metropole and Manchurian or Chinese colony. Nor were these fac-tions entirely without influence. It is telling, for example, that national dress was originally modeled on "Concordia Dress" (kyōwafuku), a standardized national costume instituted in Manchukuo in 1936. The government agency that first proposed a domestic equivalent to Concordia Dress was the Cabi-net Information Bureau, a hotbed of renovationism.[85]

Indeed, key groups in both Manchukuo and Japan saw Manchukuo as a model nation-state in which Japanese planners might institute an ideal, fascist type of polity and society, preparatory to similar reforms in Japan proper. Of course, there was disagreement as to what constituted a model nation-state and how such a model might be used to change Japan. Still, the general outlines were reasonably consistent. For leading members of the Kantō (Kwantung) army in Manchukuo, the emphasis was on creating a state-controlled form of industrial capitalism, or state capitalism. They ide-alized a "statist harmony" predicated on the vastly reduced influence of political parties and private capital, and they planned ultimately to use their achievement in Manchukuo to reform capitalism in Japan.[86] Similarly, the renovationist bureaucrats who were sent in the mid-1930s to help govern Manchukuo wished to perfect there a totalitarian and highly rational form of state control; the "modern national defense state" they planned was then to serve as a model for Japan.[87] For both factions, as for various groups of intellectuals in Manchuria, a crucial element of the new order in Manchukuo was the state-administered mass organization known as the Concordia As-sociation (Kyōwakai), established in 1932. Although in fact an agency for the purpose of mass education, mobilization, and surveillance, the Concordia

Association was imagined as a fascist-style mass party, representing to the state the interests and will of the people.[88]

Needless to say, the dream of perfect, technocratic state control over an industrialized economy and a harmoniously integrated nation was never fully realized in Manchukuo, let alone in Japan. (In Japan especially, the dogged resistance of the political parties, the business community, and the more traditionalist bureaucracy undermined the fascist New Order movement led by renovationist bureaucrats from the very moment of its inception in 1940.) Yet Manchukuo, and the puppet regimes of northern China which were directly modeled on Manchukuo, continued to occupy a special place in the renovationist imaginary as sites where the great reforms necessary for a Japan-led Asia might be initiated.[89] For example, the intellectuals who led the Shōwa Research Group (Shōwa kenkyūkai), which provided much of the ideological substance of the New Order movement in Japan, hailed Japanese military expansion into China after 1937 as an opportunity to "cooperate" with China in creating a "revived," "anticommunist," and independent Orient.[90] Miki Kiyoshi, in particular, articulated a program for the Japanese construction of a new East Asian culture of "world significance" based on the Oriental principle of "cooperativism" (kyōdōshugi).[91] While very abstract, and therefore vague in terms of policy implications, Miki's views clearly endorsed change in the nature of Japanese culture as part and parcel of the creation of a new Asian culture; as he put it in late 1938, "Japanese culture too must adapt to this new order [in Asia], and accomplish reforms."[92]

Whether or not the specific reforms mingei activists attempted to effect in China and Japan corresponded precisely to Miki's vision, or to the visions beheld by other renovationists, it is clear that they were animated by a certain broader consensus about the possibility of linking Japanese-led change in East Asia to change in Japan. Much like other policies and reforms informed by the renovationist consensus, the mingei projects in China and elsewhere also betrayed a fatal inability to overcome the contradiction between a rhetoric of genuine creativity and liberation and shared prosperity on the one hand, and the actualities of Western hegemony and Japanese imperialism on the other. Another specific area of concern for mingei activists—the chair—serves to illustrate this point. Between 1940 and 1945, the magazine Gekkan mingei repeatedly ran articles and photo features on Chinese chairs and stools; three issues even used photographs of Chinese or Chinese-inspired seating for their covers.[93] For the weaver Yanagi Yoshitaka, the Chinese chair

suggested, first of all, an avenue for the reform of the lifestyles of Japanese living in China. Yoshitaka complained in 1941, much as his uncle Muneyoshi had done several years earlier of Japanese in Korea, that "people from the inner territories" (naichijin, i.e., Japanese) were unable or unwilling to modify their lifestyles in accordance with local ways and things. Unlike the elder Yanagi in 1938, however, Yoshitaka went on to propose the contribution that regionally specific Asian material culture might make not only to Japanese daily life, but to the daily life of Asia generally. Not only would this new daily life culture improve the lives of Japanese in China, but ultimately it would represent a hybrid improvement on even the most excellent indigenous Chinese culture, and one that would redound to the credit of Japan in the world. Yoshitaka wrote of a chair he had found in a provincial Chinese market in late 1940:

> When I see everywhere I walk in China the way of living of the great majority of Japanese, who conduct their daily lives with Western-style furniture that appears luxurious at first glance and [yet] displays a low level of cultivation, I think that this one chair offers an indication of the direction for the new, healthy daily life culture that Japanese must create on the continent. . . . None of the Japanese who have worked in the interior of the continent have felt like putting roots down into the soil, and their daily lives are all dried up, and I think that this is because their lives have an impossible element, and they cannot enjoy the local daily life they have been given. In this sense, I feel a duty to create a more rational, pleasant, beautiful lifestyle. . . . This one chair gave me limitless joy and hope; how can Chinese materials, techniques, and human beings be newly made the most of [ikasu] by Japanese hands—brought up, and given strength for the sake of Japan? [The chair] is fine as it is, but the time will come when, reared in a more vital form, it will confront the world.[94]

The efforts of the Mingei Association to give concrete form to a new daily life culture demonstrate the extent to which renovationism represented a determination to achieve an indigenous, non-Western modernity which Japan might lead other Asians to adopt. And yet the new furniture and clothing envisioned and actually produced by mingei activists suggest that it remained difficult to imagine a modernity altogether different in its material, everyday details from the Western model, which had already been thoroughly assimilated by modernizing elites in Japan, and indeed throughout

**20.** The cover of the April 1941 issue of *Gekkan mingei.* Pictured is a wooden Chinese chair. Photo courtesy of Fine Arts Library, Harvard College Library.

Asia. As Kenmochi Isamu, a designer for the Ministry of Commerce and Industry's Industrial Arts Research Institute, began a 1942 *Mingei* article on Asian chairs, "Today, the question of whether to adopt a chair lifestyle, or whether to retain the older floor-sitting style [*zashiki*], only concerns the home, and it is fair to say that daily life outside the home, or public daily life, has already been completely transformed into the chair style. The interiors of government offices, companies, factories, schools, and public facilities must all be in the chair style."[95] In short, chairs had become indispensable. Nevertheless, Kenmochi argued that Japanese need not simply resign themselves to the chair-sitting lifestyle as a Western import. The existence of indigenous Chinese chairs offered an opportunity to reinvent chairs in a non-Western form for Japan as well as for Asia at large. Nor was that goal exclusively ideological. As explicated by Kenmochi, a designer attached to the government ministry primarily responsible for overseeing international trade, the Japanese adaptation of Chinese (and other Asian) chairs would also produce material benefits: "Japan must have Japanese chairs. And by extension there must be Asian chairs. Up to now quite large quantities of bentwood chairs from Japan have been consumed on the continent, and in

the Southern [Asian] regions. In future there will be many times the demand. Is it acceptable then that products continue indefinitely to be second- or even third-rate, inferior imitations of European chairs? . . . We must advance to reform not only chairs, but also desks and shelves and indeed the entire space of daily life."[96]

There is a crucial ambiguity at the heart of Kenmochi's argument for reinventing Western-style furniture along more indigenous, Asian lines, as indeed there was at the heart of the larger project of establishing a Greater East Asian culture. Although a Japanese-led autarky in East Asia was expected to produce order and prosperity for all the peoples therein, it was always possible to discern that the multinational "coprosperity" promoted by Japanese planners was hierarchically differentiated along ethnic and regional lines. Moreover it was clear that in practice, Japanese advantage was always the primary, even sometimes the exclusive consideration. Kenmochi may have believed that Japanese exports of more genuinely Asiatic furniture would improve the quality of daily life for Asian consumers, but it seems safe to presume that he was also intent on aggrandizing Japanese market share abroad. Similarly, mingei activism in China was ultimately most responsive to the narrowly Japanist priorities established by military planners. In its methods as well as its ends, the North China mingei movement consistently gave pride of place to the interests of Japanese producers and consumers. Not surprisingly, therefore, its achievements in China were limited.

By 1943 Yoshida was forced to admit that his new craft movement was far more successful in the resident Japanese community of North China, particularly of Beijing, than it was among Chinese consumers. In early 1943 he wrote a summary of the mingei events of the previous year in which he acknowledged that most of the visitors and buyers at the Chinese welfare crafts exhibits had been Japanese: "I think that our North Chinese mingei movement is close to success with regard to resident Japanese, but I have learned that with respect to Chinese people it is necessary to think over the movement's methods. If objects are not first filtered through the daily life of resident Japanese, they will not enter into the daily life of Chinese intellectuals. This is because present-day Chinese intellectuals are so Westernized."[97]

Nevertheless the support of the Japanese community was enough to warrant the continuation and even expansion of Yoshida's work. In addition to the various exhibits and exhibition sales of new Chinese mingei or welfare crafts sponsored by the People's Renovation Society in Beijing as well as other cities, North Chinese branches of Japanese department stores like

Shirogiya (in Beijing) and Daimaru (in Tianjin) began to show and sell these objects to Japanese residents as well as tourists.[98] In 1942 Yoshida was put in charge of acquiring examples of Chinese mingei for the collection of the central committee of the People's Renovation Society in preparation for the eventual establishment of what was to be called the North China Modern Mingei Museum (Kahoku gendai mingeikan); in 1943 his collecting budget was increased.[99]

Also in 1943 Yoshida helped to establish in Beijing a central People's Renovation Society agency called the North China Welfare Industries Guidance Center (Kahoku kōsei sangyō shidōjo) largely for the purpose of directing the study and reform of North Chinese handicraft production.[100] Finally, in the fall of 1943, Yoshida succeeded in opening the North China Daily Life Craft Shop (Kahoku seikatsu kōgei ten) in Beijing. The shop, which was modeled on Takumi, the Tokyo store Yoshida had originally founded in Tottori, seems to have been financed by a combination of Japanese concerns, namely the Beijing Culture Association, North China Transport (Kahoku kōtsū), and the East Asia Travel Company (Tōa ryokō sha).[101]

Writing of the opening of the shop, Yoshida reiterated his hope that it serve, if only indirectly, to promote the reform of Chinese as well as Japanese daily life. Although the immediate purpose of the store was "to be of great use in enriching the daily home life [katei seikatsu] of resident Japanese and also in raising the level of culture," as well as to serve Japanese tourists, Yoshida proposed a kind of influence by example on Chinese consumers:

> I do not think it impossible that in the future, through this shop, we might take the place of Westerners in giving objects to young Chinese that will fulfill their desire and longing for fresh new things. . . . If we say directly to Chinese that "these are healthy tools of daily life, so you Chinese use these Chinese things," they absolutely cannot accept this obediently [sunao ni]. I think the best method is for Japanese to first take healthy Chinese tools of daily life into the Japanese lifestyle, and to show a Japanese style of using and assimilating them, making them into new objects.[102]

Yoshida's ideas in late 1943 represented something of a retreat from earlier expectations about the role of Japanese like himself in actively constructing a new Asian culture of daily life for Chinese. It is likely that this retreat, with its acknowledgment of Chinese intractability, reflected not only personal experience, but also the growing weakness of the Japanese position

in China. By the middle of 1943, military defeats in New Guinea and at Guadalcanal in the Solomon Islands had not only created increasing doubt about the outcome of the war, but also forced the cancellation of a new Japanese offensive in southwest China against Chiang Kai-shek. As the war situation in the Pacific grew desperate, drawing more of Japan's dwindling resources away from the management of occupied China, the central government adopted a New Policy for China, which involved, among other things, the withdrawal of most direct Japanese intervention in Chinese administration during early 1943. Only indirect aid and guidance was to be given to Chinese administrative agencies, and Japanese army officers were instructed to "behave more respectfully" toward Chinese.[103]

Yoshida noted in a May 1943 article that as a result of the New Policy, the number of Japanese officials in the People's Renovation Society had been reduced by two thirds. He had hoped that Japanese technicians (gijutsuin) working at the Welfare Industry Guidance Center would be allowed to remain, since their work "had no political aspect," but in the end only a few stayed on, and with only "consultative status."[104] Yoshida expressed no overt dissatisfaction with these changes and their ramifications for his craft movement. Indeed, his "North China Report" for the June issue of Mingei declared, "The mingei movement in North China must come not from resident Japanese, but from among Chinese people," and he closed with the announcement of a North Chinese exhibit to be held in Beijing under Chinese direction. "I have great hopes for this," he claimed.[105]

Yet in one of the last articles he sent to Mingei from Beijing, a piece which appeared in January 1944, Yoshida suggested that the Chinese appropriation of the work he had begun had forced him to consider an altered direction for the mingei movement in China. He began the article by describing the exhibition of objects produced under the direction of the newly sinified Welfare Industry Guidance Center. He praised the show, but concluded, "Because Japanese were not involved in the exhibit and it was the work of new Chinese workers, the crafts were still at a low level." He went on to propose that the work of investigating Chinese mingei and adapting it for use in contemporary daily life—the work to which he, Okamura, Yanagi Yoshitaka, and others had devoted several years—was nearing completion. Arguing further that Japanese living in China needed to go beyond the assimilation of Chinese-produced objects of daily use to actively create their own culture of daily life, Yoshida called for the establishment of a separate craft guidance and research center to direct the work of Japanese artisans in

China producing for the resident Japanese community: "The work done by such people as Yanagi Yoshitaka, Okamura Kichiemon, and Yoshida Teizō in Juntoku and Sekimon ought to be one part of the work of this research center. So should the life of Kawai Takeichi in Hakusan. However now, because of the change in Japanese policy, everything has been transferred to the Chinese. And yet things are no longer coming from the inner territory. It is urgent that this research center be established immediately."[106]

By the end of 1943 Yoshida's vision of a vast Asian and even global new material culture governed by Japanese "art and learning" had begun to shrink within the confines of an increasingly defensive and isolated community of Japanese colonists. The story of the Japanese in China over the next two years, and of the end of Yoshida's Chinese craft movement, remain obscure, although the general outlines of debacle, rout, and flight may be surmised. Somehow or other, all of the Mingei Association members in China were fortunate enough to return to Japan by the end of the war. What, if anything, had they achieved? Accounts of the People's Renovation Society, and of wartime Japanese cultural campaigns in Asia generally, usually stress the empty opportunism of Japanese propaganda and suggest that such institutions and efforts were "but a minor footnote in the tragic history" of Japan's relations with the rest of Asia.[107] Certainly the Japanese attempt during the 1930s and early 1940s to construct a Greater East Asian culture, like the attempt to control Asia, was neither successful nor just. Yet however inadequate and self-serving many of the colonial ideals and practices of Japanese in Korea, China, and Southeast Asia have come to seem, it is important to recognize their significance not only for the story of Japanese imperialism abroad, but also as a means of understanding developments within Japan itself.

## Ryūkyū Fever

With the Meiji state's incorporation of the northern island formerly known as Ezochi in 1869 as Hokkaido, and of the Ryūkyū kingdom in 1879 as the prefecture of Okinawa, Japan established modern national boundaries containing what had long been indeterminate peripheral zones to the north and south. Over the ensuing decades, the ethnically and culturally distinct inhabitants of those zones were reclassified as Japanese nationals and from a legal perspective rendered identical to subject-citizens throughout the new nation. The process of Japanizing Okinawans and the indigenous northern

peoples known collectively as "Ainu" included assimilationist policies of what David Howell has called "ethnic negation."[108] Yet until the 1930s, assimilationism—the effort to make ethnic Okinawans and Ainu conform in appearance, behavior, and even consciousness to norms of the majority or "Yamato" Japanese—occurred in only somewhat desultory fashion. Assimilationist pressures increased, however, with economic depression and the escalating war effort; in Okinawa, especially, the combination of extreme poverty and a strategic military situation produced a growing sense among many Okinawans themselves, as well as among military and government authorities, that conspicuous ethnic difference was no longer tolerable. It was in this context that, in 1939, a group of mingei activists led by Yanagi traveled to Okinawa and claimed to discover there the survival of a pristine and extraordinarily beautiful premodernity. They criticized the modernizing, assimilationist policies of local government, thereby launching what would become a national debate on Okinawan difference and its merits for the larger Japanese polity.

In early 1939 the Mingei Association was suddenly gripped by a fascination with Okinawa so great that members referred to it as a type of fever, a "beautiful disease."[109] The most immediate cause of enthusiasm for Okinawa, the remote island chain making up Japan's poorest, southernmost prefecture, was Yanagi's visit there at the end of 1938. He undertook the four-day ocean voyage at the invitation of the education department of the Okinawan prefectural government to discover what he described to his friends as a "handicraft paradise" (kōgei no tenkoku).[110] Yanagi returned to Tokyo in late January 1939 with many Okinawan handicraft objects, and a plan. Only a few days after his return he wrote to Takeuchi Kiyomi, a mingei activist in Kurashiki, that he and eight others would soon revisit Okinawa and that "[this] will be the greatest work of the Folk-Crafts Museum this year."[111]

The interest of Yanagi and others in the Mingei Association was also based on some earlier acquaintance with Okinawa and its handicraft products. Hamada and Kawai had both visited Okinawa decades earlier to study local ceramics techniques. Okinawan textiles and lacquerware were well-known in Japan, and in various publications and exhibitions the Mingei Association had already demonstrated special interest in certain distinctive varieties of Okinawan dyeing and weaving.[112] But perhaps the most important reason why Okinawa took hold of the collective imagination of the Mingei Association in 1939 was that it had already done so for many other

Japanese on the main islands. The folklorist Yanagita Kunio is commonly considered to have launched both his new discipline of native ethnology, as well as a new academic fascination with Okinawa, in the early 1920s with the establishment of his Southern Islands Discussion Group (Nantō dan-wakai).[113] At the same time that a growing number of Japanese scholars were building upon the theory, most famously elaborated by Yanagita, of the origins of Japanese culture in the South Seas, Okinawa began to figure more frequently in the Japanese press as an exotic site for tourist pleasures.[114] The growing academic and popular interest in "Ryūkyū," the exoticizing referent favored by many main-island Japanese, was bolstered during the 1930s by increasing state concern with the mobilization of a strategic peripheral zone.[115]

In a statement published in *Gekkan mingei* in late 1939, Yanagi acknowledged the larger context of Japanese interest in Okinawa at the same time that he tried to distinguish his own approach from it: "In the academic field there are doubtless many excellent pieces of research, but many have done no more than treat Ryūkyū as likely data, and they have not been able to go from there to respect and affection for Ryūkyū. However we, fortunately, are people who have walked intimately in this land, and who have been struck by unlimited astonishment, and felt an endless joy."[116] The interpretive framework within which Yanagi and the rest of the Mingei Association explained their concern with Okinawa derived directly from the scholarship of Yanagita and others who claimed to discover in Okinawan culture the living vestiges of ancient Japanese civilization. In an article published earlier the same year Yanagi described Okinawa as a place where "crafts are continuing in a pure condition." Drawing upon current linguistic theories, he added, "In order to know ancient Japanese [language] in a living form there is nothing for it but to go to Ryūkyū; crafts too are that way."[117]

In preparation for the first group trip in March 1939, Yanagi determined not only that he and his associates would find in Okinawa the survival of a "pure Japan," but that the work to be done there included the further development of Okinawa's "distinctive character" (*tokushoku*). Just as he had done several years earlier in rural Korea, Yanagi looked forward to investigating in Okinawa a pristine way of life that included handicrafts but also "nature, buildings, carvings, food, customs, and language." Moreover, just as other mingei activists would attempt in Korea and also China, Yanagi expected to shape the new production and adaptation of Okinawan material culture in ways largely dictated by the requirements and tastes of metro-

politan Japanese consumers: "In which direction should what kind of things be made, and in what form? We, who know the demands of the inner territory [naichi], can perhaps give some effective suggestions."[118]

Yanagi's use here of the term "inner territory" or naichi with reference to the main islands points to how, despite assertions of Okinawa's original Japaneseness, he and other Japanese were wont to see Okinawa as a place external to modern Japan. Moreover, that externality had colonialist overtones, linking Okinawa to other "external" or "outer territories" (gaichi) such as Korea, Taiwan, Manchukuo, and occupied China. In a sense the mingei activists' habitual use of naichi in an Okinawan context referred to the simple geographical fact that the prefecture of Okinawa, like that of the northern island of Hokkaido, lay at some remove from the politically, economically, and culturally central island of Honshu. And yet in 1939, when Japan and its Asian colonies were regularly denoted by the terms, respectively, of naichi and gaichi, the term naichi signified much more than geographic centrality. The colonialist implications of the idea that Okinawa might belong to Japan at the same time that it remained outside the inner territory were reinforced by the distinctive cultural and ethnic identity of native Okinawans and the persistent forms of political, social, and economic discrimination to which they were subjected by non-Okinawan Japanese. As the Okinawan scholar Iha Fuyu wrote in the 1920s, Okinawans were "Japan's oldest colonized people."[119]

In the early phase of their enthusiasm, mingei activists emphasized not only Okinawa's difference from main-island Japan, but also its links to other parts of Asia. Yanagi wrote in 1939 that the three main influences on Okinawan pottery culture were China, Korea, and the early modern Japanese domain (han) of Satsuma. Similarly, others stressed the Chinese elements in Okinawan dyework and the evidence in Okinawan weaving of influences from the Philippines or Borneo or even the indigenous tribal cultures of Taiwan.[120] In addition to noting the historic connections between Okinawa and other Asian cultures, mingei activists cited the relevance of their work in Okinawa for the various projects they had already undertaken in Asian territories under Japanese control. As the weaver Tonomura Kichinosuke put it in 1939, in the ecstatic register of much mingei writing about Okinawa in this period, "The path into such places as Korea, China, and Manchuria has been made clear to us. Astonishment, respect, and love are the shortest path to an understanding of the new paradise."[121]

Yet for all its paradisal Asian exoticism, Okinawa was an integral part of the Japanese nation-state, and as such had a legal and political status very different from that of Japan's colonial territories. One consequence of the difference, as mingei activists found to their consternation in early 1940, with the eruption of the so-called dialect controversy, was that local elites had their own well-established views on the significance of distinctively Okinawan culture and on the proper relationship between Okinawa and the rest of Japan. Moreover, they were capable of enacting official policies based on those views and of defending those policies effectively against the criticism of outsiders—even the criticism of famous outsiders from Tokyo, or the very heart of the naichi.

The controversy began during the Mingei Association's second group expedition to Okinawa at the end of 1939. Led and organized by Yanagi, the "Ryūkyū tour group" (Ryūkyū kankō dan) numbered twenty-six and included several bureaucrats from the Japan Travel Association (Nihon ryokō kyōkai) and the International Tourism Office (Kokusai kankō kyoku), along with several photographers, a movie crew from the Shōchiku film company, the writer Yasuda Yōjurō, and sundry others.[122] (Each participant paid 100 yen to cover expenses for travel and a stay in Naha of about five days.)[123] Although most of the group returned to Tokyo in early January 1940, Yanagi and his closest associates stayed on somewhat longer, renting a house in the Okinawan capital of Naha to pursue various handicraft projects.[124] As it turned out, much of the Mingei Association cohort's remaining time in Okinawa was actually taken up by their participation in a lively public debate that began during a round-table discussion held in Naha on 7 January 1940 and that continued in dozens of articles in newspapers and magazines over the next year.

The round-table discussion was organized by the Okinawa Association for Tourism (Okinawa kankō kyōkai) and the Okinawa Locality Association (Okinawa kyōdo kyōkai) to treat the theme of tourism in Okinawa. Participants included about fourteen of the mingei contingent, along with various local notables such as the chief of police, a middle school principal, the director of the local chamber of commerce, and the editor of the daily newspaper, Ryūkyū shinpō. The controversy began when Mizusawa Sumio, the representative of the Tourism Office in Tokyo, stood up to deliver his impressions of Okinawa. After noting the desirability of improved roads and hotel facilities, along with the importance of preserving scenic buildings

and landscapes, Mizusawa commented on the unpleasant ubiquity of post-
ers promoting the use of standard Japanese language (hyōjungo). Not only
did the posters, which bore such slogans as "Always, crisply and clearly,
standard Japanese" and "Standard Japanese with the whole family," give the
visitors from Tokyo a "strange feeling" (kii no kan), but Mizusawa suggested
that the prefectural campaign to promote standard Japanese was perhaps
"going too far." He added that what really ought to be prohibited was not
local dialects but modern eyesores such as a concrete wall erected in the
castle town of Shuri.[125]

Mizusawa's comments initiated an extended and heated debate between
the group from Tokyo, led by Yanagi, and those representing official Okina-
wan policy, led by the local police chief, Yamauchi, on the general question
of whether or not features of traditional, distinctively Okinawan culture such
as language, architecture, and burial customs should be preserved. Although
the round-table discussion itself ended inconclusively on a vague note of
reconciliation, the debate was featured prominently the next day in all three
of the Okinawan dailies. The publicity led to an increasingly rancorous
exchange of published views by Yanagi and his sympathizers on the one
hand, and the Okinawan prefectural government's education department
and various Okinawan intellectuals on the other. The debate was taken up
over the summer of 1940 by national newspapers and magazines based in
Tokyo and continued on both the local Okinawan and national Tokyo levels
for much of the year.

The basic conflict driving the "dialect controversy" was between the Min-
gei Association, which sought to preserve what it identified as distinctive
Okinawan traditions against the homogenizing effects of modernization,
and two linked local forces: the Okinawan prefectural government and na-
tive Okinawan elites. In keeping with policies established by the Meiji state
toward minority ethnic groups such as Okinawans and the Ainu, local gov-
ernment in Okinawa had long sought to promote the cultural assimilation,
or Japanization, of Okinawans. The campaign to Japanize Okinawa and
Okinawans gained greater momentum in the 1930s, owing to a combination
of economic and political factors. It was hardly likely, therefore, that local
officials would brook any interference in their work from a group of writers
and artists visiting from Tokyo. Representatives of local government were
joined in their opposition to the Mingei Association by Okinawan intellec-
tuals and other elites, who understood the impulse on the part of "main-
islanders" to identify and preserve Okinawan difference as merely another

attempt by condescending Japanese to deny Okinawans the rights and privi-
leges of full identity as subjects of the Japanese empire.

According to Shikiba Ryūzaburō, "What particularly caught [the mingei
group's] eye" on the day after the round-table discussion "was that in spite of
the fact that opinions on a variety of other subjects came up during the
discussion, all the newspapers dealt for the most part only with the issue of
standard Japanese language."[126] Standard Japanese, namely the type of Japa-
nese that had been developed as the national language beginning in the late
nineteenth century on the basis of the Tokyo-area dialect, had been officially
promoted in Okinawa from as early as the 1880s. Beginning in the 1920s and
1930s, however, the continuing inability of most Okinawans other than a
small educated elite to use anything other than their own languages became
identified for the Okinawan public as a pressing social problem. This was
largely in connection with the discrimination encountered by the growing
numbers of Okinawan emigrants to western Japan as well as to Japanese
colonial regions. Also, from the late 1930s local authorities were encouraged
by national wartime mobilization efforts to undertake steadily more aggres-
sive campaigns to encourage all Okinawans to learn and use standard Japa-
nese.[127] A special concern for the prefectural government was the rapid incul-
cation of Japanese-language competency in Okinawan military recruits.[128]
Thus in 1940, when Yanagi and his companions steamed in from Tokyo to
criticize prefectural policy on language reform, they took on an issue that was
more complex and sensitive than they knew.

The members of the Mingei Association were perhaps most surprised and
aggrieved by the reaction of many Okinawan intellectuals. Yoshida Tsugu-
nobu, for example, wrote an article for the Okinawa edition of the *Asahi
shinbun* titled "Pet Prefecture" ("Aiganken"), in which he accused the "min-
gei people" (*mingeikatachi*) of irresponsibility and condescension: "What they
say is always this: 'Because we've taken all this trouble to come so far, it's a
problem for us if you don't retain your unusual and interesting things.' They
are making the prefecture too much the object of their curiosity. . . . But
what's really bad is when they think [of it] as nothing more than an ornamen-
tal plant or a pet animal."[129] Yoshida, a native Okinawan, was also an official
in the education department of the prefectural government. Recently re-
turned from Tokyo, where he had earned a degree at Tokyo Imperial Univer-
sity, he had fresh memories of his own struggle to master standard Japanese.
He was galled further by the refined airs and affectations of the mingei
group, who seem to have reminded him of the privileged metropolitan

intellectuals he had known and resented in Tokyo.[130] For his own part Yoshida was determined to improve the lot of fellow Okinawans through his work as a government official; his special concern was the reform or modernization of Okinawan daily life. Yoshida's opinions were echoed by those of numerous other Okinawan cultural elites. Dissenting views supporting the position of the Mingei Association were also aired from time to time, but the majority opinion was largely critical of Yanagi and his group, who were depicted as thoughtless outsiders who would compromise the social and economic betterment of Okinawans for their own capricious pleasures.[131]

Stung by these accusations of selfish frivolity, the Mingei Association group countered by lamenting the backwardness of Okinawan intellectuals, who failed to recognize the value of their own culture. It is revealing that the visitors from Tokyo, when challenged, justified their championship of Okinawan premodern culture in terms that drew upon conventional, and colonialist, hierarchies of relative evolution: "When we ask ordinary people of culture in the center [chūō no ippan bunkajin] about this issue, the opinion of many is that 'Ryūkyū today is just like the civilization-and-enlightenment Japanese of an earlier era, [in their attitude] toward Western culture.' [We] want the people in Okinawa today who advocate the reform of custom [fūzoku kairyō] and intend to move to the so-called cultural vanguard to reflect deeply on how they are viewed by intellectuals of the center."[132] In asserting the superior enlightenment of the center over the Okinawan periphery, mingei activists attempted to depress the pretensions of Okinawan elites by invoking the semicolonial differences of status and power to which many Okinawans were already reacting.

Nevertheless, the leaders of the Mingei Association were also forced to make certain adjustments in their own position as they defended themselves against their Okinawan critics. Judging by the written record, the mingei group found it especially necessary to repudiate any suggestion that their advocacy of Okinawan difference ran counter to wartime policies promoting national unity. Over the course of 1940, Yanagi and other spokespeople for the Mingei Association dropped the earlier emphasis on Okinawan culture's uniquely hybrid, Asian character and focused instead on its Japaneseness. Where many Okinawans saw cultural difference as a source of inequality and discrimination (both within Okinawa and between Okinawa and the rest of Japan), and some local and central officials feared it as a source of disunity or even resistance, Yanagi and his associates now defended it as a source of regional—rather than Asian—strength for the nation. This position was

based on two assumptions which came to prominence over the course of the debate. First, the mingei activists presumed an original Japanese cultural unit to which Okinawa belonged and whose characteristics it more authentically preserved than did the Japanese center. Second, they proposed that the Japanese center, weakened by urbanization and Westernization, could be reformed only by the revival of the discrete regional identities in which authentic Japaneseness still survived. Therefore, in its cultural difference Okinawa was both originally Japanese and also assimilable to the rest of non-central Japan.

In the context of the debate, the representatives of the Mingei association made this argument in terms of the Okinawan language or "dialect."[133] As the debate continued, it returned again and again to the question of whether or not mingei activists opposed the prefectural government's campaign to promote standard Japanese. Yanagi and other members of the association stated repeatedly that they objected not to the goal of promoting the acquisition and use of standard Japanese by Okinawans, but rather to methods which attempted to accomplish this goal by suppressing and demeaning the Okinawan dialect.[134] There was much indignant discussion, for example, of a method employed by several elementary schools in Naha, whereby any child caught speaking Okinawan was forced to wear a placard (fuda) of disgrace until he or she discovered another child guilty of the same transgression.[135]

Although Yanagi and his supporters criticized the inhumanity of efforts to compel Okinawans to give up their native tongue, their strongest arguments for preserving and esteeming the Okinawan language revolved around the notion of its value for Japanese. In a statement he published in Okinawan newspapers in January 1940, Yanagi referred to the uses of regional dialects, and especially that of Okinawa, in the future creation of a "purified" Japanese language:

> The particular weakness of the language of Tokyo lies in its unnecessary intermixing with Western language. Today, when national consciousness is swelling, naturally it is right that there be a purification movement [junka undō] for the Japanese language. This ought to be seen as a great and splendid work of the 2600th year of the Imperial Era. So on this occasion, what regional language [chihō go] is useful in the purification of standard Japanese? The Okinawan language must be seen as the most important. One must not be ignorant of the intimate future rela-

tions between standard language and the Okinawan language. One reason why we cannot forbid respect for the Okinawan language is for the sake of the establishment of correct standard language.[136]

Just as regional dialect served the "correct standard Japanese" of the center, the leaders of the Mingei Association maintained that the regional cultures formed in part by dialects were useful and necessary for the creation of a correct national culture. In a joint statement published in the first special issue of *Gekkan mingei* on the dialect controversy, the Mingei Association stressed what it perceived as the larger significance of the debate:

> We believe that this Okinawan problem is not one limited to Okinawa prefecture alone. This must be a problem that can be connected to all the various localities of Japan now. Also this is not just a problem of language, of standard Japanese and dialect. We must take it up here as a problem that extends widely to the entirety of Japanese culture. To put it clearly, our mingei movement is not just a revivalist movement [fukko undō]. Much less is it a movement to halt the progress of present-day culture. The fundamental significance of the mingei movement in contemporary Japan is as a movement to make Japanese culture more Japanese by supplementing with mingei those parts of present-day culture that have become degraded and weak, and at the same time it must be a movement that makes [Japanese culture] even stronger.[137]

Thus by early 1940 the Mingei Association was asserting Okinawa's status as a region of Japan, distinguishable from other regions only by the relative fidelity with which it preserved archaic Japanese culture, and also—perhaps—by the obstinacy and perversity of its intellectual elites.[138] In an exchange published over the summer of 1940 in the *Tōkyō asahi* newspaper and the magazine *Shinchō*, Yanagi took the writer Sugiyama Heisuke to task for suggesting that Okinawa might be classed with non-Japanese regions such as Korea and China. Yanagi wrote, "Okinawa is not the same as Korea or Taiwan, much less places such as China. Mr. Sugiyama writes that 'the [Okinawan] accent is close to that of a Chinese person's Japanese, and for this reason one senses plainly their sense of inferiority [hikeme] when they have contact with us,' but this sense of inferiority certainly will not be eliminated by the campaign to promote standard Japanese, but rather by Okinawans seeing correctly that their local culture has value, and that it is clearly a part of Japanese culture."[139]

The Mingei Association lost the debate on Okinawan culture. The Okinawan prefectural government was undeterred in its campaign to promote standard Japanese and discourage use of local dialect. Nor were Yoshida and his colleagues working on daily life reform prevented from continuing their efforts to make Okinawans wear shoes and conventionally Japanese attire or cremate their dead. The Mingei Association found it expedient after 1940 to give up its group visits to Okinawa, along with its most active efforts to revive and develop Okinawan crafts. The last working visit, made in the late summer of 1940 by Yanagi, Tanaka Toshio, and a photographer, was badly marred by the continuing controversy; Tanaka described their stay as "extremely unpleasant" and noted "terrible obstacles to work."[140] Yet at the same time the Mingei Association found the Okinawan fracas richly rewarding. As members themselves noted, the publicity produced by the debate greatly raised public consciousness of mingei activism and increased the numbers of its sympathizers.[141] Even if many Okinawans resisted efforts by the Mingei Association to portray Okinawan culture and society as a living museum of the Japanese past, that image found a willing audience—and market—in central Japan. In addition to special best-selling Okinawan issues of both Gekkan mingei and Kōgei, the Association published a lavishly illustrated book on Okinawan weaving.[142] Hamada had several one-man exhibits in Tokyo, at the Mitsukoshi department store and at the gallery Kyūkyūdō, of the pottery he had produced in Okinawa. And the mingei shop Takumi offered plenty of Okinawan objects for sale.[143] In November 1940 the Mingei Association organized a three-part exhibition in commemoration of what was widely celebrated as the anniversary of 2,600 years since the semi-mythical founding of the Japanese state; two of the three exhibitions were Okinawan spectacles. The entire Folk-Crafts Museum was given over to a month-long show of "Ryūkyūan Craft Culture," and the Mitsukoshi department store was host to a display of photographs of "Ryūkyū Scenes."[144] Beginning in 1940 Okinawan objects became a regular feature of mingei exhibitions at the Folk-Crafts Museum and elsewhere.

Moreover the Mingei Association's views on Okinawan culture received the general approval of the Tokyo intellectual establishment. With a few notable exceptions, most of the commentary published in Tokyo-based periodicals supported the position of Yanagi and his group. And even though the Mingei Association was unable to affect actual policy in Okinawa, its representations of Okinawa as a paradise of the premodern Japanese exotic were endorsed not only by metropolitan consumers and intellectuals, but also by

the central government. Two officially approved documentaries, or "culture films" (bunka eiga, from the Nazi German term Kulturfilm), made by the Mingei Association and titled Ryūkyū no mingei (Ryūkyū Mingei) and Ryūkyū no fūbutsu (Ryūkyū Scenes), opened to a favorable reception in Tokyo theaters in July 1940.[145] Ryūkyū no mingei, which featured sequences of handicraft production interspersed with scenes of "traditional" life and set to a soundtrack that included Yanagi's wife, Kaneko, singing Okinawan folksongs, was selected for recommendation by the Ministry of Education. As a result the film was entered in a national culture film contest, where it placed eighth in a field of forty-six, and an English-language version was produced for distribution abroad.[146] A member of the imperial family, Prince Takamatsu, even requested a private screening of the film.[147]

Why would the state permit and even approve films, exhibits, and other Mingei Association activities eulogizing a distinctively Ryūkyūan culture at the same time that it promoted heavy-handed assimilation in Okinawa prefecture? One answer is that the Japanese state was by no means perfectly coherent or efficient, and that it was as capable in 1940 as at any other time of inconsistent, even contradictory policies. In particular, 1940 and 1941 saw the brief rise to influence of one particular faction—the renovationist coalition of career bureaucrats, intellectuals, military leaders, and politicians responsible for the so-called New Order (shintaisei)—which tried to institute reforms that often ran counter to the views and interests of other well-entrenched groups in officialdom. While many of the renovationist initiatives quickly ran aground, other policies concerning the revival of distinctive regional cultures were able to gain more headway. One of the key institutional achievements of the renovationist New Order movement was the establishment of the Cultural Section of the Imperial Rule Assistance Association, launched in October 1940. Under the leadership of the playwright Kishida Kunio, the Cultural Section built an ambitious and wide-reaching program to promote the development of autonomous local daily life cultures in the regions of Japan.[148] Kishida's well-publicized views on the true nature of Japanese culture and on the proper relation of region to metropolitan center closely resembled those expressed by Yanagi and other Mingei Association spokesmen. As Kishida wrote in one of his numerous publications from the period, "The correct tradition of Japanese culture exists today not within the culture of the center, which has developed under the influence of foreign culture, but rather within regional culture; without the healthy development of this regional culture it will be impossible to establish the

criterion of a new national culture."[149] The Cultural Section's assistant director, Kamiizumi Hidenobu, expanded upon this point in one of his own books: "In this way the path of regional culture leads to national culture, and national culture leads to a broad Asian culture. The creation of a Japanese culture that may give birth to a world culture is possible through these stages."[150]

Kishida and Kamiizumi were vague on the question of the extent to which future Japanese culture, or Asian culture, or finally world culture would preserve the existence of differentiated regional or national cultures. Others in the renovationist camp—such as the planners and administrators of Manchukuo and visionary ideologues like Miki Kiyoshi—were somewhat more explicit about their commitment to a future in which at least some nations, as well as larger transnational polities such as the "New Order in East Asia," might be founded on a (hierarchical) multiplicity of distinct cultures and ethnicities. In this they suggested an alternative to the older Japanese model of nation and empire, which mandated a monoethnic nation to which peripheral, subject peoples and cultures were to be assimilated.[151] Thus the coincidence of assimilationist policies in Okinawa with celebrations of Okinawan difference in Tokyo may also have reflected the uneasy coexistence of two rather different conceptions of how a nation could and should be constructed internally, and how it ought to relate to nations and cultures at or beyond its legal borders.

And yet the tension between assimilating Okinawan culture and preserving it, or between the monoethnic vision of a colonialist Japanese nation and the multiethnic vision of an anticolonialist Japanese-led East Asia, may also have been more apparent than real. In some ways the preservationism of mingei activists in Okinawa was arguably quite assimilationist. Just as they had done nearly a decade earlier in the San'in region, and later in Korea and China, the Mingei Association members who admired Okinawan handicrafts also presumed to supervise their continuing or revived manufacture. Yanagi and others of the group who traveled to Okinawa repeatedly denied any intention to "guide" or "teach" Okinawans. They claimed instead, "We are going ourselves to study, and therefore are not in a position of guidance."[152] Nevertheless the project of helping to "build a new Ryūkyū on top of the unique Ryūkyū that bears a brilliant tradition" did require management and direction.[153] Often that management and direction sought to reshape Okinawan handicraft production in ways suggested by Japanese models. Even before first departing for Okinawa in the spring of 1939, Yanagi

had collected materials from Kutani, a celebrated Japanese center of pottery production, to aid in the new production he planned of Okinawan *aka-e* ceramics ("red painting," or ceramics decorated with an enamel overglaze). Serizawa Keisuke was commissioned to produce new designs, later learned and executed by Okinawan artisans, for the colorful patterns decorating aka-e pottery.[154]

The mingei experts from the inner territory assumed the exclusive right to determine which sorts of Okinawan handicraft production were authentic and deserved revival or development. For example, they condemned a type of Okinawan pottery called *kotenyaki*, which the Tsuboya kilns had begun to produce during the 1920s and 1930s. Yanagi commented at greatest length on kotenyaki in his editorial notes for the March 1939 issue of *Kōgei*, which was devoted to Okinawan pottery:

> Incidentally, there is a Ryūkyūan pottery called *kotenyaki* that has been gaining ground recently in both the Kansai [region] and in Tokyo. There are lots of flower vases, carved variously, and with various colors applied. As for patterns there are such things as human figures, birds, fish, boats, symbols, banana plants, and flowers painted in great profusion. Most people think that this is Ryūkyū pottery, but this *kotenyaki* is a very recent thing, a product of the past ten years. It is something that was conceived by a trader named Kuroda, and it is widely distributed since it has done very well. But this *kotenyaki* is the worst thing Ryūkyū has ever produced, and has none of the special character of Ryūkyū. Technically, and in a partial sense there are portions that are quite skillful, but this is nothing more than the skillful making of something extremely ugly, and it is a great error committed by Tsuboya.[155]

In an article for *Gekkan mingei*, Hamada Shōji blamed Tsuboya's "error" on the "outside world": "Why is that *kotenyaki* bad?—because it is nothing more than the directives [*sashizu*] coming from a low-level style of life. That badness is something that expresses the badness of the outside world, and is not the badness of Tsuboya. Here also can be seen the worsening direction of modern things."[156]

It is unclear whether the potters at Tsuboya were ever persuaded to desist in the production of objects which, however "bad" or "ugly," had found a lively market in central Japan. Yet the opinions of the Mingei Association carried weight, less perhaps because Okinawan artisans perceived any moral or aesthetic difference between those opinions and "bad" directives from

other Japanese outsiders than because they translated into sales. Tanaka Toshio, the young Association member and textile researcher who zealously chronicled the entire Okinawan episode, quoted a Tsuboya potter on the subject:

> I'm certain that the greatest influence of the Folk-Craft Museum's visit to Ryūkyū, and what impressed the people of the prefecture most, has to do with pottery. That is clear just from the increase in orders from people of the so-called intellectual class [chishiki kaikyū] to myself and others. At present we can respond to only a quarter of those orders. This is especially true of tableware. If we can just continue to study, this demand will increase more and more, and in the future Tsuboya pottery might be something increasingly well worth doing. Also those of the intellectual class who come to visit on a Sunday with the whole family have increased. For this reason also more money is coming into Tsuboya. Also we have opened our eyes somewhat to such things as the kotenyaki business, and have voluntarily raised the wholesale price by twenty percent. The Crafts Guidance Center [of Okinawa prefecture] and dealers are having us make lots of Hamada imitations. These sell well too.[157]

As became explicit during the debate of 1940, the Mingei Association did not in fact object to the ultimate goal of assimilation. Rather, they were concerned about the methods used to achieve that assimilation, and most of all they questioned the nature of the standard or norm to which marginal, regional, or colonial cultures were to be assimilated. In a sense they proposed a *deferred* assimilation of not only Okinawan culture, but also of the corrupt quasi-Westernized Japanese culture they deplored, to a new reformed standard that it was their mission to help define. In the end, it may be speculated that they envisioned a utopian future—a "Kingdom of Beauty"—that was very nearly as unified and harmonious and also specifically Japanese as any hidebound nationalist might have desired. Similarly, even if the renovationist ideal of nation and empire accepted the possibility of greater cultural and ethnic differentiation than did more conventional definitions, there was little disagreement on the goal of Japanese control and management of what was to remain domestically as well as internationally a highly hierarchical, unified, and cooperative system.

One final observation about the apparent contradiction between "Ryūkyū fever" in metropolitan Japan and what would become the literally killing

pressures for assimilation in Okinawa will serve by way of a conclusion.[158] Recall that mingei activists purveyed their fascination with Okinawan culture, and indeed with all the threatened, marginal cultures in and around Japan that caught their interest, in terms of material objects. The textiles and pottery that Yanagi and others acquired in Okinawa and transported to Tokyo and Osaka became emblems there of a beauty and authenticity long extinguished in modern Japan, but still to be found in the tropical paradise of Ryūkyū. The exhibitions, the show sales, the lavishly illustrated publications, and the films all functioned to commodify not only Okinawan craft objects, but more generally the narratives of loss and nostalgia for an exotic Asian past with which mingei activists and many other metropolitan Japanese invested them. In a sense, the spread of Ryūkyū fever among Japanese consumers acknowledged and perhaps even required the imminent disappearance of magical, premodern beauty in Okinawa. It is not necessary to attribute conscious assimilationist intention to those consumers, or to renovationist officials, or to the artists and writers who led the Mingei Association, to entertain the possibility that their version of preservationism was less resistance to the destruction of local difference than its accompaniment.

# Epilogue

The last wartime issue of Mingei appeared in December 1944. The next year was passed by the members of the Mingei Association, as for most Japanese, in the simple struggle for existence. Many fled bomb-ravaged Tokyo and its environs for the relative safety of rural or provincial destinations, while others straggled back to Japan from military and colonial postings in Korea, China, and elsewhere. Precious collections were buried in gardens, or broken up for safe keeping, or even lost and destroyed. Yanagi fell seriously ill and was bedridden for the last months of the war.

Nevertheless the movement and its central institutions managed a remarkably rapid postwar recovery. By January 1946 the convalescent Yanagi was already drafting the manuscript for Nihon no mingei (Folk-Crafts of Japan), which was published several years later.[1] The Folk-Crafts Museum in Tokyo reopened for weekends in January and February, and then daily beginning in March. The shop Takumi started up again. In the year following Japan's surrender, four new regional branches of the Mingei Association were established, in the prefectures of Nagano, Toyama, and Okayama and in the city of Kyoto. The first postwar issue of Mingei was put out in July 1946, and Kōgei resumed publication at the end of the year.[2]

In regaining its institutional and organizational footing after the war, the mingei movement made certain ideological adjustments. References to Greater East Asia and the holy war on corrupt Western commercialism dropped away, to be replaced by assertions of the fundamentally democratic, peaceful nature of folk-craft and a reemphasis on earlier, Anglo-American

affinities.[3] Yet much remained the same. One of Yanagi's first postwar publications, in 1946, was the book *Ima mo tsuzuku Chōsen no kōgei* (*Korean Craft, Continuing Even Now*), which was based on earlier, wartime issues of *Kōgei* devoted to new Korean mingei. One of the Mingeikan's first postwar exhibits in 1946 featured the textiles of a Taiwanese tribal people, along with Chinese objects.[4] The first general meeting of the national Mingei Association, held at the Mingeikan at the end of 1947 and attended by Morito Tatsuo, the minister of education, as well as representatives of other government agencies, focused on issues concerning the role of mingei in the material and ideological reconstruction of a "healthy" national daily life as well as manufacturing and exports. These discussions alternated with performances of Okinawan dance, lectures on Okinawan language and culture, and a screening of one of the Okinawan "culture films" made in 1940.[5]

Perhaps most striking, the process of elevating mingei to the status of national icon—a process endorsed by the state since the late 1930s—continued apace. In late 1947, mingei's significance was even consecrated by that other hardy, transwar emblem of Japanese national identity, the Japanese imperial family. The first official visit to the Mingeikan by the Shōwa emperor and empress occurred in October and was followed several months later by the visit of the dowager empress.[6] Of course, the meanings associated with mingei, as with the emperor, underwent key revisions. Much in the way that the emperor became a "people's monarch," no longer mounted on his white horse to review the imperial troops but walking humbly among his civilian subjects, so too mingei during the Occupation period became evidence of the pacific, democratic artistry of the Japanese populace, rather than the sign of communal, Asiatic strength and productivity.

Another similarity between the transwar histories of mingei and the imperial institution, concerning the unexpectedly supportive role of the erstwhile American enemy, should be noted here. Much in the way that Japan's American occupiers actually ensured and bolstered the postwar position of the Shōwa emperor, for reasons that included complex calculations of U.S. interest, the arrival of tens of thousands of U.S. troops and administrators (and their wives) opened up the promotion of mingei as national emblem to a new, powerful, and receptive population.[7] Beginning with the dramatic story of the U.S. military's effort in 1946 to requisition the Nihon Mingeikan as an officer's residence and the successful campaign by several American officers' wives to have the order rescinded, mingei in the late 1940s and early

1950s found enthusiastic champions and consumers among Americans both in Japan and in the United States. Indeed by the 1950s, the U.S. State Department was actually training young diplomats posted to Tokyo with materials designed to promote their appreciation of mingei, which was presented as integral to Japanese culture.[8]

Yet the ongoing efforts of the mingei activists themselves, along with the continuing support of the Japanese state, were probably most important to the postwar canonization of mingei. Yanagi and most of the other leading figures in the Mingei Association continued to work assiduously throughout the 1950s to spread the gospel about Japanese folk art.[9] As in the late 1930s and early 1940s, an exports-hungry state was alert to the commercial as well as political potential inherent in a native design aesthetic conveniently associated with international modernism. Much in the way that postwar West German industrial planners capitalized on the prewar (and wartime) design legacy and prestige of the Bauhaus in order to promote exports of consumer goods, the Ministry of International Trade and Industry (the postwar incarnation of the MCI) lost no time in developing mingei as a marketable design resource.[10] It hardly seems a coincidence that one of Japan's most celebrated industrial designers, Yanagi Sōri, the German-educated eldest son of Yanagi Muneyoshi and the present head of the Nihon Mingeikan, made his name in the 1950s designing flatware, ceramics, and furniture that combined modernism with a distinctly folk-craft sensibility.

In a related initiative, the Japanese state in 1950 reformed and expanded earlier (mostly Meiji-era) legislation intended to protect ancient works of art and architecture and other "tangible cultural properties" by including the category of "intangible cultural properties," which referred to traditional handicraft techniques as well as those skills associated with indigenous performing arts.[11] Beginning in the mid-1950s, an agency associated with the Ministry of Education periodically designated individuals and groups as official bearers of intangible cultural properties. Recipients of the designation, who were more colloquially known as "living national treasures" (ningen kokuhō), received an annual stipend, as well as enormous national (and international) prestige.[12] The very identification of traditional handicraft techniques as an invaluable national resource, along with the high proportion of mingei artist-craftsmen among those first named living national treasures, suggest the extent to which relations established between the Mingei Association and the state during the years of total war continued to remain

**21.** "Butterfly stools" designed by Yanagi Sōri in 1956 and manufactured in molded plywood and metal by the Tendo Company, Ltd. Collection of Museum of Modern Art, New York.

salient.[13] Of the thirty-seven individual craftspeople who had been chosen as living national treasures by 1975, five were closely associated with the early mingei movement. (A sixth, Kawai Kanjirō, declined the designation.)[14]

Ironically, the success of mingei activists in achieving national recognition for themselves, and for the category of objects they first identified and celebrated as folk-craft, was accompanied by decreasing influence for the original institutions of the mingei movement. In the first decade of the twenty-first century, the Mingei Association, its periodical publications, the Mingeikan, and the shop Takumi in Tokyo all continue to exist, but with little of their original dynamism. Many factors contributed to the decline of mingei activism over the last third of the twentieth century. Yanagi's death in 1961 and the eventual deaths of the rest of the original cohort of association leaders are certainly relevant. The growing popularity of mingei within the increasingly consumerist, mass society of postwar Japan is also a factor. Beginning with the first of several so-called mingei booms in the 1960s and 1970s, when new generations of ever more affluent Japanese discovered the charm of artifacts and technologies evoking an indigenous, preindustrial past, mingei became a household word, denoting everything from the cheap tourist souvenirs available at every provincial train station, to the upscale items sold at department stores and innumerable craft boutiques. In the process, the entire nation became dotted with mingei museums, retailers,

artisans, communities, and organizations—only some of which sought to connect themselves to the original Mingei Association in Tokyo or to its provincial branches.[15]

National economic success in the global context also helped to cast mingei activism into relative shadow. From the mid-1950s, Japanese exports of consumer goods, especially the products of the electronics and automobile industries, rose to levels that helped to establish Japan by the late twentieth century as the second-largest economy in the world. Questions of national style and the problem of crafting a marketable commodity aesthetic for Japanese exports thus became matters of much less urgency for industrial policymakers. Increasingly, it was possible to leave the work of industrial design to the operations of private capital. Indigenous handicraft traditions became only one of a variety of styles and aesthetics to which Japanese manufacturers had recourse.

Nevertheless, mingei remains an important sign of modern Japanese cultural identity. The association of modern Japaneseness with the objects and technologies of the preindustrial farming household, and also with the modernist aesthetic sensibility demonstrated in their appreciation, remains highly plausible—and useful—to a variety of groups and institutions, both in Japan and beyond. This book argues that these associations were made and not born, and that they were crafted in the context of efforts by Japanese state and society to cope with the process of rapid industrialization within a volatile and competitive international order.

# Notes

Introduction

1 See Bendix, *In Search of Authenticity*.
2 There is a very large literature on the Arts and Crafts movement in England. Two notable historical treatments are those by Stansky, *Redesigning the World*; and Thompson, *William Morris*. On arts and crafts in the United States, see Lears, *No Place of Grace*; and Boris, *Art and Labor*. See also David Crowley, *National Style and Nation-State: Design in Poland from the Vernacular Revival to the International Style* (Manchester: Manchester University Press, 1992); and Wendy R. Salmond, *Arts and Crafts in Imperial Russia: Reviving the Kustar Art Industries: 1870–1917* (Cambridge, England: Cambridge University Press, 1996).
3 On China, see Chang-tai Hung, *Going to the People*.
4 Two studies dealing with the interwar enthusiasm in the United States for folk culture and folk arts of the Appalachian region are Whisnant, *All That Is Native and Fine*; and Becker, *Selling Tradition*. On the Mexican discovery of folk art, see López, "Lo más mexicano de México."
5 The standard reading of Yanagi's given name is "Muneyoshi." The characters can also be read "Sōetsu." Yanagi often used the latter reading, as did (and do) many of his followers.
6 The standard work on Japanese Orientalism is Stefan Tanaka, *Japan's Orient*.
7 Garon, *Molding Japanese Minds*.
8 See Bourdieu, *Distinction*; Thorstein Veblen, *The Theory of the Leisure Class: An Economic Study in the Evolution of Institutions* (New York: Macmillan, 1899).
9 On the role of aesthetics in modern French national identity, see Tiersten, *Marianne in the Market*; Auslander, *Taste and Power*; and Silverman, *Art Nouveau in Fin-de-Siècle France*. On arts and crafts and the Meiji state, see Kinoshita Naoyuki, *Bijutsu to iu*

*misemono* (The Spectacle Called Art). In English, see Noriko Aso, "New Illusions"; and Hosley, *The Japan Idea*.

## 1. The Beauty of Sorrow

1   Takasaki Sōji, "Yanagi Muneyoshi to Chōsen" (Yanagi Muneyoshi and Korea), 237.

2   For the name of the museum, Yanagi insisted on using the term "minzoku," which might be translated as either "people" or "nation" and carries overtones of ethnic and racial identity, thereby flirting with Korean nationalism and arousing some discomfort among Japanese colonial authorities. See Takasaki Sōji, *Chōsen no tsuchi to natta Nihonjin* (A Japanese Who Became Part of Korea), 102–103.

3   After some years of uncertainty, Yanagi decided to render the term "mingei" into English as "folk-craft." Folk-craft, itself a neologism, has become the standard translation for mingei among those associated with the official mingei movement and its institutions. Thus the mingei museum in Tokyo calls itself the Japan Folk-Crafts Museum.

4   Koreans and most scholars of Korea (including those in Japan) now call the period of rule by the Yi royal house (1392–1910) by its realm name, Chosŏn. The term "Yi dynasty" has been abandoned partly because of the colonialist implications of its application by Japanese during the period of colonial rule, 1910–1945. The term persists, however, with reference to the specific categories of Korean art, particularly ceramic art, that Yanagi first helped to define and popularize in the 1920s and that remain salient among collectors and others today.

5   Editorial staff of *Taiyō*, eds., *Ri chō o tanoshimu* (Enjoying Yi Dynasty); Editorial staff of *Ginka*, eds., *Ri chō ni nyūmon* (Introduction to Yi Dynasty).

6   Of Tsurumi's various writings on Yanagi, see his commentary, or "Kaisetsu," for a 1975 volume collecting Yanagi's writings, in the series *Kindai Nihon shisō taikei* (Modern Japanese Thought), and also his biography of Yanagi, *Yanagi Muneyoshi*. Another prominent exponent of a similar view was Ubukata Naokichi, whose influential essay on Yanagi and Korea was first published in the journal *Shisō* (Thought) several months after Yanagi's death in 1961: "Nihonjin no Chōsenkan" (Japanese Views of Korea).

7   Nishio Makoto, Usui Yoshimi, and Kinoshita Junji, eds., *Gendai kokugo 3* (Modern Japanese 3), 208–220. For a discussion by the scholar Masuda Katsumi of his efforts to have the essay included in the textbook, despite some reluctance on the part of Ministry bureaucrats and others, see his published dialogue with Tsurumi Shunsuke in the journal *Kokugo tsūshin* (Japanese Language News): Tsurumi Shunsuke and Masuda Katsumi, "Taidan" (Dialogue).

8   In Japanese, see Ch'oe Harim, "Yanagi Muneyoshi no Kankoku bijutsu kan" (Yanagi Muneyoshi's View of Korean Art). Also see the bibliographic discussions in Takasaki Sōji, "Yanagi Muneyoshi to Chōsen: 1920 nendai o chūshin ni" (Yanagi Muneyoshi and Korea: The 1920s); and Yuko Kikuchi, "Yanagi Sōetsu and Korean Crafts within the *Mingei* Movement."

9   Of these writings, one of the most useful remains Takasaki Sōji's inquiry into Yanagi's Korean activities during the 1920s: "Yanagi Muneyoshi to Chōsen: 1920 nendai o chūshin ni." See also the art critic Idegawa Naoki's polemic, *Mingei*; Karatani Kōjin, "Bigaku no kōyō" (The Uses of Aesthetics); and the discussion in Oguma Eiji's *"Nihonjin" no kyōkai (The Boundaries of "the Japanese")*, 392–398.

10  Indeed, there has been a tendency to suggest that any colonialist tendencies evident in Yanagi's early appreciation of Korean art were corrected or "overcome" by the late 1920s, with his turn to mingei. See, for example, Ri Jinhi, "Ringoku" (Neighboring Countries). One recent exception is Yuko Kikuchi, *Japanese Modernisation and Mingei Theory*, chapter 3.

11  Yoshida Kōzō, "Tomimoto Kenkichi nenpu" (Chronological Record of Tomimoto Kenkichi), in Tomimoto Kenkichi, *Yōhen zakki (Kiln Notes)*, 198. See also Tomimoto, "Takushoku hakurankai no ichinichi" (One Day at the Colonial Exposition), in *Tomimoto Kenkichi chosakushū (Selected Writings of Tomimoto Kenkichi)*, 472, cited in Moeran, "Bernard Leach and the Japanese Folk Craft Movement."

12  It should be pointed out that unlike many of his fellow graduates of Gakushūin, the higher school attended by aristocrats and members of the imperial family, Yanagi was not independently wealthy. He was born into the Meiji technocratic elite, the second son of a talented former samurai whose mathematical and navigational skills enabled an illustrious career in the navy. Although Yanagi's father eventually achieved the rank of admiral, he bequeathed to his sons neither landed nor industrial wealth. Throughout his life, Yanagi relied instead on an income gained by his work as writer, teacher, art collector, fundraiser, and public speaker. He also depended on his wife, Yanagi Kaneko, who was a successful professional Western-style singer and voice teacher.

13  On the history and significance of Korean teabowls in the tea context, see Cort, "The Kizaemon Teabowl Reconsidered"; and Hayashiya Seizō, "The Korean Teabowl."

14  Kumakura Isao, in his history of the modern tea ceremony, notes that in the early twentieth century tea caddies (*chaire*) and especially teabowls gained enormously in importance and value relative to other objects used in the tea ceremony, such as hanging scrolls and incense containers. During the period 1924–1926 and again in 1927–1929, Korean bowls fetched the top sums for tea objects sold. Kumakura, *Kindai chadō shi no kenkyū (Research on the Modern History of the Tea Ceremony)*, 265–268.

15  In English see, for example, Yanagi, *Folk-Crafts in Japan*, 10–12; and Yanagi, *The Unknown Craftsman*, 190–196.

16  One of the earliest expressions of these views, which Yanagi was to develop throughout his career and particularly in the postwar period, is in the essays collected as *Kōgei no michi (The Way of Crafts)*, first published in 1927. See *Yanagi Muneyoshi zenshū* (hereafter YMz), 8: 205–208. Also see his 1933 lecture "Sadō to kibutsu" (Tea Ceremony and Objects), in *YMz* 17: 503–515.

17  The enthusiasm of early-twentieth-century industrialists and politicians for the tea ceremony recalls, of course, earlier periods when *chanoyu* served similar social,

political, and economic functions for Japanese elites. It was only after 1868, during the first decades of systematic Westernization, that the tea ceremony fell into relative neglect. See Varley, "Chanoyu," 161–194.

18  For a lively study of one of the central figures in this process, with special attention to his legendary art collection, see Guth, *Art, Tea, and Industry.*

19  Kumakura, *Kindai chadō shi no kenkyū,* 19, 250, 265.

20  Guth, *Art, Tea, and Industry,* 119–128; Kumakura, *Kindai chadō shi no kenkyū,* 257.

21  Takahashi Yoshio, *Taishō meiki kan (Taisho Catalogue of Famous Tea Objects).*

22  For example, by stressing the importance of tea caddies and teabowls relative to other, formerly more prominent categories of tea objects. Kumakura argues that the publication of the *Taishō meiki kan* helped to promote the sharp rise in market value of teabowls and tea caddies during the 1920s. Kumakura, *Kindai chadō shi no kenkyū,*17, 267–268.

23  Guth, *Art, Tea, and Industry,* 183; Kumakura, *Kindai chadō shi no kenkyū,* 267–268.

24  Yanagi, *Kōgei no michi,* in YMz 8: 205.

25  Quoted in Akaboshi Gorō and Nakamaru Heiichirō, *Chōsen no yakimono (Korean Pottery),* 21–22.

26  Ibid., 26. The Korean word *yobo,* which Akaboshi glosses as "laborer," is in fact a term of familiar second-person address. Akaboshi's usage suggests it had an alternative meaning in the colonialist Japanese lexicon.

27  Japanese collectors often refer to the low prices of Korean craft objects and antiques generally, and Chosŏn-period Korean ceramics in particular, during this period. See, for example, the comments of another well-known collector of Yi dynasty, Kurahashi Tōjirō, in "Chōsen kōgei zakki" (Notes on Korean Crafts), *Teikoku kōgei (Imperial Craft)* 4, no. 2 (February 1930): 32; also see the reminiscence of another collector, Nonogami Keiichi, in "Ri chō hakuji to watakushi" (Yi Dynasty White Porcelain and I), in *Ri chō hakuji shōsen (Selected [Writings on] Yi Dynasty White Porcelain),* ed. Nonogami and Itō Ikutarō, 142.

28  Asakawa Noritaka, "Chōsen kotōki no kenkyū ni tsukite" (On Research on Old Korean Ceramics), 30–31.

29  Ibid., 37, 35. Many researchers and collectors benefited from the "geographical liberation" under Japanese colonialism of Korean tombs as well as kiln sites.

30  Takahashi Yoshio, "Kaisetsu" (Commentary), *Taishō meiki kan* 6 (1931): 4–5; "Kaisetsu," *Taishō meiki kan* 7 (1928): 1, 4; "Kaisetsu," *Taishō meiki kan* 8 (1928): 1.

31  Takahashi Yoshio, "Kaisetsu," 6: 5.

32  For a brief discussion of the scientific trend in ceramics study and appreciation in Taishō Japan and its Western inspiration, see Suzuki Kenji's text in *Tōgei I (Ceramic Art I),* 110.

33  Pak Cho, *Ri chō kōgei to kotō no bi (Yi Dynasty Crafts and the Beauty of Old Ceramics),* 418, 421. Also see Nonogami Keiichi, "Ri chō hakuji to watakushi," 142.

34  In 1996, a Chosŏn-period jar of precisely the type first collected by Yanagi, Asakawa,

and their cohort was sold at Christie's for $8.6 million, then the highest price ever paid at auction for an Asian art object. See the *New York Times*, 2 November 1996, 17.

35  YMz 6: 30–31. The article appeared in the *Yomiuri shimbun*. The verb *omou* in its title, translated here as "thinking," also carries a strong sense of "yearning for" or "loving."

36  Williams, *Culture and Society*, 30–31, 42–43.

37  Yanagi, "If Japan Understood Korean Art."

38  Yanagi, "Ri chō tōjiki no tokushitsu" (Special Characteristics of Yi Dynasty Porcelain), in YMz 6: 165. This essay was first published in the September 1922 issue of *Shirakaba*, then translated in the same year into Korean for a Korean weekly newspaper.

39  Yanagi, "Chōsen no bijutsu" (Korean Art), in YMz 6: 92. This famous essay was first published in the May 1922 issue of the magazine *Shinchō* (*New Tide*).

40  Yanagi Muneyoshi and Yanagi Kaneko, " 'Ongakkai' shuisho" ("Concert" Prospectus), YMz 6: 172–173. According to Yanagi's own account in "Kare no Chōsen kō" (His Trip to Korea), which appeared in *Kaizō* (*Reconstruction*) in September 1920, this statement was sent around to Yanagi's friends.

41  Takasaki Sōji, "Yanagi Muneyoshi to Chōsen" (Yanagi Muneyoshi and Korea), 78.

42  Ibid., 97.

43  Chong-sik Lee, *The Politics of Korean Nationalism*, 114–120.

44  Peattie, "Japanese Attitudes toward Colonialism," 106; Lee, *The Politics of Korean Nationalism*, 124.

45  Robinson, *Cultural Nationalism in Colonial Korea*, 4.

46  Ibid., 4–8.

47  Robinson, "Ideological Schism in the Korean Nationalist Movement."

48  Ibid., 254.

49  Ching-chih Chen, "Police and Community Control Systems in the Empire," in *The Japanese Colonial Empire*, ed. Myers and Peattie, 222–224.

50  E. Patricia Tsurumi, "Colonial Education in Korea and Taiwan," in *The Japanese Colonial Empire*, ed. Myers and Peattie, 303–304.

51  Michael E. Robinson, "Colonial Publication Policy and the Korean Nationalist Movement," in *The Japanese Colonial Empire*, ed. Myers and Peattie, 327.

52  Yanagi, " 'Chōsen minzoku bijutsukan' ni tsuite no hōkoku" (Report on the "Korean Art Museum"), *Shirakaba*, February 1921, 130.

53  Takasaki, "Yanagi Muneyoshi to Chōsen," 100; "Chōsen minzoku bijutsukan dai jū ichi kai kaikei hōkoku" (Eleventh Financial Report on the Korean Art Museum), *Shirakaba*, November 1922, n.p.

54  Takasaki, "Yanagi Muneyoshi to Chōsen," 100–101.

55  The publication of the philosopher Watsuji Tetsurō's *Kōji junrei* (*Pilgrimage to Ancient Temples*) in 1919, in which he celebrated the ancient Buddhist art of Nara, Japan's eighth-century capital, is often cited as a key moment in the "return" to Japan

and/or Asia. The art historian Kitazawa Noriaki has also noted, in his study of the painter Kishida Ryūsei, the simultaneous rise of interest among painters in a reappraisal of *bunjinga*, a genre of Chinese-style Japanese painting that flourished during the eighteenth century and the nineteenth. See Kitazawa, *Kishida Ryūsei to Taishō abuangyardo* (*Kishida Ryūsei and the Taisho Avant Garde*) (Tokyo: Iwanami shoten, 1993), 199.

56  See Said, *Orientalism*, 78–79, for discussion of the classically Orientalist emphasis on the glory of Oriental antiquity, in opposition to the decrepitude of Oriental modernity.

57  Yanagi, "Kongetsu no sashie ni tsuite" (About This Month's Illustrations), *Shirakaba*, February 1920, 102.

58  Yanagi, "Kondo no sashie ni tsuite" (About the Illustrations), *Shirakaba*, July 1919, 108–109.

59  A third Oriental issue of *Shirakaba*, put out in July 1920, featured photographs of Buddhist statues from temples in Nara. Yanagi's first lengthy essay on Korean art, published in the June 1919 issue of the magazine *Geijutsu* (*Art*), dealt with Silla-period (57 b.c.e.–935) Buddhist sculpture.

60  Kinoshita Naoyuki, *Bijutsu to iu misemono* (*The Spectacle Called Art*), 32–34.

61  For an illuminating discussion of both the use of Buddhist statues at the World's Fairs of the late nineteenth century and the efforts by such Taishō intellectuals as Watsuji Tetsurō to turn Buddhist art to a different sort of account, see Noriko Aso's dissertation, "New Illusions."

62  Yanagi, "Kondo no sashie ni tsuite," *Shirakaba*, July 1919, 110.

63  Kakuzō Okakura, *The Ideals of the East with Special Reference to the Art of Japan*, 8. Leslie Pincus has usefully discussed the impact Okakura's ideas had on at least one important thinker of Yanagi's generation, the philosopher Kuki Shūzō. Pincus, *Authenticating Culture in Imperial Japan: Kuki Shūzō and the Rise of National Aesthetics* (Berkeley: University of California Press, 1996), 208.

64  There is a large and growing literature on the close relationship between Euro-American imperialism and the development of what Tony Bennett has called the "exhibitionary complex" of the modern museum together with various other institutions and practices. In addition to Bennett's suggestive "The Exhibitionary Complex" in *New Formations* 4 (1988): 73–102, see James Clifford, *The Predicament of Culture* (Cambridge, Mass.: Harvard University Press, 1988), especially chapter 10. Relatively recent examples of work on museums, collecting, and colonialism include Annie E. Coombes, *Reinventing Africa: Museums, Material Culture and Popular Imagination in Late Victorian and Edwardian England* (New Haven: Yale University Press, 1994); and Nicholas Thomas, *Entangled Objects: Exchange, Material Culture, and Colonialism in the Pacific* (Cambridge, Mass.: Harvard University Press, 1991), chapter 4. Among the numerous works dealing with the World's Fairs of the nineteenth and twentieth centuries, see especially Robert Rydell, *All the World's a Fair: Visions of Empire*

*at American International Expositions, 1876–1916* (Chicago: University of Chicago Press, 1984); and Mitchell, *Colonising Egypt*, chapter 1.

65  YMz 6: 89–109. "Chōsen no bijutsu" (Korean Art) was republished later the same year in Yanagi's book *Chōsen to sono geijutsu*.

66  Yanagi, "Chōsen no bijutsu," 102.

67  Ibid., 105.

68  Hatada Takashi, "Chōsen shizō to teitairon" (The Historical Representation of Korea and the Theory of Stagnation), in *Chōsen to Nihonjin (Korea and the Japanese)* (Tokyo: Keisō shobo, 1983), 66–92.

69  Kurahashi Tōjirō, "Chōsen tōki ni tsuite" (On Korean Ceramics), 37–38.

70  Tomimoto Kenkichi, "Ri chō no suiteki" (Korean Water Droppers), *Shirakaba*, September 1922, 23; also "Yōhen zakki" (Kiln Notes), in *Yōhen zakki*, originally published in 1925 and reissued in 1975 (Tokyo: Bunka shuppan kyoku, 1975), 105.

71  Kon Wajirō, "Chōsen hantō no minka chōsa" (Investigation of Folk Houses on the Korean Peninsula), in *Kon Wajirō shū (Collected Works of Kon Wajirō)*, 2: 290.

72  Quoted in Gompertz, *Korean Pottery and Porcelain of the Yi Period*, 7.

73  Kurahashi Tōjirō, ed., *Tōki zuroku (Illustrated Record of Ceramics)*, n.p. "Senjin" is a pejorative Japanese term that was commonly used during the colonial period.

74  Asakawa Noritaka, "Tsubo," *Shirakaba*, September 1922, 57, 61.

75  Aoyama Jirō, "Chōsen minzoku kōgei gaikan" (Overview of Korean Crafts), in *Aoyama Jirō bunshū (Collected Writings of Aoyama Jirō)*, 663.

76  Yanagi, "Ri chō tōjiki no tokushitsu" (Special Characteristics of Yi Dynasty Porcelain), *Shirakaba*, September 1922, 44.

77  Asakawa Noritaka, "Tsubo," 59.

78  Bernard Leach, *A Potter in Japan*, 161.

79  Evett, *The Critical Reception of Japanese Art in Late Nineteenth Century Europe*, 35–40.

80  Quoted in ibid., 40.

81  Ibid., 42–46.

82  Asakawa Noritaka, "Ri chō tōki no kachi oyobi henzō ni tsuite" (On the Value and Alteration of Yi Dynasty Ceramics), *Shirakaba*, September 1922, 2–3.

83  Yanagi, " 'Kizaemon Ido' o miru" (Viewing the 'Kizaemon Ido'), *Kōgei* 5 (May 1931); reprinted in Yanagi, *Chōsen o omou*.

84  Tomimoto Kenkichi, "Keijō zasshin" (Thoughts on Keijō), in *Yōhen zakki*, 79–80.

85  See, for example, Asakawa, "Ri chō tōki no kachi oyobi henzō," 5.

86  Yanagi, " 'Kizaemon Ido' o miru," in *Chōsen o omou*, 196.

87  Kurahashi, "Chōsen tōki ni tsuite," 20.

88  Yanagi, "An Artist's Message to Koreans: Japan's Mistaken Policy and Korea's Sad Fate," *Japan Advertiser*, 13 August 1919. This is an abridged translation of "Chōsenjin o omou," which appeared several months earlier in the *Yomiuri shimbun*.

89  Yanagi, "If Japan Understood Korean Art: An Appeal for the Establishment of an Art Gallery," *Japan Advertiser*, 23 January 1921. The article was first published as " 'Chō-

sen minzoku bijutsukan' no setsuritsu ni tsuite" (On the Establishment of the "Korean Art Museum") in *Shirakaba*, January 1921, 180–184.

90  See, for example, Yanagi's founding statement of mingei theory, *Kōgei no michi* (The Way of Crafts), first published serially in 1927 and 1928 in the magazine *Daichōwa* (*Great Harmony*). This text is discussed in some detail in chapter 2.

## 2. The Discovery of Mingei

1  For example, on page 131 of his *Hyōden Yanagi Muneyoshi* (*Critical Biography of Yanagi Muneyoshi*), Mizuo Hiroshi states that the word was created by Yanagi, Kawai, and Hamada together on a train on 28 December 1925. Hamada Shōji has claimed, however, that the word was first bruited among the three men on yet another, Ise-bound train the previous spring. See Hamada's memoir, *Kama ni makasete* (*Entrusting the Kiln*), 100.

2  Yanagi, "Mokujiki Shōnin hakken no engi" (The History of Discovering Mokujiki Shōnin) in *Yanagi Muneyoshi senshū* (*Selected Works of Yanagi Muneyoshi*), 9: 1–22 (Tokyo: Shinjūsha, 1955).

3  Mizuo Hiroshi, *Hyōden Yanagi Muneyoshi*, 115–116.

4  Ibid., 119–120.

5  Ibid., 119.

6  Ōoka Makoto, "Kaisetsu," in *Yanagi Muneyoshi zenshū* (hereafter YMz), 7: 639.

7  Nakano Yumenosuke, letter to *Echigo taimusu*, 19 October 1924. The letter appeared in the "Mokujiki Correspondence" ("Mokujiki zasshin") column in the *Echigo taimusu*, a newspaper from neighboring Niigata prefecture which did its best to fan its own Mokujiki fever.

8  "Kyūshū no ryūshakuchi de mo Mokujiki Shōnin kenkyū ga sakan da—ukkari suru to okabu o torareru" (Mokujiki Research Also Popular at His Kyushu Resting Spot: We'll Be Outdone in Our Own Specialty If We Don't Take Care), *Yamanashi nichi nichi shimbun*, 10 December 1924.

9  "Kashiwazaki no shin meisho" (Kashiwazaki's New Place of Note), *Echigo taimusu*, 12 October 1924.

10  Yanagi Muneyoshi, "Kore koso Nihon koyū no busshi to hokoru beki Mokujiki Shōnin no kenkyū" (Research on Mokujiki Shōnin, a Distinctively Japanese Buddhist Sculptor in Whom Pride Should Be Taken), *Tōkyō asahi shimbun*, 8 March 1925.

11  "Nihon koyū no busshi to hokoru beki Mokujiki Shōnin isaku no butsuzō" (Buddhist Images Left by Mokujiki Shōnin, a Distinctively Japanese Buddhist Sculptor in Whom Pride Should Be Taken), *Asahi gurafu*, 8 April 1925.

12  Komiyama Seizō, "Kaikei hōkoku" (Financial Report), *Mokujiki Shōnin no kenkyū* (*Research on Mokujiki Shōnin*) 3 (June 1925): 66.

13  Komiyama Seizō, "Tōkyō tenrankai keikyō" (State of the Tokyo Exhibition), *Mokujiki Shōnin no kenkyū* 3 (June 1925): 58.

14  Shikiba Ryūzaburō, " 'Mokujiki Gogyō Shōnin mokuchō butsu tenrankai,' 'Kōen-

kai' oyobi 'Kenkyū zasshi tokubetsu go' ni tsuite" (About the "Exhibition of Carved Wooden Buddhas by Mokujiki Gogyō Shōnin," the "Lecture Conference," and the "Special Issue of the Research Journal"), *Mokujiki Shōnin no kenkyū* 2 (April 1925): 52.

15 Letter from Yanagi Muneyoshi to Yoshida Shōtarō, 5 February 1926, in YMz 21 (I): 299–300.

16 Yanagi, "Getemono no bi," *Echigo taimusu* 771 (19 September 1926), 4. This essay is commonly cited as Yanagi's first public statement about mingei. See, for example, Mizuo Hiroshi, "Kaidai" (Bibliographical Notes), in YMz 8: 642. "Getemono no bi" is reprinted in YMz 8: 3–14.

17 "Kōgei zadankai" (Round-table Discussion on Crafts), in the New Year's supplement to the *Ōsaka mainichi shimbun*, 1 January 1929, 18.

18 Yanagi, "Zakki no bi" (The Beauty of Miscellaneous Wares), in *Watakushi no nengan* (*My Heart's Desire*), (Tokyo: Fuji shobō, 1942). The revised text is also given in YMz 8: 15–28.

19 Yanagi, "Kyōto no asaichi" (The Morning Markets of Kyoto), in *Shūshū monogatari* (*Tales of Collecting*), in YMz 16: 637–638.

20 Ibid., 16: 638.

21 Koh Masuda, general ed., *Kenkyusha's New Japanese-English Dictionary*, 4th ed. (Tokyo: Kenkyusha, 1974), 334.

22 *Kōgei no michi* was published in nine installments in *Daichōwa* (*Great Harmony*), a new magazine founded and edited by Yanagi's former classmate and fellow Shirakaba member Mushanokōji Saneatsu.

23 The first edition of *Kōgei no michi* was published in December 1928 by the Kyoto publisher Guroriasosaete; this is the text which is reproduced in YMz 8 and on which I base my discussion.

24 Yanagi, *Kōgei no michi*, in YMz 8: 90, 91, 196.

25 These ten points, which remain central to the orthodox definition of mingei, correspond more or less to the eleven characteristics listed in *Kōgei no michi*, 96–117.

26 Yanagi, *Kōgei no michi*, 125, 126, 198.

27 Ibid., 178.

28 Ibid., 131–132.

29 See Silverberg, *Changing Song*, especially 163–166 and 224–229, for discussion of Marxism in Japanese mass culture during the 1920s.

30 Yanagi, *Kōgei no michi*, 73; Penty's 1906 *Restoration of the Gild System* was one of the earliest statements of guild socialist theory and helped to inform the guild socialist movement, officially launched in England in 1915 with the establishment of the National Guilds League. See Pierson, *British Socialists*.

31 Wright, *G. D. H. Cole and Socialist Democracy*, 78.

32 Yanagi, *Kōgei no michi*, 73.

33 Ibid., 183.

34 Ibid., 107.

35 See Waswo's "The Transformation of Rural Society, 1900–1950," 6: 586–589, for a

238    NOTES TO CHAPTER 2

suggestive discussion of the reasons for the waning of the tenant-farmer movement during the late 1920s. Waswo notes that the idea of class struggle was highly uncongenial to farmers who had found it necessary to justify their very activism on the grounds that they were working for the end of true communal harmony.

36  Harry W. Laidler, *Social-Economic Movements* (London: Routledge and Kegan Paul, 1948), 339.

37  Yanagi, *Kōgei no michi*, 175.

38  Ibid., 170.

39  "Kōgei zadankai," in the New Year's supplement to the *Ōsaka mainichi shimbun*, 1 January 1929, 18.

40  Yanagi, "Getemono no bi," 6.

41  *Kōgei no michi*, 126.

42  Ibid., 80.

43  "Getemono no bi," 6.

44  See, for example, *Kōgei no michi*, 66, 116, 148.

45  Ibid., 176.

46  Ibid., 117.

47  "Getemono no bi," 13.

48  See Yanagi's letter to Yoshida Shōtarō of 5 February 1926, in YMz 21 (I): 299–300.

49  Yanagi, *Kōgei no michi*, 238, 245.

50  Ibid., 72.

51  Ibid., 207.

52  Not surprisingly, Yanagi's nationalistic assertions of the Japanese role in leading the way to a true understanding of crafts only became more strident in later years, with the advent of World War II. See, for example, his claims in *Kōgei bunka* (*Craft Culture*), a restatement of mingei theory published in 1942: "I am secretly proud of the fact that our craft movement, which has come to be known as the 'mingei movement,' does not grow out of foreign thought, but was born of Japan. I have reviewed the positions taken by Europeans and Americans on craft, but they have not been of use to me. Therefore there is no quality of imitation in the ideas set forth here. In the worlds of thought and design, which have tended so greatly to imitation, there is a great significance in building a unique way, even if it be immature. All the more must someone from Japan step ahead, holding aloft a beacon. I believe that time has now come." *Kōgei bunka* (Tokyo: Bungei shunju sha, 1942), 7–8.

53  Yanagi, *Kōgei no michi*, 202.

54  See, for example, Yuko Kikuchi, "The Myth of Yanagi's Originality," as well as chapter 2 of her book *Japanese Modernisation and Mingei Theory*. Brian Moeran, in particular, has actively promoted the idea that Yanagi is largely indebted to Morris as well as other British thinkers and artists for his ideas about mingei. See Moeran, "Bernard Leach and the Early Folk Craft Movement"; and "Yanagi Muneyoshi and the Japanese Folk Craft Movement."

55  Thompson, *William Morris* (1977), 108; Whitford, *Bauhaus*, 13–26.

56  E. P. Thompson suggests that the "over-elaboration and sweetness" in some of Morris's work—the "heavy and intricate lines of some of his later wallpapers and chintzes"—which would seem to contradict his avowed ideal of simplicity, were partly due to the need to cater to wealthy customers. See Thompson, *William Morris*, 108–109.

57  See Fujimori Terunobu's survey of modern Japanese architectural history for a discussion of the increasing sway exerted by modern design within architecture from the early 1920s, *Nihon no kindai kenchiku* (*Modern Japanese Architecture*).

58  Yanagi, *Kōgei no michi*, 11, 96–97, 262.

59  Ibid., 202–203. Influential European art and design movements that might be described in these terms include Bauhaus, De Stijl, and Russian constructivism. Izuhara Eiichi, in his history of modern Japanese design movements, states that the social (and sometimes socialist) emphasis of many 1920s Japanese designers and design organizations reflected international trends: *Nihon no dezain undō* (*Japanese Design Movements*), 89.

60  "Nihon mingei bijutsukan setsuritsu shūisho" (Prospectus for the Establishment of a Mingei Art Museum), in YMz 16: 7, 10.

61  Ibid., 6–7.

62  "Further, there [in *getemono*] is a pure Japanese world. Without hiding in foreign techniques or ending in the imitation of other countries, all its beauty flows from the nature and blood of our ancestral land, and vividly demonstrates the existence of the race [*minzoku*]." Ibid., 6.

63  Ibid., 8.

64  On the projected guild community in Hamamatsu, as well as the Hamamatsu mingei museum, see Suzuki Naoshi, *Maboroshi no Nihon mingei bijutsukan* (*The Phantasmatic Japan Mingei Art Museum*).

65  Letters from Yanagi to Hamada Shōji of 13 November and 29 December 1930, in YMz 21 (I): 404, 407.

66  On page 134 of *Hyōden Yanagi Muneyoshi*, for example, Mizuo states that this document was the "mingei movement's inaugural announcement."

67  "Nihon mingei bijutsukan setsuritsu no shūisho," 7–9.

68  Letter from Yanagi to Tonomura Kichinosuke, 28 June 1931, in YMz 21 (I): 431–432. Suzuki Naoshi notes that this assessment appears to have been related to rumors about womanizing by Aota Gorō. Suzuki, *Maboroshi no Nihon mingei bijutsukan*, 25.

69  For a thorough discussion of the Kamigamo guild, see Iuchi Katsue's two-part article "Kuroda Tatsuaki to Kamigamo mingei kyōdan" (Kuroda Tatsuaki and the Kamigamo Mingei Guild).

70  Kuroda Tatsuaki, for example, notes that health problems were relevant. Aota had contracted tuberculosis, which killed him only a few years later, and Kuroda was already suffering from the nervous complaints that plagued him through much of

his life. Kuroda, "Yanagi san to Kamigamo mingei kyōdan to watashi" (Mr. Yanagi, the Kamigamo Mingei Guild, and I), Mingei techō (Mingei Notebook), December 1961: 8–11. Also see Suzuki Naoshi, Maboroshi no Nihon mingei bijutsukan, 23–25.

71  Iuchi, "Kuroda Tatsuaki to Kamigamo mingei kyōdan," (1992), 85–88.

72  Yanagi, "Kōgei no kyōdan ni kansuru ichi teian" (One Proposal Concerning a Crafts Guild), in YMz 8: 47.

73  Ibid., 8: 53.

74  Letter from Yanagi to Tonomura Kichinosuke, 28 June 1931, in YMz 21 (I): 431–432.

75  Yanagi, "Kōgei no kyōdan ni kansuru ichi teian," 53, 56–57.

76  In addition to Iuchi's article, see the reminiscences written by Suzuki and Kuroda of their guild experiences: Suzuki Minoru, "Kamigamo kyōdan no hitobito" (People of the Kamigamo Guild) and "Aota Gorō to Kamigamo kyōdan" (Aota Gorō and the Kamigamo Guild); Kuroda Tatsuaki, "Yanagi san to Kamigamo mingei kyōdan to watakushi."

77  First of a series titled "Atarashii jidai o ikiru" (Living in a New Age), in the Ōsaka mainichi shinbun, Kyoto edition, 1 March 1928, quoted in Iuchi, "Kuroda Tatsuaki to Kamigamo mingei kyōdan" (1992), 78–79.

78  See Suzuki Minoru, "Kamigamo kyōdan no hitobito," 13, and Iuchi, "Kuroda Tatsuaki to Kamigamo mingei kyōdan" (1992).

79  Kuroda, "Yanagi san to Kamigamo mingei kyôdan to watakushi," 10.

80  Iuchi, "Kuroda Tatsuaki to Kamigamo mingei kyōdan" (1992), 76.

81  See letter from Yanagi to Yoshida Shōtarō of 15 November 1927, in YMz 21 (I): 330.

82  "Kenkō bi no seikatsu hyōgen" (The Expression in Daily Life of a Healthy Beauty), Tōkyō nichi nichi shinbun, 31 January 1928.

83  See the reminiscence by Yamamoto Tamesaburō, "Mingei undō no shoki: Mikuni sō no yūrai" (The Early Period of the Mingei Movement: The Origins of Mikuni-sō), Mingei 64 (April 1958): 14–17.

84  Yanagi, "Mikuni sō shoshi" (Brief History of Mikuni sō), in YMz 16: 18.

85  Iuchi notes that objects were still being delivered to the Mingeikan during the Exposition's run; Iuchi, "Kuroda Tatsuaki to Kamigamo mingei kyōdan" (1992), 80.

86  Yanagi, "Mikuni sō shoshi," 19.

87  Suzuki Minoru, "Kamigamo kyōdan no hitobito," 14.

88  Yamamoto, "Mingei undō no shoki," 15.

89  Yanagi, "Mikuni sō shoshi," 24.

90  Ibid., 25–26. Mikuni sō was named after the Osaka neighborhood of Mikuni, the location of Yamamoto's estate.

91  "Shin chashitsu meguri 'Mikuni sō no ki'" (Visiting New Tearooms: "Record of Mikuni sō"), Hankyū bijutsu (Hankyū Art) 7 (April 1938): 14–18.

92  For a history of modern Japanese expositions, see Yoshimi Shunya, Hakurankai no seijigaku (The Politics of Expositions).

93  Yanagi, "Mingeikan ni tsuite" (About the Mingeikan), Tōkyō nichi nichi shinbun, 4–5 May 1928.

94  Yanagi, "Mingeikan ni tsuite" (Part 2), *Tōkyō nichi nichi shinbun*, 5 May 1928.

95  Yanagi, "Mikuni sō shoshi," 24.

96  Aoyama Jirō, "Kōgei naozari nisshi" (A Diary of Neglecting Crafts), in *Aoyama Jirō bunshū* (*Collected Writings of Aoyama Jirō*), 626–627.

97  "Kindaiteki bi no kyūden" (Palace of Modern Beauty), *Tōkyō nichi nichi shinbun*, 23 March 1928.

98  Photographs of the Mingeikan appeared in the April 1928 *Kenchiku shinchō* (*Architectural Currents*) and in the special 1928 exposition issue of *Kenchiku gahō* (*Architectural Graphic*).

99  Quotes are from "Furansu bijutsu tenrankai moderu-rūmu to Mingeikan shitsunai ni tsuite no kansō" (Impressions of the French Art Exhibit's Model Room and of the Mingeikan Interior), *Kenchiku gahō* 19, no. 7 (July 1928): 8–14.

100 Both quotes are from "Tairei kinen Tōkyō hakurankai oyobi dōkaibanai Mingeikan no zōkeibi ni tsuite shoka no hihan" (Various Critiques of the Tokyo Exposition in Commemoration of the Enthronement, and of the Formal Aesthetic of the Mingeikan in That Exposition), *Teikoku kōgei* 2, no. 13 (May 1928): 82–84.

101 Yamada Atsushi, contribution to "Furansu bijutsu tenrankai moderu-rūmu to Mingeikan shitsunai ni tsuite no kansō," *Kenchiku gahō* 19, no. 7 (July 1928): 14.

102 The subject of Japanese architecture and interior design during the 1920s and 1930s, and particularly of the rise of "Japan taste" (*Nihon shumi*) in both the public and private architecture and design of this period deserves more study. Inoue Shōichi has written a study of wartime Japanese public architecture that offers a provocative, if somewhat idiosyncratic, reading of the vogue in Japan taste—especially the hybrid form of the *teikanyōshiki* style—during the late 1920s and early 1930s. Inoue, *Senjika Nihon no kenchikuka* (*Japanese Architects During the War*). In his survey history, *Nihon no kindai kenchiku*, Fujimori gives a useful if necessarily brief overview of the subject. See also the two exhibition catalogues titled *Japanese Aesthetics and Sense of Space: Another Aspect of Modern Japanese Design* (Tokyo: Sezon Museum of Art, 1990) and *Japanese Aesthetics and Sense of Space II: Modern Taste: Ornament and Eroticism 1900–1945* (Tokyo: Sezon Museum of Art, 1992).

103 See, for example, the discussion in Minami Hiroshi, *Taishō bunka* (*Taisho Culture*), 183–195. See also Takeuchi Yō, *Risshin shusse shugi* (*Careerism*), 210–218. In English, see Kinmonth, *The Self-Made Man in Meiji Japanese Thought*. On new middle-class women, see Nagy, "Middle-Class Working Women During the Interwar Years."

104 See Kumakura Isao's study of the modern history of the tea ceremony for a stimulating discussion of the transformation of tea during the late nineteenth century and early twentieth. From a subdued pastime for literary and religious men, tea ceremony became, on the one hand, a flamboyant form of conspicuous consumption among industrialists and politicians and, on the other, a feminized discipline employed to produce upward social mobility among women (and their male relatives). The latter function of the tea ceremony, which came to dominate, is particularly relevant to the development of a broad receptivity to folk craft in the middle class,

especially among middle-class women. Kumakura, *Kindai chadō shi no kenkyū* (*Research on the Modern History of the Tea Ceremony*).

105 The economic historian Mochida Keizō has studied what he calls the "taste for the pastoral" (*den'en shumi*) taken up by a number of leading literary figures during the early twentieth century, as well as its origins in a fascination with Tolstoy in particular (*Kindai Nihon no chishikijin to nōmin* [*Modern Japanese Intellectuals and Farmers*]). The conviction of the superior authenticity and beauty of rural life was especially conspicuous among, significantly, Yanagi's early cohort in the Shirakaba group. In English, see Dodd, "An Embracing Vision."

106 Fujimori has argued that both the Tudor style and the white-stucco simplicity of Spanish Mission became popular in part because they evoked (elite) country life. As he points out, the distinctive half-timbering of the Tudor style was reminiscent of Japanese farmhouse architecture. See Fujimori, *Nijon no kindai kenchiku*, 73, 95.

107 Ibid., 143–146; Dodd, "An Embracing Vision," 80–82. See also Ken Tadashi Oshima, "The Japanese Garden City: The Case of Denenchofu," *Journal of the Society of Architecture Historians* 55, no. 2 (June 1996): 140–151.

108 Vaporis, *Breaking Barriers*.

109 Some sense of the range of tourism as early as the 1920s can be gained simply by perusing the various national and regional travel magazines that began to appear. These include *Tsūrisuto* (*The Tourist*), *Ryokō kurabu* (*Travel Club*), *Tabi* (*Journey*), *Umi* (*Ocean*), *Kokusai kankō* (*International Tourism*), and *Ryojō* (*Travel Spirit*). Nevertheless, travel and especially tourism in modern Japan remain as yet largely unexplored terrain. While some work has been done on postwar Japanese tourism by anthropologists (see Marilyn Ivy, William Kelly, and Jennifer Robertson), the crucial formative periods of the late nineteenth century and early twentieth have been little studied. In Japanese, see Takaoka Hiroyuki, "Kankō—kōsei—ryokō" (Tourism—Welfare—Travel).

110 See the article "Haikara jogakusei no atarashii kotoba" (New Words Used by Stylish College Girls), *Ryokō kurabu* 6, no. 4 (April 1919): 32, for a discussion of *rokaru karaa* as a newly popular phrase to be heard in the conversation of the female students of higher schools.

111 Local women had long served in various ways to answer the demands of metropolitan male travelers. In the early part of the century, however, their status as an eroticized commodity became much more visible; travel magazines, for example, regularly featured covers and articles decorated with drawings and, later, photographs of local "beauties" (*bijin*)—young women usually dressed in native peasant costume. The topic of the local beauty was also frequently discussed in travel articles.

112 One thinks, for example, of the several celebrated Kawabata Yasunari novels, such as *The Izu Dancer* and *Snow Country*, which concern romances between the metropolitan male traveler and the rather ambiguous figure of the local serving girl/entertainer.

113 Articles were appearing as early as 1919 on the dangers of women traveling alone.

See "Wakaki fujin no anzen naru ryokōhō" (Methods of Safe Travel for Young Ladies), *Ryokō kurabu* 6, no. 3 (March 1919): 17–18, in which a characteristically ambivalent note was struck; on the one hand, the idea of a "solitary lady traveler" immediately raised the specter of her peril, while on the other the author could not deny that railways and inns welcomed the lady's custom. The happy solution he arrived at, after listing the various special measures she should take (such as reporting her status as a lone female to personnel whenever boarding a train), was that she should simply spend more money to ensure her safety.

114  "Ryokō ni nakute wa naranu yōgu" (Indispensable Items for Travel), *Ryokō kurabu* 5, no. 4 (April 1918): 42.

115  See Vaporis on early modern *omiyage* buying and selling: *Breaking Barriers*, 219–236. He notes that often the distribution of gifts by the returned Edo-period traveler was part of a larger circuit of exchange, in which recompense was being made for gifts received by the traveler before departure, or by the traveler's family during his or her absence.

116  The expanded production and consumption of *omiyage* and *meibutsu* is attested to by, among other things, the interest evinced in the omiyage industry by both central and local agencies concerned with the promotion of local manufactures. See, for example, the special April 1930 issue of *Teikoku kōgei* 4, no. 4 devoted to omiyage.

117  On the broadening interest in collecting folk toys during the 1920s and 1930s, see the essay by Saitō Ryōsuke, "Nihon no kyōdo gangu" (Japanese Folk Toys). The Chicago anthropologist Frederick Starr described the earlier, elite practice of folk toy collecting in his 1921 booklet *Japanese Collectors and What They Collect*. I am indebted to Kawagoe Akie for her discussion of the role of the Railway Ministry and various tourism bureaus in the promotion of folk toys, to be found in her paper "The Re-invention of Japanese Folk Toys through Tourism," delivered in 1995 at the American Folklore Society Meetings.

118  I am following Harry Harootunian, Marilyn Ivy, and others in translating *minzokugaku* as "native ethnology." I also occasionally refer to minzokugaku as "folklore studies," the older term by which it has been known most commonly in English, because (1) the word "folklore" suggests the central place Yanagita succeeded in retaining for the study of folk beliefs, language, and custom, as opposed to objects, within his discipline; (2) "folklore" also suggests the larger, international context of folklore studies, as developed most prominently in northern Europe and the United States, within (and against) which Yanagita and other Japanese minzokugaku scholars considered themselves to be working; and (3) the common use of the root word "folk" gives some sense of the connections between the projects of Yanagita, Shibusawa, Kon, and also Yanagi. For a different approach to many of these issues, see Christy, "Representing the Rural."

119  See the discussion of Kon in Harootunian, *Overcome by Modernity*, 178–201. See also Silverberg, "Constructing the Japanese Ethnography of Modernity."

120  Misumi Haruo and Kawazoe Noboru, *Hayakawa Kōtarō–Kon Wajirō*.

121  See the intellectual biography by Miyamoto Tsuneichi, *Shibusawa Keizō*.

122  A conspicuous example being the publication during the late 1970s of the twelve-volume *Nihon minzoku bunka taikei* (*The System of Japanese Folk Culture*), which includes a volume on Yanagi as well as one on Shibusawa, half a volume on Kon, and one on Yanagita.

123  One exception is the work of historian Kano Masanao, who has discussed the various folk-culture projects as belonging to a larger field he calls *minkangaku*. See his *Kindai Nihon no minkangaku* (*Modern Japanese Minkangaku*).

124  See, for example, Amano Takeshi, *Mingu no mikata* (*The Perspective of Folk Tools*), especially chapter 2. For a discussion of the Yanagi-Yanagita distinction or opposition, see the *zadankai* "Yanagita Kunio to Yanagi Muneyoshi." *Yanagita Kunio kenkyū* (*Research on Yanagita Kunio*) 3 (fall 1973): 2–82.

125  Yanagita, for example, is known to have read widely in the European literature on folklore and ethnology. He was especially influenced by the work of James Frazer and George Gomme, among others. See Minoru Kawada, *The Origin of Ethnography in Japan*, 108–110; and Morse, "The Search for Japan's National Character and Distinctiveness," 148–159.

126  Anthropologist Yamaguchi Masao has discussed the playfully ethnographic bent of a number of late Meiji-era collectors' groups, as well as Yanagita's ambivalent participation in them, in *"Haisha" no seishinshi* (*A History of the Spirit of "the Vanquished"*).

127  Yanagita's literary activities during the 1890s and the following decade are discussed in Morse, "The Search for Japan's National Character and Distinctiveness," 19–39.

128  Yanagita, in the 1954 issue of *Minzokugaku techō* (*Native Ethnology Notebook*), quoted in Saitō Ryōsuke, "Nihon no kyōdo gangu," 30. See Miwa Kimitada, "Toward a Rediscovery of Localism," for an alternative reading of the effects of Yanagita's social origins on his study of the folk.

129  In his biography of Kon, Kawazoe emphasizes Kon's efforts to separate himself from the aestheticizing and antiquarian *shumi* (taste, hobbyist) elements in *minka* and folklore studies, and to align himself instead with programs for social reform. *Hayakawa Kōtarō–Kon Wajirō*, 241–245, 296–298, 311.

130  Saitō Ryōsuke, "Nihon no kyōdo gangu," 35–40.

131  For discussion of Shibusawa's methods and goals and his commitment to a scientific model of research, see Christy, "Representing the Rural." The specter of *shumi* casts a long shadow: as late as 1981, the sociologist and folklorist Ariga Kizaemon felt compelled to insist that the youthful Shibusawa collected folk toys not as a hobby (*shumi*), but rather as "valuable ethnological materials" in order to "make a contribution to native ethnology." See Ariga, *Hitotsu no Nihon bunkaron* (*One Theory of Japanese Culture*), 138.

132  Ibid., 136. Ariga's only comment is: "The significance of this is that it was one of the first occasions for the exhibition of folk performing arts [*kyōdo geinō*] in Tokyo."

133  Misumi and Kawazoe, *Hayakawa Kōtarō–Kon Wajirō*, 297.

134  Kon, in particular, could be found writing on such topics as department stores (in the March 1932 issue of *Katei* [Family]), contemporary women's fashion and interior design, the history of European furniture styles and architecture (in 1936 and 1937 issues of *Jūtaku to teien* [House and Garden]), and clothing as decoration (in the March 1939 issue of *Fujin gahō* [Ladies' Graphic]). Yanagita, while less prolific than Kon, was not unfamiliar to magazine readers as a commentator on such themes as "head colds and the use of cotton" (in the May 1936 *Katei*) or the history of women's daily life (a series of articles that appeared in 1941 issues of *Fujin kōron* [Ladies' Review]).

135  "Yanagita Kunio shi no shosai" (Mr. Yanagita Kunio's Study), *Jūtaku* 17, no. 12 (December 1932): 750–751.

## 3 New Mingei in the 1930s

1  In the editorial notes for the May issue of his new magazine, *Kōgei*, Yanagi wrote of the planned trip: "Kawai and I have been to this region before, though only briefly. Because we encountered an astonishingly large number of beautiful things, I am looking forward to quite a good bag this time as well. I want to walk all over Japan in this way before it's too late. Antiques-hunting is fun, but there is deeper meaning in looking for good new crafts." "Henshū yoroku" (Editorial Notes), *Kōgei* 5 (May 1931): 56.

2  Yanagi Muneyoshi, "Henshū yoroku," *Kōgei* 6 (June 1931): 63.

3  Yanagi's celebrated essay in appreciation of Onta pottery, which appeared first in the Saga, Nagasaki, and Yamaguchi editions of the *Seibu mainichi* in July and August 1931, has been reprinted many times. Due to the patronage of mingei activists from the 1930s onward, Onta pottery remains to this day closely associated with the category of mingei pottery, and with the mingei movement in general. See the various publications by anthropologist Brian Moeran, especially *Lost Innocence*, for a discussion of the community and its interactions with the Tokyo-based mingei establishment in the postwar period.

4  Yanagi's enthusiastic sense of new purpose is palpable in various public and private writings of the summer of 1931. See his editorial commentaries for the summer issues of *Kōgei*, as well as letters and postcards he sent throughout the summer in YMz 21 (1): 426–440.

5  As Yanagi put it in the editorial commentary that concluded the magazine's first year, "It may be said that the destiny of *Kōgei* is to rear 'persons who can see' [*mieru hito*]." *Kōgei* 12 (December 1931): 64.

6  Yanagi frequently compared *Kōgei* to *Shirakaba*, as for example in *Kōgei* 12 (December 1931): 59. "Bi no hyōjun" (Aesthetic Standards) was the title of a section that appeared in the first twelve issues of *Kōgei* and in which two photographed objects were compared. One was shown to be "correct" and the other "incorrect."

7  An entry on Ōta (1890–1984) appears in *Shimane ken daihyakkajiten* (Encyclopedia of

*Shimane Prefecture)* (Matsue: San'in chūō shinpōsha, 1982), 266. Some biographical information on Yoshida (1898–1972) is to be found in Makino Kazuharu, *Yoshida Shōya to Tottori ken no teshigoto (Yoshida Shōya and the Handicrafts of Tottori Prefecture)*.

8 Ōta Naoyuki, "Chihō kōgei no shōrai" (The Future of Provincial Crafts), *Kōgei* 10 (October 1931): 1–13.

9 Yoshida Shōya, "Impaku no mingeihin shisaku" (The Trial Manufacture of Impaku Mingei Objects), *Kōgei* 10 (October 1931): 14–23. See also Ueda Kisaburō's oral history of Ushinoto: *Tōkō shokunin no seikatsu shi (The Life History of a Potter)*, 107–109, 67–70.

10 Yanagi, "Henshū yoroku," *Kōgei* 6 (June 1931): 64–65.

11 Yoshida, "Impaku no mingeihin shisaku," 18.

12 Ibid., 19–22; Ueda, *Tōkō shokunin no seikatsu shi*, 140.

13 Ueda, *Tōkō shokunin no seikatsu shi*, 123–124.

14 Yoshida, "Impaku no mingeihin shisaku," 19–22.

15 Ueda, *Tōkō shokunin no seikatsu shi*, 112–113.

16 Ueda, the editor of Kobayashi's oral history, cites the depression and Ushinoto's financial difficulties as a primary reason for Kobayashi's decision to produce mingei pottery. Ibid., 117.

17 Ibid., 80. Kobayashi's reluctance to admit profit-making as a motive for mingei production may have reflected the influence of mingei ideology, particularly as it became codified in the postwar period. In his 1984 study of Onta, the Kyushu pottery village heavily influenced by mingei activism, Brian Moeran noted that potters there accepted the mingei axiom positing an inverse relation between profit and product quality even as they grew prosperous and sought, despite criticism from the mingei establishment, to respond to changing market conditions. See Moeran, *Lost Innocence*, 194–195, 201–202.

18 Smith, *A Time of Crisis*, 49–62.

19 For a brief discussion of changes in the post–World War I industrial structure and their effects on consumer goods production, see Takufusa Nakamura, *Economic Growth in Prewar Japan*, 185–193. See Wigen, *The Making of a Japanese Periphery*, 243–266, for an analysis of the decline of handicraft industries between 1895 and 1920 in southern Nagano prefecture. She notes that in addition to changing consumer tastes and the advent of inexpensive mechanically produced goods, the decline of craft production in Nagano was caused by government intervention and by new constraints on both labor and land.

20 Ōta, "Chihō kōgei no shōrai," 2.

21 The first exhibition sale, in Kyoto, took place over three days and was reported in *Kōgei* to have sold 1,500 yen worth of goods. "Henshū yoroku," *Kōgei* 11 (November 1931): 66.

22 See, for example, advertisements for the Tokyo shops Mizusawa and Minatoya in *Kōgei* from late 1931 and 1932. By the beginning of 1933, Yoshida was noting that a certain type of new mingei necktie produced in Tottori was available for purchase at

various establishments in the three major cities, including the Mitsukoshi and Takashimaya department stores. Yoshida Shōya, "Tsūshin Tottori yori" (News from Tottori), *Kōgei* 26 (February 1933): 69.

23  Yoshida complained of inferior copies of the Tottori neckties and potholders he had helped to develop. The imitation potholders were discovered by Yanagi Kaneko selling for 10 sen apiece at the Mitsukoshi department store in Shinjuku, Tokyo. Yoshida, "Tottori tsūshin" (Tottori News), *Kōgei* 27 (March 1933): 59.

24  Ōta, "Chihō kōgei no shōrai," 13. The experience of the world depression, following as it did a decade of unprecedented liberalism in social and political thought, caused many Japanese—even public officials—to question openly the value and viability of a fully capitalist system. Of course, this phenomenon was not unique to Japan.

25  Ibid., 9.

26  Yanagi, "Henshū yoroku," *Kōgei* 10 (October 1931): 80–81.

27  See Yanagi's letters to Hamada Shōji, Tonomura Kichinosuke, and Yoshida Shōtarō during 1930–1931, in YMz 21 (I). See also his musings on his own (relative) poverty in "Henshū yoroku," *Kōgei* 11 (November 1931): 53–54.

28  See Wigen, *The Making of a Japanese Periphery*, for discussion of lacquerware, silk textiles, and paper manufacture in the eighteenth and nineteenth century in present-day Nagano region. For an overview of state as well as local initiatives promoting indigenous industries during the nineteenth century and the twentieth, see Morris-Suzuki, *The Technological Transformation of Japan*.

29  Takafusa Nakamura, *Economic Growth in Prewar Japan*, 213.

30  See chapter 4 for further discussion of the Industrial Arts Research Institute (Kōgei shidō jo), the craft reform agency established within the Ministry of Commerce and Industry in 1928.

31  See, for example, Ōishi Isamu's study of one such project in the 1920s in a Hokkaido village: *Dentō kōgei no tanjō* (The Birth of Traditional Craft).

32  Ōta began working at the Chamber of Commerce in the early 1920s. He was appointed general director in 1928. Reference is made to "mingei fever" (*mingei netsu*) in a 1933 publication of the Matsue Chamber of Commerce: *Matsue shōkō ihō* (*Matsue Commerce Bulletin*). For an account of the Chamber of Commerce's activities in the late 1920s, see Ōta Naoyuki, ed., *Matsue shōkō kaigi jo 40 nen shi* (*The 40-Year History of the Matsue Chamber of Commerce*), 35–40.

33  On Yamamoto's life and work, see Kozaki Gunji's biography *Yamamoto Kanae hyōden* (*Critical Biography of Yamamoto Kanae*). In English, Yamamoto has been discussed in Merritt, *Modern Japanese Woodblock Prints*.

34  Yanagi, "Umoreta zakki no bi" (The Beauty of Buried Wares), part 2, *Sandeii mainichi* (*Sunday Mainichi*), 10 July 1927 (Nihon Mingeikan archive). Also Yanagi, "Kōgei no michi," in YMz 8: 111.

35  Yanagi, "Mingei to nōmin bijutsu" (Mingei and Farmers' Art), *Kōgei* 51 (March 1935): 56–57. Interestingly, Yanagi began this article by comparing the error of

conflating farmers' art with mingei to that of confusing such "dangerous thought" as communism with guild socialism. Given Yanagi's ardent and public endorsement of guild socialism less than a decade earlier, this was more than an idle analogy and suggests another reason why he may have wished to dissociate himself from the Russian-tainted farmers' art movement at a time when socialist thought was increasingly unacceptable to Japanese authorities.

36  Ōta, "Chihō kōgei no shōrai," 2.

37  Yanagi, "Henshū yoroku," *Kōgei* 11 (November 1931): 56–57. Elsewhere Yanagi remarked that "the reason why officials cannot be relied on [to guide artisans], is that their work is obligatory, and thus they lack fervor." "Henshū yoroku," *Kōgei* 10 (October 1931): 81.

38  Itō Kikunosuke, *San'in no tōyō* (San'in Pottery Kilns), 133.

39  Takeuchi Kiyomi, "Sakatsu no kama to Ōharayaki" (The Sakatsu Kiln and Ōhara Pottery), *Kōgei* 32 (August 1933): 46, 48–49.

40  Yoshida Shōya, "Mingei no shidōsha, sono hoka ni san" (Directors of Mingei, and Two or Three Other Matters), *Kōgei* 15 (March 1932): 47–49; Yoshida, "Tottori mingei fukkōkai to 'Takumi' " (The Association to Revive Tottori Mingei, and "Takumi"), *Kōgei* 27 (March 1933): 31.

41  Yoshida, "Impaku no mingeihin shisaku," 17.

42  Yanagi, "Hongo no sashie" (The Illustrations for This Issue), *Kōgei* 16 (April 1932): 11–12.

43  Yoshida, "Tottori tsūshin," *Kōgei* 27 (March 1933): 59.

44  Yanagi, for example, recommended that Ōta give potters in the Shimane pottery village of Fujina works by the British potter Michael Cardew to study and emulate. See his 5 June 1931 letter to Ōta in YMz 21 (I): 428.

45  Ōta Naoyuki, "Chihō kōgei no shōrai," 7.

46  Yoshida Shōya, "Tottori mingei fukkōkai to 'Takumi,' " 28–29.

47  Abe Eijirō, *Tesuki 70 nen* (Seventy Years of Papermaking), 123–124.

48  The first such trip seems to have occurred in December 1933, when Yanagi, Kawai, Mizutani Ryōichi, and Mori Kazuki ventured to Kyushu in search of new "healthy things" (kenkō na mono) being produced by Japan's "nameless folk kilns." Their acquisitions resulted in a large exhibition sale at the Matsuzakaya department store in Tokyo in March 1934, along with a special issue of *Kōgei* (March 1934). Yanagi, "Dōjin zatsuroku" (Miscellaneous Record of the Members), *Kōgei* 38 (February 1934): 73.

49  Ishimaru Shigeharu, "Kinji zakkan" (Recent Impressions), *Kōgei* 12 (December 1931): 38–42.

50  Yoshida Shōya wrote a rather defensive rebuttal of Ishimaru several months later. See his "Mingei no shidōsha sono hoka ni san," *Kōgei* 15 (March 1932): 47–51. Yanagi's displeasure was expressed privately, as for example in his 15 December 1931 postcard to Hamada Shōji in YMz 21 (I): 458.

51  The contentious nature of these contradictions was given dramatic form in the early

1950s, when Miyake Chūichi broke away from the Mingei Association to form his own rival organization around the premise of a purist commitment to folk-craft purged of self-conscious and individualistic artistry. On Miyake Chūichi, see Tominaga Shizurō, *Mingei gotoshi hana* (*Mingei Like Flowers*).

52 Yanagi was forced to concede the faults of new mingei (its heaviness, its overly rounded and ornamented tendencies) in a conversation with Bernard Leach recorded as part of a round-table discussion held on 30 May 1934. "Riichi no hanashi o kiku zadankai" (Round-table Discussion with Bernard Leach), *Kōgei* 42 (June 1934): 33.

53 See Yoshida, "Mingei shidōsha sono hoka ni san," 48–49.

54 Yanagi, "Henshū yoroku," *Kōgei* 5 (May 1931): 60. For similar comments by Yanagi, see his "Henshū yoroku" in *Kōgei* 6 (June 1931): 65 and in *Kōgei* 14 (February 1932): 73.

55 Yanagi, "Henshū yoroku," *Kōgei* 12 (December 1931): 65; and "Henshū yoroku," *Kōgei* 13 (January 1932): 113.

56 Yanagi, "Zatsuroku" (Miscellaneous Notes), *Kōgei* 56 (September 1935): 68.

57 Yanagi, "Kyōto mingei dōkō kaiin ni" (To the Members of the Kyoto Mingei Amateurs' Society), *Kōgei* 68 (August 1936): 83–85.

58 A similar argument is put forward by Chiaki Ajioka in her dissertation "Early Mingei and Development of Japanese Crafts, 1920s–1940s"; see especially chapters 4–5. Ajioka also discusses the potter Tomimoto Kenkichi as another early member of the mingei group alienated during the 1930s by the increasing emphasis on new mingei.

   Aoyama Jirō (1901–1979) was another of the original cosigners of the 1926 "Prospectus for the Establishment of a Mingei Art Museum"; with Ishimaru he helped to found the magazine *Kōgei*. An influential literary figure and ceramics collector, Aoyama is also known for his lifelong friendship with the literary critic Kobayashi Hideo.

   Kurahashi Tōjirō (1887–1946), a publisher and ceramics collector, was an important supporter of Yanagi and his circle during the 1920s and early 1930s. He was particularly active in the promotion of antique Korean pottery and porcelain.

59 In a 1932 letter, Kurahashi attempted to persuade Yanagi to give up his preoccupation with new mingei. According to Kurahashi, the new mingei movement was a populist venture involving quantitative rather than qualitative concerns, and therefore unsuited to Yanagi's true character and abilities: 2 July 1932 letter to Yanagi, Nihon Mingeikan archive.

60 Yanagi wrote to Hamada Shōji in January 1931 of a letter he had received from Kurahashi, in which Kurahashi warned that Yanagi's "domineering ways" (*sen'ō no yarikata*) were causing Ishimaru and Aoyama to lose interest in working with him as joint editors of *Kōgei*: 2 January 1931 letter, in YMz 21 (I): 408.

61 Hata Hideo, "Yanagi Muneyoshi ron" (On Yanagi Muneyoshi).

62  In his private diary, Aoyama Jirō poured scorn on the new mingei activists. He scoffed at Shikiba Ryūzaburō, for example, as a *"getemono* genius" who was "like a guardsman for the Heian imperial palace" (referring, presumably, to Shikiba's attitude toward Yanagi and new mingei ideology). Shikiba and Yoshida were both "laughable." See the 26 February 1933 entry in "Aoyama Jirō nikki" (Aoyama Jirō's Diary).

63  For more on new mingei in Kurashiki, see the special Kurashiki issue: *Kōgei* 32 (August 1933).

64  Advertisement in *Kōgei* 10 (October 1931), n.p. See also "Kyō kara San'in mingeiten" (San'in Mingei Exhibit from Today), Kyoto edition of the *Ōsaka mainichi shimbun*, 17 October 1931 (Mingeikan archive).

65  Yanagi, "Henshū yoroku," *Kōgei* 15 (March 1932): 75.

66  Yanagi, "Henshū yoroku," *Kōgei* 16 (April 1932): 82.

67  Letters from Yanagi to Ōta Naoyuki, 21 January and 2 February 1932, in YMz 21 (I): 464–465. For more on Kawai's relationship to Kawakatsu, see his letters to Kawakatsu in Kawakatsu, *Gashin gunshin shō* (*Selection of Paintings and Correspondence*).

68  On the history of expositions in Japan, see Yoshimi Shun'ya, *Hakurankai no seijigaku* (*The Politics of Expositions*), especially chapters 3 and 4.

69  For Japan, the crucial intermediate institution linking the industrial exposition to the department store was the arcade, or *kankōba*, which flourished in the 1880s and 1890s. See ibid., 135–141; and Hatsuda Tōru, *Hyakkaten no tanjō* (*Birth of the Department Store*), chapters 1 and 2. For Europe, the relationship between the great exhibitions and department stores has been discussed by, among others, Richards, *The Commodity Culture of Victorian England*.

70  Hatsuda, *Hyakkaten no tanjō*, chapter 5. As Hatsuda acknowledges (p. 133), however, the Bon Marché in Paris and especially Wanamaker's in Philadelphia certainly offered visitors spectacle and event as well as merchandise. Nevertheless, Hatsuda's point still stands; in the U.S. case, at least, William Leach's *Land of Desire* makes clear that Wanamaker's was highly unusual in its commitment to social welfare and philanthropy.

71  On the condition of the Japanese consumer market in the 1920s and 1930s, see Nakamura Takafusa, *Economic Growth in Prewar Japan*. See also Rubinfien, "Commodity to National Brand."

72  And, as Aristide Boucicaut of the pioneering Parisian department store Bon Marché is famous for having realized, even casual visitors might well become customers once they had actually set foot in the store and exposed themselves to its seductions. See Miller, *The Bon Marché*, for discussion of the means used by Boucicaut and his managers to increase the volume of foot traffic in the store, and to persuade visitors to become shoppers.

73  Kornicki, "Public Display and Changing Values." The continuities between modern expositions and early modern exhibitions are also discussed in Yoshimi, *Hakurankai no seijigaku*, 142–144.

74 On *shogakai* and *bussankai* as precursors to early Meiji industrial expositions, see Kornicki, "Public Display and Changing Values." For a vivid discussion of the uses and abuses of Edo-style (as opposed to Kansai-style) *shogakai*, see Markus, "Shoga-kai: Celebrity Banquets of the Late Edo Period."

75 Kon Wajirō, "Depaato fūzoku shakaigaku" (Sociology of Department Store Customs), in *Kon Wajirō shū* (*Collected Works of Kon Wajirō*), 227–252.

76 It is possible, therefore, that Japanese men differed significantly from their Euro-American counterparts in their shopping habits. Certainly it remains widely assumed that European and American department store clientele were predominantly female. Perhaps as a result, however, there has been relatively little study of male shoppers and shopping. (One recent exception is the work of Christopher Breward. See his *The Hidden Consumer: Masculinities, Fashion, and City Life, 1860–1914* [Manchester, New York: Manchester University Press, 1999].) Yet, as Leora Auslander has observed, men do shop, and we have much to learn about men and department stores, among other topics. See her "The Gendering of Consumer Practices in Nineteenth-century France."

77 On "Japonisme" and "Japan taste," see Ayako Ono, *Japonisme in Britain*; and Hosley, *The Japan Idea*. In *The Technological Transformation of Japan*, Morris-Suzuki discusses the importance of industrial exhibitions as a state-sponsored means, especially in the provinces, of encouraging developments in handicraft technology. She also notes that as early as 1876, an industrial museum was opened in the city of Kanazawa in Ishikawa prefecture, where it "offered displays of craft products and equipment, as well as special exhibitions and prize competitions for industries such as ceramics, metal-working and lacquerware" (82–83, 93).

78 Promotional pamphlet produced by Matsuzakaya department store, dated March 1934 (Nihon Mingeikan archive). See also the Matsuzakaya advertisement for both shows in *Kōgei* 39 (March 1934): n.p.

79 Advertisement in *Kōgei* 74 (February 1937): n.p. See also the promotional pamphlet from Hankyū dated March 1937, announcing the opening of the mingei salesroom (Nihon Mingeikan archive). The Mitsukoshi store in Nihonbashi, Tokyo, followed suit with its own mingei salesroom in 1941. See *Mitsukoshi* (August 1941): 1.

80 For example, in October 1937 the Hankyū mingei salesroom had a show and sale of *obi* (kimono sash) textiles by artists Serizawa Keisuke and Yanagi Yoshitaka. At the same time it held a generic new mingei show and sale of seasonal items such as shawls, braziers (*hibachi*), and stew pots (*nabe*). See advertisement in *Kōgei* 79 (July 1937): n.p. More details on the various shows and sales held at the Hankyū mingei salesroom are to be found in almost every issue of the magazine *Hankyū bijutsu* (*Hankyū Art*) during the years 1937–1940.

81 Managed by Shiga Naokuni, the nephew of the writer Shiga Naoya, Takumi remains in business to this day. On Mizusawa, see Mizusawa Sumio, "Atarashii mingeihin no mise" (A New Mingei Shop), *Kōgei* 11 (November 1931): 39–43. Yanagi discusses all three shops in an article he wrote for the first issue of a magazine put out by

Takumi: " 'Takumi' no kaiten ni tsuite" (About the Opening of "Takumi"), *Gekkan Takumi* (*Takumi Monthly*) 1 (January 1934): 1 (Nihon Mingeikan archive).

82 See announcements in editorials as well as advertisements in the 1934 and 1935 issues of *Kōgei*.

83 I am borrowing the term "exhibitionary complex" from Tony Bennett's suggestive discussion of the formation of a linked network of exhibitionary institutions in nineteenth-century Europe, in his *The Birth of the Museum*, chapter 2.

84 From 1918 to 1928, "Kokuten" was a contraction for Kokuga sōsaku kyōkai tenrankai (National Painting Creative Society Exhibition). In 1928 the Society reorganized itself and became the Kokugakai (National Painting Society). Since 1928, therefore, Kokuten has referred to the annual Kokugakai tenrankai (National Painting Society Exhibition).

85 The government art exhibition Monten (from Monbushō bijutsu tenrankai, or Ministry of Education Art Exhibit) was founded in 1907. In 1919 it was amalgamated with another governmental art exhibition, the Teiten (from Teikoku bijutsuin tenrankai, or Imperial Art Academy Exhibition). In 1937 the Teiten was renamed the Shinmonten (New Ministry of Education Exhibition), and since 1946 it has been known as Nitten (from Nihon bijutsu tenrankai, or Japan Art Exhibition). See the multivolume history of this exhibition, the *Nitten shi* (*History of Nitten*).

86 In 1947 the mingei group returned to the Kokugakai, causing Tomimoto to withdraw from the society. See the 1991 Kokugakai exhibition catalogue *Kokugakai 65 nen: Kōgei no tenbō* (*Sixty-five Years of the Kokugakai: A Crafts Survey*), Tokyo: Nishibu aato fuōramu, 1991.

87 Ajioka, "Early Mingei and Development of Japanese Crafts," 267–269. Yanagi joined the hanging committee for the craft section of the Kokuten in 1930.

88 Kimura Kazuichi, "Kokuten no kōgei o miru" (Viewing the Crafts at Kokuten), *Atorie* (Atelier) 12, no. 6 (June 1935): 37. Quote translated and cited by Ajioka, "Early Mingei and Development of Japanese Crafts," 268.

89 Suzuki Kenji, *Kōgei*, 187–188.

90 Yanagi, "Dōjin zatsuroku," *Kōgei* 29 (May 1933): 114.

91 Yoshida, "Tottori tsūshin," *Kōgei* 33 (September 1933): 59; Yanagi, "Dōjin zatsuroku," *Kōgei* 41 (May 1934): 73.

92 17 April 1934 letter from Yanagi to Ōta Naoyuki, in YMz 21 (II): 21.

93 Advertisement in *Kōgei* 77 (May 1937): n.p. Also noted in Yanagi, "Mingeikan no ichinen" (One Year of the Mingeikan), *Kōgei* 83 (November 1937): 57.

94 Yanagi, "Mingeikan no ichinen," 56. To this day, the Mingeikan holds one large exhibition sale of new mingei every fall. Objects are submitted by artisans from all over the country for evaluation; those selected are displayed and sold over a period of about one week. The first day of the exhibition sale is something of a mob scene, with shoppers—some of whom have traveled significant distances—crowded outside the Mingeikan for hours before opening.

95 Advertisement in *Kōgei* 70 (October 1936): n.p.

96  Yanagi, "Mingeikan no ichinen," 60.

97  Yanagi, "Henshū yoroku," *Kōgei* 7 (July 1931): 52.

98  On the success of mingei neckties, it was reported in late 1933 that the shop Takumi sold more neckties than anything else, sending at least a thousand every month to Osaka retailers alone. See statement by Yamamoto Tetsutarō in Shikiba Ryūzaburō, "Kōgei zadankai ki" (Record of the Crafts Round-table Discussion), *Kōgei* 35 (November 1933): 61. For references to gentlemen's canes, homespun, shirting, Panama hats, and belts, see, respectively, Yoshida Shōya, "Impaku no mingeihin shisaku," *Kōgei* 10 (October 1931): 20; advertisement for Takumi in *Kōgei* 50 (February 1935): n.p.; Yoshida Shōya, "Tottori tsūshin," *Kōgei* 68 (August 1936): 87; Yoshida, "Tottori tsūshin," *Kōgei* 54 (June 1935): 42; Morinaga Jūji, "Yasugi dayori" (News from Yasugi), *Kōgei* 34 (October 1933): 78–79.

99  Yanagi, "Sashie kaisetsu," *Kōgei* 10 (October 1931): 68.

100  See Sand, *House and Home in Modern Japan*, chapter 1, for discussion of the gendered division of the early modern home and its accoutrements.

101  Bookends were featured in Yanagi, "Shinsaku shōkai" (Introduction to New Manufactures), *Kōgei* 34 (October 1933): 68. For ink stands, see Takumi advertisement, *Kōgei* 26 (February 1933): n.p. Boxes for back issues were advertised regularly in *Kōgei*.

102  The word "katei" and its associations with a feminized conception of the home are discussed in Sand, *House and Home in Modern Japan*, 25–26.

103  For references to handbags, shawls, obi, and obi cords, see, respectively, Takumi advertisement in *Kōgei* 26 (February 1933); Minatoya advertisement in *Kōgei* 43 (July 1934); Takumi advertisements in *Kōgei* 37 (January 1934) and *Kōgei* 79 (July 1937); Yoshida, "Tottori tsūshin," *Kōgei* 33 (September 1933): 60.

104  On the emergence of the modern Japanese housewife (*sengyō shufu*), see Ishii Kazumi and Nerida Jarkey, "The Housewife Is Born." Also discussed in Sand, *House and Home in Modern Japan*, 55–62. The twentieth-century housewife's responsibility for domestic textile goods may well represent a continuity with much older practices associating women with cloth wealth.

105  See, for example, the Takumi advertisement in *Kōgei* 26 (February 1933).

106  See, for example, the Takumi advertisement in *Kōgei* 35 (November 1933).

107  Opening statement by Yanagi in "Bi to shakai ni tsuite no zadankai" (Round-table Discussion about Beauty and Society), *Kōgei* 38 (February 1934): 49–55.

108  Yoshida Shōya, "Shinkō mingei zakkan" (Various Thoughts on New Mingei), *Kōgei* 74 (February 1937): 52. Several mingei coffee shops and restaurants were in fact established during the 1930s, though none as a formal enterprise of the folk-craft movement or any of its leading figures. Yoshida did eventually open a restaurant in Tottori, however.

109  Tanabe Kōji, "Kōgei kai no kaiko to kibō," (Recollections and Hopes of the Crafts World), *Bi no kuni* (*Land of Beauty*) 12, no. 1 (January 1936): 21.

110  Yanagi, "Zatsuroku," *Kōgei* 77 (May 1937): 74.

111  See, for example, features on *kasuri* weaving in *Fujin gahō* 410 (April 1938) and 425

(July 1939), and the article on weaving and dyeing by Yanagi in the fashion section of *Fujin kōron* 22, no. 4 (April 1937).

112   In *Jūtaku*, see pieces on mingei furniture and decor in 20, no. 5 (May 1935); 20, no. 12 (December 1935); and 21, no. 11 (November 1936). In *Seikatsu to shumi*, see articles and photos in 2, no. 4 (fall 1935); 3, no. 2 (spring 1936); and 3, no. 6 (December 1936).

113   Kumakura Isao, *Kindai chadōshi no kenkyū* (*Research on the Modern History of the Tea Ceremony*), 298–304.

114   Saitō Michiko, *Hani Motoko*, 131.

115   See Koyama Shizuko, *Ryōsai kenbo to iu kihan* (*The Framework Known as Good Wife, Wise Mother*), for a history of girls' higher education in the late nineteenth century and early twentieth. The growing readership for women's magazines is discussed in Barbara Satō, *The New Japanese Woman*, chapter 3. See also Nagamine Shigetoshi, *Zasshi to dokusha no kindai* (*The Modernity of Magazines and Readers*).

116   Yamazaki Kaidō, "Shumi no tōki 'Mashiko yaki'" (Tasteful Ceramics "Mashiko Pottery"), *Seikatsu to shumi* 3, no. 2 (spring 1936): 78.

117   "Wakai onna to getemono" (Young Women and Getemono), *Nihon shumi* 1, no. 1 (April 1935): 86.

118   Yamauchi Toshio, "Senshoku ni tsuite" (On Weaving and Dyeing), *Kōgei* 42 (June 1934): 63.

119   Hamada Shōji, "Kurashiki no inshō" (Impressions of Kurashiki), *Kōgei* 32 (August 1933): 51.

120   Yanagi, "Hawaii yori" (From Hawaii), *Kōgei* 32 (August 1933): 62. See also Yanagi, "Hawaii yori," *Kōgei* 31 (July 1933): 76.

121   Other examples include the folklore studies proponents discussed in the previous chapter. Jordan Sand has observed a related phenomenon in his study of the 1920s commodification of domestic architecture; as he notes, architects seeking to purvey their expertise to a mass public addressed, increasingly, a female audience. Sand, *House and Home in Modern Japan*, chapter 8. In addition, one might cite such figures as the artist Yamamoto Kanae, who taught painting in the early 1920s at the girls' higher school Jiyūgakuen, or the art-craft artist Fujii Tatsukichi, who became well-known in the 1920s and 1930s as a popularizer of *shugei* or domestic handicrafts in the mass market women's magazine *Shufu no tomo* (*The Housewife's Companion*).

122   *Fujin gahō*, for example, ran a feature article on the home and family life of the folk-craft activist Shikiba Ryūzaburō in its April 1940 issue. The July 1941 issue featured the textile dye artist Serizawa Keisuke, who produced wearable art and was photogenic to boot.

123   Bernard Leach, "A Letter to England," *Kōgei* 53 (May 1935): 25–26.

124   See Takumi advertisements in *Kōgei* 55 (July 1935) and 65 (May 1936).

125   Tanabe, "Kōgei kai no kaikan to kibō," 20.

126   The rising nationalism and "war fever" that followed the Manchurian Incident is discussed in Young, *Japan's Total Empire*, chapter 3.

## 4. Mingei and the Wartime State, 1937–1945

1  See Ienaga Saburō, *The Pacific War, 1931–1945*, on the management of Japanese soldiers in China.

2  The first regional branches were all in Tōhoku prefectures: Aomori (in the city of Hirosaki), Iwate (Morioka), and Akita (Kakunodate).

3  The celebration of folk culture under National Socialism in Germany is well-known. For Italy, see de Grazia, *The Culture of Consent*, 201–216; and Simeone, "Fascists and Folklorists in Italy." On France, see Faure, *Le Projet Culturel de Vichy*; and Lebovics, *True France*, chapter 4.

4  For critiques of the North American, and especially the U.S., resistance to identifying fascism in wartime Japan, see Bix, "Rethinking 'Emperor-System Fascism' "; and McCormack, "Nineteen-Thirties Japan."

5  Gordon, *Labor and Imperial Democracy in Prewar Japan*, 333–339. See also Tansman, introduction to *Fascist Culture in Japan*.

6  Gordon, *Labor and Imperial Democracy*, 338.

7  Fletcher, *The Search for a New Order*; Kasza, *The State and the Mass Media in Japan*; Doak, *Dreams of Difference*; Tansman, *The Aesthetics of Japanese Fascism*.

8  The classic essay on the fascist aestheticization of politics is Walter Benjamin's 1936 "The Work of Art in the Age of Mechanical Reproduction." A more recent, but also influential discussion of the topic is Susan Sontag's "Fascinating Fascism." There is a large literature on questions of aesthetics in National Socialism. More recently, studies on aesthetics in Italian fascism have begun to appear. See, for example, Falasca-Zamponi, *Fascist Spectacle*; and Ben-Ghiat, *Fascist Modernities*.

9  See, for example, Kestenbaum, "Modernism and Tradition in Japanese Architectural Ideology."

10  Even if monumental structures were rarely realized in Japan, they were imagined and even planned. See Inoue Shōichi, *Senjika Nihon no kenchikuka* (*Architects in Wartime Japan*).

11  Ben-Ghiat, *Fascist Modernities*, 7, 11–13. Ben-Ghiat writes, "The absence of a cohesive Italian taste and style, fascists felt, had allowed the country to become a cultural colony of more dominant nations. Internalizing foreign views of themselves as 'insignificant imitators,' Italians had become a people who believed that 'everything foreigners do is great, everything we do is awful' " (7). Whereas Italians' international status as "insignificant imitators" seems to have been overcome postwar, that of Japanese society and culture appears more permanently lodged, at least in the West.

12  Kunii Kitarō, "Jigen" (Timely Words), *Kōgei nyuusu* (*Craft News*) 1 (June 1932): 2–3. The Industrial Arts Research Institute (the given English name for the Kōgei shidō jo, which might be translated more literally as "Craft Guidance Institute") was established in 1928. Before *Kōgei nyuusu* the institute put out a magazine titled *Kōgei shidō* (*Craft Guidance*) on a less regular basis.

13   Johnson, *MITI and the Japanese Miracle*, 98. My discussion of the MCI in the 1920s is drawn from chapter 3 of Johnson's book.

14   Kashiwagi Hiroshi, *Kindai Nihon sangyō dezain shisō* (The Ideology of Modern Japanese Industrial Design), 157–160. The institute and its activities are also discussed in Izuhara Eiichi, *Nihon no dezain undō* (Japanese Design Movements), 93–97.

15   One of the challenges faced by any such undertaking was that of definition. In the late 1920s and early 1930s, the term *kōgei* retained a much broader field of signification than it would possess even a decade or two later. The process of Japanese industrialization was still very much under way, and its beginnings some fifty years earlier remained fresh in national memory. The traces of that process were still visible, moreover, in the rapidly shifting meanings of terms such as *kōgei*, which had once referred to industry or manufacturing technology in general. As heavy industry began to develop in Japan largely on the basis of imported technology, *kōgei* came to be associated with those lighter forms of industry in which native or hybrid technologies and modes of production continued to prevail. At the same time, in the late nineteenth century, some of those technologies and modes of production—and the term *kōgei* with them—became identified with the art industries (such as lacquerware and ceramics) so closely associated with Japan in European and North American markets. By the 1920s, therefore, policymakers were using *kōgei* quite variously; sometimes to refer to much of light industry generally, sometimes to refer to those manufacturing enterprises (such as papermaking and weaving) characterized by indigenous handicraft methods and traditions, and sometimes to indicate the art-crafts. For an account of the development of the term *kōgei*, see Iioka Masao, "Kōgei no imi to sono hensen" (The Meaning of Kōgei and Changes in That Meaning), parts 1 and 2.

16   Kunii Kitarō, "Kōgei shidō jo no shimei" (The Mission of the Industrial Arts Research Institute), *Teikoku kōgei* 2, no. 9 (September 1928): 1–3.

17   "Tenrankai kiji" (Exhibition Report), *Kōgei nyuusu* 3, no. 4 (April 1934): 29.

18   "Kōgei kenkyū zadankai: Perian joshi ni Tōhoku no kōgei o kiku" (Round-table Discussion on Crafts Research: Miss Perriand on Tōhoku Crafts), *Kōgei nyuusu* 10, no. 1 (January 1941): 16–21.

19   Suzuki Kenji, *Kōgei*, vol. 14 of *Genshoku gendai Nihon no bijutsu* (Modern Japanese Art in Living Color ), 185. See also Izuhara, *Nihon no dezain undō*, 93. The institute moved its headquarters to Tokyo in 1940.

20   The November 1935 issue of *Kōgei* was devoted to the paper manufactured in Saitama under the supervision of mingei activists working in collaboration with the prefectural government. See Yamaguchi Izumi, "Musashi shi no sosei" (The Rebirth of Musashi Paper), *Kōgei* 59 (November 1935): 108–113, for discussion of Mizutani's role in generating official support for this project. Mizutani also played a role in obtaining MCI licensing of the Mingeikan as a public corporation in late 1937. See Yanagi, "Mingeikan no ichinen" (One Year of the Mingeikan), *Kōgei* 83 (November 1937): 61.

21  Kunii, "Kōgei shidō jo no shimei," 1–2.

22  Nakamura Takufusa, *Economic Growth in Prewar Japan*, 254–261, 263–266.

23  Kunii Kitarō, "Honpō kōgyō no kōgeiteki shiten o nozomu" (Hopes for the Crafts Aspect of This Country's Industry), *Kōgei nyuusu* 1, no. 3 (August 1932): 1. Emphasis in the original.

24  Kunii Kitarō, "Kaigai o shisatsu shite toku ni kōgei rikkoku no hitsuyō o tsūkan su" (Upon Making a Tour of Observation Abroad, I Felt Especially Keenly the Necessity of Establishing the Nation's Crafts), *Kōgei nyuusu* 2, no. 8 (August 1933): 3. An illustrated feature on European goods in the Japonesque style appeared in the May 1933 issue of *Kōgei nyuusu*.

25  "Waga nōmin geijutsuhin ga Pari ni shinshutsu" (Our Farmers' Art Items Make Inroads in Paris), *Kōgei nyuusu* 3, no. 10 (October 1934): 24; "Pari ni hiraku hana waga nōson kōgei hin" (Flowers Bloom in Paris: Our Village Crafts Goods), *Kōgei nyuusu* 4, no. 5 (May 1935): 38.

26  Fujii Tatsukichi, "Kōgei henpen" (Crafts Jottings), *Bi no kuni* 11, no. 3 (March 1935): 34. See Fujii's "Shōwa 9 nen no kōgei o omou" (Thinking about the Crafts of 1934), *Bi no kuni* 10, no. 12 (December 1934): 40–43, for similar reflections on the irony of European interest in Japanese village crafts.

27  The best discussion in English of Taut's years in Japan appears in chapter 2 of Kestenbaum, "Modernism and Tradition in Japanese Architectural Ideology." In Japanese (and German), see the essays in Speidel and the Sezon Museum of Art, eds., *Bruno Taut Retrospective*.

28  Taut, *Nihon: Tauto no nikki* (Japan: Taut's Diary), 1: 2.

29  Kunii, "Kaigai o shisatsu shite toku ni kōgei rikkoku no hitsuyō o tsūkan shite," 3.

30  "Burūnō Tauto shi no hihyō" (Mr. Bruno Taut's Critique), *Kōgei nyuusu* 2, no. 9 (September 1933): 12.

31  Kunii Kitarō, "Nentō shokan" (Impressions at Year's Beginning), *Kōgei nyuusu* 3, no. 1 (January 1934): 2.

32  Taut is best known for his praise of the seventeenth-century Katsura detached palace in Kyoto, which he considered "true beauty, eternal beauty for ever inexplicable, the beauty of great art." He also stressed the idea that Katsura expressed perfectly an architecture of function, which he considered "the most important basis for the further development of modern architecture." Taut, *Houses and People of Japan*, 274, 291. One collection of his writings, the posthumously published *Nihonbi no saihakken* (The Rediscovery of Japanese Beauty; 1939), which concludes with a chapter on "The Eternal: The Katsura Detached Palace," was available in 1989 in its 46th edition.

33  For Taut's expressions of support, see his lengthy letter to Yanagi, published as "Kōgei ni tsuite no shokan" (Impressions of Craft), *Kōgei* 42 (June 1934): 48–58. His congress with Yanagi et al. is documented in his diary; see *Tauto no nikki*, 2: 74–75, 125, 135–136, 173–175, 224–228. For his reservations about mingei activism and ideology, see "Getemono ka haikara ka" (Getemono or High-Class?), in *Tauto zenshū* (The Complete Works of Taut), vol. 3.

34  See, for example, the bread basket, cigarette boxes, and yarn baskets illustrated in Speidel and the Sezon Museum of Art, *Bruno Taut Retrospective*, 284–289.

35  "Burūnō Tauto shi Nihon o haru!" (Mr. Bruno Taut Leaves Japan!), *Kōgei nyuusu* 5, no. 2 (February 1936): 32.

36  See chapter 2 of Kestenbaum, "Modernism and Tradition in Japanese Architectural Ideology."

37  "Shureeman fujin no raichō to naichi shisatsu ryokō" (Mrs. Schloemann's Arrival in Japan, and Her Tour of Observation of the Inner Territories), *Kōgei nyuusu* 8, no. 12 (December 1939): 9–10.

38  Perriand discussed the value of mingei in several round-table discussions transcribed in *Kōgei nyuusu*. See "Kōgei kenkyū zadankai"; and "Perian joshi sōsaku-hinten ni tsuite kiku" (Hearing from Miss Perriand on the Exhibition of Her Works), part 1, *Kōgei nyuusu* 10, no. 1 (January 1941): 16–21; and part 2, *Kōgei nyuusu* 10, no. 5 (May 1941): 11–17. Perriand's bamboo chaise-longue, and more generally her work in Japan, are discussed in Benton, "From Tubular Steel to Bamboo."

39  Statement by Katsumi in "Perian joshi sōsakuhin ten ni tsuite kiku," part 2.

40  Kunii Kitarō, "Shashihin kinshirei to kōgei" (The Anti-Luxury Edict and Crafts), *Kōgei nyuusu* 9, no. 7 (July 1940): 5.

41  "Kokudo no gijutsu" (Technologies of the Nation), *Kōgei nyuusu* 10, no. 7 (July 1941): 2–3. The second part of the pictorial appeared in the following issue of *Kōgei nyuusu*.

42  See "Kanso no bi wa" (As for Simple Beauty), *Kōgei nyuusu* 10, no. 11 (November 1941): 31–33. For references to visits by institute personnel to the Mingeikan in order to plan the display, see *Kōgei nyuusu* 10, no. 9 (September 1941): 35–36.

43  *Gekkan mingei* was renamed *Mingei* in 1942. Both magazines resumed publication under Shikiba and Yanagi quite promptly after the defeat, in 1947. *Kōgei* finally ended its run in 1951, but a successor to *Mingei* has survived into the present.

44  See Kasza, *The State and the Mass Media in Japan*, chapters 7 and 8.

45  The third issue of *Kōgei* (March 1931) featured woodwork of Tōhoku. In 1932 the fourteenth issue of *Kōgei* was devoted to a Tōhoku form of embroidered cloth known as *kogin*.

46  14 August 1937 letter from Yamaguchi Hiromichi to Yanagi, Nihon Mingeikan archive.

47  Hokkoku kara hasshin jikkō iinkai, eds., *Setsugai undō shoshi* (Brief History of the Snow Damage Movement), 13, 15, 2.

48  Matsuoka had presented forceful arguments about the extra expenses incurred by schooling in the snow country. These included heating costs, the repair of snow-damaged roofs, and the expense and hardship of winter travel for students. From the 1929 pamphlet "Setsugai mondai no hontai" (Substance of the Snow Damage Issue), quoted in ibid., 8.

49  Mizukoshi Keiji, "Setsugai undō" (The Snow Damage Movement), 10–11.

50  See the discussion in Yamagata Prefecture, ed., *Yamagata ken shi* (History of Yamagata Prefecture), 5: 617–618. It should be noted that the underdevelopment of the modern

Tōhoku economy can be attributed in part to the losses and debts incurred during the civil strife of the 1868–1869 Boshin wars, when much of the Tōhoku region remained loyal to the doomed old regime.

51  See Ibid., 5: 568–574 on early 1930s suffering and extremity in Tōhoku and on national relief efforts. The famine and its reportage are also discussed in Mikiso Hane, *Peasants, Rebels, and Outcastes*; and Smith, *A Time of Crisis*.

52  Tōhoku chihō nōson kōgyō shidō kyōkai, "Tōhoku chihō nōson kōgyō shidō kyōkai Shōwa 12 nen dō oyobi 13 nen dō kessan narabi jigyō hōkokusho" (Report of the Accounts and Activities of the Tōhoku Farm Village Industrial Guidance Association for Shōwa 12 and Shōwa 13), dated 31 August 1938, collection of the Snowfall Region Farm and Mountain Village Research Archive.

53  Smith, *A Time of Crisis*, 288–289.

54  Drafts of letters dated February and March 1938, and copy of the attached document "Mingei hin tenrankai shuppin yōshi" (Essential Points about Submissions to the Mingei Exhibition), collection of the Snowfall Region Farm and Mountain Village Archive.

55  Both Yamaguchi's statements and the attendance figures were reported in the Snowfall Institute's magazine, *Yukiguni* (*Snow Country*). "Mogami gun mingeihin tenrankai no bansai kōhyōkai nami zadankai ni tsuite" (About the Judging Session and the Round-table Discussion for the Mogami County Mingei Exhibition), *Yukiguni* 3, no. 8 (August 1938): 15.

56  Zushi Yasumasa, "Shōnen to mingei: Shōnai danjo shōnen mingei hin tenrankai o mite" (Youth and Mingei: On Viewing the Mingei Exhibit by Shōnai Boys and Girls), *Yukiguni* 4, no. 4 (April 1939): 19–22; and "Shōnai no shōnen mingeiten" (Exhibit of Mingei by Shōnai Youth), *Gekkan mingei* 1, no. 3 (June 1939): 2.

57  Morimoto Shinya, "Tōhoku no mingei undō" (The Tōhoku Mingei Movement), *Gekkan mingei* 2, no. 4 (April 1940): 61; Asano Chōrō, "Mingei kyōkai tayori" (News of the Mingei Association), *Gekkan mingei* 3, no. 4 (April 1941): 37. For more on the Tōhoku Industrial Development Company, see Yamagata Prefecture, *Yamagata ken shi*, 5: 625–628.

58  See Smith, *A Time of Crisis*, especially chapters 8 and 10.

59  Matsuoka Shunzō, "Tōhoku nōmingeihin iji senshō ni kansuru kengian" (Memorial Regarding the Support, Encouragement, and Selection of Tōhoku Farm Mingei), reprinted in *Yukiguni* 4, no. 5 (May 1939): 14–15.

60  Zushi Yasumasa, "Shōnai no shōnen mingeiten" (The Mingei Exhibit by Shōnai Youth), *Gekkan mingei* 1, no. 3 (June 1939): 2; see also transcription of a statement by the Snowfall Institute director Yamaguchi at a 1940 conference at the Folk-Crafts Museum, in "Chihō kōgei shinkō kikan no kessei" (The Formation of an Agency to Promote Regional Crafts), *Gekkan mingei* 2, no. 10 (October 1940): 8–28.

61  Yanagi, "Mingei to Tōhoku" (Mingei and Tōhoku), *Kōgei* 108 (January 1942): 10.

62  Morimoto Shinya, "Tōhoku no mingei undō," *Gekkan mingei* 2, no. 4 (April 1940): 60.

63  Yamaguchi Hiromichi, "Tōhoku mingeiten no shushi" (The Significance of the Tōhoku Mingei Exhibit), *Gekkan mingei* 2, no. 8 (August 1940): 2–4.

64  See Smith, *A Time of Crisis*, 288–291.

65  The buying and reading of the magazine became a national movement of sorts. See Itagaki, *Shōwa senzen, senchūki no nōson seikatsu* (*Village Daily Life During the Shōwa Prewar and Wartime*), 52–57, on the reader groups, conferences, and fairs that helped to give *Ie no hikari* its immense circulation and influence during the 1930s.

66  Ibid., 145, 169, 64–65.

67  Wigen, "Constructing Shinano," 229–242.

68  On 15 June 1941, for example, the *Tōkyō nichi nichi* newspaper sponsored a round-table discussion on the subject of Tōhoku mingei. In addition to Yanagi and several other leading members of the Mingei Association, participants included the Snow-fall Institute's Morimoto Shinya and a government official named Hata Ichirō, of the Cabinet Information Bureau. The transcript, entitled "Mingei o kataru" (Talking of Mingei), was published in the paper in eleven installments during June and July of 1941.

69  Yanagi, "Sashie kochū" (Brief Notes on the Illustrations), *Kōgei* 108 (January 1942): 79–81.

70  Tanaka Toshio, "Kaisetsu: Mingei tokuhon" (Commentary: A Mingei Reader), *Fujin gahō* 434 (April 1940): 141. The pictorial is titled "Nihon no mingei" (Japan's Mingei).

71  Yanagi, "Kongetsu no kuchie" (This Month's Illustrations), *Gekkan mingei* 1, no. 3 (June 1939): n.p.

72  "Kyōdo no kōgei hin: Yanagi Muneyoshi shi no Mingeikan o miru" (Local Crafts Items: Viewing Mr. Yanagi Muneyoshi's Mingeikan), *Shakai kyōiku shimbun*, 1 June 1939, 7 (Nihon Mingeikan archive). A bandori is a back pad made of woven straw and other materials, and used when carrying heavy loads.

73  Morimoto Shinya, "Tōhoku no mingei undō" (Tōhoku's Mingei Movement). *Gekkan mingei* 2, no. 4 (April 1940): 61.

74  Zushi Yasumasa, "Shōnai no mingei hin o tazusaete Aragi Monbudaijin o tō" (Enquiring of Minister of Education Aragi, Who Possesses Mingei Objects from the Shōnai Region), *Yukuguni* 4, no. 4 (April 1939): 23–25.

75  See Kasza, *The State and the Mass Media in Japan*, chapters 7 and 8, for discussion of the rising importance of the Cabinet Information Bureau during the years of total war.

76  For contemporary comment on Kishida's role in originating the concept, see the review of his book *Seikatsu to bunka* (*Daily Life and Culture*) in *Kōgei nyuusu* 11, 6 (June 1942): 39, and also statements by participants (including IRAA Cultural Section officials) at the round-table discussion "Dōrō bunka o kataru" (Talking about Work Culture), *Gekkan mingei* 29 (August 1941): 48. Kishida's second in command at the Cultural Section, Kamiizumi Hidenobu, associated the concept of daily life culture with Kishida in his book *Chihō to bunka* (*Regions and Culture*), 210.

77  On Miki's relationship to the IRAA's Cultural Section, see Kawanishi Teruyuki,

"Yokusan undō to chihō bunka" (The Imperial Assistance Movement and Regional Culture), 181. On Miki and the Shōwa Research Association, see Fletcher, *The Search for a New Order.*

78  I wish to thank Harry Harootunian for bringing this essay to my attention.

79  See Harootunian, *Overcome by Modernity: History*, chapter 6, for a discussion of Miki Kiyoshi's conception of *seikatsu bunka* (translated by Harootunian as "living culture") within the larger context of Miki's thought.

80  That opposition was suggested immediately to a Japanese audience by the phrases themselves, which used the same two pairs of Chinese characters, but in reverse order. It is difficult to reproduce in English the symmetrically inverse relation between *seikatsu bunka* and *bunka seikatsu*, owing largely to the awkwardness attending any effort to translate the word *seikatsu* (daily life, livelihood, living, subsistence). I have chosen to rely mostly on "daily life," at the risk of introducing a connotation of repetition and temporality not (as) present in the original term, in order to evoke its strong association with ordinariness and domesticity.

81  On *bunka seikatsu* and its evolution, see Sand, "The Cultured Life as Contested Space," 99–118.

82  Miki, "Seikatsu bunka to seikatsu gijutsu" (Daily Life Culture and Daily Life Technology), 384, 390.

83  Ibid., 387.

84  Ibid., 386, 391. Miki acknowledged that owing to its individualism and liberalism, culture life had nevertheless been especially attractive to women. He remarked, "It is natural that women, who had been constrained by so many feudal elements in daily life, should have been greatly attracted to the phenomenon of the culture life" (385).

85  Ibid., 387.

86  See, for example, Kishida Kunio, "Bunka to wa dō iu koto ka" (What Is "Culture"?), in Kishida, *Seikatsu to bunka*, 67–77 and Hata Ichirō, "Atarashii seikatsu bi to mingei no michi: Iwayuru bunka seikatsu kara seikatsu bunka e" (The New Beauty of Daily Life and the Path of Mingei: From the So-Called Culture Life to Daily Life Culture), *Fujin gahō*, no. 450 (August 1941): 93–96.

87  Miki, "Seikatsu bunka to seikatsu gijutsu," 388.

88  Ibid.

89  For further discussion of Miki's concept of cooperativism, see Fletcher, *The Search for a New Order*, 112–114, 132–133.

90  Miki, "Seikatsu bunka to seikatsu gijutsu," 390, 391.

91  Ibid., 390. For discussion of the official campaign to organize and use neighborhood associations, see Havens, *Valley of Darkness*, chapter 5.

92  Miki, "Seikatsu bunka to seikatsu gijutsu," 392, 397.

93  Robert M. Spaulding Jr. has discussed what he calls "revisionism" and "revisionist bureaucrats" in "The Bureaucracy as a Political Force." See also his "Japan's 'New Bureaucrats.'"

94  See Kasza's summary of the thought of three leading renovationist bureaucrats involved in New Order policymaking, in *The State and the Mass Media in Japan*, 200–206. On the advocacy of similar ideas by Miki, as well as by two other intellectuals active in the Shōwa Research Association, see Fletcher, *The Search for a New Order*, especially chapters 5 and 7.

95  Fletcher, *The Search for a New Order*, 150–154; Berger, *Parties out of Power in Japan*, chapters 6 and 7.

96  Gordon, *Labor and Imperial Democracy in Prewar Japan*, chapter 11 and conclusion.

97  See Miki's discussion of the importance for government of culture and a cultural policy in his essay "Bunka seisakuron" (Theory of Cultural Policy), which appeared in *Chūō kōron* (*Central Review*) in 1940. *Miki Kiyoshi zenshū* (*Collected Works of Miki Kiyoshi*) 14: 356–374.

98  Kitagawa Kenzō, "Senjika no bunka undō" (Wartime Cultural Movements), 56.

99  Cultural Section ideology is discussed in ibid., 55, and also in Akazawa Shirō, "Taiheiyō sensōka no shakai" (Society During the Pacific War), 3: 170. See also writings by Kishida and by Kamiizumi Hidenobu, the assistant director of the Cultural Section.

100 Kamiizumi paraphrased and quoted in Kawanishi, "Yokusan undō to chihō bunka," 185–186.

101 Hata Ichirō, "Atarashii seikatsu bi to mingei no michi: Iwayuru bunka seikatsu kara seikatsu bunka e" (The New Beauty of Daily Life and the Path of Mingei: From the So-Called Culture Life to Daily Life Culture), *Fujin gahō*, no. 450 (August 1941): 93–96.

102 "Chihō bunka kensetsu no rinen to hōsaku" (The Principles and Policies for the Establishment of Regional Culture), *Taisei yokusankai kaihō* (*IRAA Bulletin*), no. 10 (19 February 1941): 3. The other two categories were traditional customs and rituals expressing Japanese communal life, and local arts (*kyōdo geijutsu*) such as theater, folk song and dance, *waka* and *haiku*.

103 Kishida, *Seikatu to bunka*, 343; Kamiizumi, *Chihō to bunka*, 14.

104 Kishida, *Seikatsu to bunka*, 344–345; Kamiizumi, *Chihō to bunka*, 270.

105 Shikiba Ryūzaburō, "Henshū kōki" (Editorial Postscript), *Gekkan mingei* 1, no. 3 (June 1939): 38.

106 Shikiba, "Henshū kōki," *Mingei* 4, no. 1 (January 1942): 80. Shikiba wrote similarly in editorials for the August 1940, July 1941, and February 1942 issues. Another leading mingei activist, the philosopher Muraoka Kageo, expressed similar sentiments in "Mingei kyōkai dayori" (News from the Mingei Association), *Mingei* 4, no. 8 (August 1942): 65.

107 See Berger, *Parties Out of Power*, chapter 6, for an account of planning for the New Order during 1940.

108 Shikiba, "Shashi kinrei to mingei" (The Anti-Luxury Edict and Mingei), *Katei* 10, no. 9 (September 1940): 29. Another statement citing the antiluxury edict as an affirmation of mingei is to be found in Arai Nobuo, "Takumi tayori" (News from Takumi), *Gekkan mingei* 2, no. 8 (August 1940): 19.

109 Yanagi was an active participant in the round-table discussion or *zadankai* published in the special issue "Nōson to rōmusha no bunka" (Farm Villages and the Culture of Workers), *Gekkan mingei* 3, no. 3 (March 1941): 46–63. In the same discussion, Tanaka Toshio, one of the Mingei Association organizers of the project, concluded, "With this [project], we have come into contact, up to a point, with modern industry; in future, shouldn't we really go much further to consider also the creation of machine-made crafts?" (63)

110 Nihon mingei kyōkai, "Shintaisei no te kōgei bunka sōshiki ni taisuru teian" (Proposal Regarding the Organization of Handicrafts Culture in the New Order), *Gekkan mingei* 2, no. 10 (October 1940): 2–4. Presumably the Association leadership expected to play a substantial role in the proposed new organization.

111 Tanaka Toshio, "Mingei kyōkai dayori" (News from the Mingei Association), *Gekkan mingei* 2, no. 10 (October 1940): 61. Von Dürckheim was a German diplomat in Japan. He had a very successful postwar career in the West as a theorist and popularizer of Zen Buddhism.

112 Nihon mingei kyōkai, "Joshi rōmusha no seikatsu yōshiki no mondai" (The Issue of the Form of Daily Life for Female Workers), *Gekkan mingei* 3, no. 3 (March 1941): 3; Tanaka Toshio, "Mingei zakki" (Mingei Miscellany), *Gekkan mingei* 2, no. 8 (August 1940): 33.

113 Nihon mingei kyōkai, "Joshi rōmusha no seikatsu yōshiki no mondai," 2.

114 Shikiba, "Joshi rōmusha no seikatsu chōsa" (Survey of Female Workers' Daily Life), *Gekkan mingei* 3, no. 3 (March 1941): 146.

115 Nihon mingei kyōkai, "Joshi rōmusha no seikatsu yōshiki no mondai," 2–3.

116 Ibid., 4.

117 Ibid., 7.

118 Ibid., 10.

119 "Katei ryō sekkei zu" (Plans for the Construction of the Family Dormitory), *Gekkan mingei* 3, no. 3 (March 1941): 12–18.

120 Nihon mingei kyōkai, "Joshi rōmusha no seikatsu yōshiki no mondai," 7.

121 "Katei ryō sekkei zu," 12–17.

122 Nihon mingei kyōkai, "Joshi rōmusha no seikatsu yōshiki no mondai," 7. The special issue contained a long illustrated article on the subject of *sashiko* as mingei.

123 Ibid., 7.

124 Ibid., 13.

125 Ibid., 9.

126 Statement by Tanaka Toshio in the *zadankai* "Nōson to rōmusha no bunka," *Gekkan mingei* 3, nos. 3 (March 1941): 59.

127 Shikiba, "Joshi rōmusha no seikatsu chōsa," 121.

128 For a useful discussion of this dilemma in Japan, see Yoshiko Miyake, "Doubling Expectations," 267–295. On Germany, see Bridenthal, Grossman, and Kaplan, eds., *When Biology Became Destiny*. On Italy, see de Grazia, *How Fascism Ruled Women*. The special issue of *Gekkan mingei* included an article, translated from the German, on

female factory workers in Nazi Germany and the importance of reconciling their productive and reproductive roles.

129  Nihon mingei kyōkai, "Joshi rōmusha no seikatsu yōshiki no mondai," 3–4.

130  Only eleven out of 362 respondents were willing to claim experience of romantic love. Shikiba was inclined to believe this figure, as the questionnaire was anonymous. To the question "What sort of person would you like to marry?" 136 gave variants of the answer "don't know." The next most common answers were "a healthy person" (29), "a soldier" (25), "an earnest [majime] person" (17), no response (15), "a kind [yasashii] person" (10). One respondent wished for "a silent person," and another ventured to say that she didn't want to marry. Shikiba, "Joshi rōmusha no seikatsu chōsa," 127–129.

131  Ibid., 127–128, 129.

132  Ibid., 140, 136–137. Shikiba's concern was elicited, presumably, by the responses to the following question: "What cosmetics do you buy?" The top two responses were "cream" (192) and "I don't buy cosmetics" (69). Cream, as Shikiba pointed out, referred to hand cream, which was actually so necessary to work at a spinning factory that some felt it should be supplied by the company.

133  Ibid., 140.

134  A transcript of the discussion appeared in the June issue of Gekkan mingei. "Seikatsu bunka no shomondai" (Various Problems of Daily Life Culture), Gekkan mingei 3, no. 5 (June 1941): 2–21.

135  Transcripts were published in Gekkan mingei. "Dōrōsha no jūtaku ni tsuite" (About Worker Housing), Gekkan mingei 3, no. 6 (July 1941): 10–30; "Dōrō bunka o kataru" (Discussing Work Culture), Gekkan mingei 29 (August 1941): 40–60.

136  Takaoka Hiroyuki, "Sōryoku sen to toshi" (Total War and Cities), 148–149. On Germany, see Baranowski, Strength through Joy. For Italy, see de Grazia, The Culture of Consent.

137  De Grazia, The Culture of Consent, 238–240.

138  Takaoka, "Sōryoku sen to toshi," 151–154.

139  The term kōsei is conventionally translated as "welfare," particularly in connection with the Welfare Ministry founded in 1938. However, it can also be translated as "recreation," as in the instance of the Recreation Association.

140  This narrative is drawn largely from Takaoka, "Sōryoku sen to toshi," 150–156. He discusses key government officials' admiration for the Italian National Organization of Afterwork and the German KdF not only in "Sōryokusen to toshi," but also in his essay "Dai Nippon sangyō hōkokukai to 'dōrō bunka' " (The Japanese Industrial Patriotic Association and "Work Culture").

141  Statement by Tanaka Toshio, "Atarashiki seikatsu bunka no shomondai" (Various Problems of the New Daily Life Culture), Gekkan mingei 3, nos. 1–2 (January–February 1941): 50. Presumably Tanaka was referring either to the female workers at the Kurashiki nylon-spinning factory, or to female workers at a similar plant. The Takurazuka Gekidan is a well-known cabaret revue, based in Osaka, in which all

roles, male and female, continue to be played by female performers. See the study by Robertson, *Takarazuka*.

142  Statement by Yamamoto Shōzō in "Dōrō bunka o kataru," *Gekkan mingei* 3, no. 7 (August 1941): 47.

143  Statement by Kamiizumi, "Dōrō bunka o kataru," *Gekkan mingei* 3, no. 7 (August 1941): 50.

144  Ibid., 49.

145  See Takaoka's discussion of the recreation versus reconstruction positions on work culture in "Dai Nippon sangyō hōkokukai to 'dōrō bunka,' " 52–61. Takaoka notes that the effort to "reconstruct" worker culture was largely abandoned after 1943 in favor of a return to "recreation."

146  Baranowski, *Strength through Joy*, 46.

147  See ibid., chapter 3. An important earlier discussion of the Beauty of Labor office is in Rabinbach, "The Aesthetics of Production in the Third Reich." See also chapter 1 of Betts, *The Authority of Everyday Objects*.

148  Statement by Taniguchi Kichirō, "Seikatsu bunka no shomondai" (Various Problems of Daily Life Culture), *Gekkan mingei* 3, no. 5 (June 1941): 9. The model barracks for the autobahn is discussed in Baranowski, *Strength through Joy*, 77–78. She notes that Albert Speer, director of Beauty of Labor, received the contract thanks to his close relationship to Hitler, whose pet project the autobahn was. She also points out that in fact autobahn workers endured "dismal working conditions."

149  "Dōrō bunka o kataru," *Gekkan mingei* 3, no. 7 (August 1941): 53–55. Tellingly, this discussion of joy in work was accompanied by several comments to the effect that women workers should not feel excessive joy in their work, since they must marry and rear children.

150  Perhaps the most concrete achievement of all the talk and planning was the establishment, in July 1941, of a Worker Housing Research Group headquartered at the Mingei Association. See "Rōmusha jūtaku kenkyūkai shuisho" (Prospectus for a Worker Housing Research Group), *Gekkan mingei* 3, no. 6 (July 1941): 32–34.

151  Takaoka Hiroyuki, "Kankō—kōsei—ryokō" (Tourism—Welfare—Travel), 28.

152  Masao Maruyama, "The Ideology and Dynamics of Japanese Fascism," 50.

153  On the successful opposition by private industry to state efforts at economic rationalization ca. 1940, see Gordon, *Labor and Imperial Democracy in Prewar Japan*, 320–330; Fletcher, *The Search for a New Order*, 150–154.

154  Ōhara Sōichirō, statement in the *zadankai* "Nōson to rōmusha no bunka," in *Gekkan mingei* 3, no. 3 (March 1941): 47–48.

155  Rabinbach, "The Aesthetics of Production in the Third Reich," 43.

## 5. Renovating Greater East Asia

1 Prasenjit Duara, *Sovereignty and Authenticity*, 9, 1–2.

2 The analysis of Japanese imperialism in terms of "formal" and "informal" empire is most fully developed in the three-volume series of essays edited by Duus, Myers, and Peattie, *The Japanese Colonial Empire*, *The Japanese Informal Empire in China*, and *The Japanese Wartime Empire*. See, especially, Peattie's introduction," 3–52; and Duus, "Japan's Informal Empire in China." I follow Duara here in observing a distinction between Manchuria and China in the interwar years. The incorporation of the region known as Manchuria into the Chinese nation-state was a long-term, contested historical process by no means complete in 1931. As Duara puts it, "I continue to use the term Manchuria for this period so as not to foreclose what was still an open-ended historical situation by imposing the perspective of subsequent historical developments and nationalist historiography." Duara, *Sovereignty and Authenticity*, 41. Of course this is in no way to legitimate the Japanese army's seizure of Manchuria, which by the twentieth century was populated largely by Chinese immigrants.

3 On Manchukuo's official multiculturalism and multiethnicity as at least in part an outcome of anticolonialist nationalism, see Duara, *Sovereignty and Authenticity*, 60–61, 73–74. Komagome Takeshi questions the idea that the extreme forms of assimilationism associated with wartime Japanese imperialism, or *kōminka*, were instituted throughout the empire; in particular, he notes the latitude of policies effected in China and Manchuria. Komagome, *Shokuminchi teikoku Nihon no bunka teigo* (*The Cultural Integration of the Japanese Empire and Colonies*), 13.

4 On the question of assimilationism in Taiwan, see Ching, *Becoming "Japanese."* Japanese efforts to recognize and preserve native culture in Taiwan are discussed in Kawamura Minato, "*Daitōa minzokugaku" no kyojitsu* (*The Truths and Falsehoods of "Greater East Asian Folklore Studies"*), chapter 3; Kleeman, *Under an Imperial Sun*, part 2; Yuko Kikuchi, *Japanese Modernization and Mingei Theory*, 163–167, 176–189. Kikuchi also discusses the brief engagement of the Mingei Association, and more particularly Yanagi Muneyoshi, in Taiwanese arts and crafts during the early 1940s.

5 Howell, *Geographies of Identity in Nineteenth-Century Japan*, 11. Howell discusses the Meiji-era policies of ethnic negation toward the Ainu in chapter 8.

6 Yanagi, "Henshū yoroku" (Editorial Comments), *Kōgei* 16 (April 1932): 81.

7 Yanagi, "Henshū yoroku," *Kōgei* 17 (May 1932): 67; "Zatsuroku" (Miscellaneous Notes), *Kōgei* 51 (March 1935): 66.

8 Yanagi, "Hongo no sashie" (This Issue's Illustrations), *Kōgei* 23 (November 1932): 1, 10.

9 Kawai discussed his work with the artisan, whom he called "Son-kun," in "Wara kōhin to sono sakusha" (Straw Craft Objects and Their Maker), *Kōgei* 51 (March 1935): 1–12.

10 Yanagi, "Zatsuroku," *Kōgei* 55 (July 1935): 36–37.

11  Kawai Kanjirō, Hamada Shōji, and Yanagi, "Zenra [Chŏlla] kikō" (Zenra [Chŏlla] Travelogue), *Kōgei* 82 (October 1937): 1.

12  See chapter 1 for discussion of these associations.

13  Detailed in Kawai, Hamada, and Yanagi, "Zenra kikō."

14  Ibid., 23.

15  Ibid., 24.

16  Ibid., 15, 17.

17  See chapter 1 for a discussion of Yanagi's influential characterization of Korean art and culture during the early twentieth century in terms of the "beauty of sorrow."

18  For examples, see Kawai, Hamada, and Yanagi, "Zenra kikō," 10, 11, 17, 36; see also Yanagi, "Sashie kochū" (Notes on the Illustrations), *Kōgei* 82 (October 1937): 76, 80, 83.

19  For typical references to this process in Japan, see Yanagi, "Sashie kochū," *Kōgei* 82 (October 1937): 59, 64, 69.

20  Yanagi, Kawai, and Hamada, "Chōsen no tabi" (Korean Travels), *Kōgei* 69 (September 1936): 96–97.

21  See, for example, Kawai, Hamada, and Yanagi, "Zenra kikō," 5, 13, 21, 36, 41–42.

22  Yanagi, Kawai, and Hamada, "Chōsen no tabi," 97, 98.

23  Yanagi, "Sashie kochū," *Kōgei* 69 (September 1936): 78–79.

24  Yanagi, "Sashie kochū," *Kōgei* 82 (October 1937): 60, 64, 69.

25  Ibid., 56.

26  Statement by Kawai, Hamada, and Yanagi in the Takashimaya department store (Nihonbashi, Tokyo store) promotional pamphlet, dated April 1938 (Nihon Mingeikan archive).

27  Unattributed opening statement in ibid.

28  See, for example, "Osaka Takashimaya mingeihin uriba yori" (From the Mingei Shop in the Osaka Takashimaya), *Gekkan mingei* 1, no. 5 (August 1939): 33–34; also see advertisements for Takumi in *Gekkan mingei* 1, no. 4 (July 1939), 1, no. 5 (August 1939), and 2, no. 2 (February 1940).

29  "Matsuzakaya sakuhin 'Shinkoku fū kagu ten'" (Matsuzakaya Goods "Exhibit of New National-style Furniture"), *Jūtaku to teien*, March 1935, 126.

30  "Takumi kyūkoku" (Urgent Notice from Takumi), *Gekkan mingei* 1, no. 9 (December 1939): 17; "Chōsen zen nyūka" (Korean Tables Newly Arrived), *Gekkan mingei* 2, no. 2 (February 1940): 36–37. See also the notice of a show and sale of new Korean mingei, "mostly tables," at the Hankyū department store, in *Hankyū bijutsu* 29 (February 1940): 9.

31  Yanagi, "Zatsuroku," *Kōgei* 82 (October 1937): 87.

32  Takashimaya department store (Kyoto store) promotional pamphlet, dated midsummer 1938 (Nihon mingeikan archive).

33  See Yoshimi Shunya, *Hakurankai no seijigaku* (The Politics of Expositions), 207–217, for a discussion of colonial pavilions in Japanese expositions. Louise Young notes that

while Japanese tourism in Manchuria grew significantly during the 1930s, the expense of continental travel "made it impossible for most Japanese to consider the journey." Young, *Japan's Total Empire*, 263.

34  Yanagi, "Zatsuroku," *Kōgei* 82 (October 1937): 86.

35  Kawai, Hamada, and Yanagi, "Zenra kikō," 12, 14, 16, 22.

36  According to Kan, two of the most important Tokyo dailies, *Tōkyō asahi shinbun* and *Tōkyō nichi nichi shinbun*, together published dozens of editorials on a wide variety of Korean issues during the 1920s. Between 1932 and 1945, however, the total number of Korea-related editorials published in the two newspapers comes to eight. Kan Donjin, *Nihon genronkai to Chōsen* (The Japanese Press and Korea), 348–349, 353.

37  Yoshida Shōya, "Shina mingei no genchi hōkoku" (On-the-spot Report on Chinese Mingei), *Gekkan mingei* 2, no. 2 (February 1940): 2. Yoshida's articles, which took the form of diary entries, were first published in *Impaku jihō*, the Tottori daily newspaper. Some appeared as well in the *Ōsaka mainichi* newspaper.

38  Yoshida Shōya, *Yurin tanka* (Stretcher on Wheels; 1940). A revised edition of this book was published in 1971 with the subtitle *The Military Account of an Army Doctor with a Heart and Eye for Mingei*.

39  Shikiba Ryūzaburō, "Henshū kōki" (Editorial Postscript), *Gekkan mingei* 2, no. 6 (June 1940): 56; Makino, *Yoshida Shōya to Torrito ken no teshigoto* (Yoshida Shōya and the Handicrafts of Tottori Prefecture), 86.

40  Makino, *Yoshida Shōya to Tottori ken no teshigoto*, 86.

41  Taylor, *Japanese Sponsored Regime in North China*, 67. For more on the People's Renovation Society, see Akira Iriye, "Toward a New Cultural Order." There is also some discussion of the society in Komagome Takeshi, *Shokuminchi teikoku Nihon no bunka tōgō* (The Cultural Integration of the Japanese Empire and Colonies), chapter 6; and Boyle, *China and Japan at War*, chapter 5.

42  Iriye, "Toward a New Cultural Order," 259.

43  Taylor, *Japanese Sponsored Regime in North China*, 67–68.

44  Shikiba, "Henshū kōki," *Gekkan mingei* 2, no. 6 (June 1940): 56.

45  Yoshida, "Hokushi kara" (From North China), *Gekkan mingei* 1, no. 1 (April 1939): 7.

46  Lincoln Li, *The Japanese Army in North China*, 147. See also Young's lucid discussion of the economic policies and goals of the Kwantung army in Manchukuo, in *Japan's Total Empire*, chapter 5.

47  Young, *Japan's Total Empire*, 203–205, 240. See also Myers, "Creating a Modern Enclave Economy."

48  This observation is complicated by the fact that handicraft production is classed conventionally as belonging to traditional or even "primary" industry, as opposed to modern heavy industry. In this sense Yoshida's proposal conforms not to military economic policy, but to the more familiar colonial pattern endorsed by many of those critical of the army—that is, that "Japanese capital and know-how [be] combined with China's resources" (quoted in Young, *Japan's Total Empire*, 230). Perhaps the larger point is that Yoshida's ideas about Japan's proper role in Asia, like those

of many other Japanese at the time, had multiple, sometimes conflicting sources and implications.

49 Yoshida, "Shina mingei no genchi hōkoku," Gekkan mingei 2, no. 2 (February 1940): 2.

50 Yoshida, "Pekin tsūshin" (Beijing News), and "Inhoapan," Gekkan mingei 2, no. 4 (April 1940): 7, 20. "Inhoapan" is the Japanese transliteration of a Chinese term for a type of textile dyework.

51 Okamura Kichiemon, "Senzen Kahoku no senbutsu" (Dyed Goods in Prewar China), Mingei 496 (April 1994): 51.

52 Kinmonth, The Self-Made Man in Meiji Japanese Thought, 346.

53 Okamura, "Senzen Kahoku no senbutsu," 52–53; Muraoka Kageo, "Pekin saiyū" (Revisit to Beijing), Mingei 4, no. 12 (December 1942): 41.

54 Shikiba, "Sentō chiku no kōgei undō" (Crafts Movement in Combat Regions), Gekkan mingei 3, nos. 1–2 (January–February 1941): 3.

55 Shikiba, "Henshū kōki," Gekkan mingei 1, no. 10 (October 1940): 80; "Henshū kōki," Gekkan mingei 1, nos. 11–12 (November–December 1940): 118.

56 Shikiba, "Sentō chiku no kōgei undō," 2.

57 Yoshida, "Kōmin kōgei no teishō" (Proposal for People's Welfare Crafts), Gekkan mingei 3, nos. 1–2 (January–February 1941): 6.

58 Komagome Takeshi observes that People's Renovation youth training institutes became crucial sites for the larger "war of ideology" Japanese authorities were increasingly concerned to wage in China. Given the limited resources available for such efforts, and the near collapse of the Chinese educational system in Japanese-controlled territories, the training institutes seemed the most practical and efficient way of conveying pro-Japanese messages to Chinese villagers. See Komagome, Shokuminchi teikoku Nihon no bunka teigo, 312–314.

59 For the difficulties besetting Japanese settlements in Manchuria, and on the strategic use of settlements by military and other authorities, see the discussion in Young, Japan's Total Empire, 341–349 and chapter 9.

60 One notable example is the Manchukuo official Fujiyama Kazuo, who was put in charge of the Manchukuo National Central Museum. Fujiyama believed that the only way Japanese colonists could survive, let alone thrive, in Manchukuo was by adopting elements of the daily life culture of more successfully adaptive ethnic groups, such as Chinese and Russian immigrants. See Kawamura Minato's discussion of Fujiyama in Manshū no hōkai (The Collapse of Manchukuo), 77–86. Kawamura emphasizes what he considers to be the idiosyncratic nature of Fujiyama's critical attitude toward the customs and material culture of Japanese colonists. My own research suggests, however, that by the early 1940s many Japanese observers shared Fujiyama's concerns about Japanese colonists' daily life culture.

61 Muraoka Kageo, "Mingei kyōkai tayori" (News from the Mingei Association), Mingei 4, no. 5 (May 1942): 27.

62 Muraoka Kageo, "Mingei kyōkai tayori," Mingei 4, no. 9 (September 1942): 35.

63 Shikiba, "Henshū kōki," Mingei 4, no. 10 (October 1942): 72.

64 Shikiba, "Henshū kōki," *Mingei* 5, no. 1 (January 1943): 72. The Mingei Association's celebration of Oroqen handicrafts may be understood to represent another accommodation of mingei activism to the strategic needs and interests of the Japanese military. The disproportionate nature of the intense interest taken by Japanese in a population numbering no more than several thousand in the 1930s reflects the ideological significance with which the Oroqen were invested, as a "Tungusic" race whom ethnologists claimed was related to ancestral Japanese. Also relevant, however, is the strategic value of the Oroqen, who served the Japanese army as spies and border patrols. See Duara, *Sovereignty and Authenticity*, 180–188, for discussion of Japanese ethnological study of the Oroqen. Kawamura Minato links Japanese interest in the Oroqen to the latter's strategic importance in *Manshū no hōkai*, 220–221.

65 According to the potter Kawai Takeichi's statement at a 1982 round-table discussion of the Manchukuo trip, Yanagi had originally arranged that Kawai Kanjirō join the group. Kawai's uncertain health forced him to drop out, however, and his nephew Takeichi went to Manchukuo in his place. See Nishigaki Tatsusaburō, "Manshū–Pekin mingei kikō: Kaisō zadankai no ki (jo)" (*Manchuria and Beijing Mingei Travelogue: Transcript of a Retrospective Round-table Discussion, Part I*), in *Mingei* 370 (October 1983): 23.

66 Tonomura Kichinosuke, preface to *Manshū–Pekin mingei kikō* (*Manchuria and Beijing Mingei Travelogue*), 2–3; much of this book was originally published serially in *Mingei* in 1943 and 1944. The museum was never realized.

67 Tonomura, *Manshū–Pekin mingei kikō*, 231.

68 Ibid., 155–156.

69 Ibid., 149, 232; Shikiba Ryūzaburō, "Manshū no mingei" (Mingei of Manchukuo), *Kaitaku* 8, no. 6 (November 1944): 48.

70 Shikubu, "Manshū no mingei," 48–49.

71 See the discussion of *seikatsu bunka* in chapter 4.

72 This rhetoric is discussed, for example, in Reynolds, "Imperial Japan's Cultural Program in Thailand," 98–99.

73 Okamura Kichiemon, "Tairiku no fukusō" (Clothing on the Continent), *Gekkan mingei* 3, no. 9 (September 1941): 44.

74 Yoshida, "Pekin seikatsu to shokki" (Daily Life and Tableware in Beijing), *Mingei* 4, no. 2 (February 1942): 39–40.

75 Inoue Masahito, *Nihonjin to yōfuku* (*Japanese People and Western Clothing*). Inoue discusses the Tokyo and Osaka surveys on pp. 70–73. Minami Hiroshi stresses resource conservation as the major factor behind the development of national dress and standard dress in his account, in *Shōwa bunka* (*Showa Culture*), 112–115.

76 Muraoka Kageo, "Pekin saiyū (1)," *Mingei* 4, no. 12 (December 1942): 41, 42.

77 Iriye, "Toward a New Cultural Order," 254.

78 Yoshida, "Hokushi no atarashiki ifuku" (New Clothing in North China), *Mingei* 4, no. 1 (January 1942): 22. The article is dated late 1941.

79  Ibid.; Yoshida, "Hokushi tsūshin" (News from North China) *Mingei* 5, no. 3 (March 1943): 19.

80  In addition to Muraoka's comment cited above, Shikiba remarked in 1943 that he was thinking of having members of the Mingei Association wear the summer version of what he called Yoshida's "continental dress." Shikiba, "Henshū kōki," *Mingei* 5, no. 7 (July 1943): 40.

81  Shikiba, "Henshū kōki," *Mingei* 4, no. 1 (January 1942): 80.

82  "Hokushi no atarashii kōgei" (New Crafts of North China), *Hokushi (North China)* 37 (June 1942): 25–26.

83  Yoshida, "Hokushi tsūshin," *Mingei* 5, no. 4 (April 1943): 5.

84  Komagome Takeshi, *Shokuminchi teikoku Nihon no bunka teigō,* 356–389.

85  Inoue Masahito, *Nihonjin to yōfuku,* 47. On the renovationist character of the Cabinet Information Bureau, see Kasza, *The State and the Mass Media in Japan,* 200–206.

86  Young, *Japan's Total Empire,* 196–201.

87  Mimura, "Technocratic Visions of Empire," 97–116; Duara, *Sovereignty and Authenticity,* 67.

88  See the discussions of the Concordia Association in Duara, *Sovereignty and Authenticity,* 73–76; and Young, *Japan's Total Empire,* 287–290.

89  On the use of the Manchukuo model or blueprint for army administration of occupied territories in China, see Young, *Japan's Total Empire,* 222. Komagome makes a similar point and notes that the People's Renovation Society was modeled on the Concordia Association, in *Shokuminchi teikoku Nihon no bunka teigō,* 299.

90  Fletcher, *The Search for a New Order,* 114–115.

91  Ibid., 112. Miki Kiyoshi's views on Japanese culture, particularly the culture of daily life, are discussed in chapter 4.

92  Miki Kiyoshi, "Tōa shisō no konkyo" (The Foundation of Asian Ideology), *Kaizō* 20, no. 12 (December 1938): 8–20, quoted in Komagome, *Shokuminchi teikoku Nihon no bunka teigō,* 307. See also Fletcher, *The Search for a New Order,* 111–112.

93  See the article on Chinese bamboo chairs by Hamada Shōji in the February 1940 issue of *Gekkan mingei;* Yanagi Yoshitaka writes of Chinese chairs in the January–February 1941 issue. Other issues with articles or photo features on Chinese chairs are November 1942, January 1943, January 1944. Chinese or Chinese-inspired chairs or stools appeared on the covers of the April and August 1941 issues and the January 1944 issue.

94  Yanagi Yoshitaka, "Hokushi orimono nikki" (North China Weaving Diary), *Gekkan mingei* 3, nos. 1–2 (January–February 1941): 27.

95  Kenmochi Isamu, "Tōyō no isu: Toku ni Shina no isu ni tsuite" (Oriental Chairs: And Especially about Chinese Chairs), *Mingei* 4, no. 11 (November 1942): 15.

96  Ibid., 23. As Kenmochi pointed out, the "Greater East Asian war" was rapidly bringing under Japanese control other Asian regions with chair-sitting traditions, such as Malaysia and India. He also noted that medieval Japanese military commanders used stools.

97   Yoshida, "Hokushi tsūshin," Mingei 5, no. 3 (March 1943): 18–19.

98   Ibid., 20; also see Muraoka Kageo, "Pekin saiyū (1)," Mingei 4, no. 12 (December 1942): 43.

99   Yoshida, "Hokushi tsūshin," Mingei 5, no. 4 (April 1943): 6.

100  Ibid., 5–6.

101  Yoshida, "Hokushi tsūshin," Mingei 5, no. 11 (November 1943): 17–18.

102  Ibid., 18–19.

103  Boyle, China and Japan at War, 309–310; Iriye, "Toward a New Cultural Order," 273.

104  Yoshida, "Hokushi tsūshin," Mingei 5, no. 5 (May 1943): 12.

105  Yoshida, "Hokushi tsūshin," Mingei 5, no. 6 (June 1943): 29.

106  Yoshida, "Kahoku no mingei undō ni tsuite" (About the Chinese Mingei Movement), Mingei 6, no. 1 (January 1944): 3, 4–5.

107  Iriye, "Toward a New Cultural Order," 254; see also, for example, Goodman, introduction to Japanese Cultural Policies in Southeast Asia During World War 2, 1–6; and Li, The Japanese Army in North China, especially chapter 5.

108  Howell, Geographies of Identity in Nineteenth-Century Japan, 11.

109  Shikiba, "Ryūkyū netsu" (Ryūkyū Fever), Gekkan mingei 1, no. 8 (November 1939): 27.

110  See Yanagi's 1939 postcards of 1 January to Tonomura Kichinosuke and 7 February to Yoshida Shōtarō in YMz 21 (II): 161, 163.

111  Letter of 2 February 1939, in YMz 21 (II): 162.

112  See, for example, the special Okinawan textiles issue of Kōgei 49 (January 1935). The Folk-Crafts Museum put up an exhibit of Okinawan dyework in the spring of 1938.

113  For an illuminating discussion of Nantō studies and Yanagita's role in its development, see Kano Masanao, Okinawa no fuchi (The Okinawan Abyss), chapter 6.

114  Ibid., 192. See also the articles and features about Okinawan travel that begin to appear with increasing frequency in Japanese travel magazines during the late 1920s and 1930s.

115  See Kano, Okinawa no fuchi, 237–238, on the development of governmental and military interest in Okinawa during the 1930s.

116  Yanagi, "Ryūkyū de no shigoto" ([Our] Work in Okinawa), Gekkan mingei 1, no. 8 (November 1939): 8.

117  Yanagi, "Naze Ryūkyū ni dōjin ichidō de dekakeru ka" (Why the Fellows Are Going Together to Ryūkyū), Gekkan mingei 1, no. 1 (April 1939): 2.

118  Ibid., 4.

119  Quoted in Kano, Okinawa no fuchi, 203.

120  Yanagi, "Yakimono" (Pottery); Serizawa Keisuke, "Somemono" (Dyework); Tanaka Toshio, "Orimono" (Weaving); all in "Ryūkyū kōgei kaisetsu" (Commentary on Ryūkyū Crafts), Gekkan mingei 1, no. 8 (November 1939): 1, 3, 5–6.

121  Tonomura Kichinosuke, "Ryūkyū no chikamichi" (The Ryūkyū Short-Cut), Gekkan mingei 1, no. 8 (November 1939): 18.

122  Suzuki Sōhei, "Matatabi Ryūkyū e" (Again to Ryūkyū), Gekkan mingei 2, no. 2 (Feb-

ruary 1940): 42; Yanagi, "Henshū kōki" (Editorial Postscript), *Kōgei* 102 (March 1940): 59.

123  Letter of 19 December 1939 from Yanagi to Takeuchi Kiyomi, in YMz 21 (II): 184.

124  Yanagi, "Henshū kōki," *Kōgei* 102 (March 1940): 60.

125  Quoted in Tanaka Toshio, "Mondai no suii" (The Progress of the Issues), *Gekkan mingei* 2, no. 3 (March 1940): 5.

126  Quoted in Tanaka Toshio, "Mondai no suii," 7.

127  Hokama Shūzen, "Okinawa ni okeru gengo kyōiku no rekishi" (The History of Language Education in Okinawa), 2: 191, 203–205; on the prefectural government's effort to link language reform to national wartime mobilization from 1939, see also Kano, *Okinawa no fuchi*, 270.

128  See discussion in Oguma Eiji, *Tan'ichi minzoku shinwa no kigen* (The Origins of the Myth of a Single Race), 413.

129  Quoted in Tanaka, "Mondai no suii," 7–8.

130  In a postwar memoir, Yoshida wrote that he had found "insufferable" the "aristo-cratic tastes" of the mingei activists, garbed in their homespun suits. Elsewhere he expressed disgust for "bourgeois" intellectuals he had known in Tokyo, such as Hani Gorō and Shimizu Ikutarō, whose hair "glittered with pomade" and who "talked only of how the coffee in such-and-such a place was simply undrinkable." Quoted in Oguma Eiji's discussion of Yoshida, in "*Nihonjiin*" no kyōkai (The Boundaries of "the Japanese"), 400–401.

131  Tanaka, "Mondai no suii," 9, 11, 16–17.

132  Tanaka Toshio, "Sono go no Ryūkyū mondai" (Follow-up on the Ryūkyū Issues), *Gekkan mingei* 2, no. 5 (May 1940): 10.

133  The use of the term "dialect" (*hōgen*) to refer to the various languages used in Okinawa in the early twentieth century itself bears some ideological freight, as it assumes a fundamental connection among those languages, and between them and Japanese. In fact linguists are by no means in agreement that such connections originally existed.

134  See, for example, Yanagi's review of his own position on this issue in Henshū bu (Editorial Department), "Mondai sainen no keika" (The Course of the Reigniting of the Issue), *Gekkan mingei* 2, nos. 11–12 (November–December 1940): 37–38.

135  See, for example, Tanaka Toshio, "Mondai no suii," 15.

136  Yanagi, "Kokugo mondai ni kanshi Okinawa ken gakumubu ni kotaeru sho" (Letter in Response to the Okinawan Education Department with Regard to the Issue of National Language), *Gekkan mingei* 2, no. 3 (March 1940): 24.

137  Nihon mingei kyōkai dōjin, "Warera wa kono mokuteki no tame ni tokushū suru" (We Are Putting Out a Special Issue for This Purpose), *Gekkan mingei* 2, no. 3 (March 1940): 3.

138  Mingei writers in the early 1940s regularly paired Okinawa and Tōhoku as two Japanese regions blessed by their distance from the degraded metropolitan center.

On occasion there were also comments about the curious difference between obstructionist Okinawan elites and their more enlightened counterparts in Tōhoku. See, for example, "Mingei zakki," *Gekkan mingei* 2, no. 4 (April 1940): 53.

.139 Quoted from Yanagi's 1 June 1940 article in the *Tōkyō asahi shinbun*, in Henshū bu, "Mondai sainen no keika," *Gekkan mingei* 2, nos. 11–12 (November–December 1940): 30.

140 Tanaka Toshio, "Mondai sainen no keika," 37; see also Yanagi's complaints in August 1940 postcards from Okinawa to Tonomura Kichinosuke and Shiga Naoya, in YMz 21 (II): 198.

141 Tanaka Toshio, "Sono go no Ryūkyū mondai," and Shikiba, "Henshū kōki," *Gekkan mingei* 2, no. 5 (May 1940): 12, 70.

142 Mingei kyōkai, eds., *Ryūkyū no orimono* (*Weaving of Ryūkyū*) (Tokyo: Mingei kyōkai, 1940).

143 Suzuki Junji, "Okinawa kōgeihin no seichō o nozonde" (Hoping for the Growth of Okinawan Crafts), *Gekkan mingei* 2, no. 3 (March 1940): 75.

144 "Mingei kyōkai tayori" (News from the Mingei Association), *Gekkan mingei* 2, nos. 11–12 (November–December 1940): 29; see also the promotional pamphlet published by the Mingei Association, "Ryūkyū kōgei bunka tenrankai kaisetsu" (Commentary on the Ryūkyū Crafts Culture Exhibition) (Tokyo: November, 1940) (Mingeikan archive).

145 "Mingei kyōkai tayori," *Gekkan mingei* 2, no. 7 (July 1940): 73; Yanagi, "Henshū kōki," *Kōgei* 103 (October 1940): 96. "Culture films" had become a feature of the Japanese mass media from about 1937. As nonfiction films that were considered to "elevate national consciousness, establish public morality, correct the understanding of Japan's domestic and international situation, serve as propaganda for the administration in matters pertaining to the military, industry, education, fire prevention, nutrition, etc., or contribute to the advancement of public welfare in other ways," culture films were inspected by Home Ministry censors free of charge. See discussion in Kasza, *The State and the Mass Media in Japan*, 237; and High, *The Imperial Screen*, chapter 3.

146 Shikiba, "Henshū kōki," *Gekkan mingei* 2, no. 7 (July 1940): 73; "Meaki to mekura" (Eyes Open and Eyes Blinded), *Gekkan mingei* 2, no. 8 (August 1940): 4.

147 Tanaka Toshio, "Mingei kyōkai tayori," *Gekkan mingei* 2, no. 6 (June 1940): 34; Yanagi, "Henshū kōki," *Kōgei* 103 (October 1940): 96.

148 On the hundreds of regional culture organizations and movements sponsored by the Cultural Section of the IRAA as part of its "regional culture movement" (*chihō bunka undō*), see Kawanishi Teruyuki, "Yokusan undō to chihō bunka" (The Imperial Rule Assistance Movement and Regional Culture); and Kitagawa Kenzō, "Senjika no chihō bunka undō" (Regional Culture Movements in Wartime), in *Bunka to fuashizumu* (*Culture and Fascism*), ed. Kitagawa Kenzō and Akazawa Shirō (Tokyo: Nihon keizai hyōronsha, 1993), 207–245.

149 Kishida Kunio, "Chihō bunka no shin kensetsu" (The New Establishment of Re-

gional Culture), in Kishida, *Seikatsu to bunka* (*Daily Life and Culture*) (Tokyo: Aoyama shuppansha, 1941), 333. According to an editorial note, the essay originally appeared in July 1941. At a later point in the essay (pp. 342–343), Kishida names mingei as one of the four categories of regional cultural tradition that the Cultural Section wished to have revived and developed. The other three were customs and events expressing a spirit of cooperative daily life; literature and "local arts" (*kyōdo geijutsu*); local monuments and landscape features.

150   Kamiizumi Hidenobu, *Chihō to bunka* (*Regions and Culture*), 16.

151   For an analysis of the historical development of this older model, see Howell, *Geographies of Identity in Nineteenth-Century Japan.*

152   Yanagi, "Naze Ryūkyū ni dōjin ichidō de dekakeru ka," 4; see also Tonomura Kichinosuke, "Ryūkyū no orimono ni tsuite" (About Ryūkyū Weaving), *Gekkan mingei* 1, no. 4 (July 1939): 15; and Tanaka Toshio, "Mingei kyōkai no Ryūkyū kō wa donna eikyō o nokoshita ka" (What Has Been the Influence of the Mingei Association's Trip to Ryūkyū?), *Gekkan mingei* 1, no. 8 (November 1939): 56.

153   Yanagi, "Ryūkyū de no shigoto," 11.

154   Tanaka Tōtarō, "Ryūkyū aka-e tōki" (Ryūkyū Aka-e Ceramics), *Gekkan mingei* 1, no. 2 (May 1939): 27. A photograph of an Okinawan aka-e plate decorated with what Yanagi calls a "new experimental" pattern appears at the beginning of *Gekkan mingei* 1, no. 8 (November, 1939): n.p.

155   Yanagi, "Henshū kōki," *Kōgei* 99 (March 1939): 70–71.

156   Hamada Shōji, "Tsuboya no seikatsu" (Daily Life at Tsuboya), *Gekkan mingei* 1, no. 8 (November 1939): 16.

157   Tanaka, "Mingei kyōkai no Ryūkyū kō wa donna eikyō o nokoshita ka," 39–40.

158   I am thinking here of the deaths of hundreds of thousands of native Okinawans in the final year of war. See Tomiyama Ichirō, *Senjō no kioku* (*Memories of the Battlefield*); and Field, *In the Realm of a Dying Emperor.*

## Epilogue

1   Mizuo, *Hyōden Yanagi Muneyoshi* (*Critical Biography of Yanagi Muneyoshi*), 242.

2   Yanagi, "Henshū kōki" (Editorial Postscript), *Kōgei* 115 (December 1946): 63–64.

3   See, for example, articles by Yanagi, Shikiba, and Nakamura Sei in *Mingei* 70 (July 1946).

4   Yanagi, "Henshū kōki," *Kōgei* 116 (March 1947): 48–49.

5   Muraoka Kageo, "Nihon mingei kyōkai dai ikkai rengō kyōgikai," (The First Federated Mingei Association Conference), *Kōgei* 119 (July 1948): 69–74.

6   See Yanagi, "Ryōheika no gyōkō kei" (Report of the Visit by Their Majesties the Emperor and Empress) and "Kōtaikō heika no gyō kei" (Report of the Visit by Her Imperial Majesty the Empress Dowager), *Kōgei* 119 (July 1948): 57–65, for an account of the imperial visits.

7   John Dower, *Embracing Defeat: Japan in the Wake of World War II* (New York: New Press,

1999). See also Herbert P. Bix, *Hirohito and the Making of Modern Japan* (New York: HarperCollins, 2000).

8  Personal communication by Vincent Brandt, who underwent such training in 1954–1955. As he recalls, his cohort of Foreign Service Institute trainees was shown several films about folk pottery production in Japan and given lectures and presentations on mingei by Gregory Henderson, the U.S. Cultural Affairs officer in Tokyo.

9  The proselytizing of Yanagi, in particular, took a very literally religious turn in the postwar years, as he became increasingly preoccupied with the relationship between mingei aesthetics and Buddhist thought and practice. See the discussion in Nakami Mari, *Yanagi Sōetsu: Jidai to shisō* (*The Times and Thought of Yanagi Sōetsu*), chapter 11.

10  See the suggestive if sketchy discussion in Kikuchi, *Japanese Modernization and Mingei Theory* of various official and semiofficial industrial design initiatives and organizations in the 1950s. For the early postwar history of West German industrial design, see Betts, *The Authority of Everyday Objects*.

11  For a discussion of the Meiji-era legislation, see Aso, "New Illusions," 87–95. See also Christine Guth, "Kokuho: From Dynastic to Artistic Treasure," *Cahiers d'Extreme-Asie* 9 (1996–1997), 313–322.

12  See Michele Bambling, "Japan's Living National Treasures Program: The Paradox of Remembering."

13  The Mingei Association was actively involved in the campaign to "preserve traditional technology" (*dentōteki gijutsu hōzon*), which was undertaken by the Ministry of Commerce and Industry in 1941 and 1942. The MCI was concerned about the possible loss of handicraft techniques due to the wartime restrictions imposed on civilian manufacturing and wished to pursue the possible relevance of ceramic, basketweaving, and other handicraft technologies for new military as well as export applications. In 1942, the MCI began designating individual artisans for special permission to continue work; most of the leading mingei artist-craftsmen received such designations. See Brandt, "The Folk-Craft Movement in Early Shōwa Japan," 318–319.

14  Those who accepted the designation were Tomimoto Kenkichi, Hamada Shōji, Serizawa Keisuke, Kuroda Tatsuaki, and Abe Eijirō. More recently, in 1996 the potter Shimaoka Tatsuzō, who studied under Hamada Shōji and is therefore an artist with strong mingei affiliations, was named a living national treasure.

15  For an interesting discussion of the mingei pottery village of Mashiko, and particularly of the views and motivations of the potters who chose to live and work there in the 1960s and 1970s, see Holmes, "The Transition of the Artisan-Potter to the Artist-Potter in Mashiko, a Folkware Kiln Site in Japan."

# Bibliography

Primary Sources

**ARCHIVES**

Nihon Mingeikan archive, Tokyo

Sekisetsu chihō nōsanson kenkyū shiryō kan (Snowfall Region Farm and Mountain
  Village Research Archive), Shinjo, Yamagata

**FILMS**

Ryūkyū no fūbutsu

Ryūkyū no mingei

**PERIODICALS**

Atorie (1924–1941)

Bi no kuni (1925–1941)

Fujin gahō (1905–1944, 1944–)

Fujin kōron (1916–)

Gekkan mingei (1939–1944, 1947; renamed Mingei in January 1942)

Hankyū bijutsu (1937–1941)

Hokushi (1939–1943)

Jūtaku (1916–1943)

Jūtaku to teien (1934–1939)

Kōgei (1931–1943, 1947–1948)

Kōgei nyuusu (1932–1974)

Mingei techō (1958–1982)

Mitsukoshi (1938–1943)

Mokujiki Shōnin no kenkyū (1924)

Nihon shumi (1925)

Ryokō kurabu (1916–1919)
Seikatsu bijutsu (1941–1943)
Seikatsu to shumi (1934–1936)
Shirakaba (1910–1923)
Tabi (1928–1944, 1946– )
Taisei yokusankai kaihō (1940–1944)
Takumi (1934–?, 1952–1954)
Teikoku kōgei (1927–1938)
Yukiguni (1938–1943)

Published Sources

Abe Eijirō. *Tesuki 70 nen: Abe Eijirō no sekai* (*Seventy Years of Papermaking: The World of Abe Eijirō*). Tokyo: Arō aato waakusu, 1980.

Adachi, Barbara C. *The Living Treasures of Japan*. Tokyo: Kodansha International, 1973.

Ajioka, Chiaki. "Early Mingei and Development of Japanese Crafts, 1920s–1940s." Ph.D. diss., Australian National University, 1995.

Akaboshi Gorō, and Nakamaru Heiichirō. *Chōsen no yakimono: Ri chō* (*Korean Pottery: Yi Dynasty*). Kyoto: Tankō shinsha, 1965.

Akazawa Shirō. "Taiheiyō sensōka no shakai" (Society During the Pacific War). In *Jū go nen sensō shi* (*History of the Fifteen-Year War*), ed. Fujiwara Akira and Imai Seiichi, vol. 3: 153–192. Tokyo: Aoki Shoten, 1989.

Akazawa Shirō, and Kitagawa Kenzō, eds. *Bunka to fuashizumu* (*Culture and Fascism*). Tokyo: Nihon keiza hyōronsha, 1993.

Ama Toshimaro. *Yanagi Sōetsu: Bi no bosatsu* (*Yanagi Sōetsu: Bodhisattva of Beauty*). Tokyo: Riburopōto, 1987.

Amano Takeshi. *Mingu no mikata: Kokoro no katachi* (*The Perspective of Folk Tools: The Shape of the Heart*). Tokyo: Daiichi hōki shuppan, 1983.

Aoyama Jirō. *Aoyama Jirō bunshū* (*Collected Writings of Aoyama Jirō*). Tokyo: Ozawa shoten, 1987.

———. "Aoyama Jirō nikki" (Aoyama Jirō's Diary). *Shinchō* 90, no. 6 (June 1993): 104–157.

Ariga Kizaemon. *Hitotsu no Nihon bunkaron* (*One Theory of Japanese Culture*). Tokyo: Mirai-sha, 1981.

Asakawa Noritaka. "Chōsen kotōki no kenkyū ni tsukite" (On Research on Old Korean Ceramics). In *Keimeikai dai gojūgo kai kōenshū* (*The Fifty-fifth Collected Lectures of the Morningstar Society*), 55. Tokyo: Keimeikai jimusho, 1934.

Aso, Noriko. "New Illusions: The Emergence of a Discourse on Traditional Japanese Arts and Crafts, 1868–1945." Ph.D. diss., University of Chicago, 1996.

Auslander, Leora. "The Gendering of Consumer Practices in Nineteenth-century France." In *The Sex of Things: Gender and Consumption in Historical Perspective*, ed. Victoria de Grazia, with Ellen Furlough. Berkeley: University of California Press, 1996.

——. *Taste and Power: Furnishing Modern France.* Berkeley: University of California Press, 1996.

Bambling, Michele. "Japan's Living National Treasures Program: The Paradox of Remembering." In *Perspectives on Social Memory in Japan*, ed. Yun Hui Tsu, Jan van Bremen, Eyal Ben-Ari, 148–169. Folkestone, Kent, England: Global Oriental, 2005.

Baranowski, Shelley. *Strength through Joy: Consumerism and Mass Tourism in the Third Reich.* Cambridge, England: Cambridge University Press, 2004.

Becker, Jane S. *Selling Tradition: Appalachia and the Construction of an American Folk, 1930–1940.* Chapel Hill: University of North Carolina Press, 1998.

Bendix, Regina. *In Search of Authenticity: The Formation of Folklore Studies.* Madison: University of Wisconsin Press, 1997.

Ben-Ghiat, Ruth. *Fascist Modernities: Italy, 1922–1945.* Berkeley: University of California Press, 2001.

Benjamin, Walter. "The Work of Art in the Age of Mechanical Reproduction." In *Illuminations*, ed. Hannah Arendt, 217–251. New York: Schocken Books, 1969.

Bennett, Tony. "The Exhibitionary Complex." In *The Birth of the Museum: History, Theory, Politics.* London: Routledge, 1995.

Benton, Charlotte. "From Tubular Steel to Bamboo: Charlotte Perriand, the Migrating Chaise-longue and Japan." *Journal of Design History* 11, no. 1 (1998): 31–58.

Berger, Gordon. *Parties out of Power in Japan: 1931–1941.* Princeton, N.J.: Princeton University Press, 1971.

Betts, Paul. *The Authority of Everyday Objects: A Cultural History of West German Industrial Design.* Berkeley: University of California Press, 2004.

Bix, Herbert. "Rethinking 'Emperor-System Fascism': Ruptures and Continuities in Modern Japanese History." *Bulletin of Concerned Asian Scholars* 14, no. 2 (April–June 1982): 2–19.

Boris, Eileen. *Art and Labor: Ruskin, Morris, and the Craftsman Ideal in America.* Philadelphia: Temple University Press, 1986.

Bourdieu, Pierre. *Distinction: A Social Critique of the Judgement of Taste.* Trans. Richard Nice. Cambridge, Mass.: Harvard University Press, 1984.

Boyle, John Hunter. *China and Japan at War, 1937–1945: The Politics of Collaboration.* Stanford: Stanford University Press, 1972.

Brandt, Lisbeth Kim. "The Folk-Craft Movement in Early Shōwa Japan, 1925–1945." Ph.D. diss., Columbia University, 1996.

Bridenthal, Renate, Atina Grossman, and Marion Kaplan, eds. *When Biology Became Destiny: Women in Weimar and Nazi Germany.* New York: Monthly Review Press, 1984.

Ching, Leo. *Becoming "Japanese": Colonial Taiwan and Identity Formation.* Berkeley: University of California Press, 2001.

Ch'oe Harim. "Yanagi Muneyoshi no Kankoku bijutsu kan" (Yanagi Muneyoshi's View of Korean Art). *Tenbō*, no. 211 (July 1976): 94–103.

Christy, Alan S. "The Making of Imperial Subjects in Okinawa." *Positions* 1, no. 3 (winter 1993): 607–639.

——. "Representing the Rural: Place as Method in the Formation of Japanese Native Ethnology, 1910–1945." Ph.D. diss., University of Chicago, 1997.

Cort, Louise. "The Kizaemon Teabowl Reconsidered: The Making of a Masterpiece." *Chanoyu Quarterly*, no. 71 (1992): 7–30.

Csikszentmihalyi, Mihaly, and Eugene Rochberg-Halton. *The Meaning of Things: Domestic Symbols and the Self.* New York: Cambridge University Press, 1981.

de Grazia, Victoria. *The Culture of Consent: Mass Organization of Leisure in Fascist Italy.* Cambridge, England: Cambridge University Press, 1981.

——. *How Fascism Ruled Women: Italy, 1922–1945.* Berkeley: University of California Press, 1992.

de Waal, Edmund. *Bernard Leach.* London: Tate Gallery Publishing, 1999.

Doak, Kevin Michael. *Dreams of Difference: The Japan Romantic School and the Crisis of Modernity.* Berkeley: University of California Press, 1994.

Dodd, Stephen H. "An Embracing Vision: Representations of the Countryside in Early Twentieth-Century Japanese Literature." Ph.D. diss., Columbia University, 1993.

Duara, Prasenjit. *Sovereignty and Authenticity: Manchukuo and the East Asian Modern.* Lanham, Md.: Rowman and Littlefield, 2003.

Duus, Peter. "Japan's Informal Empire in China: An Overview." In *The Japanese Informal Empire in China, 1895–1937,* ed. Peter Duus, Ramon H. Myers, and Mark R. Peattie, xi–xxix. Princeton, N.J.: Princeton University Press, 1989.

Editorial staff of *Ginka*, eds. *Ri chō ni nyūmon (Introduction to Yi Dynasty).* Tokyo: Bunka shuppan kyoku, 1998.

Editorial staff of *Taiyō*, eds. *Ri chō o tanoshimu (Enjoying Yi Dynasty).* Tokyo: Heibonsha, 1998.

Evett, Elisa. *The Critical Reception of Japanese Art in Late Nineteenth Century Europe.* Ann Arbor: University of Michigan Press, 1982.

Falasca-Zamponi, Simonetta. *Fascist Spectacle: The Aesthetics of Power in Mussolini's Italy.* Berkeley: University of California Press, 1997.

Faure, Christian. *Le Projet Culturel de Vichy: Folklore et Révolution Nationale, 1940–1944 (The Vichy Cultural Project: Folklore and National Revolution, 1940–1944).* Lyon: Presses Universitaires de Lyon, 1989.

Field, Norma. *In the Realm of a Dying Emperor: Japan at Century's End.* New York: Vintage, 1991.

Fletcher, William Miles, II. *The Search for a New Order: Intellectuals and Fascism in Prewar Japan.* Chapel Hill: University of North Carolina Press, 1982.

Forty, Adrian. *Objects of Desire.* New York: Pantheon Books, 1986.

Frolet, Elisabeth. *Yanagi Sōetsu, ou, Les éléments d'une renaissance artistique japonaise (Young Sōetsu, or, the Elements of a Japanese Artistic Renaissance).* Paris: Publications de la Sorbonne, 1986.

Fujimori Terunobu. *Nihon no kindai kenchiku (Modern Japanese Architecture).* 2 vols. Tokyo: Iwanami shinsho, 1993.

Garon, Sheldon. *Molding Japanese Minds: The State in Everyday Life*. Princeton, N.J.: Princeton University Press, 1997.

Gluck, Carol. "The People in History: Recent Trends in Japanese Historiography." *Journal of Asian Studies* 38, no. 1 (November 1978): 25–50.

Gompertz, G. St. G. M. *Korean Pottery and Porcelain of the Yi Period*. London: Faber and Faber, 1968.

Goodman, Grant K. Introduction to *Japanese Cultural Policies in Southeast Asia During World War II*, ed. Grant K. Goodman, 1–6. New York: St. Martin's Press, 1991.

Gordon, Andrew. *Labor and Imperial Democracy in Prewar Japan*. Berkeley: University of California Press, 1991.

Guth, Christine M. E. *Art, Tea, and Industry: Masuda Takashi and the Mitsui Circle*. Princeton, N.J.: Princeton University Press, 1993.

Hamada Shōji. *Kama ni makasete (Entrusting the Kiln)*. Tokyo: Nihon keizai shinbun sha, 1976.

Hane, Mikiso. *Peasants, Rebels, and Outcasts: The Underside of Modern Japan*. New York: Pantheon, 1982.

Harootunian, Harry. *Overcome by Modernity: History, Culture, and Community in Interwar Japan*. Princeton, N.J.: Princeton University Press, 2000.

Hata Hideo. "Yanagi Muneyoshi ron" (A Theory about Yanagi Muneyoshi). *Chawan (Teabowls)* 11 (January 1932): 56–59.

Hatada Takashi. *Chōsen to Nihonjin (Korea and the Japanese)*. Tokyo: Keisō shobo, 1983.

Hatsuda Tōru. *Hyakkaten no tanjō: Meiji Taishō Shōwa no toshi bunka o enshutsu shita hyakkaten to kankōba no kindaishi (Birth of the Department Store: Modern History of the Department Store and the Arcade, Which Staged the Urban Culture of Meiji, Taisho, and Showa)*. Tokyo: Sanseidō, 1993.

Havens, Thomas R. H. *Valley of Darkness: The Japanese People and World War II*. New York: Norton, 1978.

Hayashiya, Seizō. "The Korean Teabowl." *Chanoyu Quarterly*, no. 18 (1977): 28–46.

High, Peter B. *The Imperial Screen: Japanese Film Culture in the Fifteen Years' War, 1931–1935*. Madison: University of Wisconsin Press, 2003.

Hokama Shūzen. "Okinawa ni okeru gengo kyōiku no rekishi" (The History of Language Education in Okinawa). In *Waga Okinawa (Our Okinawa)*, ed. Tanigawa Kenichi, 2: 187–216. Tokyo: Mokujisha, 1970.

Hokkoku kara hasshin jikkō iinkai, eds. *Setsugai undō shoshi: Yukiguni ni hi o tomoshita hitobito (Brief History of the Snow Damage Movement: The People Who Brought Light to the Snow Country)*. Shinjo: Sekisetsu chihō nōsanson kenkyū shiryōkan nai, 1990.

Holmes, Ann Sommer. "The Transition of the Artisan-Potter to the Artist-Potter in Mashiko, a Folkware Kiln Site in Japan." Ph.D. diss., New York University, 1982.

Hosley, William N. *The Japan Idea: Art and Life in Victorian America*. Hartford, Conn.: Wadsworth Atheneum, 1990.

Howell, David L. *Geographies of Identity in Nineteenth-Century Japan*. Berkeley: University of California Press, 2005.

Hung, Chang-tai. *Going to the People: Chinese Intellectuals and Folk Literature, 1918–1937*. Cambridge, Mass.: Harvard University Press, 1985.

Idegawa Naoki. *Mingei: Riron no hōkai to yōshiki no tanjō* (Mingei: The Collapse of Theory and the Birth of a Style). Tokyo: Shinchōsha, 1988.

Ienaga, Saburō. *The Pacific War, 1931–1945: A Critical Perspective on Japan's Role in World War II*. New York: Pantheon Books, 1978.

Iioka Masao. "Kōgei no imi to sono hensen" (The Meaning of Kōgei and Changes in That Meaning), part 1. *Kyūshū sangyō daigaku geijutsu gakubu kenkyū hōkoku* (Research Reports of the Art Department of Kyushu Industrial College) 22 (1991): 60–67.

———. "Kōgei no imi to sono hensen" (The Meaning of Kōgei and Changes in That Meaning), part 2. *Kyūshū sangyō daigaku geijutsu gakubu kenkyū hōkoku* (Research Reports of the Art Department of Kyushu Industrial College) 23 (1992): 49–57.

Imai Nobuo. "Shirakaba" no shūhen: Shinshū kyōiku to no kōryū ni tsuite (At the Periphery of "Shirakaba": Relations with Shinshū Education). 3rd ed. Nagano: Shinano Kyōikukai shuppanbu, 1986.

Inoue Masahito. *Nihonjin to yōfuku: Kokuminfuku to iu mōdo* (Japanese People and Western Clothing: The Fashion Known as "National Dress"). Tokyo: Kōsaido shuppan, 2001.

Inoue Shōichi. *Senjika Nihon no kenchikuka* (Architects in Wartime Japan). Tokyo: Asahi sensho, 1995.

Iriye, Akira. "Toward a New Cultural Order: The Hsin-Min Hui." In *The Chinese and the Japanese: Essays in Political and Cultural Interactions*, ed. Akira Iriye, 254–274. Princeton, N.J.: Princeton University Press, 1980.

Ishii, Kazumi, and Nerida Jarkey. "The Housewife Is Born: The Establishment of the Notion and Identity of the Shufu in Modern Japan." *Japanese Studies* 22, no. 1 (2002): 35–47.

Itagaki Kuniko. *Shōwa senzen, senchūki no nōson seikatsu: Zasshi "Ie no hikari" ni miru* (Village Daily Life During the Shōwa Prewar and Wartime: As Seen in the Magazine "Ie no hikari"). Tokyo: Mitsumine shobō, 1992.

Itō Kikunosuke. *San'in no tōyō* (San'in Pottery Kilns). Tokyo: Kokusho kankōkai, 1980.

Iuchi Katsue. "Kuroda Tatsuaki to Kamigamo mingei kyōdan" (Kuroda Tatsuaki and the Kamigamo Mingei Guild), part 1. *Hokkaidō ritsu kindai bijutsukan kiyō* (Bulletin of the Hokkaido Modern Art Museum) (1991): 69–81.

———. "Kuroda Tatsuaki to Kamigamo mingei kyōdan" (Kuroda Tatsuaki and the Kamigamo Mingei Guild), part 2. *Hokkaidō ritsu kindai bijutsukan kiyō* (Bulletin of the Hokkaido Modern Art Museum) (1992): 69–89.

Ivy, Marilyn. *Discourses of the Vanishing: Modernity, Phantasm, Japan*. Chicago: University of Chicago Press, 1995.

Izuhara Eiichi. *Nihon no dezain undō* (Japanese Design Movements). Tokyo: Perikansha, 1992.

*Japanese Aesthetics and Sense of Space: Another Aspect of Modern Japanese Design*. Tokyo: Sezon Museum of Art, 1990.

*Japanese Aesthetics and Sense of Space II: Modern Taste: Ornament and Eroticism 1900–1945*. Tokyo: Sezon Museum of Art, 1992.

Jinno Yuki. *Shumi no tanjo: Hyakkaten ga tsukutta teisuto* (*The Birth of Taste: The "Taste" Created by Department Stores*). Tokyo: Keisō shobō, 1994.

Johnson, Chalmers. MITI and the Japanese Miracle: The Growth of Industrial Policy, 1925–1975. Stanford: Stanford University Press, 1982.

Kabushiki gaisha Hankyū hyakkaten shashi henshū iinkai, eds. *Kabushiki gaisha Hankyū hyakkaten 25 nen shi.* (*Twenty-five-Year History of Hankyū Department Store*). Osaka: Hankyū hyakkaten, 1976.

Kamiizumi Hidenobu. *Chihō to bunka* (*Regions and Culture*). Tokyo: Takayama shoin, 1942.

Kan Donjin. *Nihon genronkai to Chōsen: 1910–1945* (*The Japanese Press and Korea: 1910–1945*). Tokyo: Hōsei daigaku shuppankyoku, 1984.

Kano Masanao. *Kindai Nihon no minkangaku* (*Modern Japanese Minkangaku*). Tokyo: Iwanami shoten, 1983.

———. *Okinawa no fuchi: Iha Fuyu to sono jidai* (*The Okinawan Abyss: Iha Fuyu and His Times*). Tokyo: Iwanami shoten, 1993.

Karatani Kōjin. "Bigaku no kōyō: 'Orientarizumu' igō" (The Uses of Aesthetics: After "Orientalism"). *Hihyō kūkan* 2, no. 14 (1997): 42–55.

Kashiwagi Hiroshi. *Kindai Nihon sangyō dezain shisō* (*The Ideology of Modern Japanese Industrial Design*). Tokyo: Ōbunsha, 1979.

Kasza, Geoffrey J. *The State and the Mass Media in Japan: 1918–1945.* Berkeley: University of California Press, 1988.

Kawabata, Yasunari. *Snow Country*. Trans. Edward Seidensticker. New York: Vintage Books, 1957.

Kawada, Minoru. *The Origin of Ethnography in Japan: Yanagita Kunio and His Times.* Trans. Toshiko Kishida-Ellis. New York: Kegan Paul International, 1993.

Kawakatsu Kenichi. *Gashin gunshin shō* (*Selection of Paintings and Correspondence*). Tokyo: Heibonsha, 1971.

Kawamura Minato. "*Daitōa minzokugaku*" no kyojitsu (*The Truths and Falsehoods of "Greater East Asian Folklore Studies"*). Tokyo: Kōdansha, 1996.

———. *Manshū no hōkai: "Daitōa bungaku" to sakkatachi* (*The Collapse of Manchukuo: "Greater East Asian Literature" and Writers*). Tokyo: Bungei shunju, 1998.

Kawanishi Teruyuki. "Yokusan undō to chihō bunka" (The Imperial Rule Assistance Movement and Regional Culture). In *Kindai tennōsei kokka to shakai tōgō* (*The Modern Emperor State and Social Integration*), ed. Umahara Tetsuo and Kaketani Saihei, 181–202. Kyoto: Bunrikaku, 1991.

Kelly, William. "Japanese No-Noh: The Crosstalk of Public Culture in a Rural Festivity." *Public Culture* 2, no. 2 (spring 1990): 65–81.

Kestenbaum, Jacqueline Eve. "Modernism and Tradition in Japanese Architectural Ideology, 1931–1945." Ph.D. diss., Columbia University, 1996.

Kikuchi, Yuko. *Japanese Modernisation and Mingei Theory: Cultural Nationalism and Oriental Orientalism.* London: Routledge Curzon, 2004.

———. "The Myth of Yanagi's Originality." *Journal of Design History* 7, no. 4 (1994): 247–266.

——. "Yanagi Sōetsu and Korean Crafts within the *Mingei* Movement." *Papers of the British Association for Korean Studies (BAKS Papers)*, no. 5 (1994): 23–38.

Kinmonth, Earl H. *The Self-Made Man in Meiji Japanese Thought: From Samurai to Salaryman.* Berkeley: University of California Press, 1981.

Kinoshita Naoyuki. *Bijutsu to iu misemono: Abura-e chaya no jidai (The Spectacle Called Art: The Era of the Oil Painting Teahouse).* Tokyo: Heibonsha, 1993.

Kishida Kunio. *Seikatsu to bunka (Daily Life and Culture).* Tokyo: Aoyama shuppansha, 1941.

Kitagawa Kenzō. "Senjika no bunka undō" (Wartime Cultural Movements). *Rekishi hyōron (History Critique),* no. 465 (January 1989): 45–62.

Kitazawa Noriaki. *Kishida Ryūsei to Taishō abuangyardo (Kishida Ryūsei and the Taisho Avant Garde).* Tokyo: Iwanami shoten, 1993.

Kleeman, Faye Yuan. *Under an Imperial Sun: Japanese Colonial Literature of Taiwan and the South.* Honolulu: University of Hawaii Press, 2003.

Komagome Takeshi. *Shokuminchi teikoku Nihon no bunka teigo (The Cultural Integration of the Japanese Empire and Colonies).* Tokyo: Iwanami shoten, 1996.

Kon Wajirō. *Kon Wajirō shū (Collected Works of Kon Wajirō).* 9 vols. Tokyo: Domesu shuppan, 1971–1972.

Kornicki, P. K. "Public Display and Changing Values: Early Meiji Exhibitions and Their Precursors." *Monumenta Nipponica* 49, no. 2 (summer 1993): 167–196.

Koyama Shizuko. *Ryōsai kenbō to iu kihan (The Framework Known as Good Wife, Wise Mother).* Tokyo: Keisō shobō, 1991.

Kozaki Gunji. *Yamamoto Kanae hyōden: Yume oki senkaku no gaka (Critical Biography of Yamamoto Kanae: Pioneering Artist with Many Dreams).* Nagano shi: Shinnōro, 1979.

Kumakura Isao. *Kindai chadō shi no kenkyū (Research on the Modern History of the Tea Ceremony).* Tokyo: Nihon hōsō shuppan kyōkai, 1980.

——. *Mingei no hakken. (The Discovery of Mingei).* Tokyo: Kadokawa shoten, 1978.

Kurahashi Tōjirō. "Chōsen tōki ni tsuite" (On Korean Ceramics). In *Keimeikai kōenshū* 29. Tokyo: Keimeikai jimusho, 1928.

——, ed. *Tōki zuroku: Ri chō hakuji (Illustrated Record of Ceramics: Yi Dynasty White Porcelain).* Tokyo: Kōseikai shuppanbu, 1932.

Leach, Bernard. *Beyond East and West: Memoirs, Portraits, and Essays.* New York: Watson-Guptill Publications, 1978.

——. *Hamada, Potter.* Tokyo: Kodansha International, 1975.

——. *A Potter in Japan: 1952–1954.* London: Faber and Faber, 1960.

Leach, William. *Land of Desire: Merchants, Power, and the Rise of a New American Culture.* New York: Pantheon Books, 1993.

Lears, T. J. Jackson. *No Place of Grace: Antimodernism and the Transformation of American Culture, 1880–1920.* Chicago: University of Chicago Press, 1981.

Lebovics, Herman. *True France: The Wars over Cultural Identity, 1900–1945.* Ithaca, N.Y.: Cornell University Press, 1992.

Lee, Chong-sik. *The Politics of Korean Nationalism.* Berkeley: University of California Press, 1963.

Li, Lincoln. *The Japanese Army in North China, 1937–1941*. Oxford: Oxford University Press, 1975.

López, Rick A. "Lo más mexicano de México: Popular Arts, Indians, and Intellectuals in the Ethnicization of Postrevolutionary National Culture, 1920–1972." Ph.D. diss., Yale University, 2001.

Makino Kazuharu. *Yoshida Shōya to Tottori ken no teshigoto (Yoshida Shōya and the Handicrafts of Tottori Prefecture)*. Tokyo: Makino shuppan, 1990.

Markus, Andrew. "Shogakai: Celebrity Banquets of the Late Edo Period." *Harvard Journal of Asiatic Studies* 53, no. 1 (1993): 135–167.

Maruyama, Masao. "The Ideology and Dynamics of Japanese Fascism." In *Thought and Behavior in Modern Japanese Politics*, trans. and ed. Ivan Morris, 25–83. London: Oxford University Press, 1969.

Masuda Katsumi. "Taidan: Kindai Nihon no riteihyō—Yanagi Muneyoshi o megutte" (Dialogue: Modern Japanese Milestones—With Reference to Yanagi Muneyoshi). *Kokugo tsūshin*, no. 179 (September 1975): 2–21.

*Matsue shōkō ihō (Matsue Commerce Bulletin)*, no. 111 (1933).

McCormack, Gavan. "Nineteen-Thirties Japan: Fascism?" *Bulletin of Concerned Asian Scholars* 14, no. 2 (April–June 1982): 20–32.

Merritt, Helen. *Modern Japanese Woodblock Prints: The Early Years*. Honolulu: University of Hawaii Press, 1990.

Miki Kiyoshi. "Bunka seisakuron" (Theory of Cultural Policy). In *Miki Kiyoshi zenshū* (*Collected Works of Miki Kiyoshi*), 14: 356–374. Tokyo: Iwanami shoten, 1985.

———. "Seikatsu bunka to seikatsu gijutsu" (Daily Life Culture and Daily Life Technology). In *Miki Kiyoshi zenshū* (*Collected Works of Miki Kiyoshi*), 14: 384–401. Tokyo: Iwanami shoten, 1985.

Miller, Michael. *The Bon Marché: Bourgeois Culture and the Department Store, 1869–1920*. Princeton, N.J.: Princeton University Press, 1981.

Mimura, Janis. "Technocratic Visions of Empire: Technology Bureaucrats and the 'New Order' for Science-Technology." In *Japanese Empire in East Asia and Its Postwar Legacy*, ed. Harald Fuess, 97–116. Munich: Iudicium, 1998.

Minami Hiroshi. *Shōwa bunka, 1925–1945 (Showa Culture, 1925–1945)*. Tokyo: Keisō shobō, 1987.

———. *Taishō bunka (Taisho Culture)*. Tokyo: Keisō shobō, 1965.

Misumi Haruo, and Kawazoe Noboru. *Hayakawa Kōtarō–Kon Wajirō*. Vol. 7 of *Nihon minzoku bunka taikei (The System of Japanese Folklore Culture)*. Tokyo: Kōdansha, 1978.

Mitchell, Timothy. *Colonising Egypt*. Berkeley: University of California Press, 1988.

Miwa, Kimitada. "Toward a Rediscovery of Localism: Can the Yanagita School of Folklore Studies Overcome Japan's Modern Ills?" *Japan Quarterly* 23, no. 1 (1976): 44–52.

Miyake, Yoshiko. "Doubling Expectations: Motherhood and Women's Factory Work under State Management in Japan in the 1930s and 1940s." In *Recreating Japanese Women, 1600–1945*, ed. Gail Lee Bernstein, 267–295. Berkeley: University of California Press, 1991.

Miyamoto Tsuneichi. *Shibusawa Keizō: Minzokugaku no sōshikisha* (Shibusawa Keizō: System-atizer of Ethnology). Vol. 3 of *Nihon minzoku bunka taikei* (The System of Japanese Folklore Culture). Tokyo: Kōdansha, 1978.

Mizukoshi Keiji. "Setsugai undō: Yamaguchi Hiromichi no koto" (The Snow Damage Movement: About Yamaguchi Hiromichi). *Aoi zora* (Blue Skies), no. 46 (December 1991).

Mizuo Hiroshi. *Hyōden Yanagi Muneyoshi* (Critical Biography of Yanagi Muneyoshi). Tokyo: Chikuma shobō, 1992.

Mizutani Saburō. *Kurahashi san no omoide* (Recollections of Mr. Kurahashi). Tokyo: Mizutani Saburō, 1947.

Mochida Keizō. *Kindai Nihon no chishikijin to nōmin* (Modern Japanese Intellectuals and Farm-ers). Tokyo: Ie no hikari kyōkai, 1997.

Moeran, Brian. "Bernard Leach and the Japanese Folk Craft Movement: The Formative Years." *Journal of Design History* 2, nos. 2–3 (1989): 139–144.

——. *Lost Innocence: Folk Craft Potters of Onta, Japan.* Stanford: Stanford University Press, 1984.

——. "Yanagi Muneyoshi and the Japanese Folk Craft Movement." *Asian Folklore Studies* 20, no. 1 (1981): 87–99.

Morris-Suzuki, Tessa. *The Technological Transformation of Japan: From the Seventeenth to the Twenty-first Century.* Cambridge, England: Cambridge University Press, 1994.

Morse, Ronald A. "The Search for Japan's National Character and Distinctiveness: Yana-gita Kunio (1875–1962) and the Folklore Movement." Ph.D. diss., Princeton Univer-sity, 1975.

Myers, Ramon H. "Creating a Modern Enclave Economy: The Economic Integration of Japan, Manchuria, and North China, 1932–1945." In *The Japanese Wartime Empire, 1931–1945,* ed. Peter Duus, Ramon H. Myers, and Mark R. Peattie, 136–170. Prince-ton, N.J.: Princeton University Press, 1996.

Nagamine Shigetoshi. *Zasshi to dokusha no kindai* (The Modernity of Magazines and Readers). Tokyo: Nihon editaasukūru shuppanbu, 1997.

Nagy, Margit. "Middle-Class Working Women During the Interwar Years." In *Recreating Japanese Women, 1600–1945,* ed. Gail Lee Mitchell, 199–216. Berkeley: University of California Press, 1991.

Najita, Tetsuo, and H. D. Harootunian. "Japanese Revolt against the West: Political and Cultural Criticism in the Twentieth Century." In *The Cambridge History of Japan,* ed. Peter Duus, 6: 711–774. Cambridge, England: Cambridge University Press, 1988.

Nakami Mari. *Yanagi Sōetsu: Jidai to shisō* (The Times and Thought of Yanagi Sōetsu). Tokyo: Tōkyō daigaku shuppankai, 2003.

Nakamura, Takufusa. *Economic Growth in Prewar Japan,* trans. Robert A. Feldman. New Haven: Yale University Press, 1983.

Nishigaki Tatsusaburō. "Manshū—Pekin mingei kikō: Kaisō zadankai no ki (jo)" (Man-churia and Beijing Mingei Travelogue: Transcript of a Retrospective Round-table Discus-sion). *Mingei* 370 (October 1983): 22–35.

Nishio Makoto, Usui Yoshimi, and Kinoshita Junji, eds. *Gendai kokugo 3 (Modern Japanese 3)*. Tokyo: Chikuma shobō, 1974.

*Nitten shi (History of Nitten)*. Tokyo: Nitten, 1980–.

Nonogami Keiichi, and Itō Ikutarō, eds. *Ri chō hakuji shōsen (Selected [Writings on] Yi Dynasty White Porcelain)*. Tokyo: Sōjusha bijutsu shuppan, 1984.

Oguma Eiji. *"Nihonjin" no kyōkai: Okinawa—Ainu—Taiwan—Chōsen—shokuminchi shihai kara fukki undō made (The Boundaries of "the Japanese": Okinawa—Ainu—Taiwan—Korea from Colonial Control to the Reversion Movement)*. Tokyo: Shinyōsha, 1998.

——. *Tan'ichi minzoku shinwa no kigen: "Nihonjin" ni jigazō no keifu (The Origins of the Myth of a Single Race: A Genealogy of the Self-Representations of "the Japanese")*. Tokyo: Shinyōsha, 1995.

Ōishi Isamu. *Dentō kōgei no tanjō: Hokkaidō Yakumo chō no "yū chō" to Tokugawa Yoshichika (The Birth of Traditional Craft: The "Carved Bears" of Hokkaido's Yakumo Village and Tokugawa Yoshichika)*. Tokyo: Yoshikawa Hirofumi kan, 1994.

Okakura, Kakuzo. *The Ideals of the East with Special Reference to the Art of Japan*. London: John Murray, 1920.

Ono, Ayako. *Japonisme in Britain: Whistler, Menpes, Henry, Hormel and Nineteenth-Century Japan*. London: Routledge Curzon, 2003.

Ōoka Makoto. "Kaisetsu: Mokujiki hakken no imi suru mono" (Commentary: The Significance of the Discovery of Mokujiki). *Yanagi Muneyoshi zenshū (Collected Works of Yanagi Muneyoshi)*. 7: 633–647. Tokyo: Chikuma shobō, 1981.

Osabe Hideo. *Oni ga kita: Munakata Shikō den (The Demon Has Arrived: Biography of Munakata Shikō)*. 2 vols. Tokyo: Bungei shunju, 1984.

Orto, Luisa Jane. "Design as Art: 'Design' and Italian National Identity." Ph.D. diss., New York University, 1995.

Oshima, Ken Tadashi. "The Japanese Garden City: The Case of Denenchofu." *Journal of the Society of Architecture Historians* 55, no. 2 (June 1996): 140–151.

Ōta Naoyuki, ed. *Matsue shōkō kaigi jo 40 nen shi (The 40-Year History of the Matsue Chamber of Commerce)*. Matsue: Matsue shōkō kaigi jo, 1934.

Pak Cho. *Ri chō kōgei to kotō no bi (Yi Dynasty Crafts and the Beauty of Old Ceramics)*. Tokyo: Tōyō keizai nippō sha, 1976.

Peattie, Mark R. Introduction to *The Japanese Colonial Empire, 1895–1945*, ed. Ramon H. Myers and Mark R. Peattie, 3–52. Princeton, N.J.: Princeton University Press, 1984.

——. "Japanese Attitudes toward Colonialism: 1895–1945." In *The Japanese Colonial Empire: 1895–1945*, ed. Ramon H. Myers and Mark R. Peattie, 80–127. Princeton, N.J.: Princeton University Press, 1984.

Pierson, Stanley. *British Socialists: The Journey from Fantasy to Politics*. Cambridge, Mass.: Harvard University Press, 1979.

Pincus, Leslie. *Authenticating Culture in Imperial Japan: Kuki Shūzō and the Rise of National Aesthetics*. Berkeley: University of California Press, 1996.

Pinkus, Karen. *Bodily Regimes: Italian Advertising under Fascism*. Minneapolis: University of Minnesota Press, 1995.

Poole, Janet. "Colonial Interiors: Modernist Fiction of Korea." Ph.D. diss., Columbia University, 2004.

Rabinbach, Anson. "The Aesthetics of Production in the Third Reich." Journal of Contemporary History 11 (1976): 43–74.

Reynolds, E. Bruce. "Imperial Japan's Cultural Program in Thailand." In Japanese Cultural Policies in Southeast Asia During World War 2, ed. Grant K. Goodman, 93–116. New York: St. Martin's Press, 1991.

Ri Jinhi. "Ringoku: Yanagi Muneyoshi to Chōsen" (Neighboring Countries: Yanagi Muneyoshi and Korea). In Nihonjin to rinjin (The Japanese and [Their] Neighbors), ed. Nakane Chie, 89–121. Tokyo: Nihon YMCA Dōmei shuppanbu, 1981.

Richards, Thomas. The Commodity Culture of Victorian England: Advertising and Spectacle, 1851–1914. Stanford: Stanford University Press, 1990.

Robertson, Jennifer. Takarazuka: Sexual Politics and Popular Culture in Modern Japan. Berkeley: University of California Press, 1998.

Robinson, Michael Edson. Cultural Nationalism in Colonial Korea, 1920–1925. Seattle: University of Washington Press, 1988.

——. "Ideological Schism in the Korean Nationalist Movement, 1920–1930: Cultural Nationalism and the Radical Critique." Journal of Korean Studies, no. 4 (1982–1983): 247–252.

Rubinfien, Louisa. "Commodity to National Brand: Manufacturers, Merchants, and the Development of the Consumer Market in Interwar Japan." Ph.D. diss., Harvard University, 1995.

Said, Edward. Orientalism. New York: Pantheon Books, 1978.

Saitō Michiko. Hani Motoko: Shōgai to shisō (Hani Motoko: Her Life and Thought). Tokyo: Domesu shuppan, 1988.

Saitō Ryōsuke. "Nihon no kyōdo gangu: Sono ayumi to keifū" (Japanese Folk Toys: Their Development and Genealogy). In Kyōdo gangu jiten (Dictionary of Folk Toys), ed. Saitō Ryōsuke, 19–50. Tokyo: Tōkyōdō shuppan, 1971.

Sand, Jordan. "The Cultured Life as Contested Space: Dwelling and Discourse in the 1920s." In Being Modern in Japan: Culture and Society from the 1910s to the 1930s, ed. Elise K. Tipton and John Clark, 99–118. Honolulu: University of Hawaii Press, 2000.

——. House and Home in Modern Japan: Architecture, Domestic Space, and Bourgeois Culture, 1880–1930. Cambridge, Mass.: Harvard University Press, 2003.

Sato, Barbara. The New Japanese Woman: Modernity, Media, and Women in Interwar Japan. Durham, N.C.: Duke University Press, 2003.

Shiga, Naoya. A Dark Night's Passing, trans. Edwin McClellan. Tokyo: Kodansha International, 1979.

Shikiba Ryūzaburō. Mingei to seikatsu (Mingei and Daily Life). Tokyo: Ochanomizu shobo, 1943.

Shillony, Ben-Ami. Politics and Culture in Wartime Japan. Oxford: Oxford University Press, 1981.

Silverberg, Miriam. Changing Song: The Marxist Manifestos of Nakano Shigeharu. Princeton, N.J.: Princeton University Press, 1990.

——. "Constructing the Japanese Ethnography of Modernity." *Journal of Asian Studies* 51, no. 1 (February 1992): 30–54.

Silverman, Debora L. *Art Nouveau in Fin-de-Siècle France: Politics, Psychology, and Style*. Berkeley: University of California Press, 1989.

Simeone, William E. "Fascists and Folklorists in Italy." *Journal of American Folklore* 91, no. 359 (1978): 543–557.

Smith, Kerry. *A Time of Crisis: Japan, the Great Depression, and Rural Revitalization*. Cambridge, Mass.: Harvard University Press, 2001.

Sontag, Susan. "Fascinating Fascism." In *Under the Sign of Saturn*, 73–105. New York: Farrar, Strauss, and Giroux, 1980.

Spaulding, Robert M., Jr. "The Bureaucracy as a Political Force, 1920–1945." In *Dilemmas of Growth in Prewar Japan*, ed. James William Morley, 33–80. Princeton, N.J.: Princeton University Press, 1971.

——. "Japan's 'New Bureaucrats.' " In *Crisis Politics in Prewar Japan: Institutional and Ideological Problems in the 1930s*, ed. George M. Wilson, 50–81. Tokyo: Sophia University Press, 1970.

Speidel, Manfred, and the Sezon Museum of Art, eds. *Bruno Taut Retrospective: Nature and Fantasy*. Tokyo: Treville Co., 1994.

Stansky, Peter. *Redesigning the World: William Morris, the 1880s, and the Arts and Crafts*. Princeton, N.J.: Princeton University Press, 1985.

Starr, Frederick. *Japanese Collectors and What They Collect*. Chicago: The Bookfellows, 1921.

Steele, M. William. "Nationalism and Cultural Pluralism in Modern Japan: Sōetsu Yanagi and the Mingei Movement." In *Kindaika to kachikan (Modernization and Values)*, ed. Masayoshi Uozumi and M. William Steele. Tokyo: International Christian University, Asian Cultural Research Institute, 1992.

Stewart, Susan. *On Longing: Narratives of the Miniature, the Gigantic, the Souvenir, the Collection*. Durham, N.C.: Duke University Press, 1993.

Stinchecum, Amanda Mayer. "Bashōfu, the Mingei Movement and the Creation of a New Okinawa." In *Material Choices: Refashioning Bast and Leaf Fibers in Asia and the Pacific*, ed. Roy Hamilton and B. Lynne Milgram. Los Angeles: UCLA/Fowler Museum, forthcoming.

Suzuki Kenji. *Kōgei (Craft)*. In *Genshoku gendai Nihon no bijutsu (Modern Japanese Art in Living Color)*, ed. Sōga Tetsuo. Vol. 14. Tokyo: Shogakkan, 1980.

——. *Tōgei I (Ceramic Art I)*. In *Genshoku gendai Nihon no bijutsu (Modern Japanese Art in Living Color)*, ed. Sōga Tetsuo. Vol. 15. Tokyo: Shogakkan, 1979.

Suzuki Minoru. "Aota Gorō to Kamigamo kyōdan" (Aota Gorō and the Kamigamo Guild). *Mingei techō* 108 (May 1967): 13–16.

——. "Kamigamo kyōdan no hitobito: Yanagi sensei o shinonde" (People of the Kamigamo Guild: In Memory of Professor Yanagi). *Mingei techō* 43 (December 1961): 11–15.

Suzuki Naoshi. *Maboroshi no Nihon mingei bijutsukan: Enshū no mingei undō to sono gunzō (The Phantasmatic Japan Mingei Art Museum: The Mingei Movement and Its Group in Enshū)*. Iwata: Shūgetsu bunka shūdan, 1992.

Takahashi Yoshio. *Taishō meiki kan* (*Taisho Catalogue of Famous Tea Objects*). 9 vols. Tokyo: Taishō meiki kan hensanjo, 1922–1931.

Takaoka Hiroyuki. "Dai Nippon sangyō hōkokukai to 'dōrō bunka': Chūō honbu no katsudō o chūshin ni" (The Japanese Industrial Patriotic Association and "Work Culture": Centering on the Activities of the Central Office). *Senjika no senden to bunka* (*Wartime Propaganda and Culture*), no. 7 (2001): 37–80.

———. "Kankō—kōsei—ryokō: Fuashizumu ki no tsuurizumu" (Tourism—Welfare—Travel: Tourism in the Fascist Period). In *Bunka to fuashizumu* (*Culture and Fascism*), ed. Kitagawa Kenzō and Akazawa Shirō, 9–52. Tokyo: Nihon keizai hyōronsha, 1993.

———. "Sōryoku sen to toshi: Kōsei undō o chūshin ni" (Total War and Cities: Centering on the Recreation Movement). *Nihon shi kenkyū* (*Research in Japanese History*), no. 415 (March 1997): 145–169.

Takasaki Sōji. *Chōsen no tsuchi to natta Nihonjin: Asakawa Takumi no seishō* (*A Japanese Who Became Part of Korea: The Life of Asakawa Takumi*). Tokyo: Sōfūkan, 1982.

———. "Yanagi Muneyoshi to Chōsen: 1920 nendai o chūshin ni" (Yanagi Muneyoshi and Korea: The 1920s). *Chōsen shi sō*, no. 1 (June 1979): 65–107.

———. "Yanagi Muneyoshi to Chōsen: Kankei nenpu" (Yanagi Muneyoshi and Korea: A Chronology). In Yanagi Muneyoshi, *Chōsen o omou* (*Thinking about Korea*), ed. Takasaki Sōji, 237–246. Tokyo: Chikuma shobō, 1984.

Takashimaya bijutsubu 80 nen hensan iinkai, ed. *Takashimaya bijutsubu 80 nen shi* (*The 80-Year History of the Art Department of Takashimaya*). Osaka: Kabushiki gaisha Takashimaya, 1992.

Takenaka Hitoshi. *Yanagi Muneyoshi—mingei—shakai riron: Karuchuraru sutadeiizu no kokoromi* (*Yanagi Muneyoshi—Mingei—Social Theory: An Essay in Cultural Studies*). Tokyo: Akashi shoten, 1999.

Takeuchi Yō. *Risshin shusse shugi: Kindai Nihon no roman to yokubō* (*Careerism: Modern Japanese Novels and Desire*). Tokyo: Nihon hōsō shuppan kyōkai, 1997.

Tanaka, Stefan. *Japan's Orient: Rendering Pasts into History*. Berkeley: University of California Press, 1993.

Tanigawa Kenichi, ed. *Hōgen ronsō* (*Dialect Controversy*). Vol. 2 of *Waga Okinawa* (*Our Okinawa*). Tokyo: Mokujisha, 1970.

Tansman, Alan. *The Aesthetics of Japanese Fascism*. Berkeley: University of California Press, forthcoming.

———. Introduction to *Fascist Culture in Japan*, ed. Alan Tansman. Durham, N.C.: Duke University Press, forthcoming.

Taut, Bruno. *Houses and People of Japan*. Tokyo: Sanseido, 1937.

———. *Nihon: Tauto no nikki* (*Japan: Taut's Diary*), trans. Shinoda Hideo. Vol. 1. Tokyo: Iwanami shoten, 1955.

———. *Nihonbi no saihakken* (*The Rediscovery of Japanese Beauty*). Tokyo: Iwanami shoten, 1998.

———. *Tauto zenshū* (*The Complete Works of Taut*). 6 vols. Tokyo: Ikuseisha Kōdōkaku, 1942–1944.

Taylor, George E. *Japanese Sponsored Regime in North China*. 1939; New York: Institute of Pacific Relations, 1980.

Thompson, E. P. *William Morris: Romantic to Revolutionary*. New York: Pantheon Books, 1977.

Thornbury, Barbara E. *The Folk Performing Arts: Traditional Culture in Contemporary Japan*. Albany: State University of New York Press, 1997.

Tiersten, Lisa. *Marianne in the Market: Envisioning Consumer Society in Fin-de-Siècle France*. Berkeley: University of California Press, 2001.

Tomimoto Kenkichi. *Tomimoto Kenkichi chosaku shū (Selected Writings of Tomimoto Kenkichi)*. Tokyo: Satsuki shobō, 1981.

———. *Yōhen zakki (Kiln Notes)*. Tokyo: Bunka shuppan kyoku, 1975.

Tominaga Shizurō. *Mingei gotoshi hana—Miyake Chūichi (Mingei Like Flowers—Miyake Chūichi)*. Osaka: Nihon Kōgeikan, 1981.

Tomiyama Ichirō. *Senjō no kioku (Memories of the Battlefield)*. Tokyo: Nihon keizai hyōron sha, 1995.

Tonomura Kichinosuke. *Manshū—Pekin mingei kikō (Manchuria and Beijing Mingei Travelogue)*. Tokyo: Kayōsha, 1983.

Tottori Mingei Kyōkai, ed. *Yoshida Shōya: Mingei purodyūsaa (Yoshida Shōya: Mingei Producer)*. Tottori shi: Tottori mingei kyōkai, 1998.

Tsurumi, E. Patricia. *Factory Girls: Women in the Thread Mills of Meiji Japan*. Princeton, N.J.: Princeton University Press, 1990.

Tsurumi Shunsuke. *Yanagi Muneyoshi*. Tokyo: Heibonsha, 1976.

Tsurumi Shunsuke, and Masuda Katsumi. "Taidan: Kindai Nihon no riteihyō—Yanagi Muneyoshi o megutte" (Dialogue: Modern Japanese Milestones—With Reference to Yanagi Muneyoshi). *Kokugo tsūshin*, no. 179 (September 1975): 2–21.

Ubukata Naokichi. "Nihonjin no Chōsenkan: Yanagi Muneyoshi o tōshite" (Japanese Views of Koreans: Yanagi Muneyoshi). *Shisō* (October 1961): 66–77.

Ueda Kisaburō. *Tōkō shokunin no seikatsu shi: mingei Ushinoto no oyakata no shōgai (The Life History of a Potter: The Career of the Master of the Mingei [Kiln] Ushinoto)*. Tokyo: Ochanomizu shobo, 1992.

Vaporis, Constantine. *Breaking Barriers: Travel and the State in Early Modern Japan*. Cambridge, Mass.: Council on East Asian Studies, Harvard University, 1994.

Varley, Paul. "Chanoyu: From the Genroku Epoch to Modern Times." In *Tea in Japan: Essays on the History of Chanoyu*, ed. Paul Varley and Kumakura Isao, 161–194. Honolulu: University of Hawaii Press, 1989.

Warner, Langdon. *The Enduring Art of Japan*. New York: Grove Press, 1952.

Waswo, Ann. "The Transformation of Rural Society, 1900–1950." In *The Cambridge History of Japan 6*, ed. Peter Duus, 541–605. New York: Cambridge University Press, 1988.

Wendelken, Cherie. "Pan-Asianism and the Pure Japanese Thing: Japanese Identity and Architecture in the Late 1930s." *positions: east asia cultures critique 8*, no. 3 (winter 2000): 819–828.

Whisnant, David E. *All That Is Native and Fine: The Politics of Culture in an American Region.* Chapel Hill: University of North Carolina Press, 1983.

Whitford, Frank. *Bauhaus.* London: Thames and Hudson, 1984.

Wigen, Kärin. "Constructing Shinano: The Invention of a Neo-Traditional Region." In *Mirror of Modernity: Invented Traditions in Modern Japan*, ed. Stephen Vlastos, 229–242. Berkeley: University of California Press, 1998.

———. *The Making of a Japanese Periphery, 1750–1920.* Berkeley: University of California Press, 1995.

Williams, Raymond. *Culture and Society, 1780–1950.* New York: Columbia University Press, 1960.

Wright, A. W. *G. D. H. Cole and Socialist Democracy.* Oxford: Oxford University Press, 1979.

Yamada Mitsuharu. *Fujii Tatsukichi no shōgai (The Life of Fujii Tatsukichi).* Nagoya: Fūbaisha, 1974.

Yamagata Prefecture, ed. *Yamagata ken shi (History of Yamagata Prefecture),* vol. 5. Yamagata: Yamagata Prefecture, 1986.

Yamaguchi Masao. *"Haisha" no seishinshi (A History of the Spirit of "the Vanquished").* Tokyo: Iwanami shoten, 1995.

Yanagi Muneyoshi. *Yanagi Muneyoshi senshū (Selected Works of Yanagi Muneyoshi).* 10 vols. Tokyo: Shunjūsha, 1954–55.

———. *Yanagi Muneyoshi zenshū (Collected Works of Yanagi Muneyoshi)* [YMz]. 22 vols. Tokyo: Chikuma shobō, 1980–1992.

Yanagi, Sōetsu. *Folk-Crafts in Japan.* Trans. Shigeyoshi Sakabe. Tokyo: Kokusai Bunka Shinkokai, 1936.

———. *The Unknown Craftsman: A Japanese Insight into Beauty.* Adapted by Bernard Leach. Trans. Mihoko Okamura. New York: Kodansha International, 1972.

Yoshida Shōya. *Mingei nyūmon (Introduction to Mingei).* Tokyo: Hoikusha, 1973.

———. *Yurin tanka (Stretcher on Wheels).* Tokyo: Bokuya shoten, 1940; repr., Tokyo: Makino shuppansha, 1971.

Yoshimi Shun'ya. *Hakurankai no seijigaku: Manazashi no kindai (The Politics of Expositions: The Modernity of the Gaze).* Tokyo: Chūkō shinsho, 1992.

Young, Louise. *Japan's Total Empire: Manchuria and the Culture of Wartime Imperialism.* Berkeley: University of California Press, 1998.

# Index

Abe Eijirō, 97, 276 n. 14
Ainu, 175, 176, 208, 212
Akaboshi Gorō, 17, 19
Aota Gorō, 62, 63–64, 110
Aoyama Jirō, 33, 60, 65, 70, 101, 250 n. 62
Aoyama Tamikichi, 101
Ariga Kizaemon, 244 nn. 131–132
Arisaka Yōtarō, 80
Ariyoshi Chūichi, 26
Art Nouveau, 55, 59. *See also* France
Arts and Crafts movement: in England, 1, 51, 53, 58–59; in Europe and the United States, 1
*Asahi gurafu (Asahi Graph)*, 45
*Asahi shinbun (Asahi Newspaper)*, 213, 216
Asakawa Noritaka, 7, 11, 15, 17–20, 33–35, 177, 183
Asakawa Takumi, 11, 33, 42, 177, 183
Asia: arts of, 3, 19, 27, 29; Japanese efforts to control and reform, 3, 5, 173–176, 180, 185–186, 187, 189, 195–204, 219; seikatsu bunka and, 6, 146, 155, 186, 195–207; the West and, 10, 27, 36, 188, 197; modernity of, 69, 234 n.56; Japanese regional culture in rela-

tion to, 154, 219; mingei activism and, 155, 174, 175, 186–207; Korea and, 180, 185–186. *See also* Orient

Bauhaus art and design school, 59, 135, 225, 239 n. 59
Beauty of Labor office, 170, 172. *See also* Germany: Nazi; Strength through Joy
Beijing, 187, 188, 189, 191, 192, 198, 204–206. *See also* China
Blake, William, 22
Borneo, 210
Buddhism: tea ceremony and, 14; Zen, 14; sculpture and, 22, 28–29, 40–48, 177; ancient Oriental civilization and, 27–29, 33, 47; Shingon sect of, 42; Yanagi Muneyoshi's ideas about art and, 51, 60, 276 n. 9; priests or monks of, 44, 185; Daihonkyō sect of, 88; concept of *tariki* and, 96. *See also* Mokujiki Shōnin
Bunka seikatsu (culture life), 148–150, 153. *See also* Seikatsu bunka

Cabinet Information Bureau, 124, 136, 146, 153, 166, 169, 200. *See also* Renovationism

A version of chapter 1 was published as "Objects of Desire: Japanese Collectors and Colonial Korea" in *positions: east asia cultures critique* 8, no. 3 (winter 2000): 711–746.

Kim Brandt is an associate professor of Japanese history
at Columbia University.

Library of Congress Cataloging-in-Publication Data
Brandt, Lisbeth K. (Lisbeth Kim)
Kingdom of beauty : mingei and the politics of folk art in
Imperial Japan / Kim Brandt.
p. cm. — (Asia-pacific: culture, politics, and society)
Includes bibliographical references and index.
ISBN 978-0-8223-3983-0 (cloth : alk. paper)
ISBN 978-0-8223-4000-3 (pbk. : alk. paper)
1. Folk art—Japan. 2. Decorative arts—Japan
3. Art, Japanese—20th century.
4. World War, 1939–1945—Art and the war
I. Title.
NK1071.B73 2007
745.0952—dc22                           2006037999